ART POTTERY
OF AMERICA

by Lucile Henzke

77 Lower Valley Road, Atglen, PA 19310

Dedication

To Jerry, my husband and best friend, who assisted me every step of the way, and all our many friends who encouraged us and contributed much valuable information.

The Grueby piece on the cover is courtesy of JMW Gallery, Boston, Massachusetts.

Revised edition 1996

Printed in China

ISBN: 0-7643-0159-4

Published by Schiffer Publishing, Ltd.
77 Lower Valley Road
Atglen, PA 19310
Please write for a free catalog.
This book may be purchased from the publisher.
Please include $2.95 postage.
Try your bookstore first.

We are interested in hearing from authors
with book ideas on related subjects.

Acknowledgments

The author expresses her sincere thanks to everyone who contributed to this collection of facts and permitted examination of their collections and other materials. To the following she owes deepest gratitude: Mrs. Charles G. Benham, Brenda A. Brown, Rumell and R. L. Culps, Virginia Cummins, Mark and Dick Downey, Ruth Dumas, Joseph F. Estes, John Frank, Dr. and Mrs. Gordon Gifford, Ervalee Hecker, Sharon and Bob Huxford, Phyllis Larson, Rena and Bryce London, Moses Mesre, the Ohio Historical Society, Mrs. Nelson Rainey, Norris F. Schneider, Charles Sherrell, Joyce Smalley, Catherine W. Smither, the Stangl Pottery, Marjo and Len Tunnell, Arthur (Art) Wagner, and E. Stanley Wires.

Thanks are also extended to museums and libraries that so generously assisted along the way.

Special acknowledgment is made to Mr. Albert Christian Revi for his constant encouragement, guidance, and tolerance and to *Spinning Wheel Magazine* for permitting use of material appearing in its publications.

Heartfelt thanks are given to Oma Anderson for permission to scan through her vast library of information to obtain a portion of pertinent data for this treatise.

A very special credit is due a young and talented artist friend, David Thompson, for his generous contribution of some of the sketches appearing in this book.

To Frances Hall, the author gives many, many thanks for her immense assistance and patience, without which this book would not be as complete.

Black and white photos by Wade H. Knight, Dallas, Texas; Jesse Johnson, Fort Worth, Texas; and Raymon Orren, Fort Worth, Texas.

Color photos by Wade H. Knight, Dallas, Texas; and Edward D. Sutton, Photo/Sutton, Hurst, Texas.

Introduction

This story of American art pottery is a chronology of events from the beginning days to the time the potteries closed their doors. Nothing has been included that did not seem a reasonable assumption from the records and research. In writing about this fascinating art, the author had but one idea in mind, and that was to influence her readers to enjoy what they collect.

There are few social phenomena in American history more striking than the growth of the arts in the late nineteenth and early twentieth centuries. The United States was just beginning to awaken to the importance of these as a part of its economy, with ceramic arts being one of the most important. Perhaps, among the most significant of these arts is art pottery. It is a ware fashioned of clay, crafted for ornamental use only, and is covered in a variety of unique glazes. Ceramics exhibit the creator's own skill and individuality in shape and decoration.

Prior to 1870, most of the art pottery was imported from England, Germany, other European countries, as well as the Orient. At the turn of the century, movie palaces, plush hotels and homes with parlors were barren indeed without some specimens of art pottery on display. Educators in the United States, realizing the importance of teaching the ceramic arts in native institutions and educational facilities, added the art of potting to their curriculum. Alfred University, under the supervision of Professor Charles F. Binns, an Englishman, was the first to place this teaching into effect. Other schools soon followed...among them, Sophia Newcomb Memorial College in New Orleans, La., under the supervision of Professor Ellsworth Woodard. Another was the I. Broome School of Industrial Arts of Trenton, New Jersey.

Art pottery, as a popular commodity, actually had its beginning in 1876 when the World's Fair, commonly called the Centennial, was held in Philadelphia. This attraction was attended by artists who were already beginning to test native clays and perfect new glazes. These talented people were especially inspired by the displays shown by the French and Japanese, thus encouraging them to further research and work at their task. The first to delve seriously in this medium were T. J. Wheatley, Louise McLaughlin, Maria Longworth Nichols (Storer) and a few others.

Potteries began to appear all across the nation. Many became successful while others lasted only a short while. Those who were already in operation commenced creating art wares. Artists and artist chemists, from abroad as well as local talent, were employed by these potteries.

There were a number of significant indigenous glazes and decorations produced by American art potters and each one is something to be studied and admired. The mixture of these glazes were jealously guarded secrets. Often times the men who mixed them were given a scale or measure which would automatically indicate when a sufficient amount of a certain ingredient had been added. In this manner, the workmen really didn't know the exact formula. Perhaps the most beautiful and important innovation among glazes was the "under-the-glaze" slip painting. This technique was patented by T. J. Wheatley in September, 1880. Others were experimenting with this type decoration, including Matt Morgan, Maria Longworth Nichols and Louise McLaughlin. In the May issue (1881) of *Harper's* magazine, Dr. Marcus Benjamin stated: "Wheatley was unselfish in regard to his discoveries and those who desired to learn these new processes were welcome to his establishment on Hunt Street in Cincinnati, Ohio".

The artists and artist-chemists were

constantly experimenting with new type glazes, decorations and shapes. The result was new lines were introduced frequently. Intricate and rich glazes were developed similar to the Chinese type, such as: "Sang de Boeuf" (Roseville's "Mongol") and Dedham's ("Sang de Chelsea"). One unique glaze was a type using a variety of colors with overflowing and running effects, such as: Dedham's ("Volcanic"), Clifton's ("Crystal Patina") and Fulper's ("Flambe") lines. Consequently, these have an ever changing and variable beauty imparted to each article. Later, matt glazes were developed. These were distinguished by the absence of gloss, with their soft smooth surface and were decorated in every conceivable manner...hand painted, sgraffito, intaglio, molded in high or low relief and sometimes further embellished with silver or copper. Ordinarily on pottery with a matt finish, the decoration and glaze were fired separately. However, on some pottery the glaze and decoration were fired at the same time. The most beautiful and fascinating ware, in the history of ceramics in the United States, was perhaps created in the period from 1880 to the 1920s. Actually it would be an impossibility to place an exact date on works of art. Hopefully, there will always be creative artisans among us as long as there is an America.

At the beginning of World War I, the cost of producing hand decorated art pottery became exorbitant and was augmented by art ware cast in molds and then finished by hand. The finishing could be accomplished by non-artists and sold at a more realistic price. Many of these pieces were assuredly works of art, reflecting the fine ability and artistic acheivement of the designers and sculptors.

Almost all the potteries gave each line they produced a name, often times suggestive of its color or decoration. At times, the wares were named for the talented innovators. Others were given a name at random, however, each piece was given a definite name. This became a custom among all important potteries and is a practice that has continued.

The custom of placing a factory mark on the base of the ware was used extensively, from the outset, making identification less difficult. Few pieces escaped being so marked, however, identical pieces will occasionally be found that carry a paper label or some type of company mark, such as a number. Many times, marks include the entire name of the pottery or potter, such as: Van Briggle and Weller. Others are marked with monograms which include the pottery location. On some of the earlier wares, the line name will appear along with the company marks.

Many of the hand decorated wares were artist signed or monogrammed. Some were also dated, especially Rookwood pottery, who definitely included a system of dating within the company marks. As a puzzling complication, identical signatures or monograms are found on pieces produced by different potteries. This resulted from a few artists who moved from one well known pottery to another. In 1904, Dr. Edwin Atlee Barber compiled a book titled "Marks of American Potters" in which he recorded a brief company history and their marks together with artists and their monograms. This book definitely left invaluable thumbnail sketches of those who participated in early ceramics history of America.

Few potteries in the United States are today actively creating so called art pottery. Hand decorated ware is no longer economically feasible, however, there are some hand-thrown sculptured and decorated wares being produced presently. These few excellent pieces are produced in very limited quantities, a situation that strengthens the importance of "art pottery" in American history.

Due to the controversy concerning the definition of "art pottery" per se, the author wishes to explain that all articles included in this treatise might not be considered art pottery by some collectors and authorities, however, art pottery simply defined is...any article created by a gifted artist, for beauty rather than utility, and could encompass even table ware. To quote an old cliche'. "Beauty is in the eye of the beholder".

The following is an excerpt taken from an article written in December, 1905, by Lura Milburn Cobb, after she had visited several of the potteries in Zanesville, Ohio. We feel it is quite a tribute to the creators of American art pottery.

In this lovely spot, art is truly the child of nature. The genius of the art-

ist here calls together the primeval elements from beneath his feet to do his bidding. Earth, water and fire bend to the task, and to him bring the product of their united labors. He clothes the varied shapes of beauty in the soft rich colors that please him best, and then across each shining bosom he lays, with exquisite grace, a nodding iris, a spray of apple blossoms, or a rosy thistle bloom, and in their fadeless, triumphant beauty sends them forth to adorn and bless the homes and lives of the children of men.

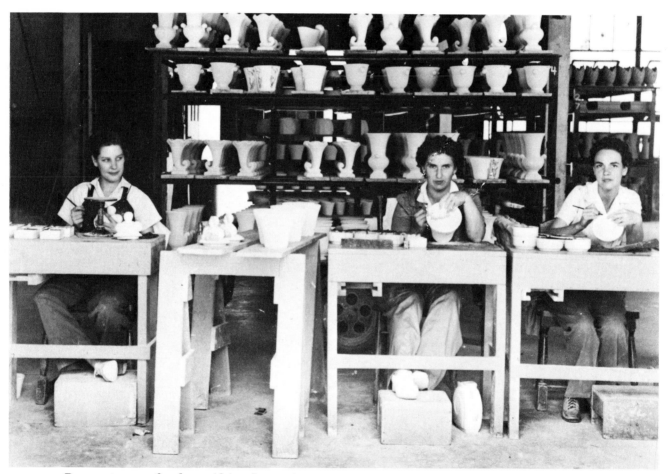

Decorators of the Abingdon Art Pottery in 1944. Pictured from left to right--Doris Kilpatrick, Bernice McMillan, and Arlene Cobb. The ware on the cart behind the decorators is waiting to be decorated

Table of Contents

Acknowledgments iii

Introduction iv

Abingdon Pottery 9

Arequipa Pottery 17

Avon Pottery 22

Buffalo Pottery - Deldare 24

Bybee Pottery 30

Camark Pottery 32

Cambridge Art Potter 39

Chelsea Keramic Art Works - Dedham Pottery 42

Cincinnati Art Pottery 48

Clewell Art Ware 49

Cordey China Company - Cybis 51

Cowan Pottery 60

Frankoma Pottery 63

Fulper Pottery - Stangl Pottery 73

Gates Pottery - Teco Ware 82

Grueby Pottery 84

Haeger Pottery Incorporated 87

Imperial Porcelain Corporation 95

Jugtown Pottery 126

Lonhuda Pottery 129

McCoy Pottery 132

M. Louise McLaughlin Pottery 140

Maria Pottery 141

Price Guide 169

Matt Morgan Art Pottery 147
Muncie Pottery 149
Newcomb Pottery 151
Niloak Pottery 159
J. B. Owens Pottery 163
Paul Revere Pottery 169
Pauline Pottery 171
Pennsbury Pottery 174
Peters and Reed — Zane Pottery 177
Pigeon Forge Pottery 180
Pisgah Forest Pottery 182
A. Radford and Company 186
Red Wing Potteries Incorporated 191
Rookwood Pottery 195
Roseville Pottery 226
Southern Potteries Incorporated, Blue Ridge Line 257
Tiffany Pottery 261
Van Briggle Pottery 265
Vernon Kilns 271
Weller Pottery 277
T. J. Wheatley and Company — Wheatley Pottery
 Company 349
Pottery Tiles 352
Bibliography 361
Index of Lines and Patterns 362
Index of Pottery Locations 364
General Index 364

Abingdon Pottery
1934—1950

The real beginning of the Abingdon Pottery goes back to August, 1908, when the Abingdon Sanitary Manufacturing Company was organized in Abingdon, Illinois with Dr. C. F. Brodway as president and F. L. Torrance as secretary. In September of that year, James Simpson, one of the founders of the Company, came to Abingdon from New Castle. He was joined by Albert Simpson, Carl Smith, Sam Hoover, and Dominick Fiacco...men all experienced in the pottery business.

In 1922, when J. E. Slater assumed the Company presidency, business began to prosper. The North Plant was completed a few years later on the present site in Abingdon. During the depression year of 1934, more revenue was needed and Abingdon pottery came into being. The Sanitary Manufacturing Company was facing bankruptcy and it became too expensive to keep two plants in operation.

Raymond E. Bidwell, who had been elected president in 1933, originated the idea of producing art pottery in the plant using the same equipment and material as was used in the production of plumbing fixtures, consequently, the most recognizable feature of Abingdon pottery is the material it is made of; a true white vitreous porcelain.

The Pottery engaged several experienced artisans in the field of ceramics. The first designer was Eric Hertslet of St. Louis. He was at Abingdon for only a short time as he lost his life in an airplane crash shortly after joining the organization. Other designers were Leslie Moody and his wife Frances, V. B. Stockdale, George Bidwell, and Ralph Nelson. Both of the Moodys were experts in the field of ceramics and pottery, as Mr. Moody had graduated as a ceramic major from Ohio State, and Mrs. Moody had a similar background.

Prior to coming to Abingdon, Mrs. Moody was involved in a small business selling ceramics she designed and produced. At Abingdon she designed and sculptured several figurines between 1935 through 1939. These include "Scarf Dancer", "Fruit Girl", "Kneeling Nude", "Nescia Ceramic Figure", and "Shepherdess and Fawn".

Ralph Nelson, who was in charge of the modeling department, was a skilled artist who had been trained by both American and Italian modelers. Along with Mr. Nelson; Joe Pica and Harley Stegall were instrumental in developing more than one thousand designs produced at Abingdon. Arsenio Ippolito, who was employed from 1923 to 1936, was credited with developing new glazes during the latter years of his tenure with the company. He worked with glazes of all colors, but stated that the most difficult one to perfect for Abingdon was the black. When it was used on hard porcelain, it tended to run and did not cover well.

George E. Bidwell joined the Abingdon organization in 1939 and was appointed superintendent of the art ware division. In 1941, vases were introduced in two-tone combination, such as; pink lined in ivory, blue lined in ivory and several others; all lined in ivory.

Early in 1942, the hand decorating department was organized with Bernice McMillan in charge. She had been employed in the decorating department at the Haeger Pottery in Macomb, Illinois. Along with her came three other decorators; Eunice McHendry, Delores Helms and Arlene Cobb.

The production of art pottery was expanded in 1945; advertisements were appearing in home magazines. During this same year the name of the Company was changed to Abingdon Potteries, Inc. In October of 1947, the controlling stock of the Company was sold to Briggs Manufact-

uring Company of Detroit. The following year (1948) R. E. Bidwell retired as president. He was replaced by J. M. Lewis, whose tenure with Abingdon Pottery was 29 years.

In 1950, the art pottery production was discontinued and the remaining stock was sold at half price. Some of the equipment was purchased by the Haeger Pottery and others. The molds were sold to Pigeon Pottery at Barnhart, Missouri and later were used at Western Stoneware, Monmouth, Illinois. The Pottery is presently the Briggs Division of the Celotex Corporation and only plumbing fixtures are in production.

The wares made by Abingdon other than the figurines were cookie jars, vases, planters, small animals, tea pots, lamps, bookends, pitchers, candle holders and others. A vast array of color was used; blue, green, grey, yellow, pink, ivory, black, white and practically any other shade one can think of. Some attractive articles will be found that are decorated in a soft matt finish, somewhat similar to English Royal Worcester and other European wares. These are a warm tan with decal flowers edged in gold. Other shades were also used including silver and gold. These were Abingdon blanks purchased by Chicago decorating firms to be decorated and marketed as their own products. They usually have the Abingdon mark as well as the decorating studio's logo. The studios also purchased blanks from other potteries such as Weller, McCoy, Redwing and others.

All pieces of Abingdon were intended to be marked and all workers were so instructed, however, as in all potteries, some pieces escaped unmarked.

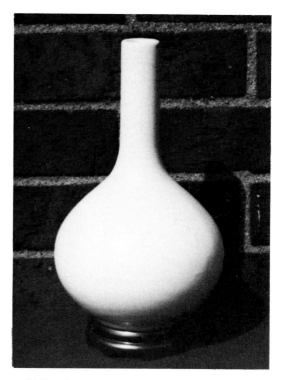

Abingdon Pottery; Sang vase, 10 in. high. #304, white matt glaze. Robert M. Rush collection

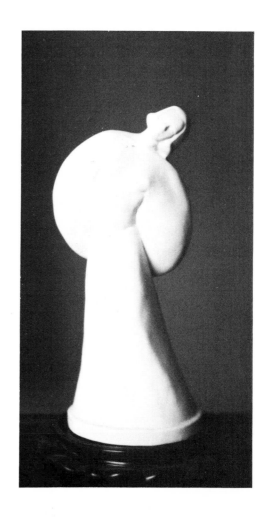

Abingdon Pottery 10" figurine "Scarf Dancer" by Mrs. Moody. Color-white. Collection of Mrs. Ford Perry

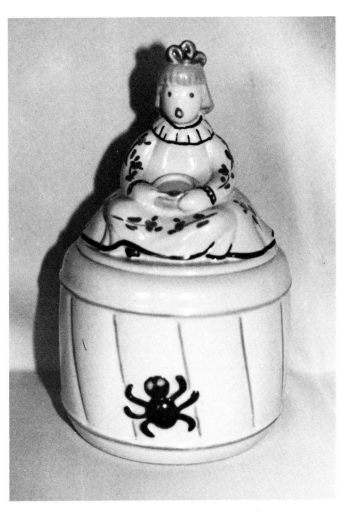

Abingdon Pottery nursery rhyme cookie jar, 10½". "Little Miss Muffet". London collection

Abingdon Pottery cookie jars. Nursery rhyme variety. Left: Humpty Dumpty 10½". Center: Three Bears 8". Right: Jack in the Box 10½". London collection

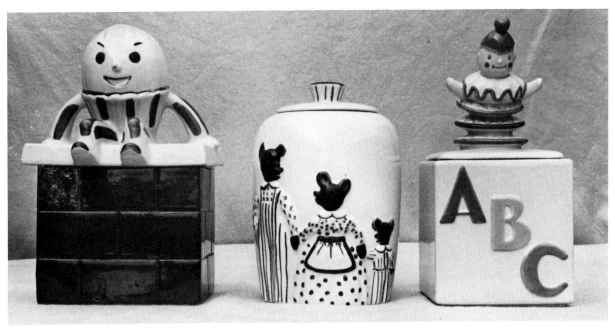

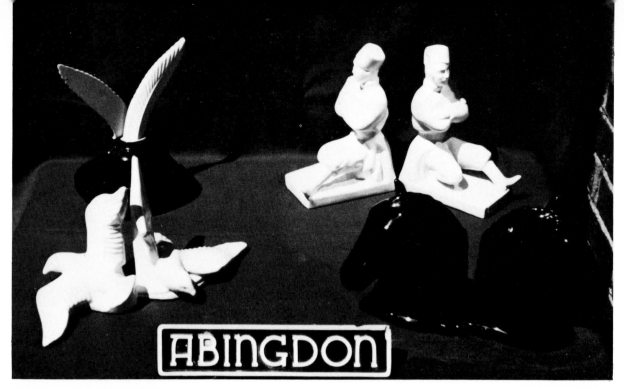

Abingdon Pottery pieces created by Mrs. Moody. Upper left: Quill bookend. White with black base. Lower left: White Sea Gull bookends. Upper right: Russian dancer, white bookends. Lower right: Black horse heads, bookends

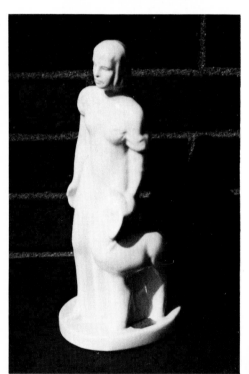

Abingdon Shepherdess and Fawn, 8".
Collection of Robert M. Rush

Abingdon Pottery; vase, 8 in. high. #181 floral yellow and pale green. Collie Tea Tile, #401, color-cream. Square leaf vase #708, white with green leaves. Collection of Robert M. Rush

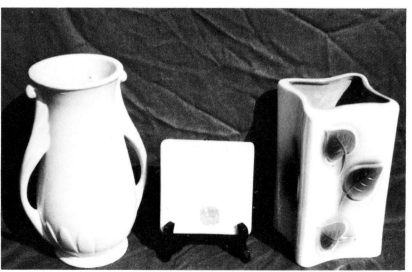

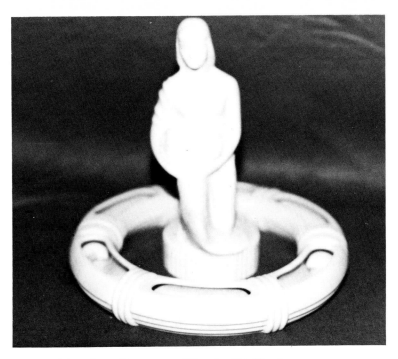

Abingdon Pottery; "Fruit Girl" de-signed by Mrs. Moody, 1937-38. The Arc-de-Fleur around her sold separately. Color-beige. London collection

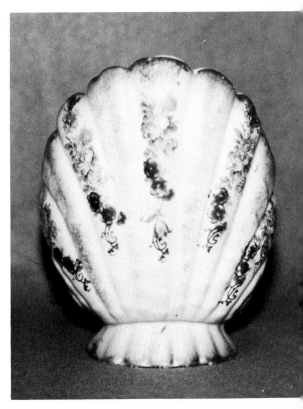

Abingdon Pottery shell vase 8". Decorated by Chicago Decorating Studio. Cream color. London collection

Abingdon Pottery; Cookie jar. White with hand painted flowers. "Smiling Hippopotamus". London collection

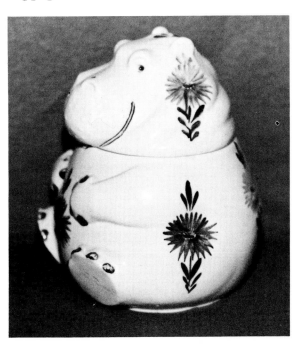

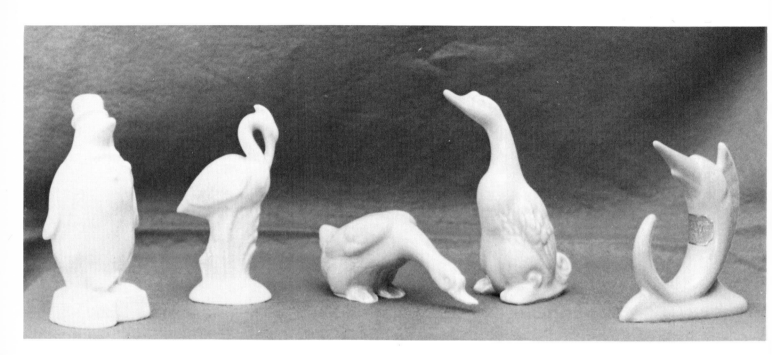

*Abingdon animal collection of Rena
& Bryce London*

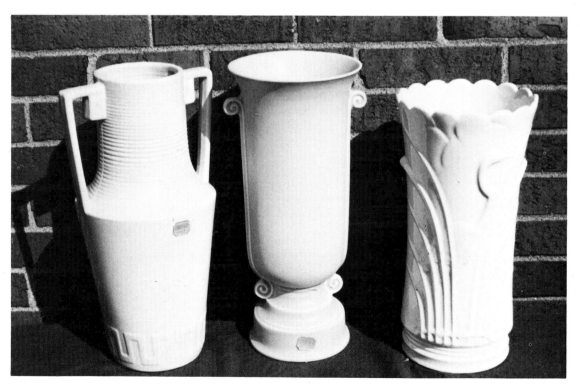

*Abingdon Pottery, left to right; 603
Grecian vase, 8". 412 Valuti vase, 8". 487
Egret floor vase, 7½". Collection of Rena
& Bryce London*

Abingdon Pottery ad from [Better Homes and Garden[October-48. Collection of Rena & Bryce London

Abingdon Pottery ad from [Better Homes and Gardens] December-48. Collection of Rena & Bryce London

A partial list of artists and their marks:

Arlene Cobb	*///*	Betty Dye	*X X*
Hortense Moshier	*H*	Laurence Stoneking	*L S*
John Ross	*J R*		

Marks:

A l

A B I N G D O N

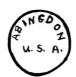

All marks impressed or stamped

All paper labels

Arequipa Pottery
1911—1918

The name of Dr. Philip King Brown is closely bound up in the history of Arequipa Pottery. He founded the Arequipa Tuberculosis Sanatorium at Fairfax, California, in 1911. As project director, he raised the initial capital and acquired the grounds free of charge. It was located above a picturesque canyon in Marlin County. The name Arequipa means "the place of peace," and it was just such a place for the ailing girls who must while away so many long hours.

Several different projects were undertaken, such as basketweaving, loom work, typing, and other things believed to have therapeutic value. Most of these projects proved to be unsatisfactory because of high cost or the fact they were not practical for the patients to handle.

Dr. Brown, who was endeavoring to place the sanatorium on a paying basis, conceived the idea of pottery-making. Dr. Hall, of the Marblehead Pottery of Massachusetts, had established just such a project for the emotionally distressed or disturbed patients with some success. Also, a pottery had proved advantageous to "The Saturday Evening Girls," of the Paul Revere Pottery. This measure of success gave Dr. Brown the encouragement to embark on just such a project himself. Dr. Brown engaged Frederick Hurten Rhead, a ceramist who had formally worked for the Roseville Pottery in Ohio, to aid in the organization of the Arequipa Pottery. Some of the older and more capable boys were brought in from an orphanage in San Francisco to assist with the heavy chores.

From the outset, the girls were allowed to help with every operation that was not too strenuous, which included the decorating of the wares. This proved to be wondrous therapy for the patients. Unluckily, however, this adventure could not operate on a paying basis. In 1914 Rhead was replaced by Albert L. Solon, an Englishman. Even with this change in personnel it was impossible to get Arequipa on a sound financial level and it continued to lose money. Solon consequently resigned, to accept a position at what is now known as San Jose State College.

Solon was replaced by F. H. Wilde in 1916. Mr. Wilde had previous experience in organizing two successful California potteries. The Arequipa system was revised to some extent and things began to look brighter until America's entry into World War I. Production was curtailed due to rising prices, and the closing of the Pottery became compulsory.

Arequipa was made of fine local clays and the decorations, all hand done, were of the modeled and sgraffito types. The motifs were derived from the local flora. The glaze is a soft velvetlike matt glaze. The colors were especially lovely, with rich shades of color, one brushed over the other, with swirls and highlights, such as green with yellow spots. The classic forms were very reminiscent of other pottery of the period.

At the Panama Pacific Exposition in 1915, the girls were allowed to exhibit their wares and demonstrate "throwing on the potters wheel." They were also paid a small salary, plus a percentage on what they sold. This undertaking proved to be quite successful and a gold and two bronze medals were awarded to Arequipa.

Among the agents and outlets for Arequipa pottery were John Wanamaker in New York, Bigelow, Kennerd and Company in Boston, Marshall Field in Chicago, and Dohrmann and Company and The White House in San Francisco. Arequipa is well represented in the Smithsonian Institution.

Although Arequipa Pottery proved to be a financial failure, and was practically totally dependent on individual donations, it did prove, most importantly, that per-

sonal interest and craftsmanship were of marvelous therapeutic value.

A regular system of marking the wares was used throughout the entire existence of the Pottery.

Arequipa vase. Plum glaze, 10 in. high, 5½-in. diameter. Courtesy of the Smithsonian Institution

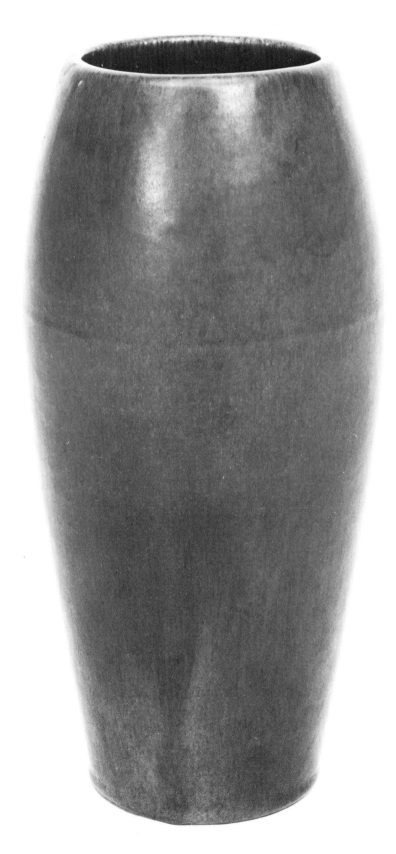

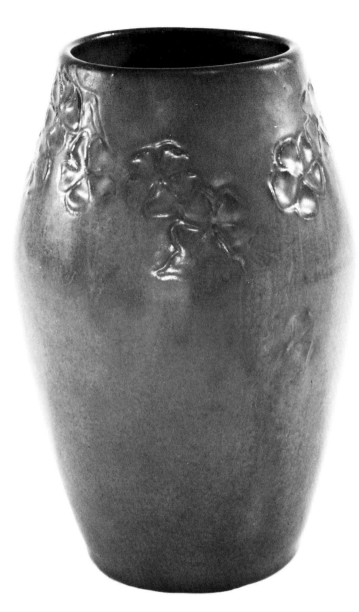

Arequipa vase. Pinkish orange luster glaze, 8¾-in. high, 5½-in. diameter. Courtesy of the Smithsonian Institution

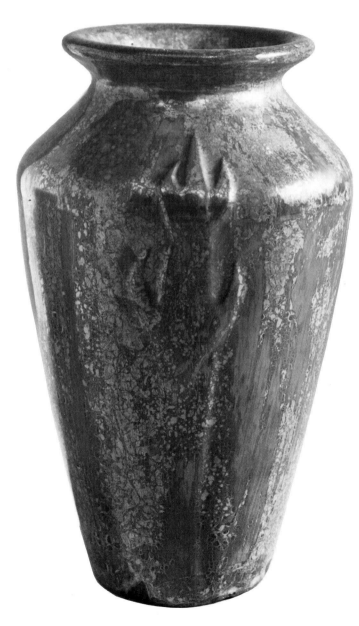

Arequipa vase. Blue-gray glaze, 8 in. high, 6 in. diameter. Courtesy of the Smithsonian Institution

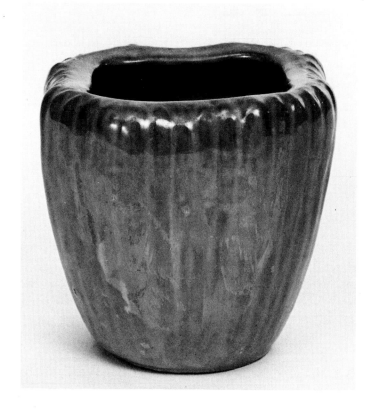

Arequipa vase. Yellow luster, 4 in. high, 4 3/8-in. diameter. Courtesy of the Smithsonian Institution

Arequipa bowl. Mottled aqua and blue glaze, 2 3/8-in. high, 6 in. diameter. Courtesy of the Smithsonian Institution

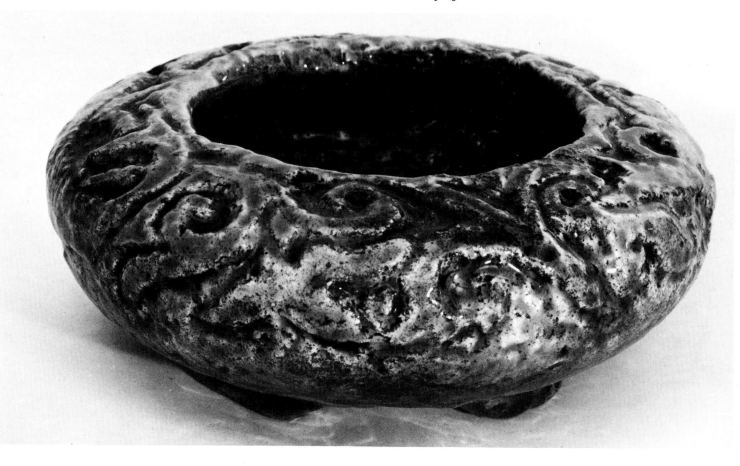

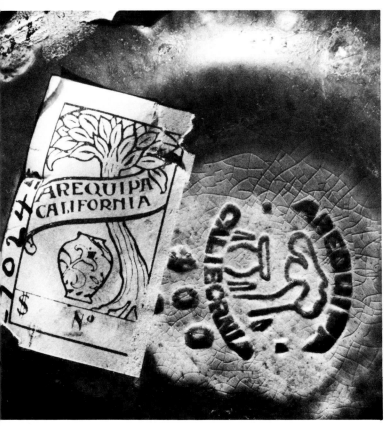

Base of Arequipa piece showing both impressed mark and paper label. Courtesy of the Smithsonian Institution

Arequipa Pottery

Marks:

Printed

Incised by hand

Paper label.
Price and number
also shown at bottom
of label

Impressed

Impressed

Avon Pottery
1886—1887

The Avon Pottery was founded by Karl Langenbeck in January of 1886, in Cincinnati, Ohio. Prior to the opening of this Pottery, Langenbeck had been associated with the Rookwood Pottery, where he had been employed for approximately one year. Avon Pottery was in existence for only one and one half years.

Langenbeck was destined to become one of America's foremost ceramic chemists. In 1895 he wrote a book entitled *Chemistry of Pottery.*

Avon Pottery made the usual ornamental pieces in graceful classical forms. These wares were decorated with both modeled and sgraffito techniques. Heads of elephants, rams, and other animals were modeled and applied as handles to many pieces of this pottery. One variety of ware was the matt glaze on yellow clay. Another was a type similar to Rookwood's standard glaze ware and their Iris ware.

During the brief tenure of the Avon Pottery, Artus Van Briggle worked there as an apprentice, before joining the Rookwood organization in 1887. He later organized the Van Briggle Pottery in Colorado Springs, Colorado.

James McDonald was the principle decorator and did most of the credible art work at Avon. Karl Langenbeck was later associated with the Grueby Pottery, the American Encaustic Tiling Company, and was the organizer of the Mosaic Tile Company of Zanesville, Ohio.

The Avon (Cincinnati, Ohio) firm only used the name "Avon", incised on the base, when and if the wares were marked. The name "Avon" did not include lines or any other accompanying marks. This mark should not be confused with the marks used later by the Wheeling, West Virginia Combine, whose marks include lines, dates and designs incorporated with the name "Avon".

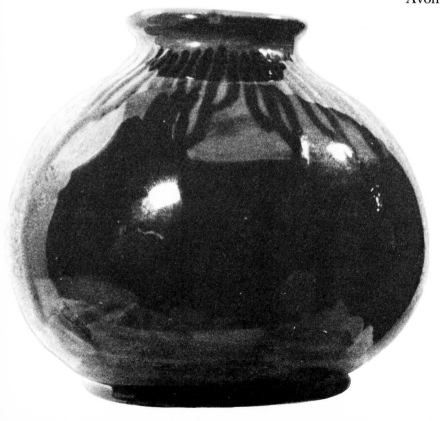

Avon vase. Black stylized trees silhouetted against a deep rust background, marked "Avon," 4 in. high. Collection of Bill G. Smith; Gilbert photo

Avon Pottery

marks:

Avon

AVON

Marks used by the...
Wheeling Potteries Company,
Vance, and/or Avon Faience Company.

AVON

1902

All marks impressed or imprinted

Avon. F.co.
Tiltonville

Impressed or imprinted

The Combine had its beginning in November, 1900 when the Vance Faience Company was incorporated by a group of business men in Tiltonville, Ohio. In 1902, the name was changed to Avon Faience Company. An Englishman, William P. Jervis was acting manager and designer, and was assisted by Fredrick Hurten Rhead. In 1903, the Avon Faience Company in conjuction with Wheeling, Riverside, and La Belle Potteries incorporated to form "The Wheeling Potteries Company". Each of these four individual firms were designated as separate departments of the Wheeling Potteries Company. Art wares for the Wheeling Potteries was created by the Avon Faience department until about 1905.

Buffalo Pottery
1903—1956
Deldare
1908—1909

The Buffalo Pottery was organized in 1902 in Buffalo, New York, and began operations in a new building at Seneca and Hayes Streets in 1903. From the very outset, the company operated nine kilns and employed over one hundred people.

Buffalo Pottery was established by the Larkin Company, manufacturers of soap and toilet products, which had its beginning in 1875, when an enterprising soap salesman, John Durrant Larkin (1845—1926) decided to manufacture his own products. The original product was a bar of yellow laundry soap called "Sweet Home." This product was followed by a liquid soap, also called "Sweet Home" (1879) and a boxed soap powder known as "Boraxine" (1881). Tucked inside each package of Boraxine was a colored lithograph. Thus, the Larkin Company first introduced this method of merchandising to the American housewife. By 1883, fancy toilet soap, cold cream, tooth powder, and other toilet products were added to the Larkin lines. These products were packaged in fancy boxes, always including a premium.

It was Elbert Hubbard, Larkin's brother-in-law and business partner, who became the promoter and introduced the "Club Plan" of premium merchandising. The principle of this plan was that after purchasing a given amount of Larkin products a premium was received. This proved to be so successful that the Larkin Company decided to manufacture their own premium products (among them pottery), thus capturing all the profits.

Elbert Hubbard is perhaps best remembered as the author of the famous book *A Message to Garcia,* published in 1899. Hubbard was also publisher and editor of two small magazines called *Fra* and *Philistine* and a monthly publication known as *Little Journeys.* Hubbard and his wife were lost when the English liner *Lusitania* was torpedoed and sunk, May 7,

1915, by a German submarine, off Head of Kinsale, Ireland.

Operations at the Buffalo Pottery began in 1903 with John D. Larkin as president, a post he held until his death, when he was succeeded by his son, John D. Larkin, Jr. Louis H. Bown, a native of Trenton, New Jersey, was appointed first general manager of the company. Bown brought with him several talented artists and craftsmen, including William J. Rea, who was given the position of production manager.

The first wares produced by the Buffalo Pottery were dinner sets in semivitreous china in the style of the imported French dinnerware and in a blue willow pattern that was exceptionally well executed. They also produced calendar plates and commemorative and historical pieces very similar to wares made by Doulton and other English potters. These dishes were very popular and the company began selling them to retail stores as well as using them as premiums for the Larkin Company.

In 1908 Buffalo Pottery entered the art-pottery field when Bown introduced "Deldare Ware." The development of Buffalo Deldare may be accredited to three men; Bown, Rea, and an artist named Ralph Stuart. Deldare Ware is characterized by a rich olive drab (green) clay formula developed by Rea. Pieces made on this body have been discovered dated as early as 1907 and as late as 1914. These pieces are known as "Deldare Specials" and are not marked with the Deldare mark. These were probably special order pieces or pieces made for the employee's own use. The scarcity of such pieces make them choice collectibles.

Ralph Stuart, Rea, and Bown studied such English literature as *Vicar of Wakefield* and *Cranford* for design ideas. Scenes from these books were reproduced from

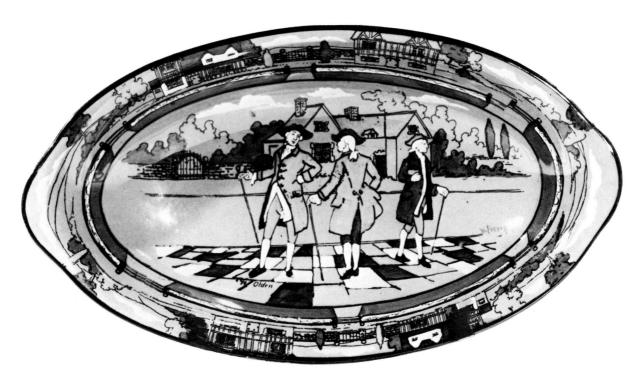

"Deldare" pretzel dish. Titled "Ye Olden Times," signed "W. Foster," 6½ by 12 in. Orren photo

patterns by the Buffalo artists in mineral colors under a fine high-gloss glaze on the regular Deldare Ware produced in 1908 and 1909 and also on the revived issues of 1924 and 1925. The patterns were stamped on the article and the artist filled in the colors as designated by the head designer. The only freehand work the artists were allowed to do was the addition of the white clouds in any manner they chose. Each piece is signed by the artist who finished it.

Many collectors have inquired as to the source of the name "Deldare." No proof has been found that accounts for its origin, although many suggestions have been given. Presently, an air of mystery continues regarding this title. No doubt the three men who developed Deldare could greatly enlighten us on the subject if they were alive today.

The regular Deldare Ware is always banded with a continuous scene, with a titled scene in the center. The borders are always matching while the center subjects change. There are two different patterns in the regular dated Deldare. The first, "The Fallowfield Hunt," has a border of hunters on horseback, racing across the countryside. The subjects in the center follow the hunt from "The Start" to "The Return." These include "Breaking Cover," "The Dash," "The Death," "The Hunt Supper," and "Breakfast at the Three Pigeons." These titles are always written on the face of the article near the bottom. "The

Fallowfield Hunt" scenes were reproduced from the popular colorful prints drawn by the celebrated English artist Cecil Charles Windsor Aldin (1870—1935).

The second pattern, "Ye Olden Times," has a continuous border of old-time two-story houses with the center scenes of the local genre, both indoors and outdoors. The titles of these include "Ye Olden Days," "Ye Lion Inn," "Ye Town Crier," "Ye Village Street," "Ye Village Gossips," and numerous others. Both patterns were made in dinnerware including all sorts of accessories. "Ye Olden Times" pattern was reissued in 1924 and 1925 and was marked and dated correctly. Increased wages and the high price of materials made this ware costly to produce. Because of the exorbitant retail price, it ceased to sell readily and was discontinued again.

A calendar plate was issued in 1910 on the regular Deldare body and is considered extremely rare. This was the only year a calendar plate was produced on the Deldare body.

In 1911 the Buffalo Pottery created a new line which they named "Emerald Deldare." This ware is of the same rich olive drab clay, banded with stylized flowers and geometric designs. A most

popular decoration to be found on Emerald Deldare are the scenes from "The Tours of Dr. Syntax." However, other very popular decorations were also used in art nouveau motifs, geometric designs, stylized flowers and butterflies, dragonflies, peacocks, and outdoor scenes of lakes and mountains. It might be noted here that in 1909 the Pottery produced some pieces with Dr. Syntax scenes. However, these were done in blue instead of the regular Deldare colors. The original caricatures in the Dr. Syntax series were painted in water colors by Thomas Rowlandson while William Combe wrote the verses that accompanied each one.

In 1912, a ware called "Abino" was introduced. This line is decorated with rural, Dutch mill, pastoral, and natural scenes. Abino ware apparently received its name because the designs were similar to the picturesque scenery found at Point Abino, a resort on Lake Erie, a few miles from Buffalo.

Other lines created about this time were "Luna Ware," a pale blue clay formula body, "Cafe'-au-Lait," a soft tan body, and "Ivory Ware" on an ivory clay body. These lines were occasionally de-

corated with the identical subjects as were used on Deldare Ware.

The Buffalo Pottery, at the beginning of World War I, began producing chinaware for the government for use in the Armed Forces and, except for brief periods, has been manufacturing mostly hotel china. The name of the pottery was changed to Buffalo China, Inc., in 1956.

In 1925 the Buffalo Pottery brought out a reproduction of the famous "Portland" vase which was issued again in 1946. These were made in very limited numbers and are considered extremely rare. The vase is eight inches tall with white figures on a blue background.

In 1950 a Christmas plate was introduced by the Buffalo Pottery. These plates were not sold commercially but were made to be given as a gift to customers, employees, and friends. These plates proved so popular that they were issued yearly from 1950 through 1962, with the exception of 1961. This is one more item that is eagerly sought by collectors.

Every piece of Buffalo art ware is plainly marked and frequently includes the line name and the date.

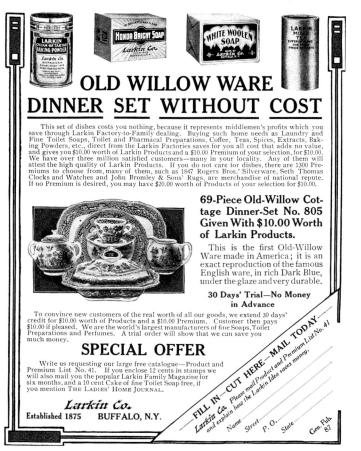

A Larkin advertisement that appeared in the "Ladies Home Journal" magazine February 1909, displaying Buffalo china, Blue Willow pattern.

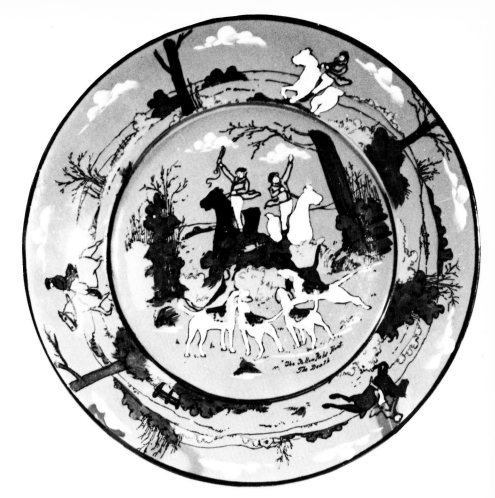

"Deldare" plate titled "The Fallowfield Hunt. The Death," signed "L. Palmer," 8¼ in. diameter. Orren photo

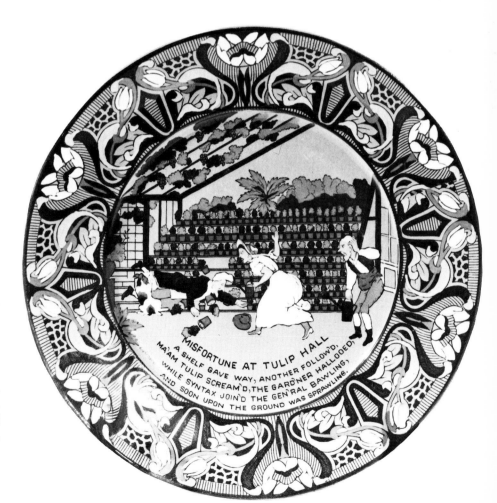

Buffalo "Emerald Deldare" plate titled "Misfortune at Tulip Hall," signed "J. Gerhardt," 8¼ in. diameter. Orren photo

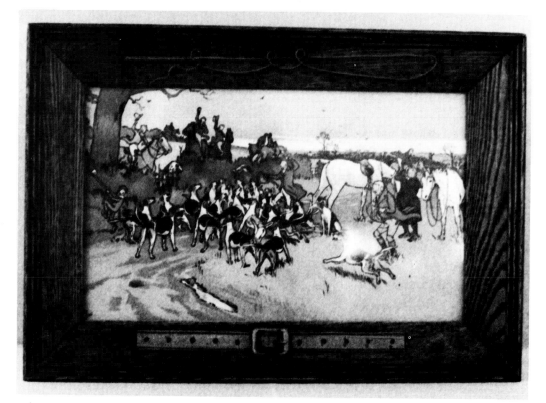

Prints copied on Deldare ware, Cecil Aldin print. "Fallowfield Hunt". "The Death". 12" x 8½". Author's collection

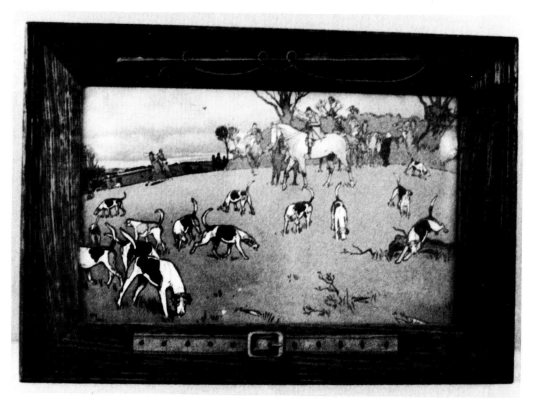

Prints copied on Deldare ware, Cecil Aldin print. "Fallowfield Hunt" scene. "The start". 12" x 8½". Author's collection

Buffalo Pottery
Deldare

marks:

Mark for Abino ware:

A partial list of Deldare decorators:

Anna, L.	Hall, P.	Ramlin, M.	Streissel, L.
Ball, H.	Harris	Ramlus, W.	Stuart, R.
Beatty, G.	Hlumne, M.	Reath, G.	Tardy
Berks, L.	Holland, P.	Robin, H.	Thompson, M.
Biddle, H.	Hones	Roth, A.	Vaise, R.
Biddle, M.	Jentshi, A.	Rowley, F.	Vogt, N.
Broel, E.	Jone, G. H.	Sauter, E.	Wade, A.
Broel, M.	Katon	Shafer, O.	Wal, F.
Bron, M.	Kekola, J.	Sheehan, N.	Wayson
Caird, K.	Lang, A.	Simpson, M.	Whitford
Ditmars, E.	Mac, F.	Simpson, R.	Wigley, J.
Dowman, E.	Mars, Ed J.	Simpson, W. E.	Wil, L.
Fardy	Missel, E.	Sned, M. or	Wilson, M. J.
Ford, H.	Munson, L.	Snedeker, M.	Wilton, B.
Foster, W.	Nakolk, J.	Souter, O.	Windsor, R.
Gerhardt, J.	Newman, L.	Steiner, M.	Wit, L.
Gerhardt, M.	Palmer, L.	Stiller	

Bybee Pottery
1845—

The Bybee Pottery is located just a few miles southeast of Lexington, Kentucky, in the small rural village of Bybee, situated in the foot hills of the Cumberland Mountains in Madison County.

The Pottery is owned and operated by Walter Cornelison, who is of Dutch descent, and the fourth generation to create ceramic ware in this location. He was preceded by James Eli, Walter, and Ernest Cornelison. Actually, a fifth generation is at work, as Walter's three children, aid their father with the pottery.

According to legend, the Pottery was operating as early as 1809, however, the existing records of the sales indicate it was a flourishing business by 1845. Operation of the Pottery is conducted in a picturesque log building reported to be over a century old. It was built with solid walnut beams and has uneven dirt floors. Over the past years, these floors have risen in height several inches due to accumulating dirt and bits of clay that have been dropped when the potter was trimming and grinding the pottery.

The last time the author visited the location, the Company was still in existance, making pottery using the same old fashioned techniques that were used over a century ago. The clay was ground in an antique pug mill and weighed on the old balances. Every article from the outset has been thrown on the potter's wheel and shaped into pieces for ornamental and practical use.

The fine rich clay used at the Pottery is from Madison County about three miles from their location. It is reported to be some of the richest clay to be found anywhere in the world, and it can be used without any added chemicals or other added clays. Records indicate that the old Kentucky settlers mined this clay and then used it to make crude utilitarian dishes at Fort Boonesboro.

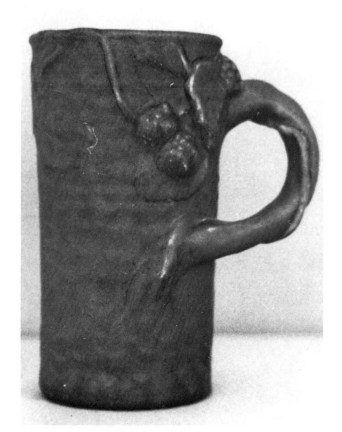

Bybee 7" handled vase. Dark green matt. Paper label. Author's collection

Bybee; bowl, 8½ in. diameter. Green matt. Paper label. Author's collection

During the 1920s and 1930s some fine pieces of art ware were created at Bybee. This ware is reminescent of many other American Potteries, being made with heavy matt glazes in green and blue, comparable to those produced by Hampshire, Teco and Marblehead. A few sculptured pieces were produced. Other products were classical vases, bowls, candlesticks and others...some with fancy handles. Items were sold locally as well as in several other locations throughout the state.

At the time the Pottery was visited, only utilitarian ware was in production with about a dozen different colored glazes in use. According to Mrs. Cornelison, a very few pieces are currently being marked. If so, they are marked "Bybee Pottery", incised in script by hand. She also stated a stamp using the words "Cornelison Pottery" was employed in the 1930s and 1940s. The marks that have been found on the art work, is a stamped or impressed mark in the shape of the map of Kentucky. The words "Genuine Bybee" or "Genuine Handmade Bybee" are printed inside the map. An elaborate gold paper sticker was also used on the art ware using the same design. The paper label refers to the Pottery location as the Bybee Pottery Company, Lexington, Kentucky.

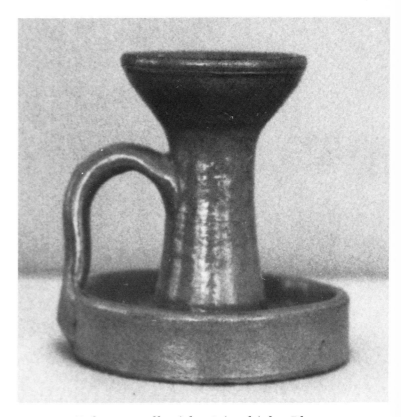

Bybee; candlestick, 4 in. high. Blue matt glaze. Paper label. Author's collection

Bybee Pottery

Marks:

Paper label

Stamped

Camark Pottery
1926—

Nestled in the picturesque pine forest of southern Arkansas, in the town of Camden, is the Camark Pottery, organized in the early part of 1926. The name Camark was derived from the first three letters of Camden and the first three letters of Arkansas. Mr. J. Carnes, organizer of the Pottery, transported to Arkansas from other locations, all available talent including J. B. Lessell and his wife Jenny. Mr. Lessell, prior to his migrating to America, was a native of Mettlach, Germany.

Before participating in the Camark enterprise, the Lessells had worked for several Potteries in the Zanesville area, including Weller, Owens and others. In Zanesville, they are best known for their work with metallic luster glazes. His employment at Camark was very brief as he passed away shortly after starting his work there. He died in Newark, Ohio, but was returned to Zanesville for burial.

The names of other artists who Mr. Carnes employed are rather evasive as no records have been found of the people who worked at the Pottery. Mr. Arthur Wagner, of Zanesville, quoted in a letter to this author that "he had been invited to come to the Camark Pottery, but he refused to leave Zanesville".

Some of the early pieces that were produced at Camark are signed by Mr. Carnes indicating he did some art work. At the outset, he aspired to create art collector articles using varied glazes and diverse techniques. He tried to duplicate every sort of ceramic ware, this resulted in a wide variety of products.

One of the first managers and salesmen was Mr. Ed Sebaugh, a native of Zanesville, Ohio. In 1941, Charles Dean "Bullet" Hyten, former operator of the Niloak Pottery, held that position until his death in 1944.

The earliest wares made at Camark are very reminescent in finishes and shapes of those made at Weller, Owens and other Ohio Potteries. At least two or three of these look-alikes were created by Lessell during his brief tenure at Camark. he designed an exact duplicate of Weller's "LaSa" line. It is marked in the identical manner as LaSa, with the name "Le-Camark" incorporated within the design near the bottom of the item. Another line created is almost an exact replica of Weller's "Marengo". The only difference is, the linear decoration in the Camark ware is noticeably wider, and it is also marked "Le-Camark" incorporated within the design and is sometimes signed Lessell. Mr. Wagner claimed no Weller was signed by Lessell.

Almost every conceivable type of clay products were created at Camark. One of the most outstanding lines are pieces with the black mirror-like glaze, decorated in gold used together with luster colors, very similar to a line made at Owens Pottery. A majolica type ware is reminescent of the earthenware made in Italy. Another interesting line is one similar to Roseville's "Carnelian". Pieces were made that were glazed with fine heavy glazes similar to Van Briggle and Teco ware, in shades of dark green, dark blue, and maroon. Another type of an attractive glaze used, was two different color glazes blended together, one running down over the other in a smooth matt finish similar to wares made at the Muncie and Niloak Potteries. The shades are light harmonies of green and pink, blue and green, blue and gray, and other blending colors.

The various products made at Camark are vases, wall pockets, jardinieres with matching pedestals, huge floor type jug vases, animals, birds, pitchers, match box holders, string holders, planters and many other items. The finest wares were produced prior to World War II. It is assumed that about this period in time Mr.

Carnes passed away and the Pottery was purchased by Mary Daniel, who retained no records of the preceding owners. Prior to the death of Art Wagner in 1977, the author obtained some information, through correspondence, concerning the Camark organization. Mr. Wagner, a former Weller artist, had worked with the Lessells when they resided in Zanesville, prior to their migrating to the Camark Pottery. Hopefully, some catalogs or someone connected with the previous owners and artists, will be discovered. An early picture of a Camark Company photo showing the early lines appeared in the *American Art Pottery* magazine, edited by Duke Coleman, April 1978...No. 23.

The Camark Pottery is currently in production making a line of ware for the florist trade and gift shops. The only mark on these wares is a paper label. The earlier ware had a system of marking and numbering but were not consistant, consequently, many pieces are found with no marks. Some marks have been covered or dimmed by the heavy glazes. Several marks were used, the earliest being a map of Arkansas with the words Camark Pottery printed in the center. These marks were stamped on the base in gold or black. This design was used for most of the paper labels, and is being used currently.

Camark Le-Camark vase. Same as Weller Marengo in design. Marked on side in design; Le-Camark. Collecion of J. D. Alsbrook

Sketches of wares by Art Wagner, known to have been made at Camark Pottery

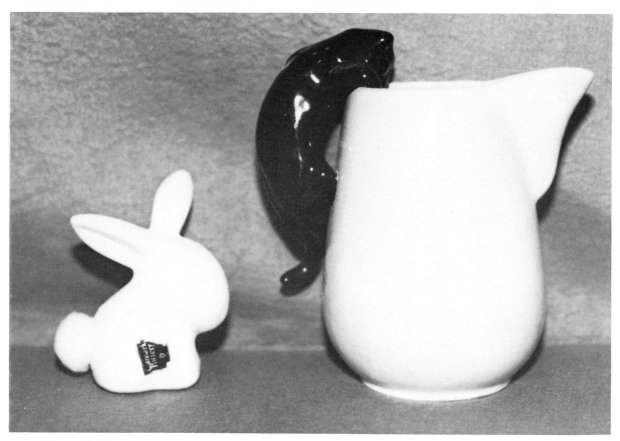

Camark bunny cotton dispenser with paper label only. Cat pitcher USA Camark impressed

Camark; two pink and green vases reminiscent of Roseville's Cornelian. One on left is marked CAMARK in block letters. The one on the right is not marked

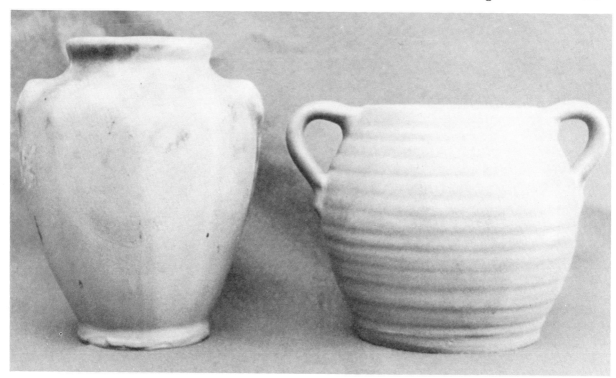

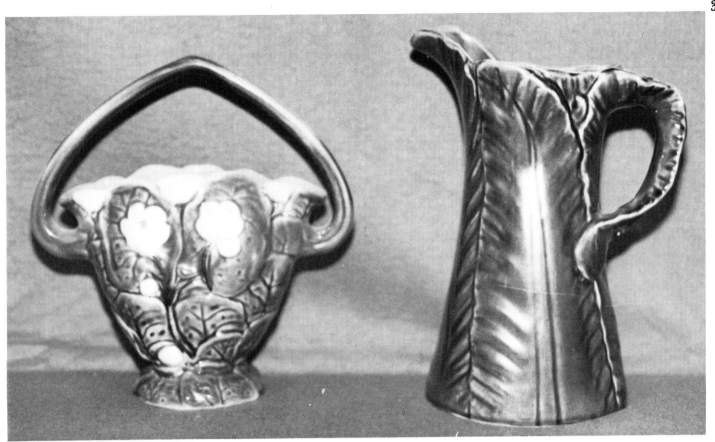

Camark; Majolica type pieces. Basket
USA Camark 805K. Leaf pitcher USA
Camark N10. Both impressed marks

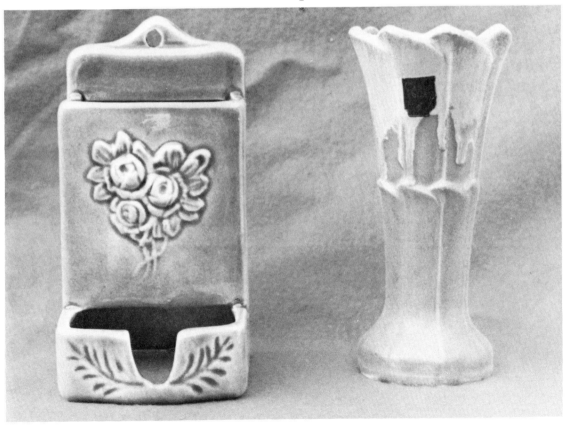

Camark match-holder, USA Camark-
impressed. Vase-gold paper label only

Camark; resembles pottery produced by Muncie. Camark is impressed in small block letters on the bottom

Not marked except with the paper label. Pocket in back for plants or flower holder

Heavy Indian type pottery. Both paper label and CAMARK in block letters, impressed in the bottom. Collection of J. D. Alsbrook

Paper label on bottom. Map of Arkansas divided into 3 parts. Shape-990; Finish-86. Dark maroon

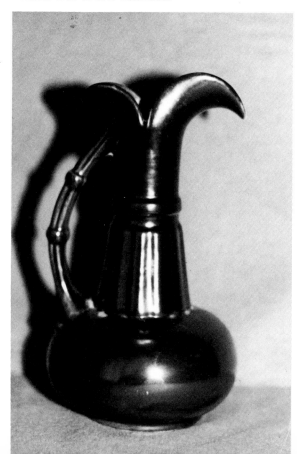

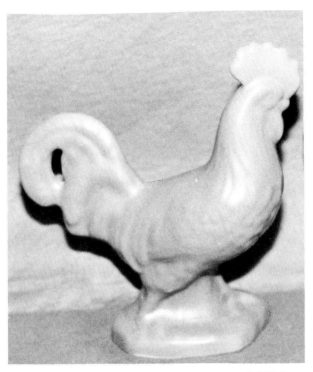

Camark blue rooster is stamped USA Camark 501 in blue on the bottom

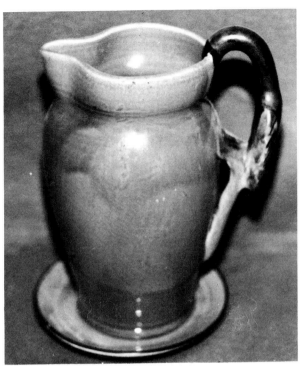

Early ware—Majolica type marked with Camark in the map of Arkansas in gold on the bottom

Impressed mark CAMARK. Heavy glaze

Camark with paper sticker. Shape 598; Finish 10

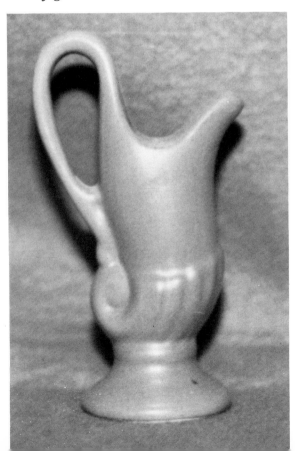

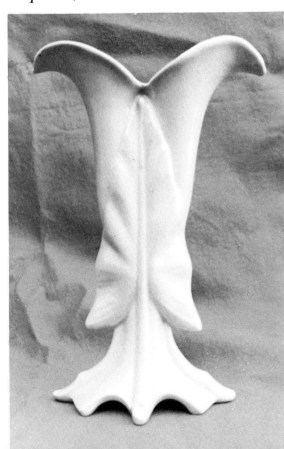

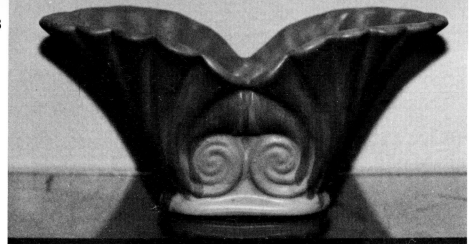

Impressed CAMARK shaded green to blue

Very rare sticker. Marked CAMARK DELUXE ARTWARE in rare round paper sticker. Collection of Rena & Bryce London

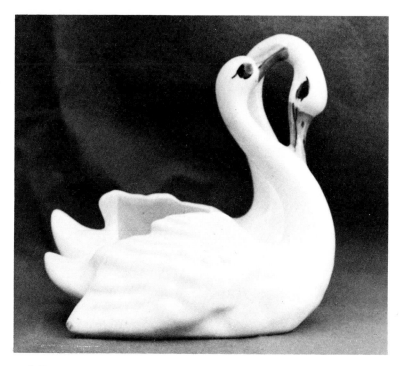

Camark Pottery

Marks:

Paper label or
printed on bottom

Gold paper label

Paper label

CAMARK

CAMARK

Impressed or stamped...
different sizes

USA
CAMARK

Impressed or stamped

Cambridge Art Pottery
1895—1917

The Cambridge Art Pottery Company of Cambridge, Ohio, was one of many potteries to locate in the rich Ohio Valley, entering the ceramic field during the heyday of art pottery.

The company manufactured an art line in the faience type of ceramics. These were made in various shaped vases, ornamental type wares as well as table service pieces. The company mark was used along with the added line name. About 1900, a line called "Terrhea" was created. This line was very similar to Weller's Louwelsa, Owens' Utopian, and Rookwood's standard brown ware. Exceedingly fine work was produced between 1900 and 1910, such as beautiful portraits and outstanding florals in slip underglaze painting. Most of these pieces were dated and signed by artists who are known to have worked at other Ohio potteries, especially in the Zanesville area.

Cambridge vases. Left: Dark brown with yellow flowers, marked "Cambridge," 4 in. high; RIGHT: dark brown with yellow flowers, marked "Terrhea," 9 in. high. Knight photo

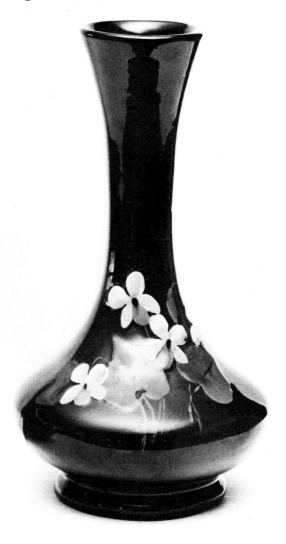
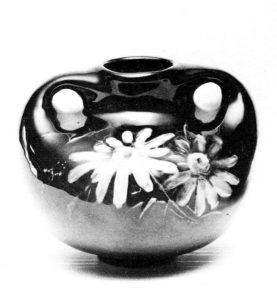

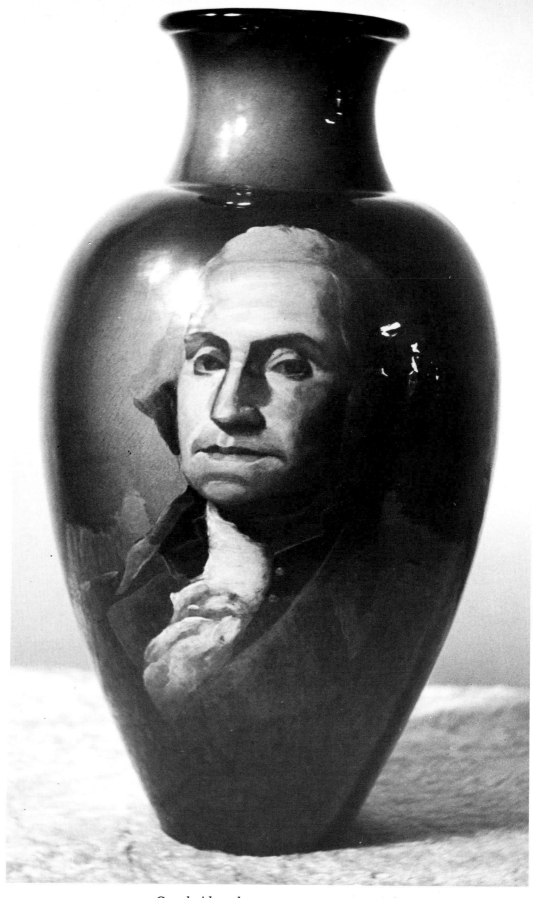

*Cambridge brown ware vase. High
glaze, marked "Cambridge" inside an
acorn, signed by artist "A. Williams—
1902," 24 in. high. Fox photo*

Cambridge Art Pottery

marks:

CAMBRIDGE

Printed

OAKWOOD

Printed

GUERNSEY

Printed

ACORN

Printed

Stamped

TERRHEA

28

Impressed

CAMBRIDGE

105

Impressed

 CAMBRIDGE

Impressed

Chelsea Keramic Art Works
1866—1894
Dedham Pottery
1895—1943

In 1866 Alexander W. Robertson established the Chelsea Keramic Art Works at Chelsea, Massachusetts. He was joined by his brother, Hugh Cornwall Robertson, in 1868. Their production consisted mainly of flowerpots, bean pots, and simple vases. James Robertson, who had already gained recognition as an experienced potter in England and Scotland, joined his sons in 1872. Almost immediately the firm began to produce a more decorative type of pottery, for example, the "Redware" (terra cotta), which was quite ornate. The company name of Robertson and Sons was adopted, but the initials C K A W (Chelsea Keramic Art Works) were also used.

Hugh Robertson was one of the artists, along with Maria Longworth of Rookwood fame, who was inspired by the Oriental art works that were displayed at the Philadelphia Centennial Exposition in 1876. He devoted several years to perfecting the "Oxblood" (Sang de Bouef) and craquelle glazes, which to that time had been peculiar to the orient. Other color glazes emerging from experiments were dark yellow (mustard color), turquoise, purple, maroon, sea green, and apple green. Several awards were won by this ware, including a gold medal at the St. Louis World's Fair and awards at the Paris and San Francisco World's Fairs.

James Robertson died in 1880 and Alexander Robertson migrated to California in 1884. Hugh Robertson remained at the Chelsea plant, where he continued his work in perfecting the Oriental secrets of glazing. However, in 1889, after twenty years of hard work with practically no profits because of costs of production, he closed the Chelsea Pottery and took a position with the Low Art Tile Company, where he stayed for only a brief period of time. During his twenty years at the Chelsea plant, many fine pieces of pottery were produced but were not well received by the public. In 1890 he assisted his brother, George W., in establishing the Robertson Art Tile Company at Morrisville, Pennsylvania, where he did the modeling for the embossed-tile designs.

In 1891 Hugh Robertson was engaged by a group of Boston businessmen, who reopened the pottery, to manage the Chelsea Keramic Art Works. In 1895 the operation was moved to Dedham, Massachusetts, and the name was changed to Dedham Pottery. This move from Chelsea was made because the damp climate was not inducive to pottery making. It was at Dedham where Hugh Robertson was to gain fame and recognition for his many years of hard work. Perhaps one could consider him a genius in his profession. He was successful in practically all his undertakings, his main objective being a devotion to strict detail. He used simple lines and nothing was added that might detract from the beauty of the color. At the Dedham plant, the craquelle glaze was perfected and used extensively on the wares. This glaze was first used on tall pieces, such as vases. The Chinese-like crackle stoneware, with the blue-in-glaze border decoration, had flowers and animals as motifs. These included iris, clover, magnolia, grape, poppy, waterlily, azalea, polar bear, elephant, swan, lion, crab, turtle, owl, duck, turkey, butterfly, bird, and rabbit. The most popular pattern was the rabbit, designed by Joseph L. Smith, a teacher at the Boston Museum of Fine Arts School (1889-93). This pattern was adopted as the company trade mark. At first a raised rabbit was used, but this was soon discontinued because of the loss of many pieces due to cracking in the molds. During the early period, the rabbit decor went counterclockwise, and this is perhaps the rarest of the crackleware. Later the design was changed to run clockwise. Some of the previously mentioned patterns were

made on special order only. The forms were mostly tableware although, on occasion, odd pieces were produced.

Charles Davenport, a talented artist and decorator who spent thirty-five years with Dedham Pottery making the intriguing borders on the Dedham ware, is living in retirement on beautiful Cape Cod. He relates that one day, a certain Republican, who had just learned that the elephant was to become the party's official symbol, came to the factory and commissioned a set of tableware with elephant borders. This freehand type of decoration required a superb sense of spacing, since there is just so much room for a certain number which should be spaced evenly. Mr. Davenport states that this was the only profitable mistake he had ever made when it came to judging distance. The border was to consist of thirteen elephants, but when he got down to the last elephant, he found there wasn't enough room left for a repeat pattern. Rather than discard the entire plate, he filled in the small space with a baby elephant. The person who had ordered the pattern was quite delighted with the design and, apparently, so was the general public. Consequently, the elephant became the second most popular pattern among the forty-eight patterns created over the years. Mr. Davenport's initials will be found hidden in the blue borders of some of these pieces. He was also a fine sculptor and made some of the small animals. His sister Maud Davenport, worked at the Pottery as a decorator from 1904 until 1929. On close scrutiny, one will find a small "o" hidden within the border on some articles she finished.

One important glaze improved upon at Dedham was the Chinese red glaze (Sang de Boeuf) and the other slow-flowing type glazes that were used by the old Japanese. One rather extraordinary glaze was produced by the use of two glazes, one running down over the other. This process was called "Volcanic Ware," which was rather heavy and not too popular. Dedham pottery was completely handmade ware, although it does appear to be stencil work. Each piece of this pottery always carries a company mark on the base.

The gray clay used at Dedham came from Kentucky and the kiln that was in operation was very large, capable of holding more than two thousand pieces at one time. As previously stated, no stencils or decals were used—only free-hand work, painted by artists, decorated this ware. From the outset, Dedham pottery was expensive, as it was the only American-made craquelle ware. It was sold from coast to coast by many fine dealers, including Paul Elder of San Francisco, who also was an outlet for the fine Newcomb pottery.

Hugh Robertson died in 1908 and was succeeded as head of the company by his son, William Robertson, who had contributed a great deal to the successful development of the craquelle process. After William Robertson's death in 1929, his son, J. Milton Robertson, supervised operations until 1943, when the Dedham Pottery closed.

J. Milton Robertson died on May 17, 1966, taking with him the formula for the unique Dedham glaze.

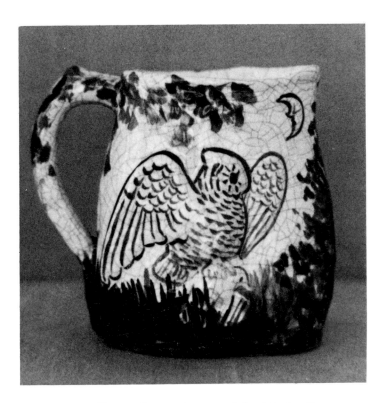

Dedham, "Morning & Night Pitcher"; 5" [night side]. Author's collection

44

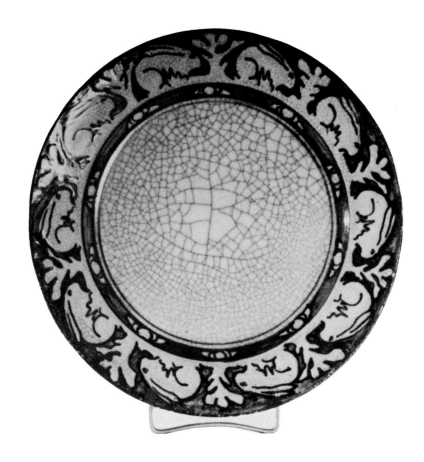

Dedham pottery plate. Two marks appear on base —the impressed rabbit and the regular stamped mark; 8 in. diameter. Author's collection; Johnson photo

Chelsea-Dedham Pottery

Bird in Orange Tree

Horse Chestnut

Dedham Pottery patterns:

Azalea

Water Lily

Swan

Magnolia

46

Dedham Pottery "patterns":

Duck

Polar Bear

Grape

Turkey

Dedham Platter
Pattern denotes the use of two motifs for decoration.
On display at the Smithsonian Institution.

Iris

Butterfly

Chelsea-Dedham pottery marks:

Impressed or stamped:

C
K A
 W

CHELSEA KERAMIC
ART WORKS
ROBERTSON & SONS

1872—1889 1872—1889

A.W. & H.C.
ROBERTSON

1868—1872

1891—1894
(CPUS) Chelsea Pottery U. S.

Limited use of this mark after 1895, on plates

 DEDHAM POTTERY

1896—1929

DEDHAM POTTERY

Registered
1929—1943

 Monogram of Hugh C. Robertson

Cincinnati Art Pottery
1879—1891

The Cincinnati Art Pottery was established in Cincinnati, Ohio, in 1879, with Frank Huntington as president. A variety of wares were produced, such as vases, bowls, and plates.

This particular Pottery created an undeglaze faience known as "Hungarian," "Portland Blue," and "Ivory Colored Faience." Of most importance was a dark blue glaze, embellished with Arabesque designs in rich gold. Cincinnati Art ware was also sold in blanks, to be decorated by "china painters," a practice in vogue during this era.

From the very outset, Cincinnati Art pottery was marked. The first mark was the figure of a turtle. In 1886 the name "Kezonta," the Indian name for turtle, was added along with the name "Cincinnati." This mark was stamped in red on the finer pieces that were decorated in the pottery's own studios. The name "Kezonta" alone was impressed on the lesser wares and on the blanks that were sold to the china painters. The company closed about 1891.

Due to the short existence of this company, examples of this ware is extremely hard to come by. Most is probably in the hands of private collectors.

Cincinnati Art Pottery company marks:

Cincinnati Art Pottery

marks:

1879–1885

1886–1890
Impressed
in semicircle

1886–1890
Stamped in red

KEZONTA

1890
Impressed (very rare)

Clewell Art Ware
1906—1965

The Clewell Art Studio, at the time of its existence, was located in southeast Canton, Ohio and was operated by Charles Walter Clewell between 1906 and the mid 1960s.

Mr. Clewell was inspired by a rare old Roman wine jug that was on display in a museum in Hartford, Connecticut. The jug was said to be over two thousand years old and had corroded and turned a beautiful shade of blue. This ancient bronze jug was reverting to its original state---a copper ore, known as chrysocola. Clewell began experiments to perfect a man-made method of corroding the copper ores, using not only chrysocola, but cuprite, malachite and azurite. After experimenting quite diligently with several methods, he eventually achieved success in perfecting an art ware in breath taking shades of blues and greens, with a beautiful patina finish, similar to nature's own corrosion which would neither wash or wear off. No two pieces were ever quite alike, as is the case when corrosion happens naturally by exposure.

Clewell Art Ware was made in two types. One type is solid bronze or other metals, with the corrosion finished in a beautiful patina. The second and most important type is the use of pottery combined with metal. This type has a skin tight coating of metal finished in identical manner. Most often, bronze was used, however, pieces are found covered with brass, copper and silver without the patina finish. Occasionally, a combination of metals were used, such as---bronze with a silver inlay. The colors in Clewell ware appear in splotches with the bronze showing through. Some pieces show more color than others, consequently, their beauty is impossible to depict in sketches or black and white photos. It had been stated that Mr. Clewell guaranteed his ware to endure a life time.

Pottery blanks which were to be covered with the various metals were generally purchased from the Weller, Roseville and Owens Potteries. Others in that locale were also used. It is assumed, but not verified, that Mr. Clewell used pottery rejects or seconds for this purpose, as the flaws could not be detected under the metal. This "metal over pottery" art ware was made in various shapes and sizes, including vases, lamps, pitchers and complete stein sets. Although Clewell was advertised in magazines as distinctive gifts, it was never sold in retail outlets. Clewell's daughter was known to have been his saleslady for his products in the Ohio area.

This ware will be found marked with the name Clewell incised on the base accompanied by a number or numbers. In the event that a piece is found unmarked, it may be assumed this was accidental as pieces do escape the markings, however, it would be readily identifiable as there has never been anything quite similar to it. Every piece was made by Mr. Clewell personally and he employed no assistants. The formula for this ware is not available, however, there are two stories that exist concerning the whereabouts of these formulas. One is, the formula is locked away for safe keeping, to be opened in one hundred years. The other, all papers were destroyed or burned at the time of his death (1965), according to his wishes. Neither story has been substantiated. Perhaps the latter is the true one. After Clewell died, the remaining stock was sold by his daughter to collectors in the vicinity and some to art institutes.

Clewell's rare skill and artistic talents were recognized by fellow artists during his life span. He was elected master-craftsman by the Boston Society of Arts and Crafts. At the Paris International Exposition in

1937, he was awarded the "Deploma de Medalle D'Argent" for his display of "Bronze over Pottery" art ware.

The museum in Hartford, Connecticut that was previously mentioned, where the old Roman wine jug was on display, was the Wadsworth Atheneum and was shown in the Memorial Collection of J. Pierpont Morgan.

Clewell Art Ware

Marks:

Clewell
941

Incised

Impressed

Incised

Impressed

Clewell
288-218

Incised

CLEWELL
Canton O.

Impressed

Cordey China Company
1942 to about 1955
Cybis
1955—

The Cordey China Company was founded in 1942 in Trenton, New Jersey by Boleslaw Cybis, and is one of the lessor known American potteries. Although they did produce many beautiful pieces of art ware, many collectors do not associate Cordey with the prestigeous Cybis Porcelain Company.

Cybis, a Polish born artist (1895—1957), was the son of the chief architect of the Czarina's summer Palace in St. Petersburg, Russia. During the 1920s and 1930s, Cybis pursued a successful career in Europe. He studied the art of ceramics in Saxony and Turkey, where he resided among other potters, and here he created tobacco pipes from the local clays. In later years, he was surprised to learn these pipes had become collector's items.

Cybis toured Africa in the early 1930s, working with Picasso and Cezanne, in "color displacements". Some time was also contributed to working with stained glass. Cybis was brilliant and colorful with an intense personality, and his sculptures, murals and paintings won him great acclaim in art centers throughout Europe. He attended the Fine Arts Academy in Warsaw (1923), where he subsequently was elected Professor of Art. A winner of the Paris International Exhibition "Grand Prix", his paintings, sculptures and al fresco murals were exhibited in Moscow, St. Petersburg and other major cities throughout Europe.

In 1938, at the invitation of his government, Cybis journeyed to America with his wife Marja---also a sculptor in her own rights, to paint frescos for the Polish Pavilion, called the "Hall of Honour", at the 1939 World's Fair, in New York. After his work was completed, he decided to return to his homeland, in September of 1939. At that precise time, the Nazis were invading Poland and subsequently World War II was launched. Boleslaw Cybis and his wife decided to return to the United States, where they, in proper time, became citizens.

His primary studio was established in New York City, at the old Steinway Mansion, overlooking Long Island Sound. At this location he made hand painted plaster-of-Paris figures, to be sold in gift shops. Then in response to the strong commercial demand for decorative items, such as; figurines, lamps, and other bric-a-brac, during the World War II period, Cybis decided to relocate where more space would be available. Room was desperately needed for more artists and space for larger kilns to be constructed.

Prior to moving his business to Trenton, New Jersey, in 1942, he wandered to the southwest area of the United States to paint and sketch the American Indian. Today, these paintings when available, are very costly. In Trenton, he later located his business in a low brick building on Church Street, that had previously been a carriage house. Here he employed mostly displaced native countrymen, such as himself and ultimately became president of the company. This community, which was labeled by potters as the "Staffordshire of America", the skills and facilities were more than adequate to create his wares, however in time, the clays became exhausted and this material had to be imported from other locations. After extensive experiments, Cybis developed a semi-porcelain that he called "Papka". This material was off white in color---sort of creamy bone white; soft paste or semi-porcelain in composition. This variation of pottery is very opaque and very easily damageable. Few pieces are to be found in absolutely perfect condition, however, minute damage as found on pieces decorated with flower petals, where

the petal has a slight chip, or slight damage on the lace of a figurine, the valuation of the article should not be effected.

The Cordey China Company soon became the producers of hand decorated ceramic Rococo figures, using hand-shaped ceramic flowers and porcelain lace. Cordey is said to be the first American company to utilize porcelainized lace on its sculptures. Figural pieces were made by slip casting the base figure in a mold. To this base were added hand-shaped curls, scarves, hats, ribbons, lace ruffles, flowers and other decorative ornaments. It should be noted here that each figure was assigned a number, however, two figures with identical numbers may vary greatly in color schemes and applied decorations. The colors used on Cordey most often are dusty pink, bone white or greyish blue. On occasion, dark green, purple or blue will be found. The glaze that was generally employed was a semi-gloss. The originality of the artist is one of the most appealing features of Cordey sculptures. Since all but the basic mold of each was individually crafted, no two are exactly alike, giving each its own uniqueness of character. Because of this individuality, some Cordey figural pieces are more desirable and attractive than others. The most sought after figurines are characterized by skillful decoration, fine coloring and a special quaintness of style.

The majority of Cordey pieces to be found are small figurine busts---ranging from 5" to 8" in height, however, beautiful full length figurines were also produced. Other creations were large and small lamps---both direct and indirect lighting, some small and large figural pieces, such as; poodles, swans and other type birds, vases, coffee sets, wall plaques, various covered dishes, cigarette sets, candle sticks and many other related articles---too many to mention, but all having the very distinctive look of Cordey.

Many of these pieces were decorated with their so-called trademark---a hand made rose with a leaf on each side which is often attached to the front base of a figurine. The roses are incorporated along with other flowers, swans, cherubs, birds etc. on sculptures, lamps, bottles, boxes, trays and many other articles.

Most Cordey pieces are marked with the name "Cordey" in script, which is impressed or stamped in blue on the bottom. Due to the heavy coat of glaze that has filled the impressed name, these marks are often difficult to locate, and at times, not visible at all. Practically every piece is marked on the bottom with numbers painted in blue, designating the mold number. Often there are additional blue numbers, indicating which artist decorated the creation. Artists worked by assigned numbers and were compensated accordingly. Most lamps were only identified with paper tags or pasted on labels. Since each mold was assigned a number, the earlier articles began with numbers in the three hundreds and continued upward to the eight thousands.

Cybis designed in all media and ultimately selected porcelain. In the mid 1950s he discontinued the manufacture of Cordey pottery with the "Papka" body, and began producing parian and bisque---high fired white translucent porcelains exclusively. During this transitional period (1955—56), Cybis was listed in the Trenton City Directory as president of the "Cordey China Company and Cybis Inc". Since his death, the studio which continues to bear his name is presently producing beautiful porcelain sculptures in his tradition.

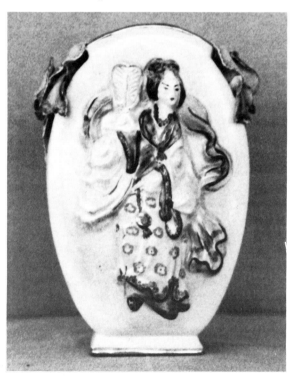

Cordey vase; 9", #7090. Author's collection

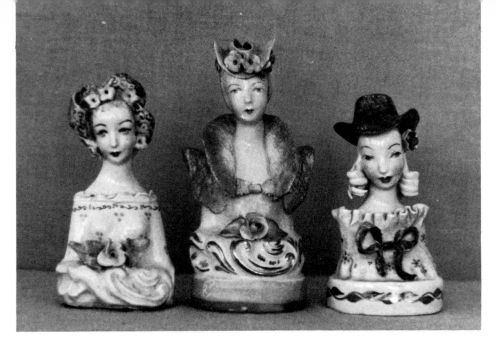

Cordey figurines; Left: 6", #5010. Center: 7½", #5027. Right: 6", #5009. Author's collection

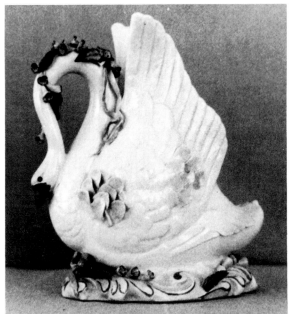

Cordey swan; 9", #7066. Author's collection

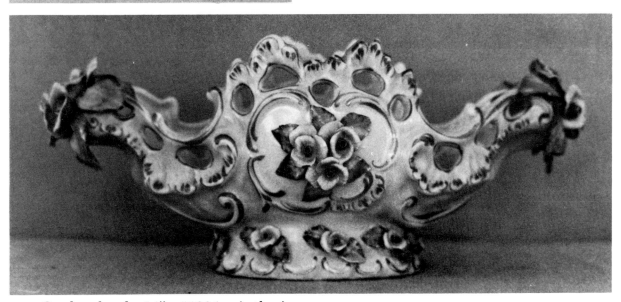

Cordey bowl; 14", #1006. Author's collection

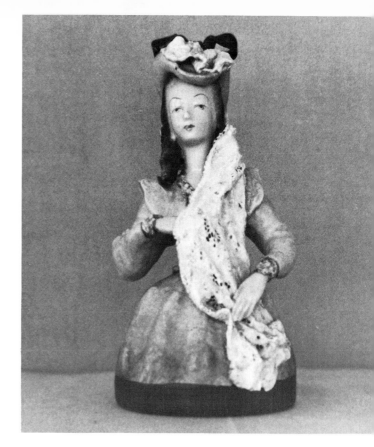

Cordey figurine; 9½". Author's collection

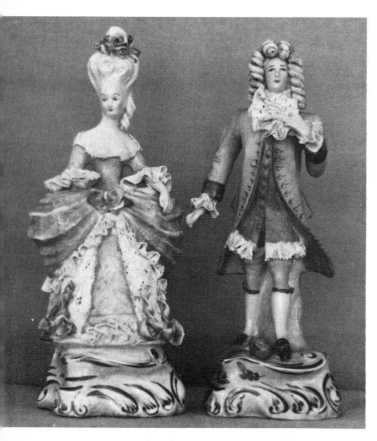

Cordey figurines; 11". Girl-#5084 and boy-#5042. Collection of Ervalee Hecker

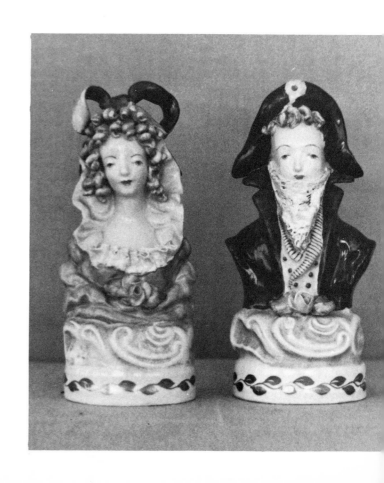

Cordey figurines; 8". Napoleon & Josephine, Nos. 5038 and 5039. Collection of Ervalee Hecker

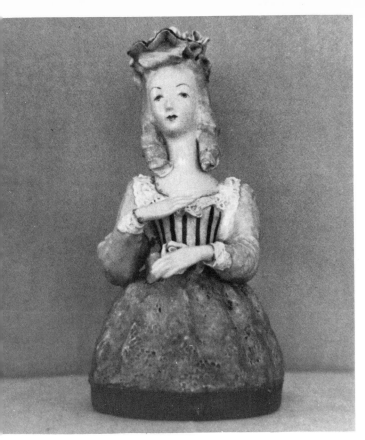

Cordey figurine; 9½", No. 5037. Author's collection

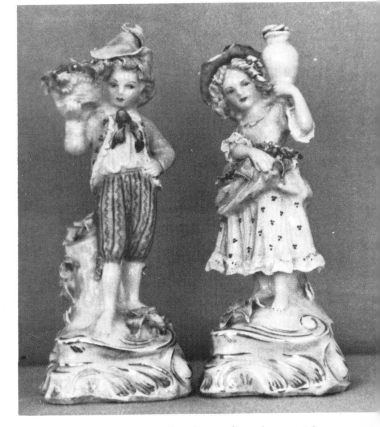

Cordey; figurines, 10 inches high. Boy-#5048, girl-#5047. Author's collection

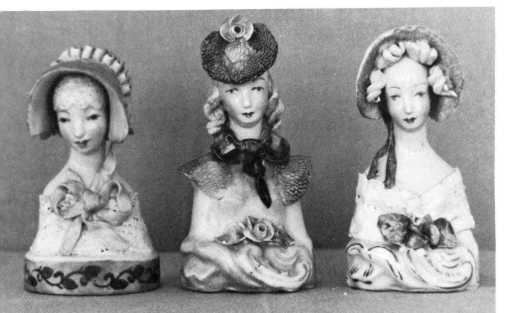

Cordey figurines; 6". Left to right: nos. 5013, 5007, and 5015. Author's collection

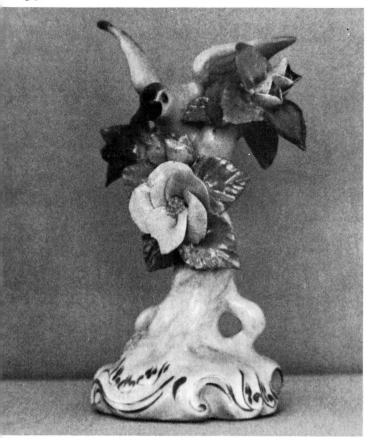

Cordey; bird, 10 in. high. #6004. Author's collection

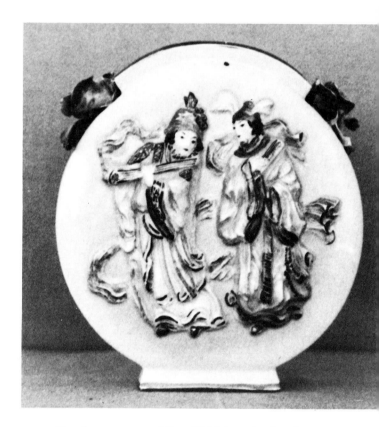

Cordey vase; 9", #7094. Author's collection

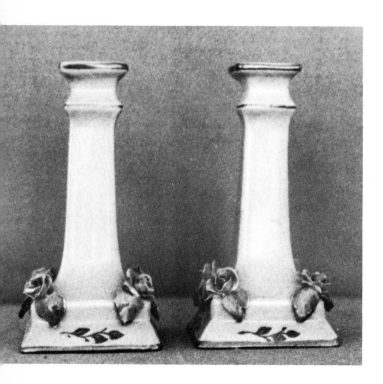

Cordey candlesticks; 7". Author's collection

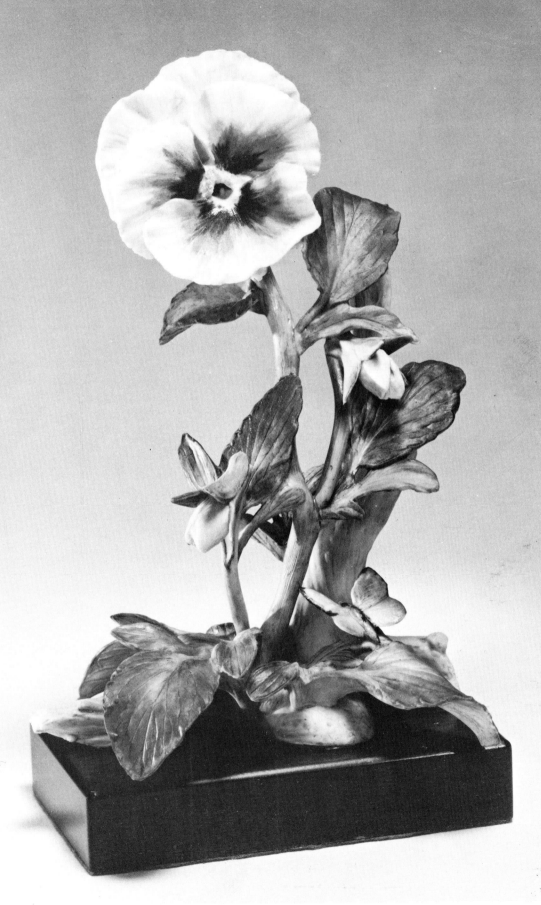

Cybis "China Maid" 1972. Restricted to 1000. Color-yellow, 7 in. high and 5 in. long. Author's collection

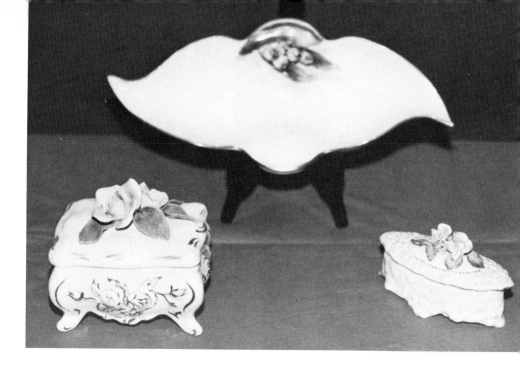

Cordey square box; 4½ x 4½".
Cordey oblong box; 5" x 2½", #1104.
Cordey long bowl; 13½", #217. Author's
collection

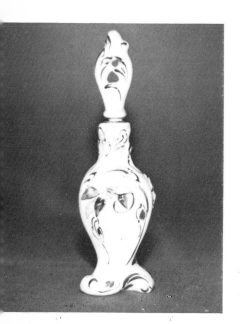

Cordey perfume; 7", #7096. Author's
collection

Left and right; Cordey perfumes 8",
#7025. Middle: Cordey vase; 6½", #5043.
Author's collection

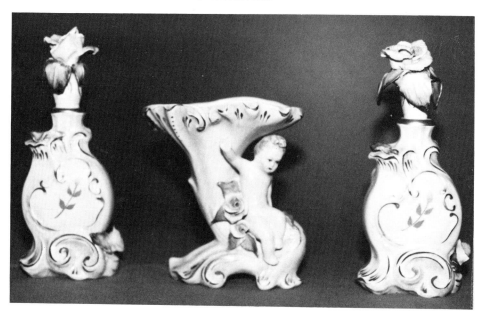

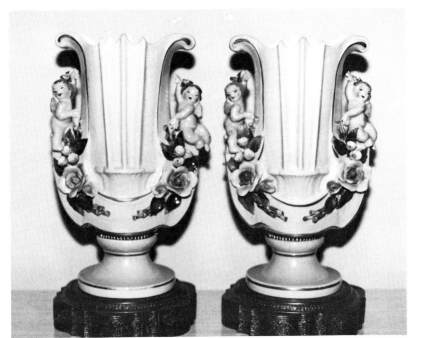

*Cordey lamps; 14"
high. Indirect lighting. Paper tag with string. Author's
collection*

*Cordey cream and sugar; #622 and 623, 3½" high.
Decorator #92. Author's collection*

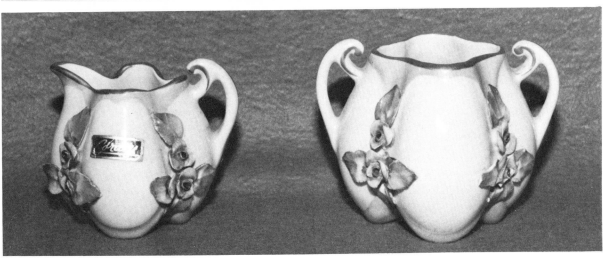

Cordey 1942 To About 1955
Cybis 1955—
Marks:

Cordey

Impressed or printed in black
or blue on the base

X

1942—1950
Used on porcelains

CYBIS

1945

Cybis

1952—1965

1942—1957
Used on porcelains

Paper tags on lamps

Cybis

1950s

CYBIS

1970s
Bird embossed

Cowan Pottery
1912—1931

Cowan pottery was developed under the guidance of R. Guy Cowan (1884—1957), who came from a family of potters, from East Liverpool, Ohio. He attended the New York School of Ceramics, at Alfred University in Alfred, New York. Here he studied under Professor Charles Binns. Upon graduating, Cowan began teaching in the Cleveland, Ohio High School system.

At first, Cowan built one kiln in his back yard, and this might be considered his beginning in the pottery business. In 1913, with the assistance and encouragement of the Cleveland Chamber of Commerce, he opened a studio in Lakewood, a suburb of Cleveland, with only three small kilns. He began to manufacture tiles and did create a limited number of art objects. Mostly red clay was utilized and various types of fine heavy glazes were developed--some of them luster. Every article in this early art ware was hand signed with his cipher, and occasionally, accompanied by the names: "Cowan Pottery" or "Lakewood Ware". At the Cleveland Museum of Art, Cowan made the tiles that covered the floor in the garden Solarium, and also the Music Room. The tiles have since been removed.

Cowan closed his studio when he enlisted in the army during World War I, and upon returning home in 1919, he reopened it, there he remained until 1920. Gas supply became short and the facility too small to operate properly. He erected a new facility in Rocky River, Ohio at 19633 Lake Road. His new place was equiped with nine kilns and gas supply was adequate. An old barn on the property was used as an office.

A fine porcelain body was developed from clays that were imported from England. These clays were purchased in an enormous amount---two and three carloads at a time. Glazes developed were most impressive and new ones were being innovated all the time. Many pieces were lined with different color glazes. There were those that had a soft waxy finish, lusters, matts and a crackle type which was extremely popular, developed by Arthur Baggs, who had previously worked at the Marblehead Pottery. Business flourished and about forty employees worked for Cowan. Several hundred dealers in the United States carried his products, including Marshall Fields, in Chicago.

About 1925, Cowan introduced the famous flower arranger bowls with the art deco figural flower holders (frogs), with matching candle holders. These were mostly finished in the soft ivory glaze. Some of the bowls were lined in other shades, such as: pink, caramel, green etc., however, a colored figural can be considered rare. The porcelain figurines in the art deco style, reminescent of the "Roaring Twenties", were usually limited editions and considered extremely rare.

Cowan won many awards for his work. His initial award was in 1917, when he won first prize at the Art Institute of Chicago. Many others followed including awards from the Cleveland Museum of Art and the Metropolitan Museum of Art.

Guy Cowan and Waylande Gregory did the designing of most of the articles, but many other talented and dedicated artists designed pieces and developed glazes for the Cowan Pottery, especially in the later years. Some were students and teachers from the illustrious "Cleveland School of Art" and other Art centers. The old "Cleveland School of Art" is now the "Cleveland Institute of Art". Here, Cowan was in charge of the ceramics department from 1929 through 1933.

Some of the artists that worked for Cowan include the following:

Russell B. Aitkin Elizabeth Anderson

Whitney Atcheley Arthur Baggs
Alexander Blazys Paul Bogatay
Dalzee Waylande De Santis Gregory
Richard Hummel A. Drexel Jacobson
Raoul Josset Paul Manship
Jose Martin Mr. McDonald
F. Luis Mora Elmer Novotny
Margaret Postgate Viktor Schreckengost
Elsa Shaw Walter Sinz
Jack Waugh Frank Wilcox
Edward Winter Thelma Winter

In 1927, a "Bread and butter" line, of inexpensive florist commercial containers was introduced, marked "Lakeware". In 1930, the "Great Depression" was in full swing, and in spite of all the financial assistance from the affluent backers of the Pottery, it could no longer operate on a paying basis and consequently, was placed in receivership. A catalog was issued and the large inventory on hand was offered for sale, probably at a large discount.

The Pottery closed in December of 1931, and the remaining stock was sold to a department store in Cleveland. In 1933, Cowan moved to Syracuse, New York and joined the Onondaga Pottery as an advisor.

Practically every piece of Cowan pottery is almost always marked on the base.

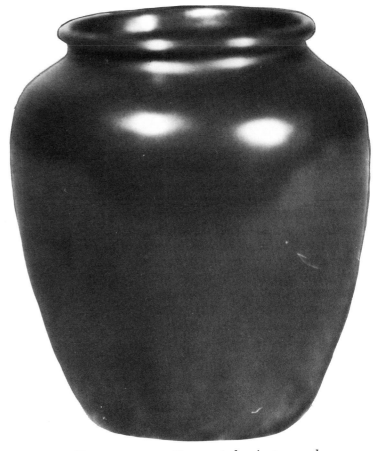

Cowan vase. Gunmetal, impressed mark, 4 in. high. Johnson photo

Cowan pottery. Left to right: Green figure, shiny, marked, 3 in. high; candlesticks, ivory, matt finish, marked, 2½-in. high; vase, light brown on red, shiny, marked, 3½-in. high. Collection of R. C. and F. G. O'Brien, Jr.; Knight photo

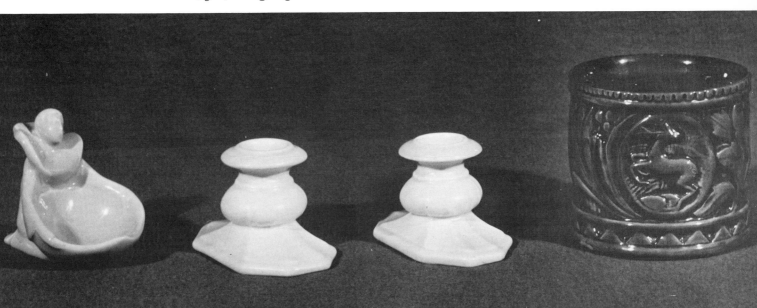

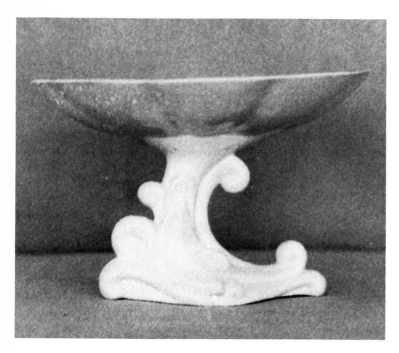

Cowan Pottery. 5" card tray. Cream color lined in pink. Author's collection

Cowan Pottery
Marks:

COWAN COWAN pottery COWAN POTTERY

Ink Stamped

 COWAN 29

Ink Stamped
Impressed or stamped in black

LAKEWARE

Impressed....Sometimes the mark includes
the Cowan name

Frankoma Pottery
1933—
Christmas Memorial Plates
1965—

Nestled in the rolling hills of Oklahoma, at Sapulpa, stands the Frankoma Pottery, Inc., owned and operated by the Frank family. Visitors are always welcome and every process is open for inspection. The Frankoma name was coined from Mr. Frank's surname and the last three letters of Oklahoma. Since the death of John Frank, November 10, 1973, his daughter Joniece, became president and chairman of the board.She is operating the business in the same traditional manner as it has been in the past.

John Frank migrated to Oklahoma from Chicago, in 1927, to take a teaching position at the University of Oklahoma, at Norman, where he taught art and pottery. His work with geological survey (unearthing Oklahoma clay deposits) brought together valuable information for his future venture of potting.

The Frankoma enterprise began in 1933, when the Franks established a small studio in their home, at Norman, Oklahoma, with only the bare necessities that were needed to work with the native clays. The clay produced an excellent quality pottery, and consequently, a portion of this product was placed on the market for sale. Artists desiring to participate in this small enterprise were welcome. One such artist was Sinclair Homer, a part Cherokee Indian, who modeled a plaque of his good friend Will Rogers. This plaque was quite popular and made for several years. Its popularity induced Homer to have the plaque copyrighted in 1935.

By 1936, the Pottery was beginning to prosper and Mr. Frank resigned his post as teacher to devote his entire time to creating smart lines of tableware for every day living. the beautiful array of colors used on Frankoma pottery is somewhat different from that found on other modern-day pottery, the glaze having a soft velvety finish that is quite pleasing to the eye. In 1938, the home studio had grown into a small factory and was moved from Norman to Sapulpa, where it continues operations today.

The clay used in Sapulpa is from "Sugar Loaf Hill" that is located near the plant. This is a red-brown clay, and when the glazes are applied in various thickness, the clay shows through, giving beautiful shadow effects. Mr. Frank and his associate, J. W. Daugherty, developed a glaze using rutile (a mineral containing titanium dioxide) in combination with some of the Frankoma colors. This is known as the "Rutile glaze". These soft shaded color effects became the recognizable characteristic of the most beautiful of Frankoma ware. The colors of these rutile glazes are: Desert Gold, Brown Satin, Woodland Moss (a blue), Peach Glow (a rosy tan), and Prairie Green. Other colors from the outset were: black, red, white, ivory, browns, blues, and shades of pink. The latest innovation is called "Rubbed Bisque", a lovely chocolate brown matt, finished by rubbing with a stain, in lieu of a glaze. Mr. Frank managed to capture, in his sculptured creations, the spirit of the Indians and the Cowboys of the southwest, as well as the fauna and flora, and the shades of the earthen colors of the land and sky.

Other fine artists also contributed to the interesting and beautiful sculptures. Bernard Frazier, twice winner at the National Ceramic Art Exhibition at Syracuse, New York, created the "Collie Head" for the Collie Club of America. Acee Blue Eagle was a well loved Indian artist and is known among collectors and notables around the world for his Indian paintings. He worked in ceramics shortly before his untimely death, and created Frankoma's "Medicine Man". Craig Shephard won second place in the National Sculpture show in Philadelphia, Pa. with his silver

model of the "Red Irish Setter". The setter was reproduced in clay, with the rutile glaze, at Frankoma. Ray Murray, a ceramic artist from Hawaii, made a sculpture of an Indian Chief, while he (Murray) was a student at the University of Oklahoma. Joseph R. Taylor was one of the most prolific artists in the production of Frankoma sculptures. He is classified as one of the most outstanding sculptors of our time and is a retired professor of art and sculpture from the University of Oklahoma. One of his most beautiful creations is the "Fan Dancer" (inspired by Sally Rand) which traveled the museum circuit as part of the annual Ceramic Sculpture Show. Other items created by Mr. Taylor are: Mountain Girl, Peter Pan, Afro Man, Afro Girl, Raring Clydesdale, Seated Puma, Reclining Puma, Puma on the Rocks, Pacing Ocelet, Charger Horse and the Seated Indian Bowl Maker. Willard Stone, a Cherokee Indian, is also a well known artist, especially in the southwest, for his wood carvings. Frankoma has reproduced in clay, the pieces of wood sculptures, they are privileged to own. These include the Indian Madonna, Indian Maiden, Mare and Colt, Coyote, and the Squirrel. Grace Lee Frank designed the lovely Madonna plaques, finished in the rich "Rubbed Bisque". She has also created many other interesting pieces in the line.

Joniece Frank, also a gifted artist, took an elective in sculpture at the Oklahoma University and worked with her father, and has sculptured many existing pieces for Frankoma.

A series of "limited edition" bottle type vases were designed by Frankoma beginning in 1969, and have continued to be issued each year. Each one is signed by either Joniece, Grace Lee or John Frank, indicating which one was the designer. They are marked with a V—1 for the first issue and then V—2 and V—3 and so on. Each is assigned a number incised in the clay on the bottom---no seconds of these were ever sold.

In the beginning, Mr. Frank hoped to create mostly sculptures, but because of a devastating fire, the depression of the 1930s and other setbacks, he resorted to more useful items, such as tableware. In 1972, he decided to reintroduce the sculptured line in a separate catalog,

Frankoma plaque of Will Rogers [1935]. Signed "Sinclair Homer," green glazed edge, 5 by 5½-in. Author's collection; Orren photo

Frankoma; plate by Dave Greer [1971], titled Seguoyahs Cherokee Alphabet. Author's collection

however due to his failing health, this line was discontinued after 1974. Consequently, these creations are the most sought after and treasured by astute collectors.

With so much emphasis being placed on Christmas plates being made abroad, Mr. Frank conceived the idea and decided to create a line of American Christmas plates. These plates were first introduced by the Franks with the thought that they would be a spiritual inspiration and a reminder of the lasting values of the Holy Scriptures, and with a hope that they would be a blessing to those who possess them. The first one was designed and issued in 1965 and is marked "First Issue," along with the other marks. John Frank did the original modeling each year until his death in 1973. The original master mold is signed by Mr. Frank and copyrighted. Each design reflects the fine ability and artistic achievements of John Frank and his daughter Joniece. The plates are done in one color only—a white semi-translucent glaze, known as "Della Robbia" white, which was developed by Frankoma Pottery. The red clay shows through leaving a hint of brown outlining each design.

The plates are uniform in size, being approximately eight and one-half inches in diameter, with the title around the lower portion of the rim, which also includes the date. The subjects are done in bas-relief and depict a biblical scene relative to the Christmas story, which are brought to life in a skillful manner. A leaflet accompanies each plate, giving the scriptural background for the inspiration for that year. It was Mr. Frank's intention to always keep the material on this same basis and, with the Scriptures being so full of inspirations, we are sure there will be ample material for many more beautiful American Christmas plates. The plates are produced in limited quantity and, on Christmas Eve, a ceremony is held at the factory, at which time all the molds, including the master mold, are completely destroyed. These, being the initial American Christmas plates, promise to be as popular and important as the Royal Copenhagen, Bing and Grondahl, Rosenthal, and Royal Bayreuth porcelain plates, and those in glass introduced by Lalique of France in 1965.

Since the death of Mr. Frank, his daughter Joniece is continuing to design the Christmas plates. In lieu of Christmas cards, the Franks, beginning in 1944 (excluding 1945 and 1946), created miniatures in pottery to send to personal friends and Frankoma dealers. Being the initial ceramic Christmas greeting, these are eagerly sought after by collectors. These Christmas cards, as they are called, bear the Frankoma mark, including the date and the words Merry Christmas or (Xmas). Grace Lee, since her remarriage in 1975, has designed and sent to their friends, ceramic cards that bear the lettering, "Grace Lee and Milton Smith" and the date. Joniece continues to create the designs for the regular pottery cards.

Frankoma Pottery. "Dreamer Girl" book ends; 7". Prarie green Rutile glaze. Author's collection

Frankoma Pottery Christmas plates. Corneilius photos

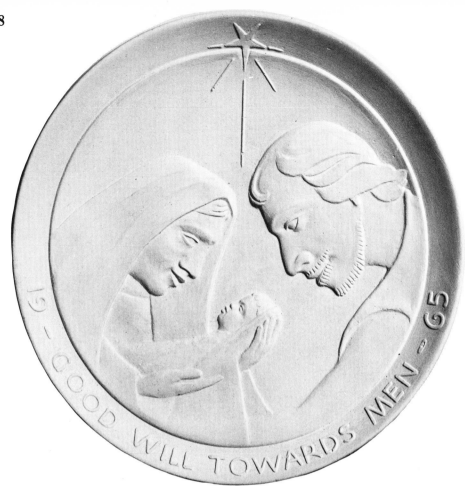

Frankoma Pottery Christmas plate. Cornelius photo

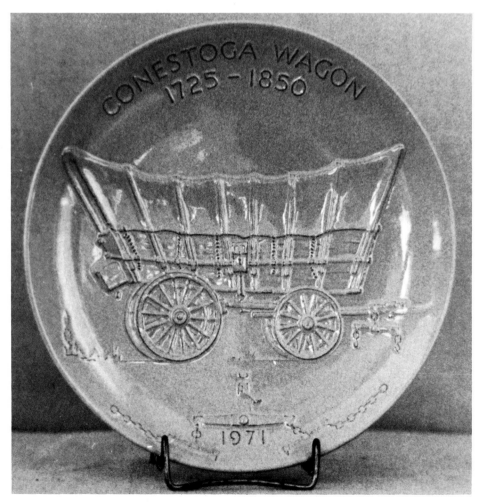

Frankoma Pottery. Conestoga plate; 8¼". Author's collection

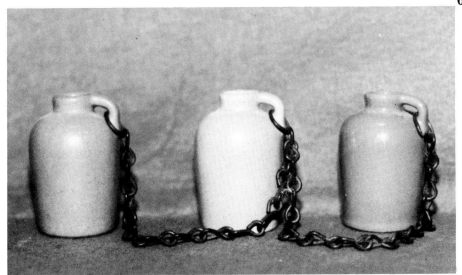

Frankoma Pottery; Wind chimes, 3 in. high. Left to right: Pink, yellow and blue. Author's collection

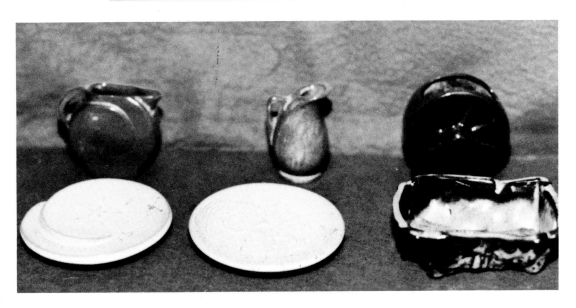

Frankoma; assortment of Christmas cards. Author's collection

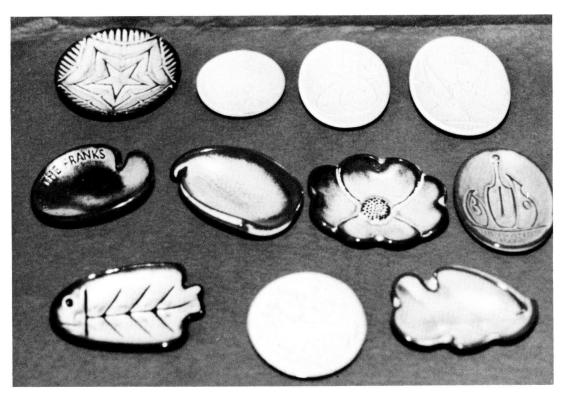

70

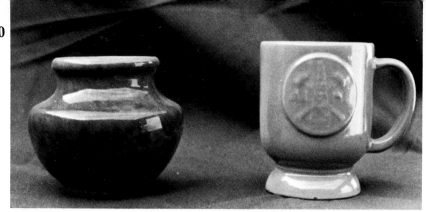

Left: *Frankoma blue vase—old Mountain Lion mark.* Right: *Mug, C2 Frankoma.*

MID-CONTINENT
SECTION
SPE
TULSA
Other side-oil derrick, crossed hammers and the letters AIME

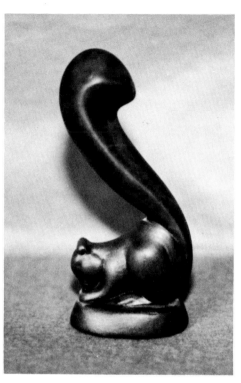

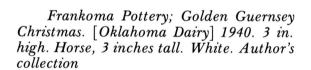

Frankoma Pottery; Golden Guernsey Christmas. [Oklahoma Dairy] 1940. 3 in. high. Horse, 3 inches tall. White. Author's collection

Frankoma-squirrel figure copied from a Willard Stone wood sculpture, with a rubbed bisque finish

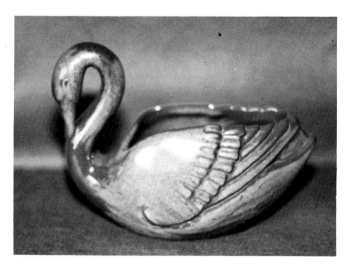

Frankoma swan planter #228. Author's collection

Frankoma; "Red Irish Setter" by Craig Shephard, 6½ in. tall. Rutile glazed. Author's collection

Frankoma; "Fan Dancer" in flower arranger bowl. Rutile glaze [Prairie green]. Author's collection

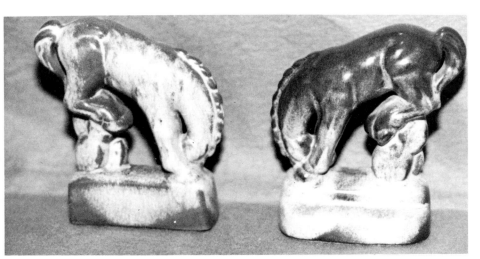

Frankoma-423; "Western Bronco" bookends. Rutile glazed. Author's collection

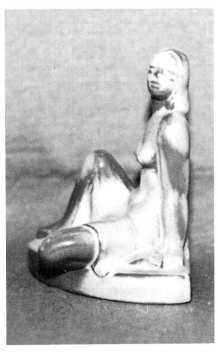

Frankoma; 136. "Mountain Girl" by Joseph R. Taylor. Bookends. 6" tall. Author's collection

Frankoma Pottery. Indian Maiden & two Chiefs. Sculptured by John Frank. Author's collection

Frankoma Pottery. Puma; 9" across. Collection of Ruth Dumas

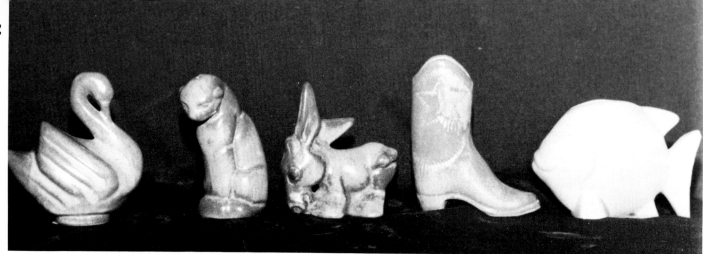

Frankoma; group of miniatures. Author's collection

Frankoma Pottery
Marks:

FRANK POTTERIES
NORMAN OKLA

Stamped in black
1933 & 1934

Impressed
1936–1938

FRANK POTTERIES
FRANK POTTERY

Stamped or impressed
1934 & 1935

FRANKOMA

Impressed
1942 to present date

FRANKOMA POTTERY
FRANKOMA

Impressed
1943 to present date

F

Impressed
Joniece Frank mark
currently in use

Fulper Pottery
1805—1929
Stangl Pottery
1929—1978

The Fulper Pottery was founded in 1805 by the Fulper Brothers in Flemington, New Jersey. The earliest Fulper ware was fashioned from the fine rich clay found in Hunterdon County. Many other potteries were also located in this section, where these rich clays were readily at hand. This area became the original American home of those potteries that are often referred to as "Bennington" type, such as Rockingham, yellow ware, and the salt glazes. "Bennington" is the name taken from the wares made by Captain John Norton at Bennington, Vermont. This type of ware duplicated those being imported from England that were glazed with the most common glazes. This was prior to the manufacturing of American art pottery. "Bennington" is more or less a utility ware and not considered an art-type ware.

At the very beginning the Fulper Company primarily manufactured drain tiles. Later other articles were added, such as drinking vessels for poultry. After 1860 beer mugs and bottles, water and vinegar jugs, butter churns, and pickling jars were added to the line. These were the typical lines created by the Fulper Pottery until 1910.

As stated in a brochure issued by the Stangl Pottery in 1965:

> One of the most unusual products created by the Fulper Company was a set of stoneware jars to provide clean, cool water. From the upper section the water passed through a specially-made "filter stone" into the lower container inside of which was a smaller jar to hold ice. The surrounding water, cooled by this "ice-chamber," was drawn off through a spigot. This was the forerunner of today's water-cooler. So great was the demand for

the "Fulper Germ-Proof Filter," as it was called, that other potteries were often contracted to help make enough to fill the orders. These "water-coolers" were to be found in every railroad station from coast to coast and in office buildings and stores through-out the nation. They were also exported in large quantities to various South American and West Indian countries.

In 1910 J. M. Stangl was given the position of ceramic engineer at the Fulper Pottery. The company was entering the art-pottery field, and all the inherent problems of launching a new product were delegated to Mr. Stangl. The first art ware was sent to stores around the country as exhibit pieces only, and some were valued as high as several hundred dollars each.

During the World War I period, when imports were cut to a minimum, a large American doll manufacturer solicited Fulper to make doll heads. Mr. Stangl created what is now known as the famous "Fulper" doll heads, which are highly prized by today's doll collectors.

By 1920 the Fulper Pottery, now headed by Mr. Stangl, was designing and producing many beautiful art lines, as well as an attractive line of monochrome dinnerware. At first this dinnerware was made in solid green, but by 1930 other colors were added. Incidentally, Fulper was the first American pottery to introduce dinnerware in glazed solid colors in this country. Fulper also produced some articles of fine bisque and porcelain, fashioned of the identical clay they used in making the doll heads.

From the early 1920s the Pottery grew steadily; by 1929 two locations were operating in Flemington. Fulper had also taken over the Anchor Pottery of Trenton,

New Jersey, in 1926. The Anchor Pottery had been operated by the Grand Union Tea Company to manufacture premium items that were given away to their customers.

On the morning of September 19, 1929, disaster struck: the main Fulper plant at Flemington burned to the ground. The news of this catastrophe was broadcast by radio and newspapers throughout the United States. The townspeople were greatly concerned since Fulper was one of the largest employers in this area. All employees were given the opportunity of transfering to the Trenton plant, where the name was immediately changed from Fulper Pottery to Stangl Pottery.

Fulper continued to manufacture art ware on a limited scale in the smaller pottery on Mine Street in Flemington. This operation lasted until 1935, when all facilities were transferred to the Trenton plant.

In 1940, Stangl introduced a fine grade of dinnerware...hand crafted and hand decorated in many beautiful designs, always in good taste. Stangl was first to use the carving process for their pattern designs. Trained artists used specially designed tools for carving of the patterns. A certain amount of pressure was applied to the white engobe (slip) with the tool, which cuts through and discloses the red clay...a Stangl trademark for many years. Between the carved lines, the artists then hand decorated the ware with various bright under glaze colors.

In 1941, when World War II curtailed imports, Stangl, always progressive, was one of the first to create authentic Audubon reproductions of hundreds of different birds. These were done in exquisite detail and unexcelled quality. The high-gloss glazes on them have never crazed. In addition to the line of pottery birds, Stangl created twelve different birds in a "porcelain" body. These were made in limited numbers, less than fifty of each being produced. Both the pottery birds and the porcelain birds, which were made in the 1940s, are eagerly sought after by today's collectors.

As did other potteries at the turn of the century, Fulper created exotic names for its wares. In the early catalogs the names were highly imaginative. For example, "mouse gray with blue of the sky flambe," "mouse gray with cat's eye and black flambe," "cucumber green," or "elephant's breath," denoting a rather gray shade, were all color descriptions.

Fulper ware was made in a variety of forms and shapes, including ashtrays, cigarette boxes, trinket boxes, bowls, vases, pitchers, and all types of table accessories, as well as exquisite dinnerware.

Many different glazes were developed to add tone and texture to the art lines. Some pieces were matt finished and some were high-gloss glazed. Some Fulper items are artist signed; however, no records were kept of the artists' names or their monograms.

Terra Rose was introduced in 1941. Shades of mauve, green or blue were brushed on over brown clay...creating unusual color combinations. These are marked with the traditional trademark, including the name "Terra Rose".

In the late 1950s, Stangl Pottery created a popular art line called "Antique Gold"...a ware produced by hand brushing 22-karat gold over a matt green glaze. Also, "Granada Gold", with gold brushed over turquoise...and "Black Gold", brushed over black. A ware called "Platina" was introduced simultaneously by brushing the pieces with platinum, resulting in a silver brushed finish.

From the outset, the Fulper Pottery marked their wares, and Stangl continued the custom of back stamping every article with the oval trademark and pattern name. The wares were sold in thousands of fine stores all over the country.

Following Mr. Stangl's death, February 3, 1972, at the age of 83, the Pottery was sold to the Wheaton Glass Company. In spite of ever effort to increase business, the Company continued to operate at a loss, and consequently, was sold in 1978 to the Susquehanna Broadcasting Company. All operations were terminated, in late 1978 at the Trenton plant.

Fulper Stangl; ceramic display sign. Blue on blue. Don Goodwin collection; Rocky Joe Denton photo

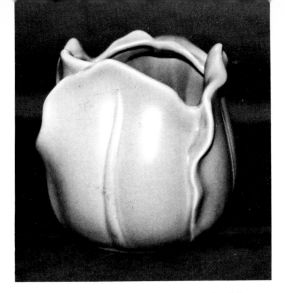

Fulper Stangl Pottery; satin blue vase, 5½ inches high. #5145. London collection

Fulper Stangl Pottery; vase, 8 inches high. #4007. Applique patent pending. White on gloss blue. London collection

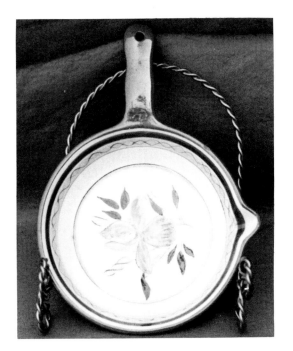

Fulper Stangl Pottery; country garden casserole, 8 inches. London collection

Fulper Stangl Pottery; creamer, sugar and pepper. #4030. Fruits and flowers pattern. London collection

Fulper Stangl Pottery; Tray, 8 inches. #4038 with platina finish [silver]. London collection

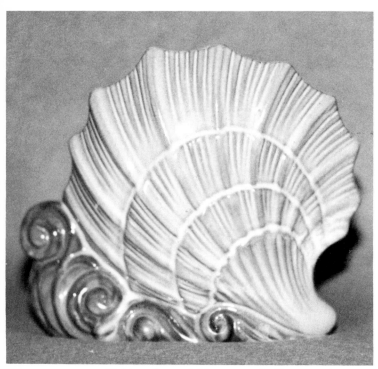

Fulper Stangl Pottery; shell vase, 8½ inches. Terra rose #3614. Beige and green. London collection

Fulper Stangl Pottery; vase, 13 inches high. Note grasshopper on base. Terra rose. Green with beige handle. London collection

Marked Fulper ware. Left to right: Bisque covered box, artist signed; green vase, 6 in. high; vase, 12 in. high, paper label with line name "Yellow Flambe"; green bowl, slightly iridescent, with frog, 8 in. diameter. Johnson photo-covered box-Ervalee Hecker collection

Listed in 1920's catalog as #5168 Stangl wig and hat stand. Hand crafted, hand painted; blonde or brunette. Collection of A. Christian Revi

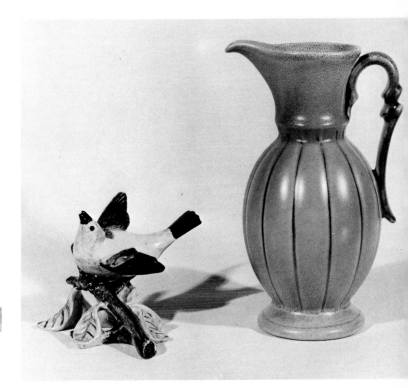

Bird, bright pink, yellow, and blue, marked, 4½ in. high; early Stangl pitcher, shades from blue to green, marked, 10 in. high. Author's collection; Knight photos

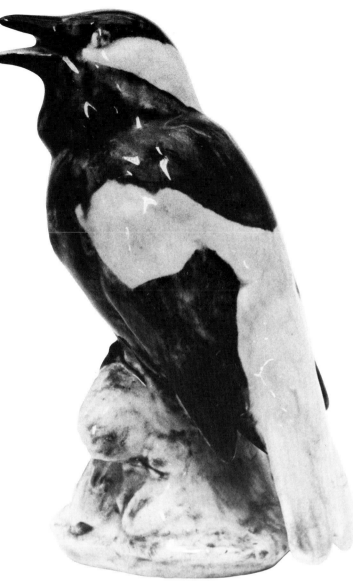

Marked Stangl, dark blue bird with light yellow, 5 in. high. Knight photo

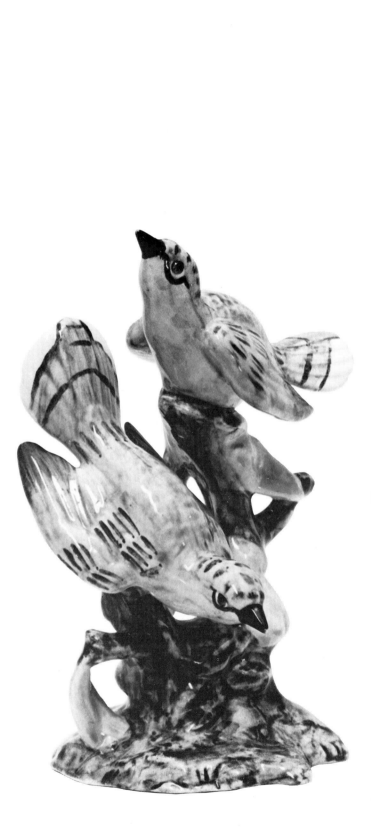

Marked bluebirds, 7½ in. high. Knight photo

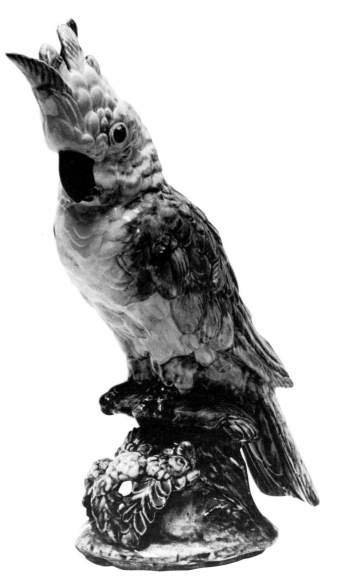

*Marked cockatoo with brilliant plum-
age, signed with artist's signature, "Jacob,"
12 in. high. Knight photo*

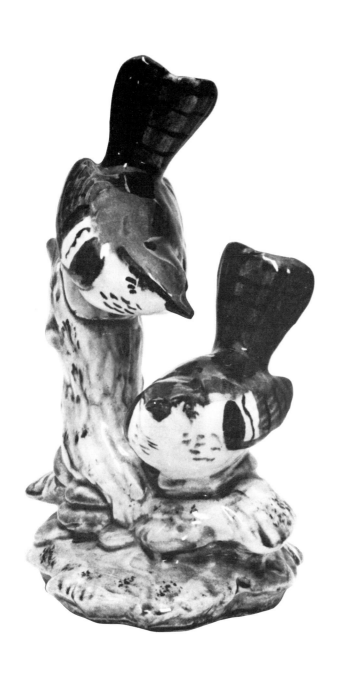

*Fulper-Stangl Ware; 6 in. high.
Brown and white finches marked Stangl.*

80

Allen hummingbirds, vivid coloring, ink-stamped "Stangl," original tag has title and no. 3634, 3½ in. high. Knight photos

Fulper—Stangl Pottery

marks:

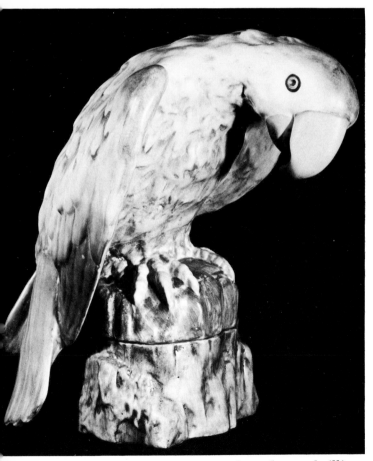

Fulper parrot perfume lamp, brilliant natural coloring, impressed mark, artist signature, 9 in. high. Knight photo

FULPER BROS.
FLEMINGTON, N.J.
Impressed

Impressed
or
stamped

Impressed
or
stamped

Impressed
or
stamped

Fulper—Stangl Pottery

marks:

Impressed
Martin Stangl's
Logo

Impressed

Stamped

STANGL

U S A

Used after 1929
Impressed

STANGL

Impressed

Paper label: Includes
number, pattern name,
and price

"STANGL," impressed;
oval mark, ink stamped

Made in Trenton USA

Hand Painted
Stangl ®
TRENTON, N.J.
OVEN PROOF
COUNTRY GARDEN ©

Ink stamped, dinnerware

Hand Painted
Stangl ®
TRENTON, N.J.
GRANADA GOLD ©
5207

Ink stamped, giftware

Gates Pottery
Teco Ware
1903—early 1920s

The Gates Pottery of Terra Cotta, Illinois introduced an Art ware known as Teco Ware in 1903. The name was derived from the first two letters of "Terra" and "Cotta", derived from the Pottery location. The Gates pottery, as it was generally referred to, had its beginning in 1881, when a Chicago lawyer, William Day Gates (1852 —1935) became interested in working with clays. He founded the "American Terra Cotta and Ceramic Company", located about 45 miles northwest of Chicago, in a picturesque valley beside a small lake.

The earliest pieces to be manufactured were terra cotta bricks, drain tiles, sewer pipes and decorative architectural items. Gates built a chemical laboratory and commenced experimenting with different glazes and molds for art ware. He developed all sorts of matt and gloss glazes. While experimenting, a lustre glaze was accidentally produced in 1898. A crystalline glaze was discovered in the same manner in 1901. Gates was awarded two gold medals, at the St. Louis Exposition in 1904, for his crystalline glazed art ware.

The rich clays used were strictly American and came almost entirely from Brazil, Indiana. In 1903, Teco Ware was created and was first introduced, to the general public in 1904, by way of advertising in different magazines, including: *"The House Beautiful" and "The Craftsman".* The address of Gates Pottery was listed as Chicago, since they maintained offices there.

Gates designed many of the earlier shapes himself, although he had many talented artists working with him. Many of his friends, who were architects, contributed designs for his products. In the *"Bayview Magazine"*...Vol 15..No. 5, an article by Mr. Peasley and Clara Ruge, states: "Besides William D. Gates, other designers for the Teco, were: F. Albert, W.

J. Dodd, Blanche Ostertog, Mundie and Dunning". Other gifted artists, who worked for Gates, included his two sons, William Paul Gates and Ellis Day Gates. Most of the experiments were conducted by Elmer E. Gorton.

The artisans were mostly influenced by the aquatic plants that grew on the premises, including: lotus blossoms, water lilies, leaves, stalks and other species. The pottery pieces were never hand painted, but molded or carved in relief. Designs were sometimes classical and other times, were created in graceful flowing lines, some with fanciful ribs and open work. The intricate open work and handles on these pieces must have made it very difficult to remove the piece from the mold.

The colors of Teco's first experimental ware included brown, buff and different shades of red. In the early 1920s, the smooth green matt glazed ware, made popular by Rookwood's molded ware, Grueby, Owens Aqua Verde and other Potteries, was being produced. The "Teco Green", as it was referred to, was advertised as a "cool, peaceful, healthful color---a tone not easily classified". For almost ten years, this matt green was the only color utilized. About 1910, other colors were added, including brown, yellow, blue, rose, grey, purple and different tones of green. Around 1913, tea sets were made, in a rose beige and silver grey, with incised designs. Other Teco items include---huge garden vases, window boxes, fireplace mantels and fountains.

The precise date the manufacturing of Teco ware was discontinued is unknown, but it is reasonable to assume it was about 1922 or 1923, since the last advertisement appeared in various chronicles in 1923.

In 1929, the Pottery was sold to George A. Berry Jr. and the name was

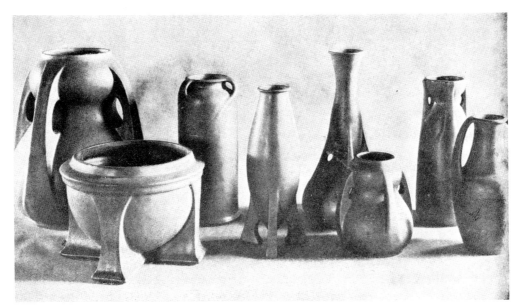

changed to "The American Terra Cotta Corporation". They made architectural products for a short period of time, then decided to try a different business, and the name was then changed to "The American Steel Treating Company".

Teco Ware; photo appeared in Bay View Magazine Vol. 15 No. 5. February 1908

Teco ware. Lush green matt glaze, marked "Teco," 2 in. high, 8 in. diameter. Collection of Andy Anderson; Knight photo

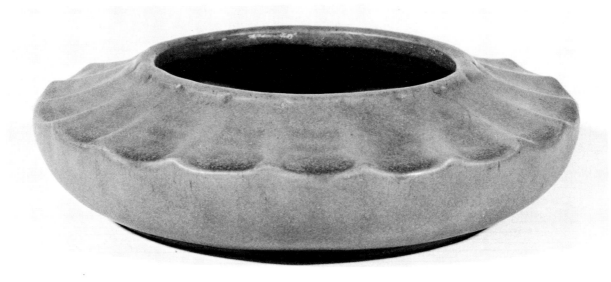

Gates Pottery
Teco Ware...1903—Early 1920s
Marks:

Impressed or Stamped

Grueby Pottery
1897—1920

William P. Grueby was actually associated with several separate pottery operations during his life time (1867—1925). He was first employed and trained at the Low Art Tile Works in Chelsea, Massachusetts. Later he was a participant in several other partnerships involving the manufacture of tile and other architectural products. Some of these firms used the Grueby name in conjunction with their respective company titles.

In 1897, William P. Grueby organized his own company; the Grueby Faience and Tile Company in Boston, Massachusetts. Included in the company personnel was George P. Kendrick; a designer and sculptor, and William H. Graves as business manager. Another important Grueby artist was Addison B. Le Boutillier, a French architect, who designed fine decorative tiles among other things. Many beautiful architectural tiles were created, by other artists, at Grueby. One such fascinating set of tiles, depicting four Apostles, was used in the Cathedral of Saint John the Devine in New York City. Other fine artists who worked at the establishment were graduates of near-by Art Schools, including the Museum of Fine Arts of Boston, Cowles Art School and the Massachusetts Normal Art School. The monogram of these artisans are included, along with the Company marks, on the base of the article.

By 1908, the Corporation was operating two separate work shops, each one using a different name. The "Grueby Pottery Company" made tiles and garden furniture, while the "Grueby Faience and Tile Company" created art ware.

About 1910 or 1911, the Company had ceased production of the art ware but continued to manufacture tile and architectural products until about 1920, when the Grueby holdings were sold to the C. Pardee Works, Perth Amboy, New Jersey. In correspondence with Mr. E. Stanley Wires, he stated, "After the Pottery was closed in Boston, Mr. Grueby was engaged by the C. Pardee Works, Perth Amboy, to manage a faience department. I think he was still with them when he died".

The majority of the art ware made at Grueby Faience Company was covered with a heavy matt glaze that had been perfected by Grueby. The ever popular green was the color most often employed, however, articles were glazed with other colors; such as an off white, pink, blue, yellow, brown, grey, and a purple with a tinge of grey. A few articles were further decorated with the motifs being tinted with a glaze and/or glazes of a different color. One style of decorating these articles was by using a round piece of clay, somewhat like a strand of spaghetti. This was inlaid in the incised outline, of the freehand designs, and then modeled by hand to the desired shape, hence, resulting in the raised outlines around the designs of leaves, flowers and other type foliage. The surface appears to be rough and lumpy, very similar to a cucumber, but it is very smooth to the touch. This technique is the recognizable characteristic of most Grueby ware, however, sometimes they did utilize the incised method of creating the design, without the inlay.

It may be interesting to note that the L. C. Tiffany Studios purchased some Grueby pottery, prior to the manufacturing of Tiffany pottery, to be used for lamp bases or to be further embellished by metals to form tea tiles, ink stands and other useful items.

Among the numerous honors awarded Mr. Grueby were two gold medals and one silver in 1900, at the Paris Exposition, and the Grand Prize in 1904, at the St. Louis Exposition.

Grueby implemented a system of marking his wares, but at times the letters are partially or completely covered by the heavy glaze and are invisible.

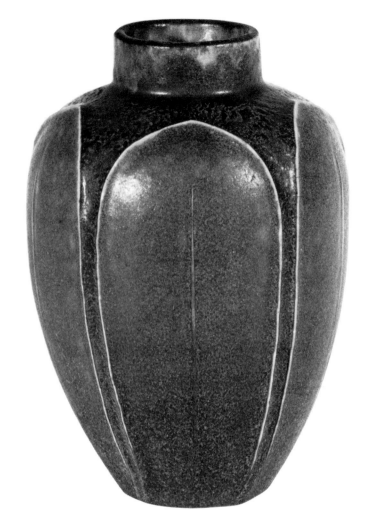

Grueby vase. Two shades of lush green, impressed mark, 5½ in. high. Knight photo

Grueby pottery tile. Tiffany mounted, designed by Le Boutillier, green on green with white tulip, 6½-in. square. Collection of Bill Runyon; Knight photo

Grueby Pottery

marks, impressed:

GRUEBY

GRUEBY POTTERY
BOSTON U.S.A

GRUEBY
BOSTON MASS.

Artists and their monograms:

Le Boutillier	*D*	Norma Pierce	
Ruth Erickson	*Æ*	Wilhelmina Post	*W.P.*
Ellen R. Farrington	*E R F.*	Gertrude Priest	
Florence S. Liley		Marie Seaman	*S M.S.*
Anna V. Lingley	*A*	Gertrude Stanwood	*S*
Lillian Newman		Kiiche Yamada	

Haeger Pottery Inc.
1871—

The Haeger Pottery was begun as the Dundee Brickyard in 1871 due to the business acumen of its founder, David H. Haeger. 1871 was the year of "The Great Chicago Fire" and David Haeger recognized the business opportunity that was presented by the need to rebuild Chicago with non-combustible materials. He purchased a small existing brickyard in Dundee and began his own production of brick and drainage tile. From this small start, the company grew to encompass additional brickyards in both Gilberts and Coal City, Illinois. From manufacturing bricks and drain tile, he entered into the industrial field of making simple red clay flower pots for the florist trade. David Haeger passed away in 1900.

In 1912, his son Edmund H. Haeger became acting supervisor of the firm and two years later (1914), the Company introduced a more sophisticated line of commercial art ware. When J. Martin Stangl left the Fulper Pottery of Flemington, New Jersey in 1914, he migrated to the Haeger firm where he assisted them in developing this new line of commercial florist ware. He remained at Haeger until 1919, when he returned to the Fulper Pottery.

At the Chicago "Century of Progress" World's Fair in 1934, Mr. Edmund Haeger installed a complete working facility to demonstrate the various pottery techniques and actually completed ceramic pieces. A special paper label was designed for that year. An interesting contrast to the Haeger display was the Indian potter Maria from New Mexico who was also demonstrating her primitive methods of potting at the fair.

The Haeger firm was always striving to keep in tune with public needs and taste, always improving the facilities and engaging every available talented artist. In 1938,

when Joseph Estes was named general manager, prior to his being appointed president (1954-1979) of the organization, a more elaborate line of art ware was introduced on the market. That same year (1938), a designer by the name of Royal Hickman joined the Company. He was considered a genius in the field of design. His work was daringly intricate with smooth flowing lines---some with delicate open work. It was only by coincidence that his given name was Royal, since the Haeger Company had previously made the decision to call the new premium line "Royal Haeger". The articles Mr. Hickman designed for this new line was marked "Royal Haeger by Royal Hickman", embossed on the base or at times, by only a paper label. The shape of the label is of an elongated crown that carries the identical credit "By Royal Hickman". Due to the fact that paper labels disappear, some pieces of Royal Hickman will not be marked at all. Later the credit "By Royal Hickman" was removed from some of the wares he designed and they only displayed "Royal Haeger U.S.A." imprinted or embossed on the bottom.

In the late 1930s, Hickman designed the popular sleek black panther. It was produced in three sizes; the largest about two feet in length. It became so popular, it was copied by several other Potteries. Hickman remained at the Haeger Pottery until 1944, when he migrated to Florida and began operating his own business. The art work he created at that time will be marked only with his name. Following World War II, he performed some free-lance work for Haeger Pottery until 1970, when he passed away.

In the 1950s, Eric Olsen, an artist and sculptor, began his employment at Haeger and is currently doing some art work there. He gained recognition for his bust of Carl

Sandburg and Edmund Haeger. One of his most notable works is the bust of the late United States Senator Everett Dirkson, that was dedicated at the opening of the Chicago Federal Building in 1971. The building has since been renamed The Dirkson Building. Olsen designed the favorite Haeger animal figurine of a bull, glazed in red or mirror black. Other artists were Franz J. Koenig, Robert Heiden, Sascha Brastoff, and Helmut Bruchman.

Sabastino Maglio, also a talented artist working at the Haeger organization as a master potter, designed a huge vase alleged to be the largest vase in the world. It is over eight feet high, weighs 650 pounds, and is decorated around the center with exotic Grecian type figures on a classical shape with arabesque decorations on the top and bottom. It is presently displayed in the Haeger showroom in Dundee. The chief designer for Haeger Pottery, at this point in time, is Glenn Richardson. Presently the unique glazes are formulated by Alrun O. Guest, the ceramic engineer. Trained in Germany to have the perfectionism of an old world craftsman, and yet inspired by the freedom of American spirit. Alrun Guest has maintained the high standards of color and form that have been the hallmarks of Haeger quality. Brenda A. Brown, a personable lady, is in charge of the company museum and tours at the plant in Dundee.

Two plants are in operation in Macomb, Illinois at the present. One produces lamp bases and shades, while the other yields a complete line of florist wares. The art line is created at the Dundee plant, still being distributed under the name Royal Haeger. Although the Pottery did produce some dinnerware, they are primarily famous for their vases, figurines, miniature animals, birds, flower arrangers, lamp bases and all sorts of unusual and useful gift accessories. Between 1946 and 1950, Haeger created a line of decorative articles that are marked "Royal Haeger" together with a number preceded by the letters R G. It was introduced as the "Flower Ware" line and the R G was the code mark for "Royal Garden". The wares included vases, pitchers, flower arrangers, jardinieres and many others, glazed in a smooth matt.

The Royal Haeger early wares are covered with a variety of glazes. One of the most attractive is a pink splotched with blue or aqua that is called "Mauve Agate". Other colors are yellow with green, grey with green, mirror black, white and several other colors---single or in combination.

At the outset, Haeger implemented a system of numbering and marking. The earliest mark used was a large letter "H" imprinted in a diamond or elongated square with the name "Haeger" printed on the cross bar of the "H". This was continued until about 1920. Paper labels have varied over the years. A current label is a gold crown, printed in black and gold, "Royal Haeger", Dundee, Ill.

This present year (1982), Haeger is celebrating their one hundred and eleventh year in the pottery business. The prosperous enterprise is still being operated by the friendly Haeger family, now in the fourth generation. The third generation, Mr. Joseph F. Estes, son-in-law of Edmund Haeger, is currently chairman of the board. The fourth generation, his son, Nicholas Edmund Haeger Estes, is president of the company's operations in Macomb. Joseph Estes' daughter, Alexandra "Lexy" Haeger Estes is president of the Dundee firm.

The current lines (1982) of Haeger being produced are lovely neoclassic and country styles created for gracious living and covered in over twenty luscious high colored glazes; always in excellent taste.

Haeger Pottery; exact replica of the first piece of art ware produced in 1914. Offered in 1971 in limited numbers [2500]. Gold tweed glaze. Handsomely boxed in a gold container. Photo courtesy of Haeger Potteries, Inc.

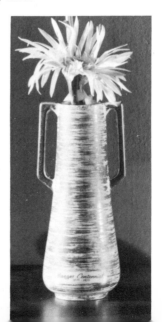

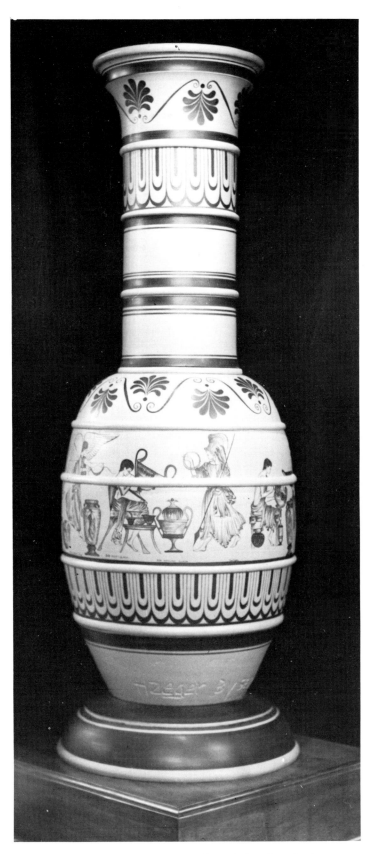

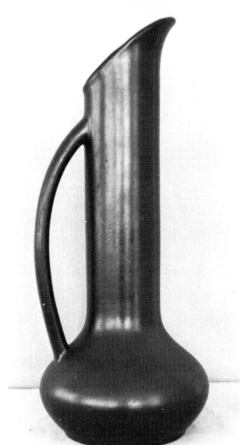

Haeger Pottery, 15" "Royal Haeger RG 86", semi-matt brown glaze. Collection of Ruth Dumas

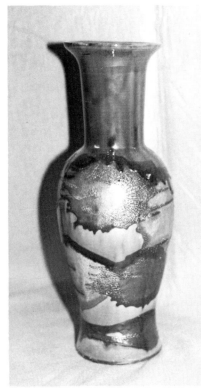

Haeger Pottery; listed in the Guiness Book of Records as the world's largest vase...over eight feet tall, weighing 650 pounds. Created by Sabastiano Maglio. Courtesy of Haeger Potteries, Inc.

Haeger Pottery 16" vase. Royal Haeger USA stamped in black ink. Color-orange splotched in brown. London collection

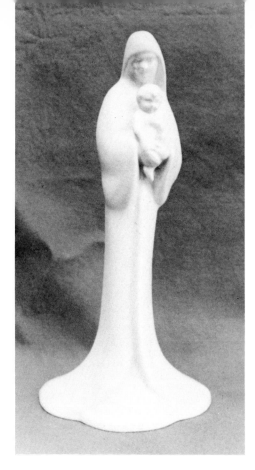

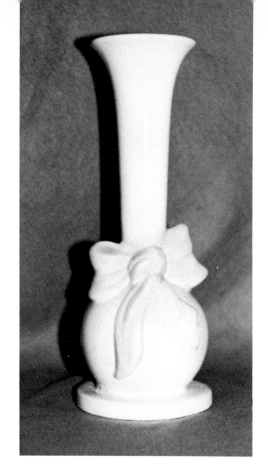

Haeger Pottery 10" Madonna. White matt glaze. Royal Haeger stamped in black ink. London collection

Haeger Pottery; vase, 7 in. high. Cream with blue bow. Marked Royal Haeger by Royal Hickman. #USA 455. London collection

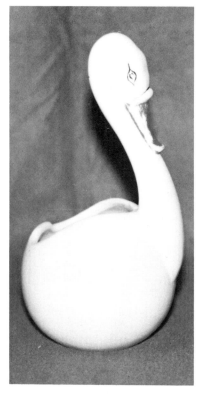

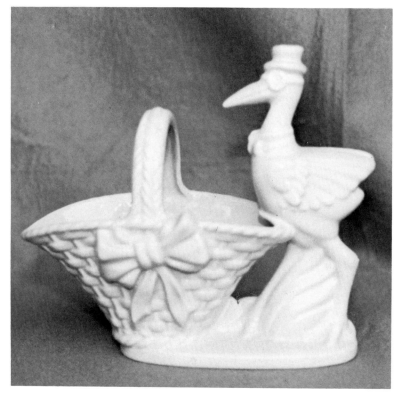

Haeger Pottery; duck planter, 7 in. high. 404 H. Marked Royal Haeger. Color-beige. London collection

Haeger Pottery 6" planter basket. White glaze. Marked Haeger USA. Stamped in black ink. London collection

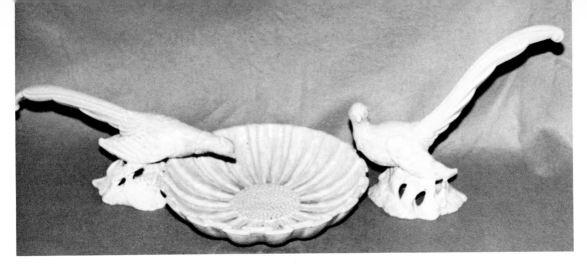

Haeger Pottery 10" bowl with birds. Color-mauve agate. Marked Royal Haeger USA. London collection.

Haeger Pottery, covered box; 8" D, gray with green flower. From the hands of Royal Hickman. Author's collection

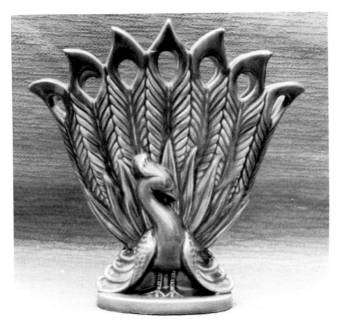

Haeger Pottery 10" Peacock vase R 453 USA. Color-blue. Green on pink. Marked Royal Haeger. London collection

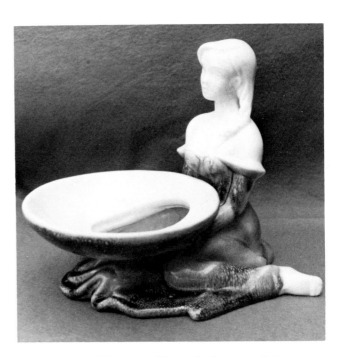

Haeger Pottery; figural planter, 8 in. high. Beige and dark brown. London collection

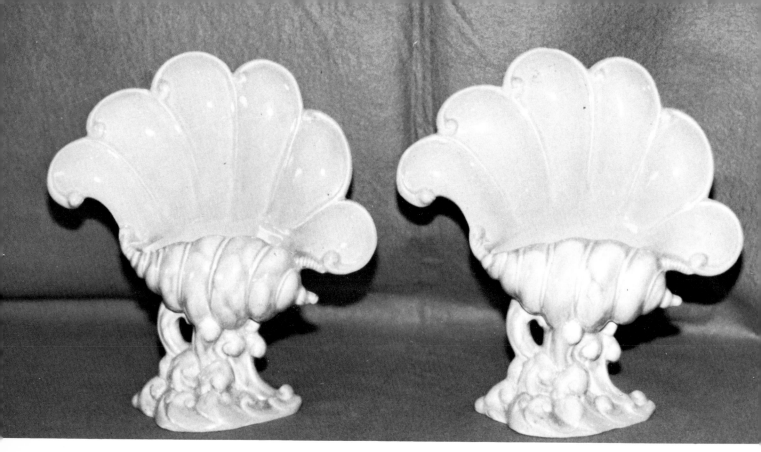

Haeger Pottery 7" shell vases. Color-
mauve agate. Marked Royal Haeger USA
#483. London collection

Haeger Pottery 10" basket vase.
Color-mauve agate. Royal Haeger by
Royal Hickman USA R131. London
collection

Haeger, 7½" long, mauve agate.
Collection of Mary and B. C. Cain

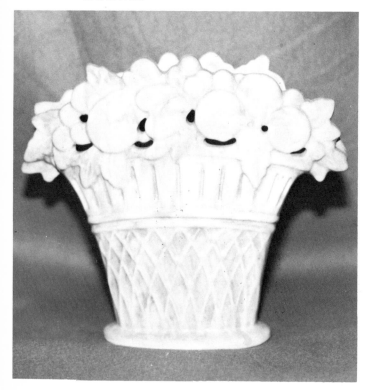

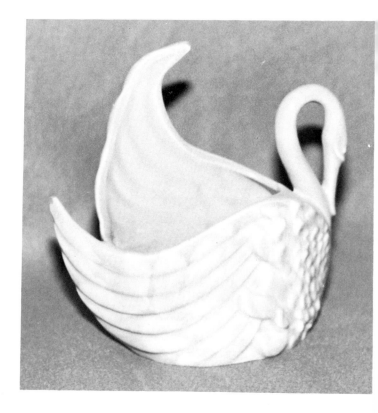

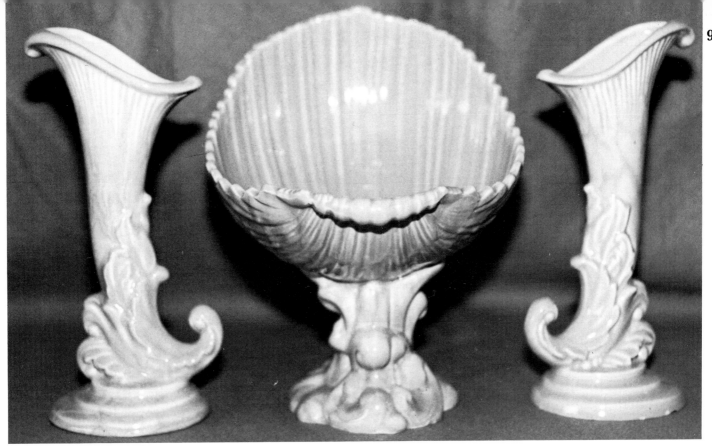

Haeger Pottery 12" Cornucopia vases.
Color-mauve agate. Marked Royal Haeg-
er. R. 332B USA. London collection

Haeger Pottery 10½" plate. Pink edge
with mauve agate center. Royal Haeger by
Royal Hickman USA 372. London collec-
tion

Haeger Pottery 10" console bowl with
10" mermaid. Color-mauve agate. Marked
Royal Haeger by Royal Hickman. London
collection

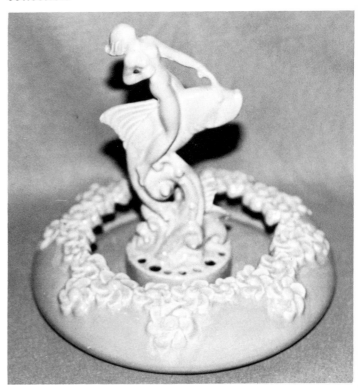

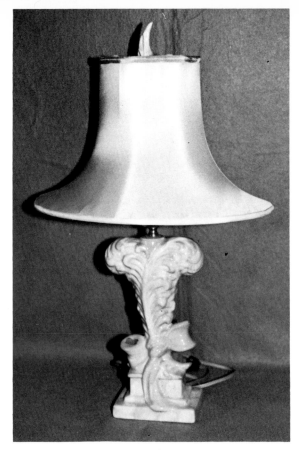

Haeger Pottery; lamp, 24 in. high. Pink and blue base [Mauve Agate]. Royal Haeger by Royal Hickman. London collection

Haeger Potteries; Blue Haeger display sign. Don Goodwin collection; Rocky Joe Denton photo

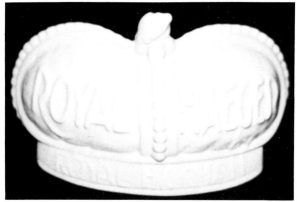

Haeger Potteries; Royal Haeger-Royal Hickman ceramic display sign. Blue glaze. Don Goodwin collection; Rocky Joe Denton photo

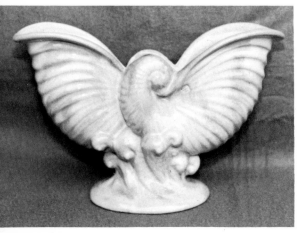

Haeger Pottery 8" shell vase. Color-mauve agate. Bottom photo shows the Haeger mark. London collection

Haeger Pottery
marks:

ROYAL HAEGER
BY ROYAL HICKMAN
USA R 237

Impressed in relief on base

Haeger
USA

Impressed on base
in relief

Impressed on bottom

Embossed gold
paper label

Early embossed gold paper label
Current-printed in black on gold

Imperial Porcelain Corporation
1946—1960

The Imperial Porcelain Corporation was established in 1946 at 1530 Bluff Street, in Zanesville, Ohio, by three local citizens; Dr. Fred Phillips, Dr. Dwight Smith and Dr. J. Diehl Sulsberger. They first presented "bread and butter" lines consisting of floral arrangers, ash trays and large pitcher and bowl sets. They aspired for better things and thus decided to create an art ware that was strickly American, to be used for packaging toiletries for Mr. Charles Hipsh of Hipsh Inc., located in Kansas City, Missouri.

It was Mr. Hipsh's desire that Paul Webb's "Blue Ridge Mountain Boys" cartoon characters be reproduced as sculptures that would retain the inherent humor and typical mountain spirit---a lasting tribute to the folk art of America. After exhaustive survey in the field of ceramic sculpturing, Mr. Hipsh finally met and was instrumental in employing Mr. P. H. Genter for the Imperial Porcelain Corporation, an artist he thought equal to the task. Mr. Genter proved to be just the artist that was desperately needed to interpret the American Folk art theme. Genter had won numerous awards all over the United States and had been chief designer for several of the nation's outstanding potteries and art ware studios. He made the necessary arrangements and consulted with Paul Webb, the cartoonist and subsequently, accomplished the project for the Hipsh firm.

Paul Webb was born in Pennsylvania in 1904. He displayed an early talent as an artist, and after preliminary training, graduated from the Pennsylvania Art Academy. The Mountain Boys theme was inspired by trips taken by Webb through the Southern Mountains and from the contacts with the rural folks of his adopted Connecticut. He subsequently gained a wide following with his cartoons which were published in Esquire Magazine, a large number of newspapers, on calendars and the like.

After the death of Mr. Genter about 1949, Denzil Harding became plant manager. Genter and Webb collaborated and designed the appealing, unique sculptures that were first released as toiletry containers for the Hipsh firm. "Luster" hair cream, bath salts, smelling salts and other articles that related to the bath and grooming were distributed in these containers. The corporation offered a line of "Blue Ridge Mountain Roys" sculptures for sale to the general public in the same high quality as the toiletry containers. These included---ash trays, pipe trays, planters, jugs and salt and pepper shakers. Vases were also made available---some in the form of the old rustic outhouses with the half moons over the door---Chic Sales style. They were reluctant to call it a "Privy", so they referred to it as a "Biffy". In 1947, the Imperial Corporation adopted the Paul Webb cartoons on utilitarian articles, namely, various size mugs, pitchers and planters.

Other American Folk lore sculptures produced by Imperial Porcelain were the characters from Al Capp's Dog Patch cartoons---Little Abner, Daisy Mae, Mammy and Pappy Yokum, Indian Joe and the Schmoos. One of the more scarce figures is "Loweezy" from the "Snuffy Smith" comic strip. It is not known whether other characters from this strip were created.

Imperial also produced miniatures called "American Folklore Miniatures" which included about 23 animals in several sizes. The largest---a Bull about 3½" in length and the smallest; a Frog and Skunk, less than 1". Some of these are the same as the figures applied to the containers. Free standing figures of people were made from the molds that were used on the various

vessels, such as, "Gran Pappy" with his jug. The miniatures that have been documented are---Bull, Cow, Calf, Sow with Pigs, sitting Pig, reclining Pig, Hounds in four positions, such as appear on containers #106 and #104. Also, Burro, Kitten (two sizes), Mule, Horse, Colt, Sheep, Lamb, Skunk (two sizes), as shown on #104 and #92, Turtle, Rabbit, Duck, Frog as shown on #105. Another is the Filpot Baby, exactly as it appears on #104 as "Oncle" Rafe. Many of these articles are stamped with the Copyright "C" in a circle on the chest or bottoms.

The cartoonists specified the color to be applied on their pieces or figures, which were all hand painted. Meeting these stringent requirements were rather expensive, as were the royalties they collected. Eventually, these expenses led to financial difficulties for the Corporation. They attempted to produce other lines, namely, garden ornaments which did not prove to be profitable, and regretfully, were forced to close in 1960. Harding purchased the plant and manufactured white pitcher and bowl sets, marked with an "H" on the base. He then changed the name to "Imperial Pottery". Disaster struck and the Pottery was completely destroyed by fire, February 22, 1967.

Most Imperial Porcelain Corporation containers are fully marked on the base. The "Blue Ridge Mountain Boys" are also marked---"Paul Webb" in relief on the side or back near the bottom. Included in the marks are the date and the number that was assigned to each item.

Pieces that have thus far been documented:

#81—Loweezy Ash Tray
#92—Willie and Gran Pappy Pipe Tray
#93—Water Pitcher (1½ quart)---"Rabbit Hunt"
#94—"Jake Handled Mug" (15 ounce)
#94A—Mug with double "Baby Rafe" handle (15 ounce)
#95—Pipe Ash Tray---"Rafe" and "Gran Pappy" at the "Biffy"
#96—Planter Box---Pop corn or pretzel bowl
#97—Salt and Pepper Shaker---Grandma and Old Doc.
 Doc Barker was the Vet.
#98—Cigarette Box and Cover

#99—Mugs---Six scenes---"Riding High", "Bearing Down", "Spring Trim", "Foto Finish", "Target Practice", "Mt. Rug Cuttin"
#100—"Biffy" Vase or Planter
#100A—"Biffy" Jug or Bottle
#100B—Leave a Note Box---with place for pad and pencil
#101—Willie with Jug and Snake planter
#101A—Willie with Jug and Snake Ash Tray
#102—"Paw" Planter or Vase
#102A—"Paw" Cigarette holder
#103—Luke and Skunk Ash Tray
#104—"Maw" and "Oncle Rafe" Planter
#104A—"Maw" and "Oncle Rafe" Jug or Bottle
#105—"Oncle Rafe", Hound and Frog Ash Tray
#106—"Barrel of Wishes" Vase with Hound Dog

Advertising blotter depicting Paul Webb cartoon characters as shown on Mug #99..."Spring Trim"

*Buffalo "Deldare" 12-in. plate; dated
1908; "Ye Olden Times" pattern with "Ye
Lion Inn" center scene; artist, H. Ball.*

*Camark vase. 9½" high. Irridescent
decor. Mark...stamped in gold. Author's
collection*

*Dedham "Night" and "Morning"
pitcher. 5" high. Picture is morning side.
Author's collection*

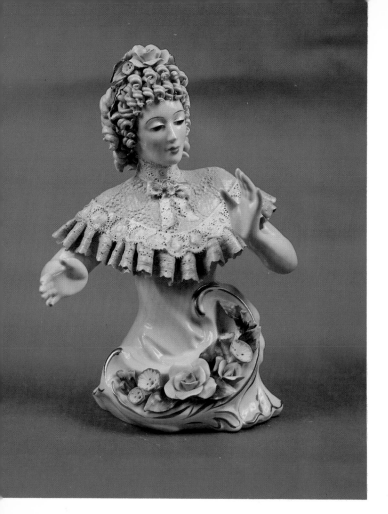

Cordey bust No. 4048. 14" high. Author's collection

Cordey figural vases. 15" high. Man-No. 541. Girl-No mark. Author's collection

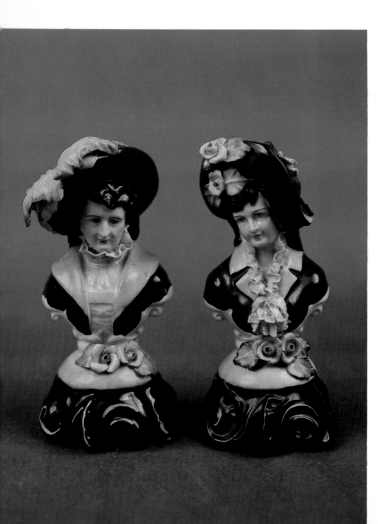

Cordey figurines. 7" high. Man-No. 5024. Girl-No. 5025. Author's collection

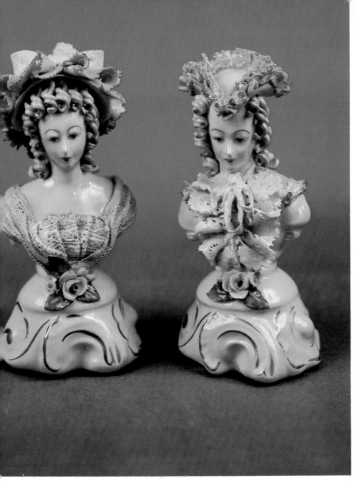

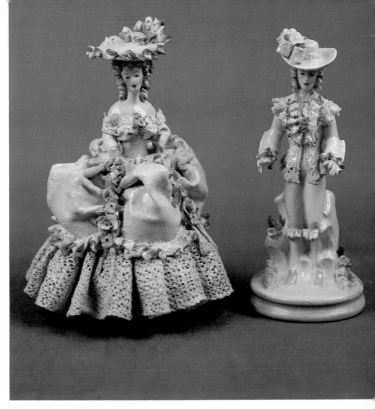

Cordey figurines. 8" high. Man-No. 4030 B. Girl-No. 4034 B. Author's collection

Cordey figurines. 7½" high. Man-No. 4013 P. Girl-No. 4014 P. Author's collection

Frankoma fan dancer. 9" high. Sculptured by Joseph Taylor. Author's collection

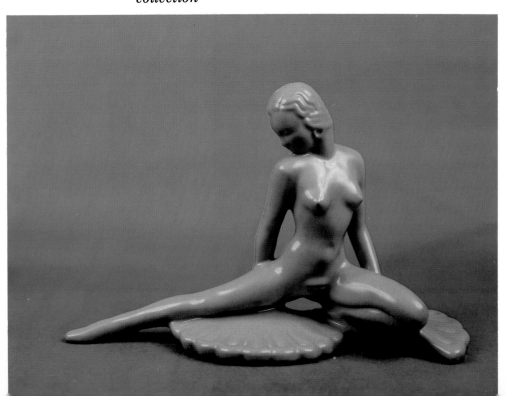

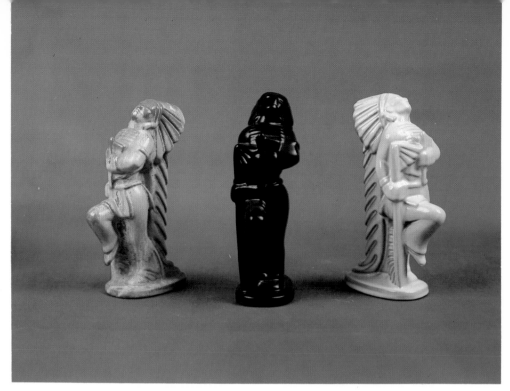

*Frankoma Indian Chiefs. 8" high.
Sculptured by Ray Murray. Black glaze...
Della Robbia glaze [white] and Desert
Sand rutile glaze. Author's collection*

*Frankoma figures. Boy 7" high...Girl
6" high. No. 702-boy; No. 701-girl.
Author's collection*

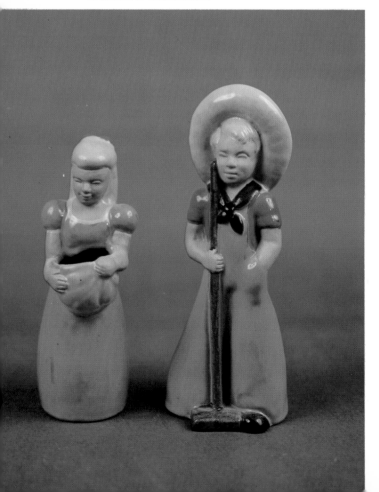

*Fulper vase. 6" high. Crystalline
glaze. Author's collection*

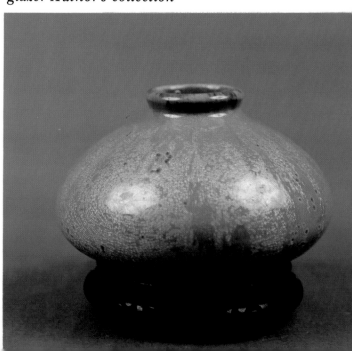

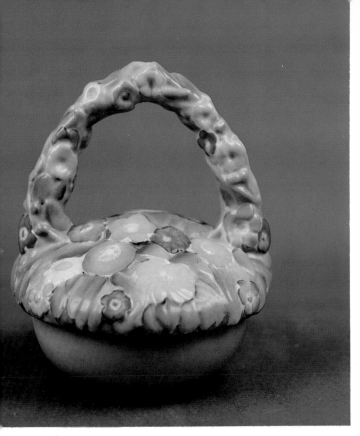

Fulper basket. 8" to top of handle. Author's collection

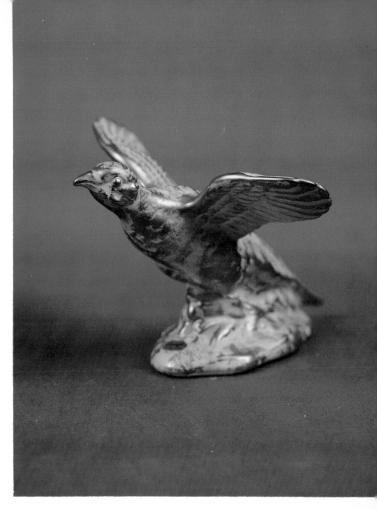

Fulper Stangl Pottery; Stangl hen pheasant, 7" high. No. 3401. Granada gold. Author's collection

Stangl pottery birds; all ink-stamped "Stangl Pottery Birds"; made in limited quantities only in the early 1940s. Left to right: 5½-in.; 3½-in.; 6½-in.; 3¼-in.; 6 in. collection of Andy Anderson

Stangl pottery birds; height 9 in.; ink-stamped "Stangl Pottery Birds"; these were made in limited quantities only in the early 1940s. Author's collection

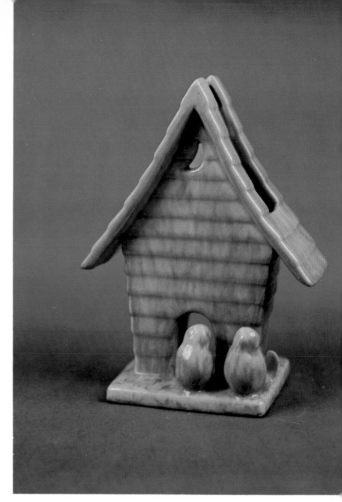

Haeger; 9" high. Royal Haeger by Royal Hickman, No. 237. Mauve Agate. Author's collection

Fulper ware. Left to right: 6-in. two-handled vase, "Mouse Gray with Blue of the Sky Flambe", ink-stamped "Fulper"; 12-in. vase "Mouse Gray with Cat's Eye and Yellow Flambe," impressed "Fulper," with added Fulper paper label.

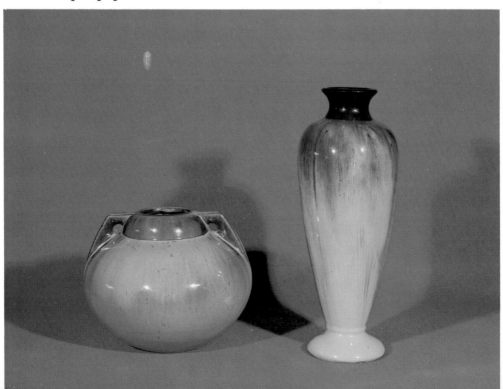

Haeger Pottery; black panther-large size R 495. Small size R 683. One of the most popular items ever made by Haeger... Black cat R 1742. Red Bull R 1510. Red Matador R 6343. These items are no longer in production. Photo courtesy of Haeger Potteries, Inc.

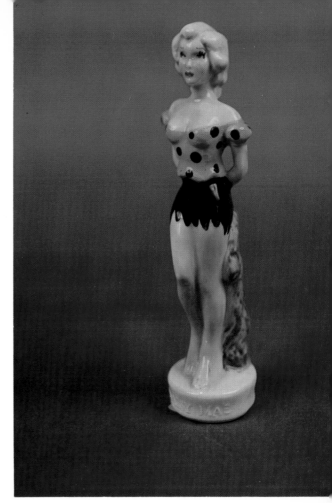

Imperial Porcelain; Daisy Mae, 6½" high. From Al Capp's Dog Patch cartoon. Author's collection

Imperial Porcelain; Paul Webb Mountain Boys No. 92. Willie and Gran Pappy tray; 8½" wide. Author's collection

Imperial Porcelain; Paul Webb Mountain Boys No. 95. Pipe and ash tray; 8" high. "Rafe" and "Gran Pappy" at the "Biffy". Author's collection

Newcomb 6-in. vase; the moon shines through trees heavily laden with Spanish moss, signed by Anna Frances Simpson

Matt Morgan 6½-in. handled jug; Limoges-type decoration; marked "Matt Morgan Art Pottery Co." [impressed]; also bears paper label; signed by William McDonald. Collection of R. E. and F. G. O'Brien, Jr.

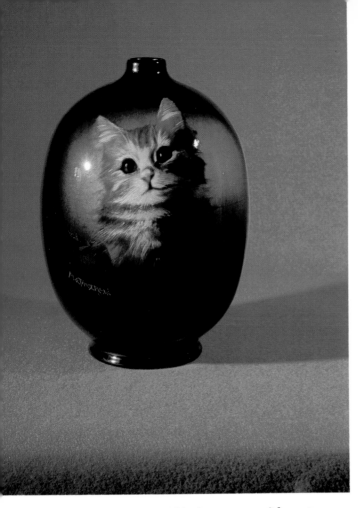

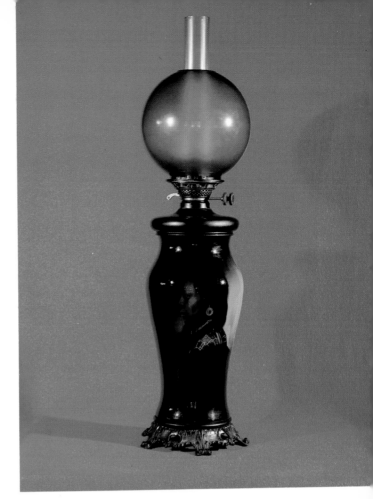

Owens 11¾ in. vase with cat; very rare; marked "Owens utopian"; signed by Mae Timberlake

Owens "Utopian" kerosene lamp; all parts original; marked "Owens Utopian"; signed by Mae Timberlake [full signature]; also bears the following, "Gentle Bird Flatheads"; overall height 31½-in. Collection of Andy Anderson

Pennsbury bowl. 11" by 8". Marked Pennsbury Pottery. Author's collection

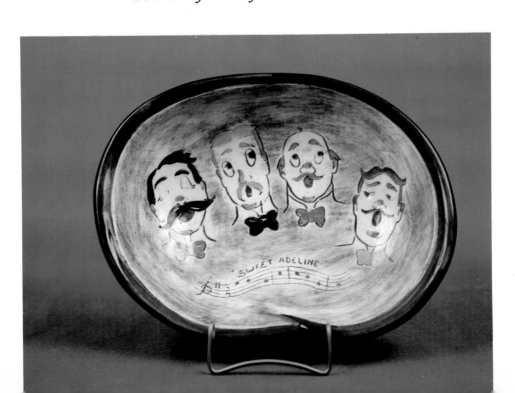

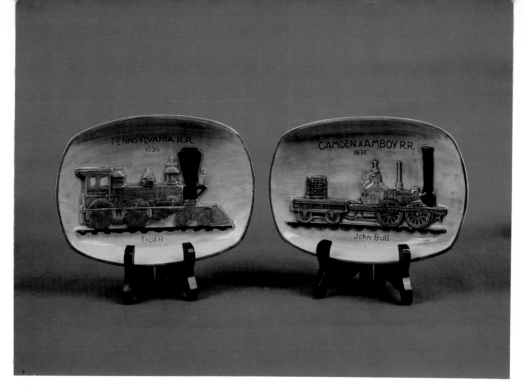

Pennsbury plaques. 5½" x 8". Mark-
ed Pennsbury Pottery. Collection of Joyce
Smalley

Pisgah forest vase; 5" high. Craquelle
glaze. Signed, W. B. Stephen. Author's
collection

Pennsbury blue bird; No. 103. 4"
high. Author's collection

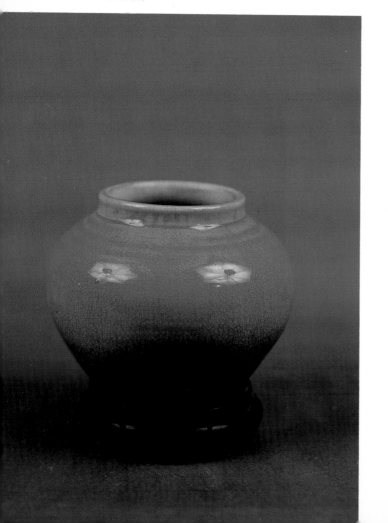

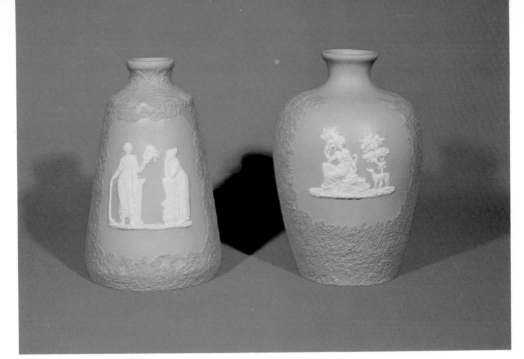

Radford reproductions from the original color; impressed mark on bottom, "An A. Radford/Reproduction/By F. Radford"; the number and date are impressed on base near the edge. **Left to right:** *Jasper #21, marked "#21 002 6 69"; Jasper #22, marked #22 002 6 69".* **Author's collection**

Redwing vase; 12" high. No. 3019. Author's collection

Redwing school boy. 8½" high. No. 1122. Author's collection

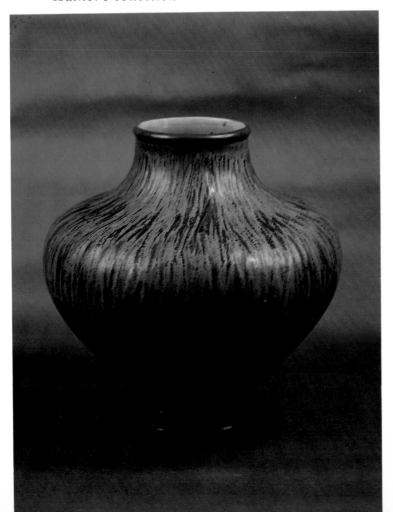

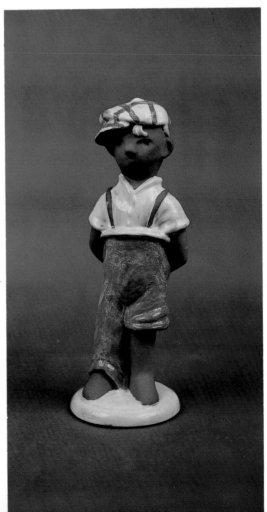

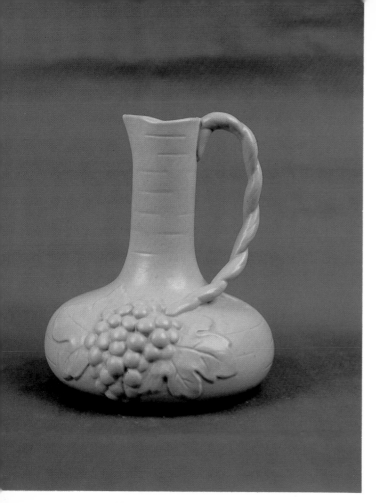

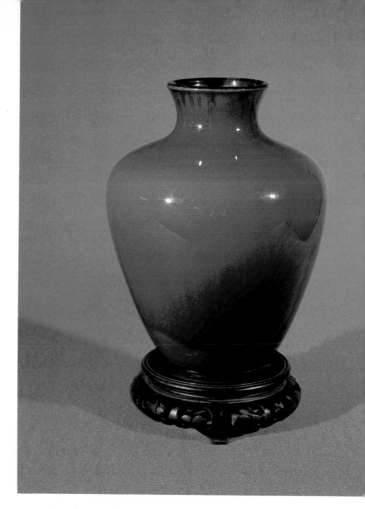

Rum Rill [Made by Red Wing].
Pitcher vase; 11" high. No. 616. Author's
collection

Rookwood 7¼-in. "Tiger Eye" vase;
dated 1932; note the aventurine effect
within the glaze.

Rookwood vases. Left to right: *6¾-*
in., "Wax Matt" glaze, dated 1933, signed
by Sallie E. Coyne, marked "Special";
7¾ in., "Wax Matt" glaze, dated 1920,
signed by Sallie E. Coyne; 8¼ in., "Wax
Matt" glaze, dated 1925, signed by

Margaret Helen McDonald; 8¼ in., "Wax
Matt" glaze, dated 1925, signed by
Margaret Helen McDonald; 7¼ in., con-
ventional decoration-painted matt, dated
1911, signed by Chas. S. Todd

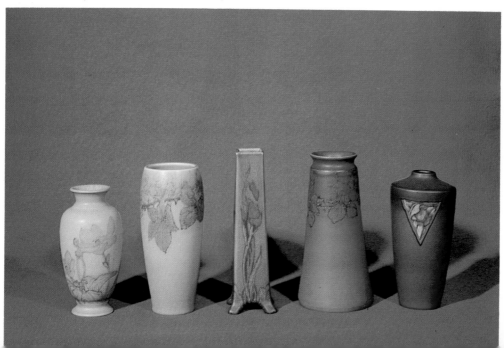

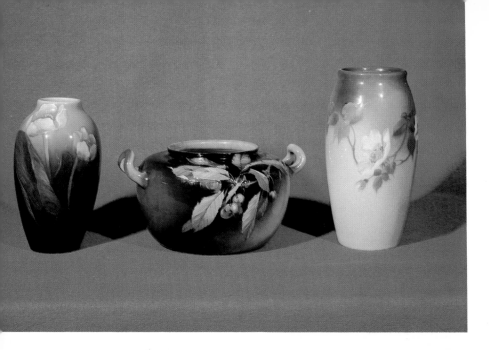

Rookwood vases. Left to right: 7¾ in., "Sea Green" glaze, dated 1903, signed by Constance A. Baker; two-handled, 5¼ in. high, 10¼ in. from handle to handle, dated 1892, signed by Albert R. Valentien; 9 in., "Iris" glaze, dated 1910, signed by Edward Diers. Collection of Dr. Tom and Mary Ann Lamb

Group of Rookwood ware, all standard brown ware glaze. Left to right: 6¼ in. vase, dated 1893, signed by Carrie Steinle; 7 in. vase with rare reversed color, dated 1904, signed by Laura E. Lindeman; jug, 8¼ in. to top of stopper, dated 1900, signed by Sallie E. Coyne; 7¾ in. vase with unusual scallop top, dated 1890, signed by Sallie Toohey

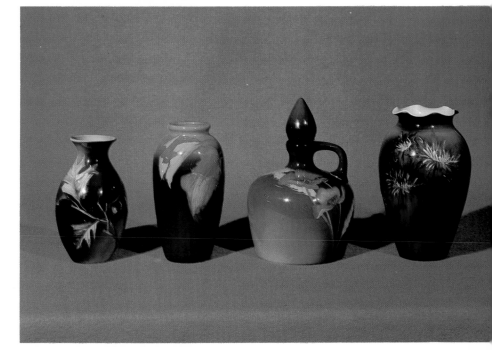

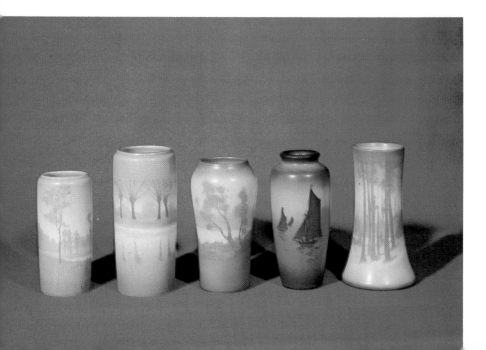

Rookwood scenic "Vellum" vases. Left to right: 6½ in., dated 1914, signed by Chas. J. McLaughlin; 7¾ in., dated 1911, signed by Kataro Shirayamadani; 7 in., dated 1921, signed by Sallie E. Coyne; 7¼ in., rare marine scene, dated 1908, signed by Sallie E. Coyne; 7½ in., dated 1919, signed by Sallie E. Coyne

Rookwood vases. Left to right: *4¾ in., incised matt, dated 1905, signed by Sarah Sax; second and fourth vases, a pair of very unusual lavender color, 7¼ in. to top of finial, plain matt finish, dated XXIV, covered pieces are a rarity; 9½ in., letter Z added to size number, painted matt, dated 1901, signed by Amelia B. Sprague; 6 in., modeled matt, letter Z added to size number, dated 1904, signed by Sallie Toohey*

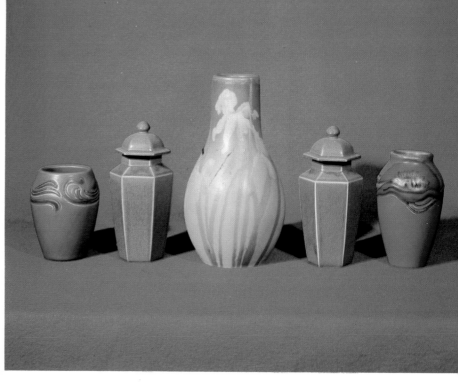

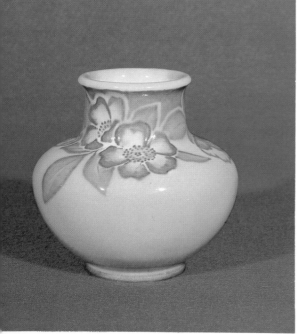

Rookwood 4¼-in. vase; rare piece marked "Special"; dated 1934; signed by Kataro Shirayamadani

Rookwood floral "Vellum" vases. Left to right: *6 in., dated 1909, signed by Edith Noonan; 7 in., dated 1930, signed by Edward Diers; 7¾ in., dated 1913, signed by Mary Grace Denzler; 10¼ in., dated 1904, signed by Mary Nourse*

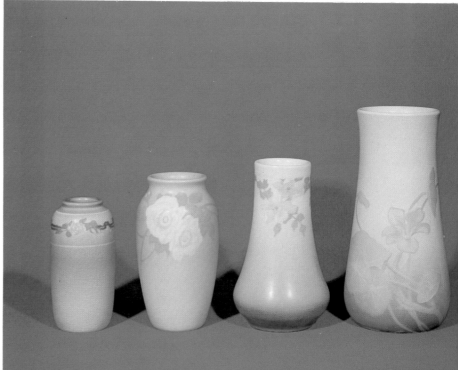

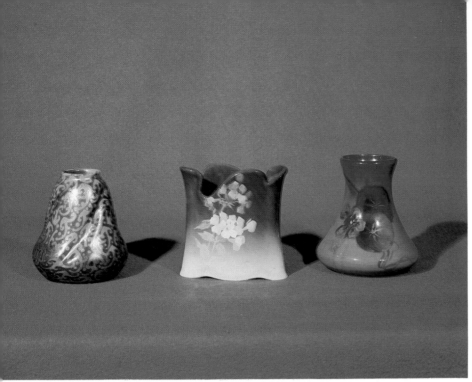

Roseville vases. Left to right: Unmarked 5½ in. "Rozane Mara"; 5½ in. flat "Rozane Royal," marked with wafer, signed by Pillsbury; 6 in. "Blue Ware" marked with black on black early paper label

Roseville Futura vase; 8½" high. Paper label. Author's collection

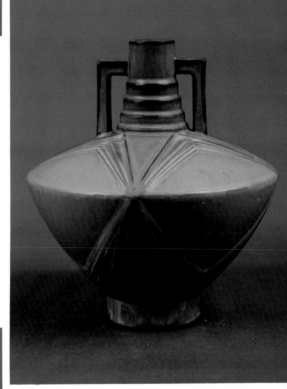

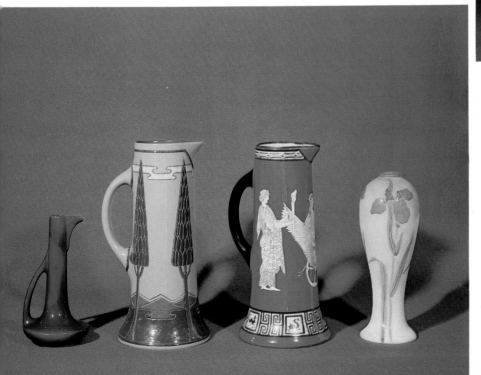

Roseville art pottery. Left to right: Unmarked 7 in. "Rozane Mongol" pitcher; 10¾ in. "Rozane Della Robbia" pitcher marked with wafer, signed by Gussie Gerwick; 10½ in. "Rozane Olympic" pitcher, ink-stamped "Rozane Pottery/Triptolemos and the Grain of Wheat"; 9 in. "Rozane Woodland" vase marked with wafer, signed "F. T."

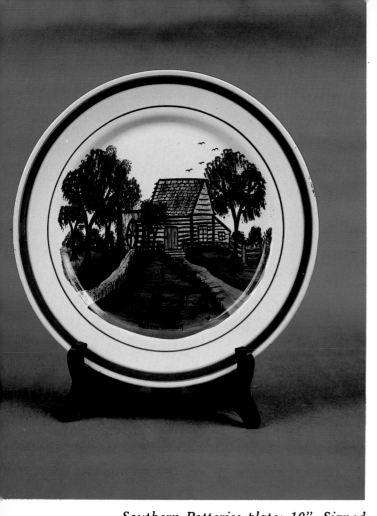

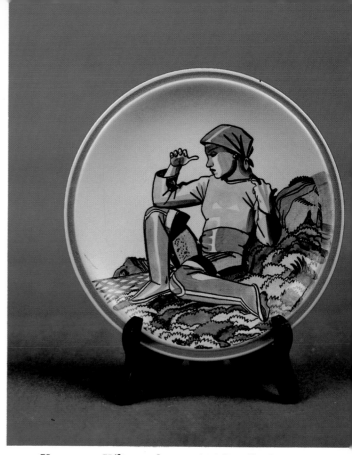

Vernon Kilns plate; 7½". "Salamina," by Rockwell Kent. Author's collection

Southern Potteries plate; 10". Signed Nelsene Calhoun. Author's collection

Vernon Kilns; Baby Weems, 6 in. high. Designed by Walt Disney. Author's collection

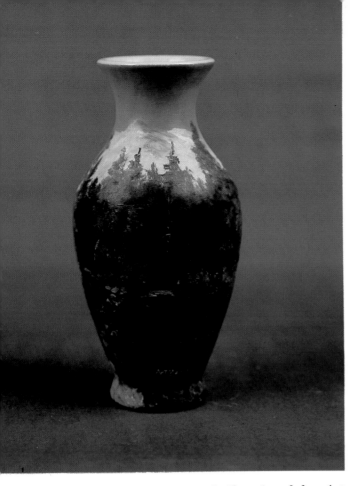

An original vase [9"] painted by Art Wagner expressly for the author, dated 1972. Author's collection

Weller "Sicardo" plaque, 10-in. diameter, a special piece made of reddish brown clay and signed "J. Sicard" on the back.

Weller vases. Left to right: 8½-in. marked "LaSa"; 5½-in. marked "Sicardo"; 7-in. "LaSa" after the third firing; 8½ in. marked "LaSa."

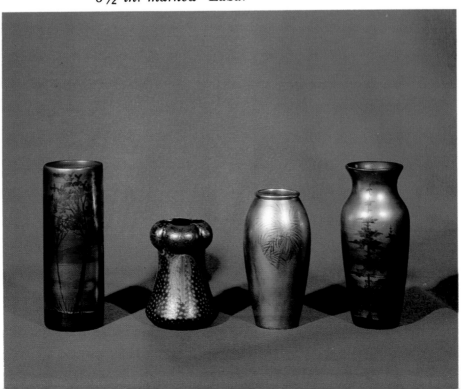

INTRODUCING THE BLUE RIDGE MOUNTAIN BOYS

Paw Willie Oncle Rafe

The characters of Paul Webb—well known to readers of ESQUIRE magazine and many newspapers—have become a national institution. As American as baseball . . . or hot dogs . . . or county fairs. these Mountain Boys have been featured in motion pictures. in large advertising campaigns. on the air and in television. They have appeared in best-selling books.

Maw Gran'pappy

Now the Blue Ridge Mountain Boys are presented by Hipsh, Inc., in permanent, translucent porcelain figurines —a lasting tribute to the folk art of America.

The "Blue Ridge Mountain Boys" as depicted in a 1947 advertising booklet from Imperial Porcelain Corporation

P. WEBB, Creator of the Mountain Boys

Paul Webb created the original "Mountain Boys" as drawings which became popular and inspired the "Blue Ridge" sculptures

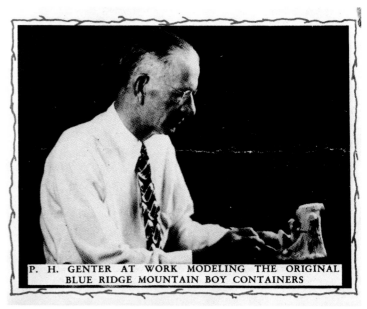

P. H. GENTER AT WORK MODELING THE ORIGINAL BLUE RIDGE MOUNTAIN BOY CONTAINERS

P.H. genter designed and sculpted the original "Blue Ridge Mountain" containers

THE MOUNTAIN BOYS — by PAUL WEBB

A cartoon by Paul Webb that appeared in the 1938 Good Housekeeping magazine depicting the "Blue Ridge Mountain Boys" characters

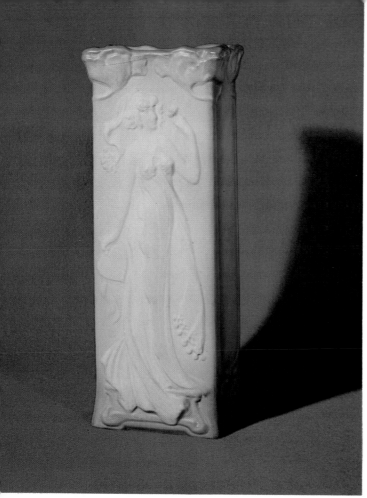

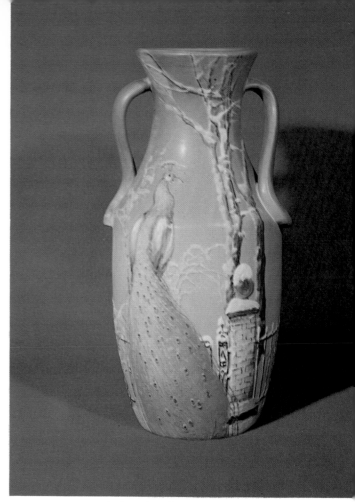

Weller 16-in. "Art Nouveau" vase; marked "Art Nouveau Mat Weller" with incised block letters. Collection of R. E. and F. G. O'Brien, Jr.

Weller 16 in. "Pictorial" vase; hand-incised mark, "Weller Pottery"; signed by Timberlake

Weller vases. Left to right: 9¼-in. "Matt Louwelsa," very rare, marked "Louwelsa"; 10-in. "Hudson," marked "WELLER" in large block letters; 11-in.

"Hudson," marked "Weller" in small block letters; 11½-in. "Hudson," marked "WELLER" in large block letters, signed by Claude Leffler.

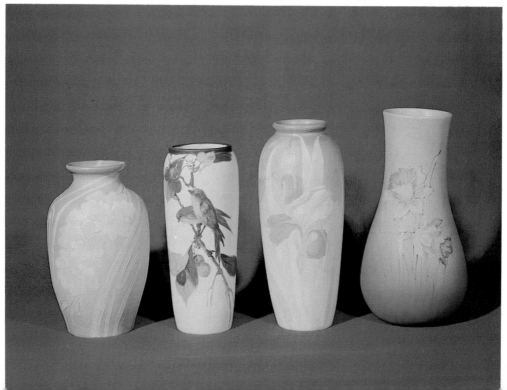

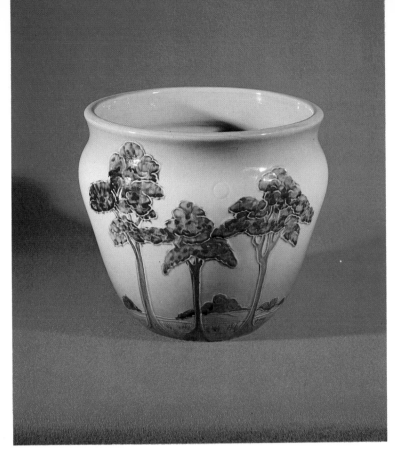

Weller 8½-in. "Jap Birdimal" jardin-
iere; marked "Weller" in small block
letters; 10 in. diameter.

Weller vases. Left to right: *7-in. "Pic-*
torial," ink-stamped "Weller Pottery",
signed by Pillsbury; 7¼-in. "Hudson,"
block letters "Weller," signed by Hood;
8¼-in. "Hudson," hand script "Weller,"
signed by Timberlake; 9½-in. "Hudson,"
ink-stamped "Weller," signed by Pillsbury.
Author's collection

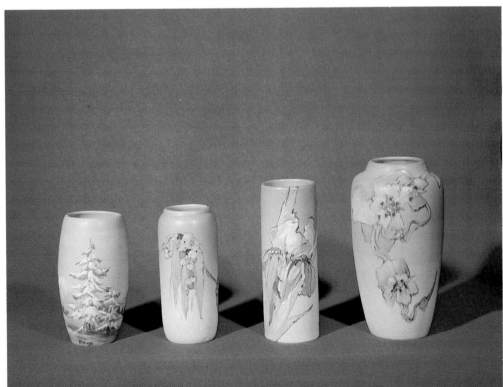

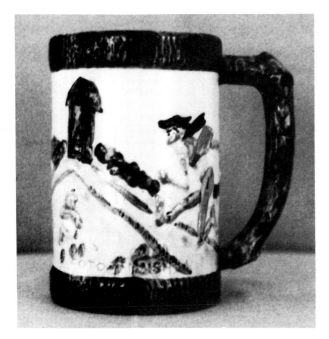

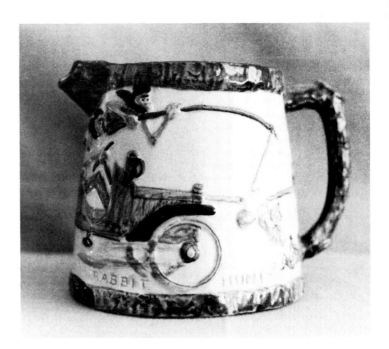

Imperial Porcelain. Mug; 6" #99.
Foto finish. Author's collection

Imperial Porcelain. Pitcher; 5" high.
Rabbit Hunt #93. Author's collection

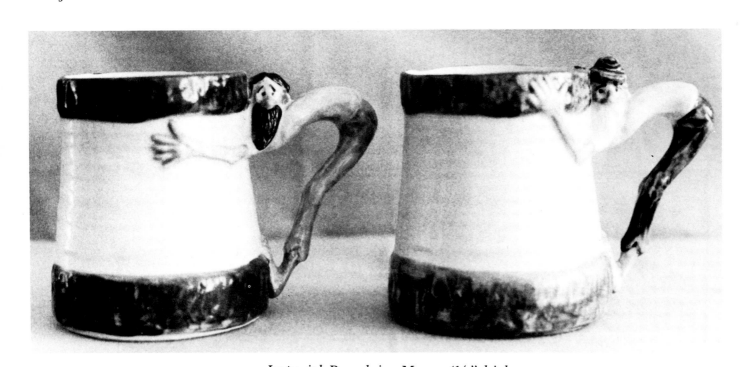

Imperial Porcelain. Mugs; 4¼" high
#94. Left: Jake #94. Right: Gran Pappy
#94B Author's collection

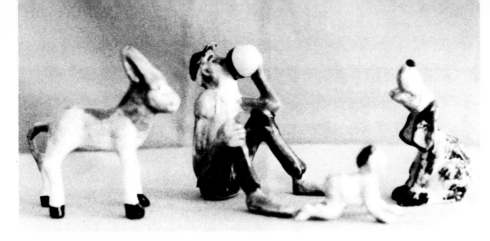

Imperial Porcelain. Assortment of "American Folklore Miniatures". Author's collection

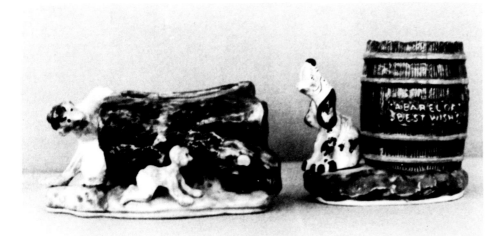

Imperial Porcelain. Left: "Maw" & "Oncle Rafe" planter #104. Right: "Barrel of Wishes" #106. Author's collection

Imperial Porcelain. "Biffy" #100B. Leave a note box. Place for pad and pencil. Author's collection

Imperial Porcelain. Left: "Maw" and "Oncle Rafe" jug or bottle #104A, 7". Right: "Oncle Rafe" hound and frog ash tray #105, 6½" Author's collection

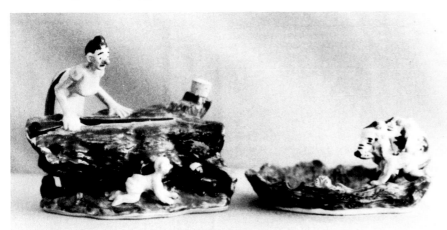

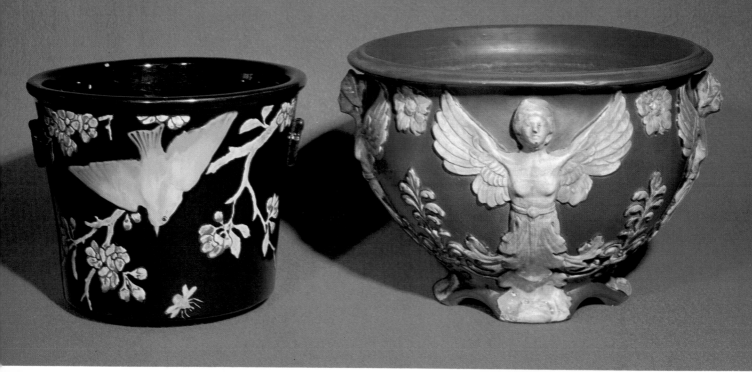

Weller vases. Left to right: *7-in. "Rosemont," marked "WELLER" in block letters; 8-in. "Flemish," marked "WELLER" in block letters. Collection of R. E. and F. G. O'Brien, Jr.*

Weller pottery. Left to right: *6½-in. pink luster vase, ink-stamped "Weller"; 7½-in. "Brighton" line parrot, marked "WELLER" in block letters; 14-in. "Eocean" vase, hand-incised script "Weller," signed by Albert Haubrich*

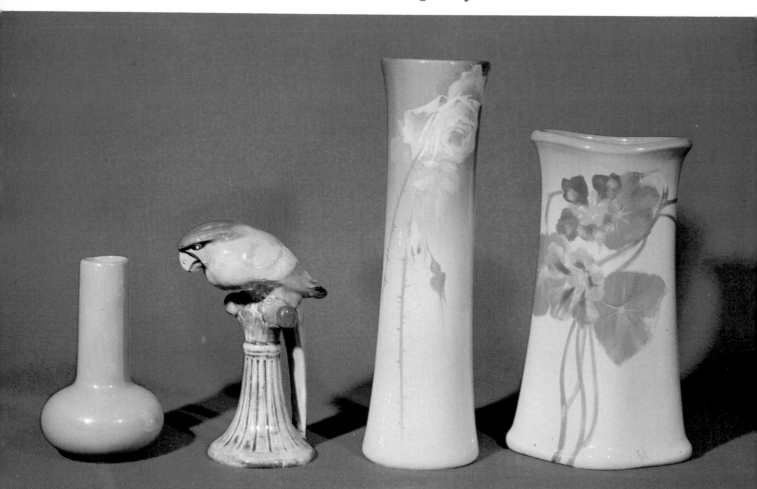

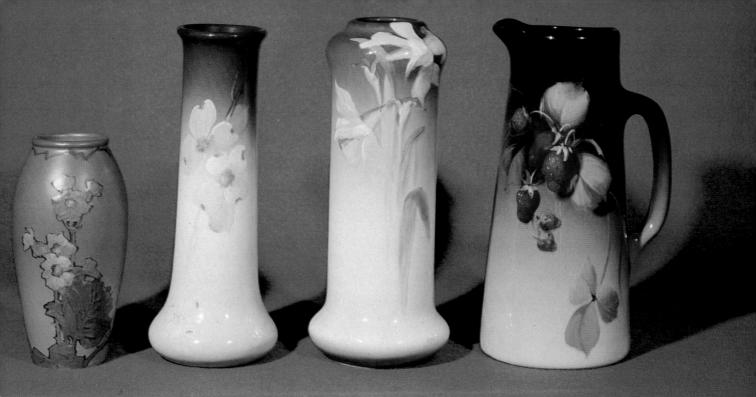

Weller pottery. Left to right: *7-in. "Delta" vase, marked "WELLER" in block letters, signed by Mae Timberlake; 10½-in. "Eocean Rose" vase, hand-incised "Eocean Rose/Weller," signed by Sarah Reid McLaughlin; 11-in. "Etna" vase, marked "Etna" with "Weller" in small letters; 11-in. "Rochelle" tankard pitcher, impressed mark "Weller Ware." Pitcher— Joyce Smalley collection*

Group of Weller's "Louwelsa" ware, all marked "Louwelsa Weller." Left to right: *8-in. two-handled vase, signed by Mary Pierce; 12-in. ewer, signed by Anna Dautherty; 12¼-in. three-footed vase, signed with a G. [an unknown signature].*

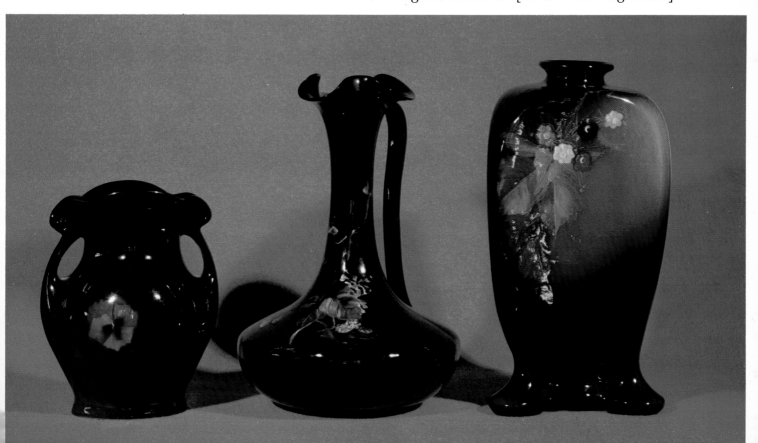

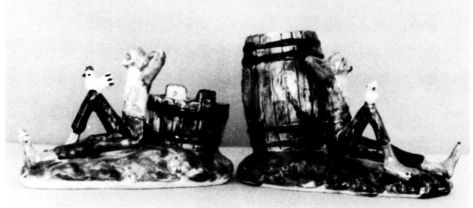

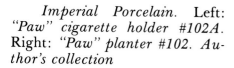

Imperial Porcelain. Left: "Paw" cigarette holder #102A. Right: "Paw" planter #102. Author's collection

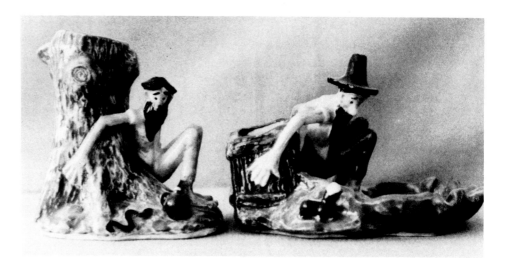

Imperial Porcelain. Grandma and Old Doc #97. Salt and Pepper; 5" high. Marked on base. Author's collection.

Imperial Porcelain. Right: Paul Webb Mountain Boys, Luke and skunk ash tray. #103. Left: Paul Webb Mountain Boys, Willie with jug and snake planter #101. Author's collection

Imperial Porcelain. "Loweezy" 5½", #81. Author's collection

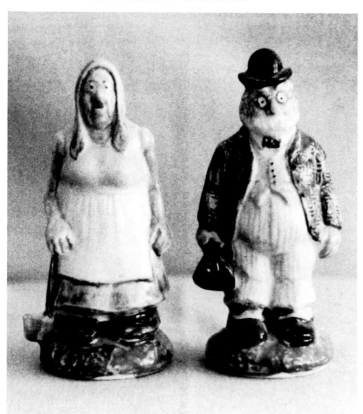

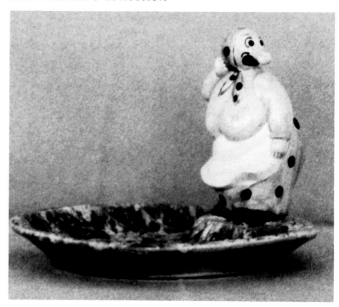

Imperial Porcelain Corporation
Marks:

COPYRIGHT 1946
HIPSH INC.
KANSAS CITY, MO
U.S.A.
CONTENTS 4 OZ.

Hair Luster

Impressed on bottom

BLUE Ridge
MT Boys
By
Paul Webb

Embossed on side

Paul Webb
©

Embossed on side

© 549
Imperial Porcelain Corp
ZANESViLLE OHIO
Hand Crafted
No 81

Impressed on bottom other than Mountain
Boys

©
COPYRIGHT 1946
Imperial Porcelain Corp
ZANESVILLE OHIO
Hand Crafted
U.S.A.
No 105

Impressed on bottom

Weller pottery. Left to right: 6-in. "Silvertone" vase, ink-stamped "Weller Ware"; 8-in. "Clarmont" two-handled vase, marked "WELLER" in block letters, also has paper label with line name; "Silvertone" vase, 8½-in. to top of handle, ink-stamped "Weller Pottery"

Group of Weller's "Louwelsa," none signed by an artist, all marked "Louwelsa Weller." Left to right: 4-in. pitcher; 5¾-in. ewer; 7-in. ewer; 5½-in. pitcher.

Weller pottery. Left to right: 4½-in. marked blue "Louwelsa" vase; "Jap Birdi-mal" teapot, 5½-in. to top of finial, signed by Mary Gillie; 9-in. "Blue Decorated" vase; marked "WELLER" in block letters.

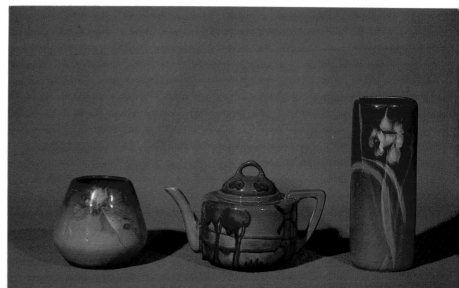

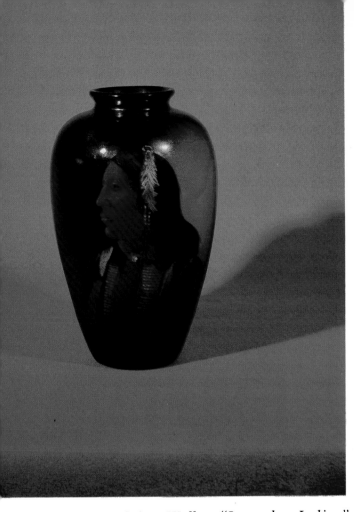

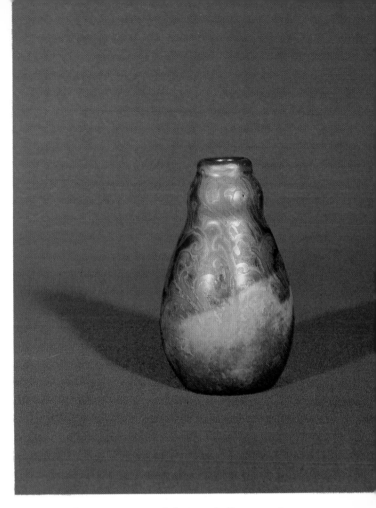

10½-in. Weller "Louwelsa Indian" vase; marked "Louwelsa Weller," incised in base "James Red Cloud, Sioux," signed by Karl Kappes.

Weller 5 in. signed "Sicardo" vase, the pale coloring in this piece shows the results of uneven firing.

Weller vases. Left to right: 11-in. unmarked "Marengo"; 12¼-in. "Lamar" with paper label; 8¼-in. unmarked "Marengo"; 11½-in. "Chengtu," ink-stamped "Weller."

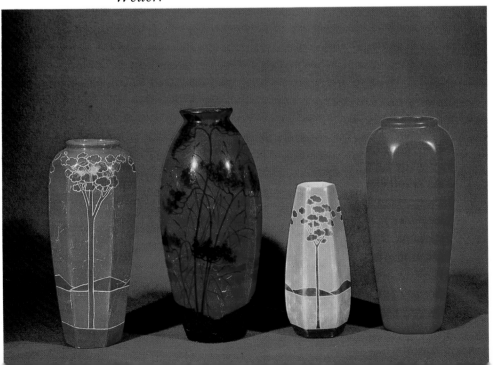

Jugtown Pottery
Early 1920s—

Jugtown Pottery was established in the early 1920s by Jacques and Juliana Busbee, in Jugtown, North Carolina.

Before prohibition began, some fifty potters in this area were making a living producing jugs for whiskey, along with other household wares. With the demand curtailed for the "little brown jug," most of the potters were forced to return to tilling the soil or other employment.

The Busbees realized the craft of potting was waning away in North Carolina, so they endeavored to revive interest in this dying art. They established a pottery in Moore County, near Seagrove, and recruited some of the farmer-potters to assist them in getting the new enterprise under way. These men were from the old school and would not deviate from the old customs. Ben Owen, a lad of seventeen, was soon employed by the Busbees. This young man had fresh ideas of his own and was also willing to accept advice from his employers. Ben turned all the shapes and, under the supervision of Jacques, soon learned how to test the clays and apply the glazes.

Searching for means of disposition of their wares, Juliana opened a combination tearoom and salesroom, known as the "Village Store," in Greenwich Village, in New York City. This shop was stocked with foods, folkcraft, and Jugtown pottery from Moore County. Employees were imported from North Carolina to bring the atmosphere of the "backwoods" to the Village Store, which seemed to appeal to the local patrons. Among the people that patronized the Store, were many VIPs. Jugtown was on its way and soon became internationally famous. Although this operation was comparatively successful, Juliana soon closed the Village Store to return to Jugtown to assist with the Pottery operation.

Jacques and Juliana Busbee were forceful and dynamic personalities and seemed to greatly intrigue people. Travelers would drive miles out of their way to visit with them in their picturesque cabin and get a specimen of their Jugtown pottery. Distribution of the pottery was made in some foreign countries as well as nationwide.

From 1922 until 1947 Jugtown was produced by Ben Owen under the direct supervision of Jacques Busbee. After the death of Jacques Busbee in 1947, Juliana continued the operation of the Pottery with the assistance of Ben Owen. This proved to be too much of a burden for her and she consequently decided to sell the Pottery. She had become so confused that two separate deeds were signed to the business and a lawsuit followed. The Pottery had to close its doors for a year. In 1960 it was reopened under new management. Juliana died in 1962. Ben Owens established a pottery of his own just a few miles away, using similar style forms and the same type of glazes as were used at Jugtown. These are marked "Ben Owen, Master Potter."

Jugtown was made in every type of utility ware, vases, candlesticks, flower bowls, and all sorts of table accessories. The glazes varied from the common salt glazes, to the heavy glazes of the type used by Grueby and Van Briggle, to glazes very similar to those used on Weller handmade lines, such as Greenbriar and Coppertone.

The pottery was made from local clays in the Oriental and classic forms so often used during this period. The colors were quite varied. The most popular shade was the Chinese blue, which ranged from light blue to dark turquoise, with reddish purple splotches. Other colors were plain gray salt glaze with cobalt decoration, cream, and shades of orange ranging from pumpkin color to a dark copper tone. Also some

ware was made in white, black, green, and a brownish orange splotched with black.

Specimens of Jugtown are on display at several museums in North Carolina, as well as the Smithsonian Institution and the Cleveland Museum of Art.

Jugtown Pottery is still in operation today (1981), making ware in the same shapes and same glazes as in the earlier period. Also, the same company mark is used as was used in the beginning.

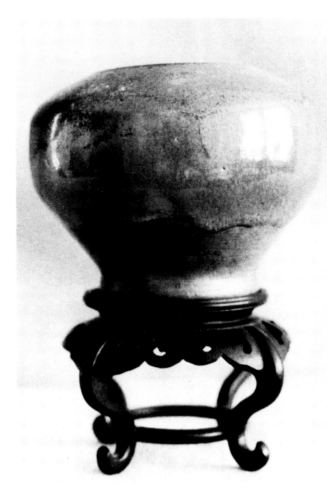

Jugtown Pottery vase; 5½". Green drip glaze over brown matt. Author's collection

Jugtown Pottery
mark:

Impressed

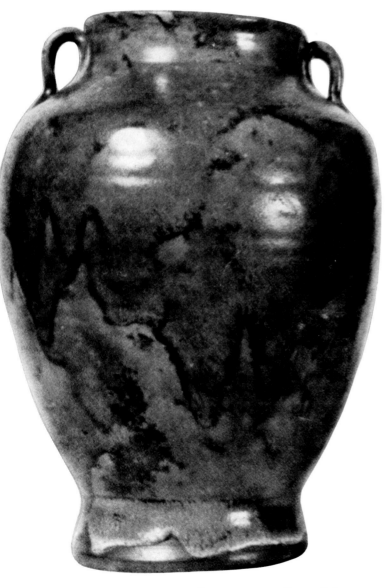

Jugtown vase. Green over yellow, 8 in. high. Johnson photo

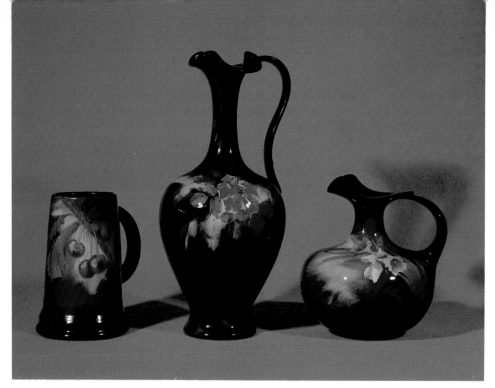

Weller's "Aurelian" ware. Left to right: Handled 6½-in. mug, mark impressed in circle, signed by Mary Gillie; 13½-in. ewer, mark hand-inscribed in circle, with full signature of H. Mitchell [Hattie Mitchell]; 7¼-in. pitcher, mark impressed in circle, signed by Delores Harvey.

Marked Weller 18-in. "Dickens Ware" vase, signed by Upjohn, dated 1901. Author's collection

Wheatley 12 in. vase; marks on the base include "No. 22," T J We Co.," and "Pat Sep 28, 1880

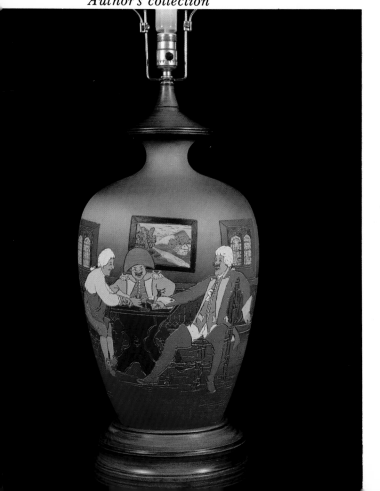

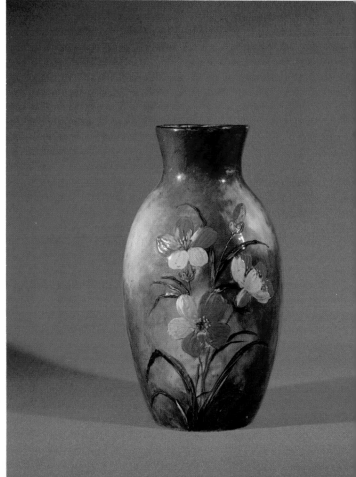

Lonhuda Pottery
1892—1895 [Ohio]
1898—1905 [Colorado]

W. A. Long, a druggist in Steubenville, Ohio, had been quite interested in art pottery and in the testing of different glazes for several years. He then decided to go into the pottery business for himself. At the time, Rookwood was building a new factory in Cincinnati, and several other firms were doing quite well in this locale. Long, with two partners, organized his Pottery in 1892 at Steubenville, Ohio. The factory was named "Lonhuda," incorporating all three names, W. A. Long, W. H. Hunter, and Alfred Day. "Lonhuda" was also the name applied to the wares.

Long hired Laura Fry, who had patented the formula for making the brown ware with slip painting under the glaze while she was working at Rookwood Pottery. This was Rookwood's "standard" glaze. In 1895 the Lonhuda Pottery was purchased by S. A. Weller. With the purchase came Long and his formula for making Lonhuda. Weller renamed this particular ware "Louwelsa," since the name "Lonhuda" belonged to W. A. Long. Later, it was rumored that Weller had stolen the formula and consequently was sued by Laura Fry. The case was dropped eventually, as no concrete evidence could be shown that he had stolen it. Prior to this time Laura Fry had sued the Rookwood Pottery on this same matter and she also lost that case.

Long stayed with Weller Pottery only a few months. In 1896 he took a position with Owens, again taking his formula with him. At Owens the brown ware was called "Utopian." His stay with Owens was also for a short period of time.

In 1898 Long migrated to Colorado, where the clays were excellent for potting. There he organized the Denver China and Pottery Company and continued to make the Lonhuda ware. This plant closed in 1905 and Long moved to Newark, New Jersey, where he organized the Clifton Art Pottery. His tenure there terminated in 1909, when he returned to Ohio, where he was employed by other potteries. Long passed away in Cincinnati in 1918. The art pottery made at this plant was influenced by the oriental shapes and glazes characteristic of this period. From time to time, Long introduced new artistic lines, among them being the "Crystal Patina." This ware had a dense white body with a pale green crystalline glaze which gave the effect of the patina on bronze. Later, the Crystal Patina was made in a wider range of colors where the colors would run and blend together. Still another line developed by Long was called "Clifton Indian Ware." This line was copied from native Indian forms and decorated on red clay. Each piece was always lined with a jet-black glaze, Long's Clifton Ware is always marked on the base and is occasionally dated. "Robin's Egg Blue Ware" consisted of a matt glaze in the exact shade the name suggests.

At a distance, one might mistake the matt-finish Lonhuda ware for a piece of Weller second-line Dickens Ware, as the finish closely resembles it. However, the sgraffito method was not used, only the soft coloring. Long also used this particular method during his tenure with Owens, the finish being called "Matt Utopian." Let us mention here again that one will find similarity in different lines due to the migrating of the artists from one company to another.

Lonhuda was always marked and is of an excellent quality. It served to introduce the slip decoration under the glaze in the Zanesville area and today is considered to be quite rare. One might wonder why Long did not continue making pottery for a longer period of time. Whatever the reason may be, it is regrettable that this

pottery could not have been made for several more years, as it does show very fine quality.

Lonhuda pottery ewer. Brown ware, signed "A. B. S."—Amelia B. Sprague, 9 in. high. Orren photo

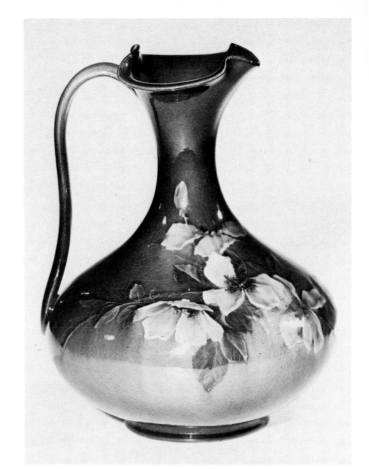

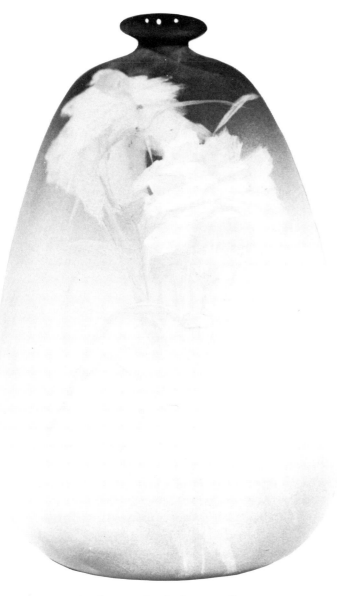

Left: *Lonhuda [Denver] pottery vase. Pastel colors on brown background, matt finish, 8 in. high. Orren photo.* Right: *Clifton pottery vase. Green with tan, marked "Clifton," 9 in. high. Johnson photo*

Lonhuda Pottery

Marks:

Impressed numbers relate to the forms.

DENVER
⬦LF⬦
LONHUDA

1898—1905
Denver

Lonhuda
LF
1892—95
Ohio

Lonhuda Marks used on early American
Indian-type pottery:

1893

1893

In 1893, a new mark was developed, con-
sisting of an Indian's head. This mark was used
on very little early American Indian-type pot-
tery.

The names and monograms of the Lonhuda
decorators:
This list is not complete.

Laura A. Fry

Sarah R. McLaughlin

Helen M. Harper

W. A. Long

Jessie R. Spaulding

Amelia B. Sprague A. B. S.

Clifton Art Pottery

marks:

Clifton
1907

Incised

McCoy Pottery

The name McCoy actually encompasses three separate Potteries, namely: **J. W. McCOY (1899—1911), BRUSH McCOY (1911—1918), and NELSON McCOY (1910 to the present time).**

The name McCoy is deeply embedded in the history of potting in Ohio, with four generations involved. It had its beginning in 1848, when W. Nelson McCoy, along with his uncle, began making stoneware crocks and jars, in Putnam, Ohio, a settlement that eventually became a part of Zanesville. A "pot wagon", pulled by a team of horses, was used to peddle their wares among the local citizens. They also built a special barge to peddle their products to their customers, along the river that leads to New Orleans, La.

In January of 1848, James W. McCoy, the son of W. Nelson McCoy, was born. In his earlier years, James W. McCoy worked at various trades until 1899, when he organized the J. W. McCoy Pottery in Roseville, Ohio. At the outset, utilitarian ware was produced, and then in a few months, a line of decorative art ware was introduced. These included jardinieres with matching pedestals, fancy pots, pitchers and mugs. In 1903, the Pottery was completely demolished by fire, but in 1905, was rebuilt and resumed business as a corporation. McCoy's brother-in-law, D. L. Melick became acting secretary in 1906.

Among the most important lines created at the J. W. McCoy Pottery were: "Mont Pelee" (1902), a lava type ware with some figurals..."Olympia" and "Rosewood" (dates unknown), both having similar finishes, with a soft tan shaded to orange with a gloss glaze....sometimes striped horizontally..."Green Matt" (1906) "Loy-Nel-Art" (1908), a brown ware very similar to Weller's Louwelsa. Another was "Renaissance" (date unknown), a brown glazed decorated with a poppy, in the art nouveau style.

In 1909, George S. Brush became a stockholder in the J. W. McCoy organization, and was appointed secretary and general manager. Preceeding his tenure with the J. W. McCoy Pottery, he was active in the potting business, having been associated with the Owens Pottery (1905), and had organized and served as manager of the Brush Pottery (1906). While at the Brush Pottery, he acquired the Union Pottery along with their molds, and began producing a full line of stoneware specialties. This Pottery burned to the ground November 26, 1908. At this time, Mr. Brush joined the J. W. McCoy firm.

In late winter of 1911, the stockholders voted to change the name to "The Brush McCoy Pottery Company". The Company expanded operations and moved into the old J. B. Owens Pottery on Dearborn Street, in Zanesville, in 1912. The Roseville operation was retained. It is common knowledge that some of the molds used by Owens were also used by the Brush McCoy Company. In 1912, the Brush McCoy Company purchased the molds, formulas and equipment that belonged to the A. Radford Company of Clarksville, Virginia. In November of 1916, the Zanesville Pottery burned, leaving only the office building standing. All operations were continued in Roseville.

Some of the most interesting lines made at the Brush McCoy Pottery were the early wares. These were: Jetwood (1923), Jewel (1923), Zuniart (1923) and Krackle-Kraft (1924). Many other lines, too numerous to mention, were produced similar to products made by other Ohio Potteries. In 1918, this Pottery was destroyed by fire. Another firm, using the name Brush Pottery opened in 1925. This Pottery is presently operating a plant in Roseville and maintaining an office in Zanesville, but should not be confused with the 1906 Brush Pottery.

In 1910, Nelson McCoy, with the backing of his father, J. W. McCoy, established the "Nelson McCoy Sanitary

Stoneware company". In the beginning, only utilitarian pieces were manufactured, for instance: churns, crocks and jugs. In the mid 1920s, they began creating a line of molded art ware, including vases, jardinieres with matching pedestals, also pots (small jardinieres). In 1933, the name was changed from "Nelson McCoy Sanitary Stoneware Company" to simply "Nelson McCoy Pottery".

By the early 1940s, the Company had expanded and more sophisticated equipment was installed and began producing numerous novelties. Cookie jars seemed to be a popular specialty, since over two hundred varieties were made with every conceivable subject depicted.

Nelson McCoy died in 1945 and was succeeded by a nephew, Nelson Melick, who had been associated with the Company for twenty years. At the death of Mr. Melick in 1954, Nelson McCoy Jr., a fourth generation, became president of the firm. This Company is presently operating (1981), and is continuing to use the name McCoy.

Very few pieces from the Brush McCoy Company are marked except the earliest lines. Many and varied marks were used by the later Brush and Nelson McCoy Potteries. The marks listed here are not a complete example of the myriad of marks used by these companies.

*Brush McCoy; 7½ in. high vase.
Brown rubbed with green*

Footnote:

For a more comprehensive study of the McCoy Potteries and a more complete catalog, the author suggests the following reference books.

"Art Pottery of the United States"...
Paul Evans. Scribners.
"Collector's Guide to American Art Pottery"...Terry and Ralph Kovel. Crown.
"The Collectors Encyclopedia of McCoy Pottery"...Sharon and Bob Huxford. Collector Books.
"The Collector's Encyclopedia of Brush McCoy"...Sharon and Bob Huxford. Collector Books.

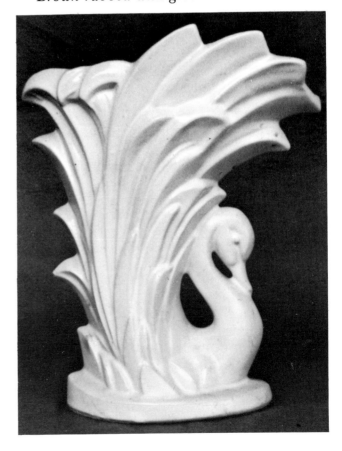

*Nelson McCoy; 9 in. high vase.
London collection*

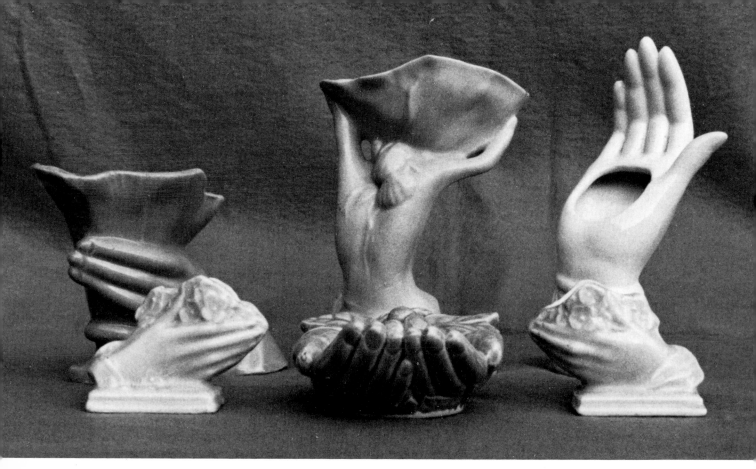

Nelson McCoy; hand vases. London collection

Nelson McCoy; deer-double vase. London collection

Nelson McCoy; "Retriever" double vase or planter. London collection

Nelson McCoy; cookie jar. London collection

Nelson McCoy; "Davy Crockett" cookie jar. London collection

Nelson McCoy; Teepee cookie jar. London collection

Nelson McCoy; Cookie wagon jar. London collection

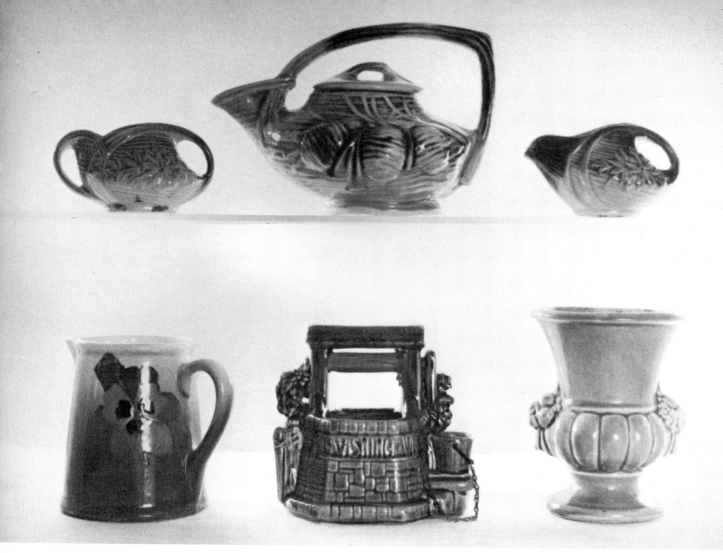

McCoy ware. Top row: *Typical tea set, green with brown trim. Nelson McCoy.* Bottom row, left to right: *J. W. McCoy, early [ca. 1910] pitcher [5½ in. high] in Weller "Eocean"-type decoration; high-glaze Nelson "Wishingwell" planter and typical Nelson McCoy vase [late] in turquoise blue. Barbara Hale collection; Johnson photo*

Nelson McCoy vases from late period. Left to right: Soft orchid with green leaves, marked, 9 in. high; white with green, note paper label, marked, 9 in. high; soft pink with green, marked, 9 in. high. Knight photo

J. W. McCoy vase. Dark brown shaded to green, marked "LOY-NEL-ART," 5½ in. high. Barbara Hale collection; Knight photo

Nelson McCoy cookie jars. Jet black glaze trimmed in gold and red, marked, late periods, 10 in. and 10½ in. high. Author's collection; Knight photo

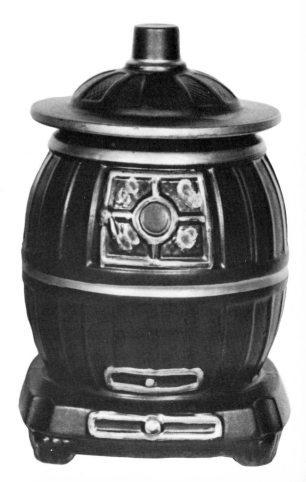

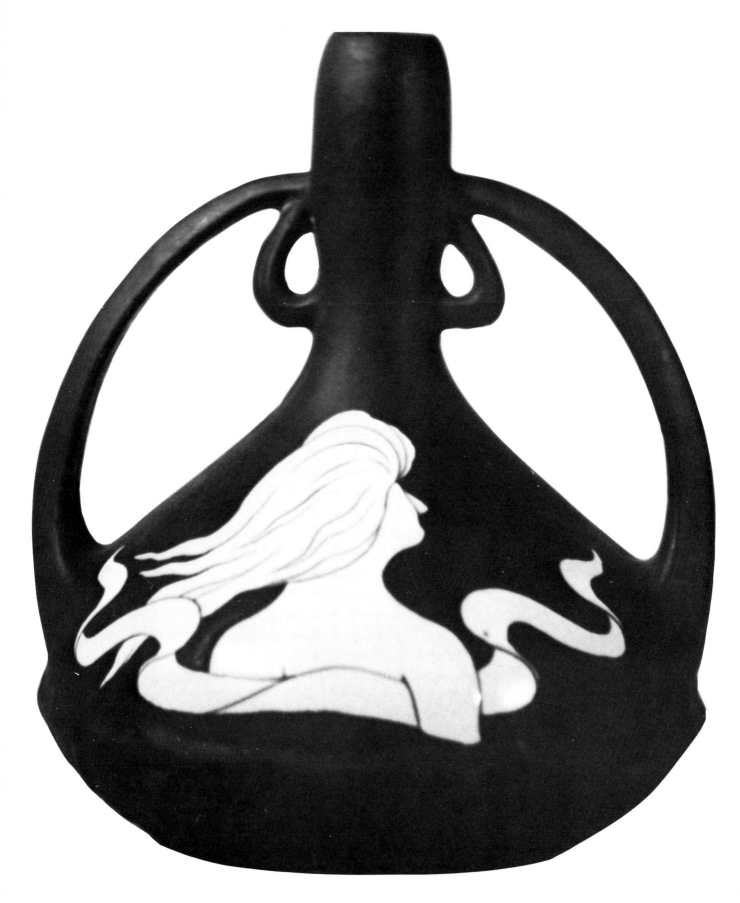

Brush McCoy-Navarre line, 9 in. high. Stamped in green on bottom

McCoy Potteries

Marks:

Nelson McCoy Marks

Mc Coy Mc Coy ᛗ
 MADE IN USA

ᛘ ᛖᛗ N M
 USA

Impressed on bottom and/or embossed
(McCoy) incorporated within the design on
the mold.

J. W. McCoy Company Marks

Mc LOY NEL ART Mc
ROSEWOOD Mc COY OLYmpia

Impressed on bottom Impressed on bottom Impressed on bottom

Brush McCoy Marks

Early Mark stamped

Paper label

USA BRUSH BRUSH
 USA USA

BRUSH
USA
730

BRUSH
USA
92

Impressed.....Used in the 1940s, 50s and 60s Marks used in the 1950s and 1960s

M. Louise McLaughlin Pottery
1876—1906

The origin of Cincinnati, Ohio, art pottery can be traced back to 1874, when Benn Pitman, a native-born schoolteacher, organized a class in china painting for the young women of the city. Benn Pitman was a brother of Sir Isaac Pitman, who invented the Pitman shorthand method.

The wares these women decorated were displayed at the Philadelphia Centennial of 1876, where they received considerable attention. These women were greatly impressed by the pottery displays of the French and Japanese, which were also on exhibition at the Centennial. On their return home, a class was organized, under the supervision of T. J. Wheatley, at the Coultry Pottery. At about this same time, Miss McLaughlin organized the Pottery Club of Cincinnati, with an original membership of fifteen. Maria Longworth, of Rookwood fame, was a guest but was not a member.

In 1879 Miss McLaughlin and Miss Longworth advanced the Frederick Dallas Pottery, which was managed by Joseph Bailey and his son, enough money to build two kilns, one for the overglaze and one for the under-the-glaze painting. For several months, these two women continued to work at the Dallas Pottery. From 1885 to 1895, Miss McLaughlin's work consisted mostly of painting on china and some designing for several other potteries. In 1889, Miss McLaughlin erected a small studio pottery on the grounds adjoining her residence, where she began to perfect new bodies and new glazes. One line that Miss McLaughlin perfected in 1900, was named "Lo'santi", derived from the early name of the city, Losantiville. Losantiville was founded in 1788 by John Filson, a schoolmaster and surveyor. The name was supposed to mean "the town opposite the mouth of the Licking" (River). Two years later, the name Losantiville was changed to Cincinnati, in honor of the Society of the Cincinnati. Historians claim Miss M. Louise McLaughlin paved the way for the most popular and beautiful pottery in American history. She ceased to work in the field of ceramics in 1906.

Pieces created by her are marked with her monogram or line name on the base. Occasionally these are impressed, on other items are painted in blue.

M. Louise McLaughlin Pottery
Marks:

M Lo'santi L M^cL

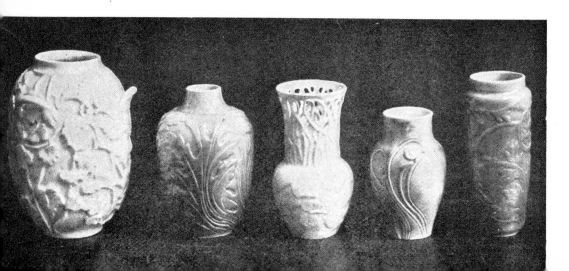

McLaughlin Pottery; "Losanti Ware" photo shown in 1907 Bayview Magazine

Maria Pottery
1908—

Indian pottery having been made for nearly two thousand years, in the Southwest, should be discussed since it had an important impact during the period of growing interest in art pottery, crafted for ornamental use only.

One of the most important is Maria pottery that was created by Maria Montoya Martinez and her husband Julian. Maria was born in 1881 in San Ildefonso, New Mexico, and was a member of the Tewa-speaking Pueblo Indian tribe. Pow-oge (word for "Pueblo"), translated as "The place where the waters meet," is a picturesque location of the upper Rio Grande, about twenty miles to the northwest of Santa Fe, New Mexico. A group of archaeologists under the supervision of Dr. E. L. Hewett arrived in 1907 to study the ruins of the old camping grounds of the Pueblo Indians here. Julian was one of the first Indians to be hired to dig in the old village at Puye Canyon and the Pajarito Plateau.

While digging in the old ruins, shards of an old Indian "pot" were uncovered. Maria, who made some pottery, was commissioned to reproduce an exact replica of the discovery, for which she was compensated with two silver dollars. She mixed the clay and modeled the shape; in the meantime, Julian rediscovered the technique used for the painted decoration. He made a syrup of guaco, then boiled it down until it was thick enough to apply to the "pot" with a brush made of chewed yucca stems. When the bowl was fired, it became an exact replica of the design and color of the shards.

Maria and Julian had revived the ancient craft of the Pueblo pottery making. This pottery was cream with black and red designs, red with black and cream designs, and some in monochrome colors. In 1908 this pottery was placed on the market and sold on a small scale. Pots and vases were the most common wares; however, plates and plaques were also produced, but these proved unsatisfactory due to an easy breakage and cracking.

Maria pottery was always fired by a primitive method. A bed was made of broken pottery and then covered with a layer of cedarwood. The "pots" were arranged on top of this pile, then covered with another layer of cedarwood. This arrangement continued until there were three rows or layers of pottery. This completed stack was then covered with cakes of dried cow dung, forming a shell-like oven with an opening at the very top through which the smoke escaped. The stack was set afire and allowed to burn until it died down. The "pots" were picked from the ashes as soon as they were cool enough to handle, being picked up with sticks.

About 1912 an important discovery was made by Maria and Julian. They noted that if the fires were smothered for a time with shovels of powdered sheep dung, the pots would have a black glaze. When the vessels were removed from the ashes, and while they were still hot, they were greased with hog lard, which gave the ware a glossy finish. About 1919 Julian discovered a slip paint that would cause the part that was painted with it (before the firing) to have a matt finish. This resulted in a shiny black body with matt designs in black, a ware known as "San Ildefonso Black on Black." This is the recognizable color of the signed Maria pottery. This technique was a carefully guarded secret for many years and was known only by the potters of San Ildefonso. One will notice that the pottery is rather thick and heavy.

Maria and Julian contributed a great deal to the potting industry in this small community, which brought economic gain

to them and their people. They also appeared at many important expositions, sponsored by the representatives of the United States Bureau of Indian Affairs. Almost immediately, this pottery became a national art interest.

In the earlier years Maria taught pottery-making and was employed to demonstrate this art, under the sponsorship of Dr. Edgar L. Hewett, at the Museum of New Mexico. It was here that the pottery was first sold to the public.

The earliest pottery bore no mark at all. About 1923 Maria was advised by a white friend that it was customary to sign American works of art. This was agreed upon and the Americanized name of "Marie" was used for the signature in the early 1920s. A short time later, about 1925, she added the Americanized form "Julian" of her husband's name. The combination of these two names was used until Julian's death in the fall of 1943. After the death of Julian, Maria's daughter-in-law, Santana (wife of Maria's eldest son, Adam), worked with Maria and the pottery was signed "Marie & Santana." About 1948 Maria changed the spelling of her name and the wares were signed "Maria and Santana."

In 1956 Maria's son, Tony Martinez (Indian name, Popovi Da) became her partner. At Tony's request, Maria marked the ware "Maria Poveka" on the undecorated articles and "Maria & Popovi" on the decorated pieces. The wares that were produced by Maria and Popovi Da (pronounced day) in the 1960s were signed jointly..Maria and Popovi Da.

Following in the footsteps of his distinguished family, his grandparents, Maria and Julian Martinez, and his father, the late Popovi Da, Tony Da continues to create beautiful innovations. After a stint in the navy, (1960—1964) he returned to San Ildefonso and moved into the home of his grandmother where he studied with Maria. He began using new materials and techniques, producing articles embellished with inlaid turquoise and heshi, and sometimes further decorated with silver and carved ironwood. He no longer produced only the traditional black but also included sienna and rich shades of tan, sometimes in combination with the black. One art form represented is the ware that is decorated with intaglio and cameo details. Tony Da mentioned, "His great aunt, Clara Montoya, Maria's baby sister, helped him polish his pots. His father, who originated the sienna color, taught him how to achieve the rich shades of tan".

Specimens may be found of the San Ildefonso Black on Black that are signed by other artists. However, these are not the genuine Maria pottery, but are made in the same locale where Maria and Julian taught their people this art.

In the collection of the American Museum of Natural History is a plaque (black and red on cream) that is signed by Maria, using her Indian name Poveka. Other specimens of Maria pottery may be seen at the Museum of New Mexico.

Photograph of Maria "The Pottery Maker." Famous for her distinctive pottery, Maria's work is exhibited in museums throughout the nation. Nowhere else has Indian Pottery been produced to match that created in New Mexico, Land of Enchantment

*Maria Pottery vases, black on black.
Left: Signed "Marie & Julian," approx-
imately 6½ in. high. Collection of Joan R.
Massey. Below: Signed "Marie & Santana,"
approximately 5½ in. high. Knight photo*

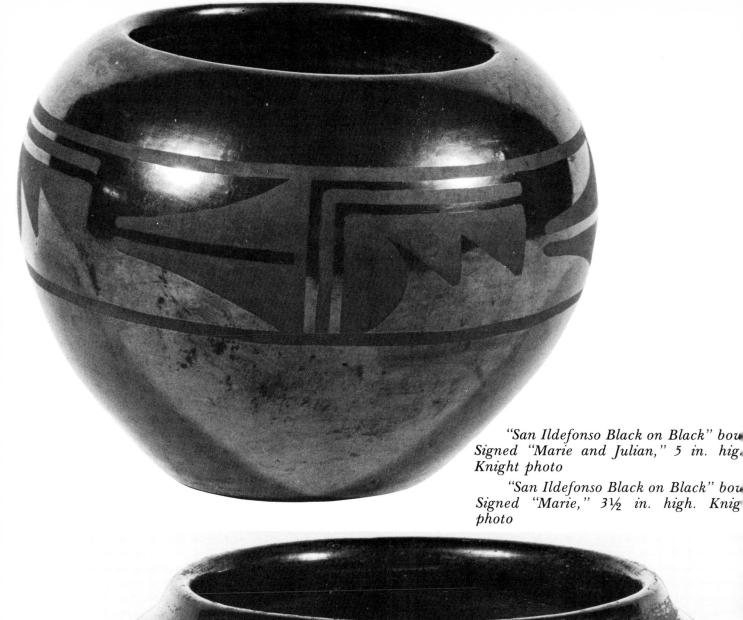

*"San Ildefonso Black on Black" bow...
Signed "Marie and Julian," 5 in. hig...
Knight photo*

*"San Ildefonso Black on Black" bou...
Signed "Marie," 3½ in. high. Knig...
photo*

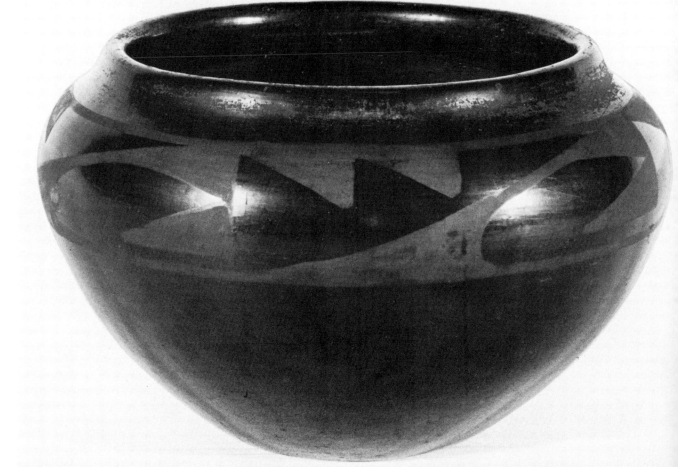

Maria Pottery

No. I 9½" black on cream with sienna

No. II Black on black signed Marie and Julian

No. III Black on black

No. IV Black and cream on red clay

No. V Red and cream on red clay

Signatures to be found on Maria Pottery.

Marie
&
Santana

1943-48

Maria
&
Santana

1948-50s

Maria
&
Popovi

Used on decorated pieces
from 1956 to early 1960s

Maria Poveka

Used on undecorated pieces
from 1956 to early 1960s

Maria
&
Popovi Da

1969 mark

All signatures are incised with a polishing
stone and the signatures will vary somewhat
from piece to piece.

Matt Morgan Art Pottery
1883—1885

In 1883 Matt Morgan founded the Matt Morgan Art Pottery in Cincinnati, Ohio. Already an achieved artist, he had worked in Spain in the pottery business, then later was brought to America from England by a New York publisher.

Morgan eventually migrated to Cincinnati, where he encountered George Ligowsky, the inventor of the "Clay Pigeons." He induced him to aid in experimentation with different native clays and glazes. This venture became the Matt Morgan Art Pottery.

At first they designed Moresque-type pottery with a Spanish accent. This ware was rich in color and profusely decorated with gold. Some of the later wares resembled the early Rookwood. This is understandable since some of the fine Rookwood artists, such as Matt A. Daly and N. J. Hirschfeld, produced art work for Matt Morgan. The modeled pieces were principally done by Herman C. Mueller in conjunction with Morgan.

The company was incorporated and the stockholders desired to place the business on a commercial basis. In so doing, the artistic element, for unknown reasons, was lost and the company failed. The molds, models, and the remaining stock were disposed of at a loss. Mr. Mueller later went into the tile business and Matt Morgan finished his career as art director for a lithographic firm.

Brown jug with gold decoration. Marked with "Matt Morgan," signed by the artist, "Matt A. Daly," 6½ in. high. Collection of Bill Runyon; Knight photo

Matt Morgan pitcher. Dark blue trimmed in gold, 6½ in. high. Orren photo

Matt Morgan Art Pottery

Company marks were impressed on the base with a number:

MATT MORGAN
- CIN. O -
ART POTTERY Cº

MATT MORGAN
CINTI O
ART POTTERY Cº

MATT MORGAN
ART POTTERY Cº

Artists names and monograms:

Matt A. Daly　　　　　　　MAD.　MADaly

N. J. Hirschfeld　　　　　　N.J.H　NH

William P. McDonald　　　W. mc D.

Muncie Pottery
1922—1939

In all parts of the United States following the Pioneer period, a period when the claims of material comforts came first, there began a demand for things in household furnishings that would provide aesthetic pleasures. Accordingly, elegant furniture, beautiful pictures and richly decorated silver and ceramics began to decorate homes. Among the most important of the ceramic wares were the handsome pieces of art pottery. In the late 1880s and early 1900s, potteries began operations all over the United States, among them the Muncie Pottery Company.

The Muncie pottey had its beginning around 1888 in Muncie, Indiana, when the Gill Clay Company pottery was founded. Charles O. Grafton, formerly of Bellaire, Ohio---and the Gill family of Muncie, owned this corporation, whose main business was the manufacture of major pots for molds used in making glass. Articles have been found in the Muncie line to be very similar to patterns produced by the Phoenix Glass Company.

Mr. Charles Benham, a son-in-law of Mr. Charles Grafton, joined the firm in the early 1920s. With Mr. Benham in charge, a new corporation was formed, and a new building was erected adjacent to the Gill Clay Pottery for the purpose of manufacturing art ware. This firm was named Muncie Pottery Company. Operations began in 1922 and continued until 1939, when the company was liquidated. The building was destroyed by fire in 1951. The Gill Pottery was liquidated in 1967 and ironically, that building was also destroyed by fire in 1969.

The Muncie organization, at its peak of production, employed about twenty people. The wares made at Muncie Pottery were breakfast and luncheon sets, bowls with frogs for flower arrangements and assorted interesting and attractive vases. The bodies of these wares were of medium thickness and of fine near porcelain finish, fired at a very high temperature. The chief characteristics of the finish on Muncie art ware are the soft flowing glazes. The color effects are lovely, with the quiet soft tones of one color running down over the other, quite similar to Roseville's Carnelian line. One needs only to examine the color and designs of several pieces to become acquainted with the characteristics of Muncie pottery. The colors are blended from pink to green, lavender to blue, and the like. This might be called the standard recognizable glaze on Muncie pottery. On occasion, however, other glazes were applied. While no surface painting, such as flowers and portraits was used, these handsome pieces were ribbed, pleated and sculptured into stunning shapes with very unusual handles. Oftentimes, as many as four handles appear on one vase. These intricate shapes could account for the vast quantities of seconds which were a contributing factor in the company never having been very successful.

The Muncie Pottery Company maintained a showroom in the Chicago Merchandise Mart. Salesmen also distributed the products throughout the country.

Most Muncie pottery is marked on the base with the name "Muncie" impressed, often accompanied by an incised number with the letter "A". At times, a number with the "A" will appear without the name Muncie. This fine pottery is one more interesting ware that is sought after by pottery collectors. With its beautiful velvety texture and the rare beauty of its unusual shapes, it should enhance any collection of American pottery.

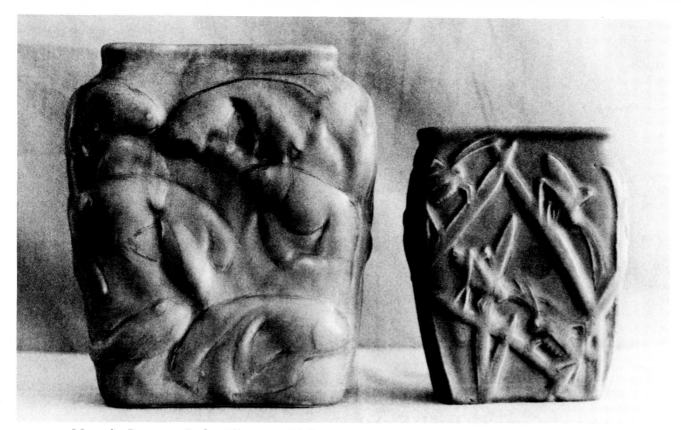

Muncie Pottery, Left: *8" vase. Pink and green drip glaze.* Right: *6" vase. Dark green matt glaze. Author's collection*

Muncie Pottery

marks:

I-A　　5A　　MUNCIE

Incised by hand　　　　Impressed

Newcomb Pottery
1895—1940s

The first and perhaps the most noteworthy appeal of Newcomb ware is in its artistic quality. This is reasonable, since it had its origin in a school of art. Newcomb pottery was developed in 1895 in the art department of Sophia Newcomb Memorial College for women, in New Orleans, Louisiana. Today, Newcomb is part of Tulane University.

There are few social phenomena in American history more striking than the growth of art at the turn of the twentieth century. America was just beginning to awaken to the importance of art as a part of its economy. Newcomb, under the direction of Professor Ellsworth Woodward, was among the first schools to realize it must abandon the exclusive traditional course in "fine art," which the community did not need financially, and to add courses of study that would combine art with industry and that would lead to application of art to industrial needs. To meet that need in such a way as to gain active cooperation from the general public was a problem—a problem with special difficulties when undertaken in a city which, at that time, was little more than a commercial port for a vast agricultural region. If no industry stood ready to use a trained designer there was no inducement to study. If no one saw inducement to study art, the deadlock would continue unbroken.

Education and progress demanded a change and the art school undertook an experiment with pottery as the object lesson. To keep the lessons on a going and developing basis, the workers must find it profitable, and so the college began paying for the product and shouldering the responsibility of disposing of it.

The school converted an old chemistry building into a pottery shop with one kiln, potter's wheels, and all the equipment that was needed for potting. The same building housed the salesrooms where visitors were always welcome. Every process was open for inspection.

Professor Woodward engaged an artist, Mary G. Sheerer, as co-director. Since Miss Sheerer was already familiar with the Rookwood style of decoration and slip painting, this constituted no problem. She was quite devoted to ceramics as an art, and made the Newcomb art department her career. The success of Newcomb was largely due to the tireless energy of this artist.

Professor Woodward also hired Joseph Fortune Meyer as technician of the clay shop. Mr. Meyer threw all the pots on the potter's wheel, after the desired shapes were sketched by Miss Sheerer. When these were completed, the pots were turned over to the girls in the art department to be decorated. Mr. Meyer threw every piece of pottery at Newcomb until he became ill in 1925. All pieces were marked, on the base, with the JM monogram.

The artists were Southern women, educated in the Newcomb School of Art, who were making a living creating this pottery, otherwise they would probably never have been producers of art at all. The Pottery was always just a studio business and never operated as a factory. The Art School, a four-year course, was really started to train girls to decorate the pots for sale. However, generally only the most talented of the senior girls were allowed to work on the pottery.

Newcomb pottery is completely indigenous. The rich cream-colored clay was found in St. Tammany Parish, Louisiana, the land of the orange and palm, the magnolia and jasmine, the bearded cypresss, the noble oak, and the stately pines. All these furnished the rich material for ornamentation. The decorations are sometimes stylized and sometimes natural.

Every piece of Newcomb pottery was

hand thrown; then, while the clay was still plastic, the design was drawn in with a soft pencil, then incised and molded with a tool. When finished, it gave the effect of low-relief modeling, which leads one to believe it was cast in a mold, when in fact it was completely handmade. If studied closely, you will find the subtle fluid lines of the leaves and flowers will never be exactly the same size or thickness. Pieces were never duplicated.

The color in effect is blue. This might be called the standard recognizable color of Newcomb pottery. It is actually a combination of blue and green with contrasting touches of yellow, white, and pink. The color was brushed or sponged on, one color over the other. When held to a strong light, this is clearly visible. Most pieces are this standard color, although, on occasion, other colors—black, white, and dark blue—were used.

Prior to 1910 a high-gloss glaze was used on a minimum number of pieces. Dr. Paul Cox, hired in 1911 as a new technician, developed the standard glaze which characterizes this ware. It is a semi-transparent matt glaze, in which the underpainting appears as through a morning mist. This entailed three separate firings. Dr. Cox was graduated in 1904 from Alfred University, in Alfred, New York, one of the first schools to teach ceramics in America. Dr. Cox remained at Newcomb until 1918 and at this writing is still living in Louisiana.

The finest pieces of Newcomb pottery were made prior to 1918; and after 1920 very little of the underglaze decoration was used. A creamy matt glaze was developed and used on plain shapes, but had very little success.

The pottery was closed in 1940 and the Newcomb Guild was established. The Guild ceased operations in 1952.

Among the agencies and outlets for Newcomb art pottery were Marshall Field and William O'Brien of Chicago; Paul Elder of San Francisco; Gustaf Stickley of New York; and Arts and Crafts Association of Philadelphia. Other outlets were in Boston, Milwaukee, Washington, D.C., and Detroit.

During the period Newcomb pottery was made, it was exhibited at several International Expositions, including the 1904 Louisiana Purchase Exposition where

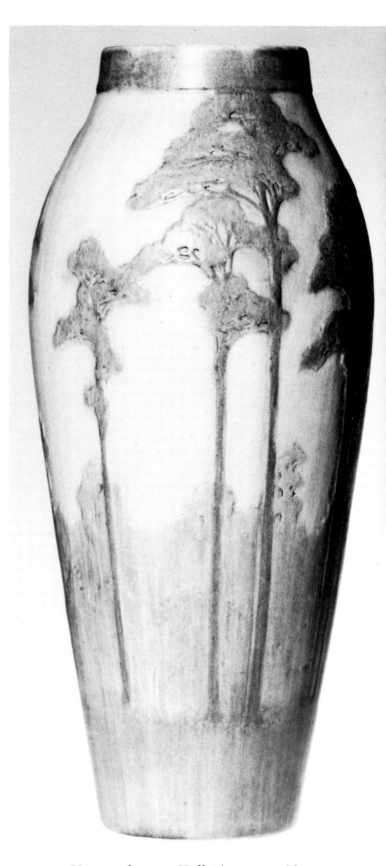

Newcomb vase. Tall pine trees, blue, 11 in. high. Signed by Anna Frances Simpson. Orren photo

a silver medal was won. Bronze medals were awarded at the World's Fair in Paris (1900) and at the Pan American Exposition at Buffalo, New York (1901). A silver medal was awarded at Charleston in 1902. In 1905 a bronze medal was awarded at Portland. Gold medals were won at Jamestown in 1905, Knoxville in 1915, and San Francisco in 1915.

A partial list of the artists working at Newcomb was gleaned from the college archives. The names and some monograms will be noted at the end of this chapter.

From the very beginning all Newcomb pottery was marked; the marks are found on the base of the article. These marks include the Pottery's mark, technician's mark, and the monogram of the artist.

Due to the scarcity of this fine art ware, pottery collectors may find it difficult to obtain a specimen; however, one can locate pieces on display at many fine museums, including the Metropolitan Museum of Art, Smithsonian Institution, and Museum of Fine Arts, Boston.

The important consideration, besides the beauty of this ware, which has a touch of the old South, Newcomb has proved that art and manufacture had been brought together on terms of mutual respect and interdependence.

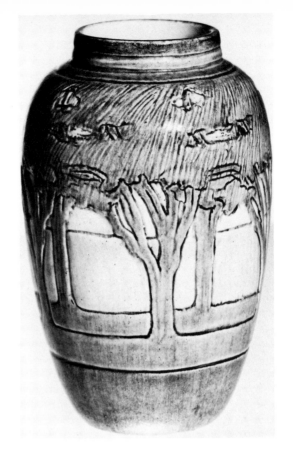

Newcomb vase encircled by a continuous pattern of trees. Signed by the artist, "Maria LeBlanc," the blue-green coloring is typical but the high-gloss glaze is uncommon, 5½ in. high, 3½ in. diameter. Collection of Bill Runyon; Orren photo

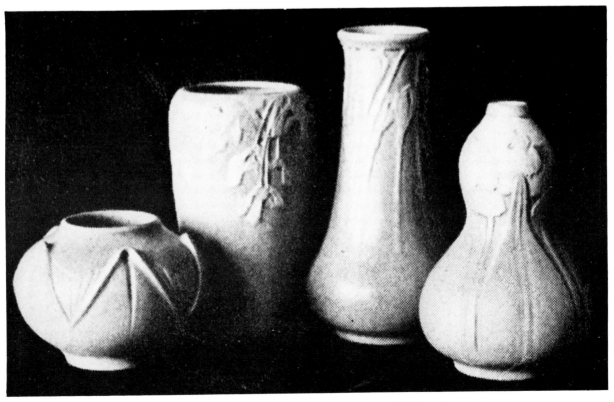

"Newcomb pottery vases which appeared in a college brochure, 1910."

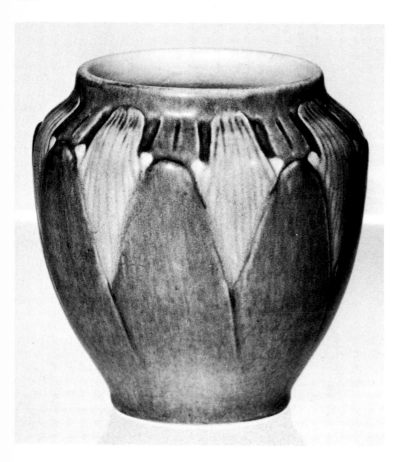

Newcomb vase. Stylized magnolia-blossom form, blue, 5 in. high. Orren photo

Newcomb Pottery. Pitcher, blue with white flowers, marked "NC," artist monogram unknown, 6 in. high; vase, blue with white flowers, marked "NC," signed by Henrietta Bailey, 8 in. high. Knight photo

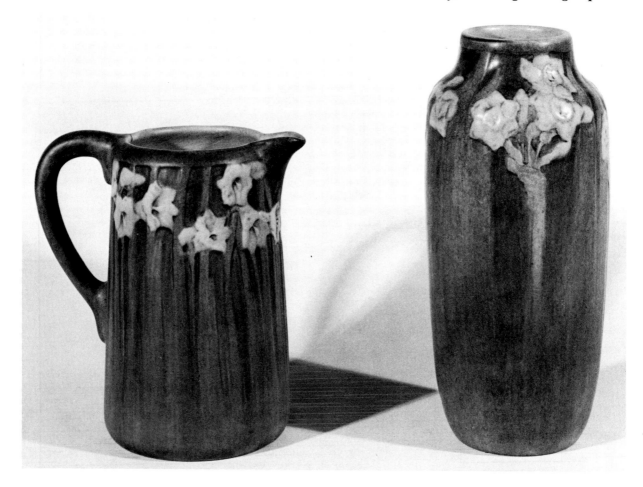

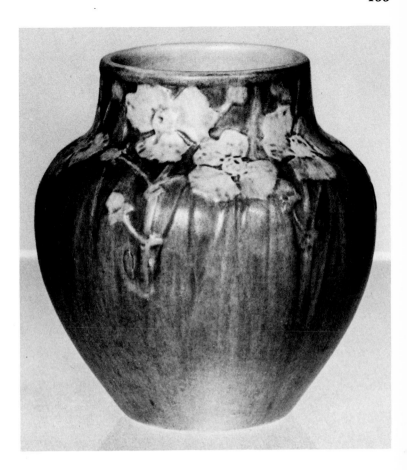

Newcomb vase. Daffodils in relief, modeled by Henrietta Bailey, blue, 5½ in. high. Orren photo

Newcomb Pottery vases. Left: Blue 6 in. signed Cynthia Littlejohn. Right: 8 in. blue, signed Sadie Irvine

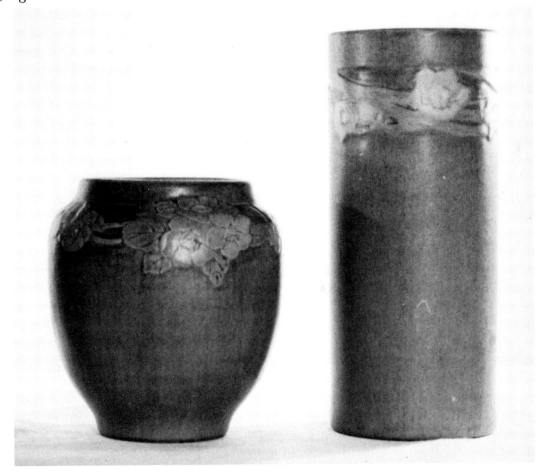

Newcomb Pottery
marks :

Impressed

Paper labels were also used with the following data:
Newcomb Pottery, New Orleans
Designs are not duplicated
Object number and price

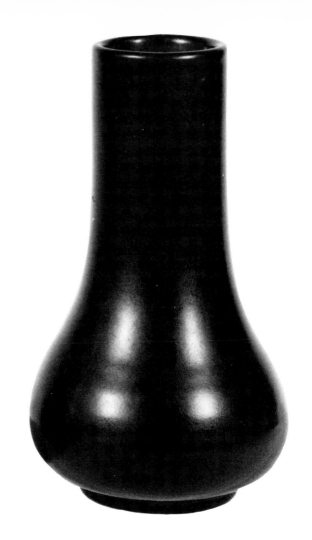

Jet black vase, marked, "JM" monogram, text numbers indicate a rare trial glaze, 7½ in. high. Collection of R. E. and F. G. O'Brien, Jr.; Knight photo

Newcomb bowl-vase with begonia-blossom decoration designed by Henrietta Bailey, blue, 5½ in. diameter. Orren photo

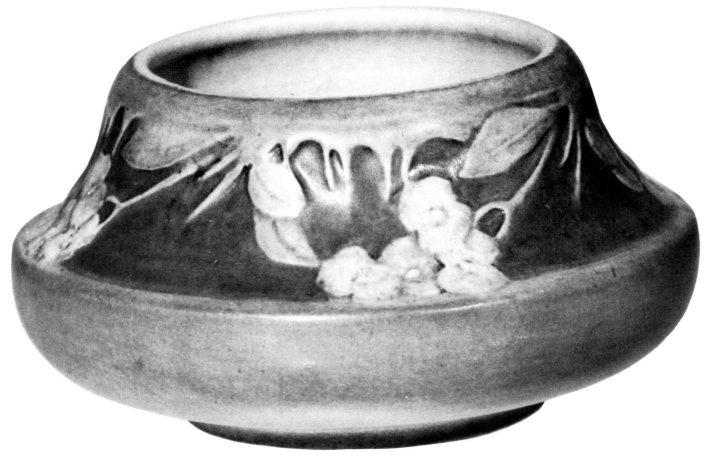

Newcomb Pottery

The mark of the potter, which appears with the mark of the artist:

Joseph Meyer

The names and monograms of the Newcomb decorators:

Letters on the base denotes the clay mixture. Letters with numbers are registration marks. One scratch through the pottery mark denotes a "second."

Henrietta Bailey	Selina E. B. Gregory
Mary F. Baker	Cecile Heller
Gladys Bartlett	Sarah Henderson
Maria Benson	Sally Holt
Mary W. Butler	Emily Huger
Corinne Chalaron	Sadie Irvine
Frances H. Cocke	Frances Jones
Olive W. Dodd	Hattie Joor
May Dunn	Irene B. Keep
Esther Huger Elliott	Roberta Kennon
Bessie A. Ficklen	Katherine Kopman

Maria Hoe LeBlanc — M.H.L. — MLeB

Jeanette Le Buef — JLeB

Sarah B. Levy — SLe

Francis E. Lines — E

Cynthia Littlejohn — CL CL

Ada Lonnegan — ALN

Julia Michel (Hoerner) — H ЛЕ

Hilda Modinger (Lewis) — HM

May Morel — M M

Leona Nicholson — LN

Charlotte Payne — C Payne

Beverly Randolph — BR

Louise Wood — LW W

Mary W. Richardson — RM

Martha Robinson — MR

Elizabeth Rogers — ESR

Amalie Roman — AR

Desiree Roman — SR

Medora Ross — MRoss

Mazie T. Ryan — MTR

Raymond A. Scudder — ASR

Mary Sheerer — MS

Anna Frances Simpson — AFS AFS

Gertrude R. Smith — S

Sabrina Wells — SEW S.E.W. SEW

Niloak Pottery
1909—1946

Niloak Pottery had its beginning in Benton, Arkansas in 1909, under the guidance of Charles Dean "Bullet" Hyten. He was the son of J. H. Hyten, a potter in his own right, who had operated a Pottery in Boonsboro, Iowa, but had moved to Arkansas for his health. Here, J. H. Hyten was employed by a Pottery which in time he purchased, and renamed the Eagle Pottery. Mr. Hyten died shortly after the purchase. His widow married another potter who directed the business until 1895, when they moved to Ohio.

Young "Bullet" Hyten, who had worked for his father, took over management of the business. At that time, he was only eighteen years old. He was joined by his two brothers and they continued to manufacture stoneware and subsequently changed the name to Hyten Brothers Pottery.

Charles "Bullet" began to test the local clays and discovered them to be fine, rich and colorful. He later opened his own Pottery and began marketing his art ware under the name Niloak. The name was derived from "Kaolin" spelled backwards. Kaolin is the name for a fine potting clay, and had been used for centuries, in the Orient, for making porcelain. Although the native clays were colorful and were used when possible, other colors were sometimes added. These colors were used in the line called "Mission". This ware is a swirled marbleized design in two or more shades, such as; brown, blue and cream. Different hues of brown, blue, green and pink were used, as well as whites and creams. All types of articles were created in the Mission line---vases, bowls, candle sticks, humidors, stamp boxes, lamps, umbrella stands, tiles, pitchers, tankards, steins, jardiniers, clock cases and many more. Some of the vases were extremely large.

The Mission line became very popular and sold readily. Business flourished and a new and modern facility was constructed. The majority of the pottery that was produced was the marbleized variety. Hyten hired extra salesmen to sell the wares all over the country. Eventually, the pottery was sold in Europe and the Far East. It was also displayed at the Chicago World's Fair.

During the depression years of the 1930s, sales dwindled rapidly, however, the relatively expensive Mission line was continued until 1942. Hyten, realizing the need for a less expensive line, developed a line of molded wares---a ware he named Hywood. This ware was covered in varied glazes---matt, semi-matt, gloss and drip glazes, where one color is running over the other. Niloak began to specialize in cast and molded wares. These were most often figurals with fine heavy glazes reminiscent of Van Briggle and the late cast in a mold Rookwood. These glazes were dark matt blue, dark maroon, and pinks. Practically every animal imaginable was created, some with pockets to be used as a planter. Originally, this ware was stamped Hywood, including the name Niloak, however, eventually, only the name Niloak was used.

Despite the fact thousands of these articles were sold, financial problems continued and Hyten was forced to mortgage the Pottery. Although he retained some stock, control of the company changed hands. Under the new management, Hyten remained for a period of time as a salesman, until 1941. The company continued to market its wares under the Niloak name and continued to mark the pieces in the same manner. In 1946, the Pottery finally closed. In 1941, Hyten joined the Camark Pottery of Camden, Arkansas as a salesman. He died in 1944.

Most Niloak is marked with an impressed or embossed "Niloak" on the base. These embossed marks were made in the mold. On miniature pieces, a single embossed "N" was used. Also used were paper labels.

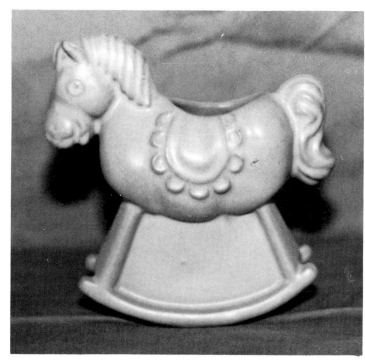

Niloak with early heavy blue glaze.
Author's collection

Niloak Pottery, Left: *8" Mission line.*
Right: *Fox, dark red matt glaze. Author's*
collection

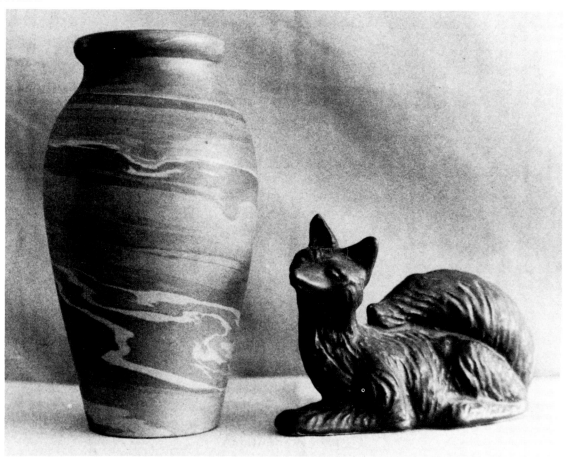

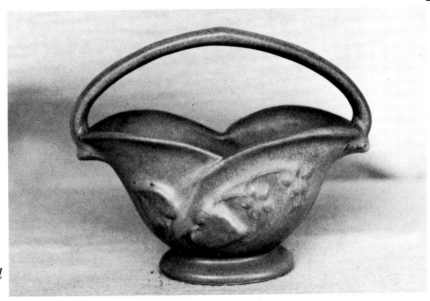

Niloak vase with drip glaze marked
NILOAK. *Authors collection*

Niloak duck and vase,
both impressed NILOAK *in*
block letters. Collection of
the author

Niloak figurines; pink
gloss glaze on left, blue gloss
on right. Author's collection

Niloak pitchers with pink matt glaze.
Author's collection

Niloak pitcher; 6" tall, pink glaze. Author's collection

Niloak
Marks:

NILOAK

NILOAK

Embossed or impressed
in different sizes.

HYWOOD
BY
NILOAK

Impressed

Paper label

NILOAK

Impressed or embossed
in fancy lettering.

N

Embossed on miniatures

Paper label

J. B. Owens Pottery
1890—1929

As did other potters of this era, Owens took advantage of the fine rich clays in the Ohio Valley.

J. B. Owens was born on a farm in Muskingum County, Ohio, December 21, 1859. The lads who grew up in this section of the country learned the art of throwing a pot almost as early as they learned the art of farming. Owens and George Young, of Roseville fame, grew up in the same area and each started his career in Roseville, Ohio.

Eagerness to sell made Owens a super-salesman. He took a position selling a line of stoneware for a pottery in Roseville and rapidly became the highest-salaried man on the sales force. In a short period of time he saved enough money to start a small stoneware pottery of his own. He engaged workmen to make the wares but he himself took the responsibility of selling them. Soon he had enough capital to erect a new plant in Roseville.

In 1891 a new subdivision, Brighton, was being laid out in Zanesville. Promoters of this subdivision encouraged Owens to build a new factory in this location. Owens promptly induced them to give him the land free of charge, along with $3,500 in cash. A new three-story building was erected, and the company was incorporated. Owens was known to be a persuasive individual and could obtain practically anything he wanted.

At this time, he engaged Karl Langenbeck as head chemist. Karl Langenbeck, as a boy in 1873, resided in Cincinnati, Ohio. He earned his spending money by making pen and ink drawings on cards, and decorating desk sets. When he received a set of china-painting colors from an uncle in Frankfort, Germany, he turned to the art of china painting. Mrs. Maria Longworth Nichols and Mrs. Learner Harrison, two of his neighbors, were captivated by the new art, and they joined him, using his colors until they could import some for themselves. Later, Karl Langenbeck became the first ceramic chemist in America. In 1886 he founded the Avon Pottery, which he operated for one and one half years. Along with Herman C. Mueller, in 1894, he organized the Mosaic Tile Co. of Zanesville, Ohio.

Owens' enterprise expanded rapidly and, in 1896, he entered the art-pottery field. His first product was the "Utopian" ware which was similar to Weller's Louwelsa, Rookwood's standard brown ware, and George Young's brown Rozane ware. During the decade he made art pottery, he employed the most talented artists in ceramics, including W. A. Long from the Lonhuda and Weller potteries; John Lessell, an expert in the field of iridescent glazes; John J. Herold; Hugo Herb, waxwork expert from Berlin; and Guido Howorth from Austria-Hungary. Howorth designed some Persian effects of unusual beauty. Frank Ferrel came to Owens about 1907, then later became designer for Roseville Pottery. These men were but few of the experts that were employed by the Owens factory. It was said that Owens, in the short period of time that he made art pottery, introduced more new lines than any other potter of that period. In 1904 Owens issued a forty-page catalog, said to be the largest ever issued by an American pottery, being fourteen by twenty inches and containing eight hundred items. He duplicated every line made by his competitors and created new ones. Some of these lines were expensive to make; others so nearly copied products of other potteries, it was hard to market them. Outlets for Owens' pottery were established in New York, Chicago, and Philadelphia. Large shipments were also sent to foreign countries, as far as Austrailia, the West Indies, and Brazil.

Owens stopped making art pottery

about 1907 or 1908 and turned to the manufacturing of commercial tile. During his years in the art-pottery business he had won four gold medals and a grand prize (at the Lewis and Clark Exposition in Portland, Oregon, in 1905). He managed to get along quite well until his factory burned in 1928. According to Owens, only East Liverpool, Ohio, and Trenton, New Jersey, outranked Zanesville as pottery centers in the country.

Against the advice of several businessmen, he rebuilt at the beginning of the 1929 depression; as a result, he lost all his properties. He moved to Homestead, Florida, where he invested in a fifteen-acre citrus grove. Owens died in 1934.

Owens art pottery is almost always marked; however, there are exceptions.

Owens Pottery line names, with approximate dates of presentation and descriptions:

ABORIGINE 1907—Indian-type pottery.
ALPINE 1905—Matt finish on soft shaded background with freehand slip decoration. Each has a white top, like a snow-capped mountain.
AQUA VERDI 1907—Embossed classical figures and designs with semigloss in green glaze.
ART VELLUM WARE 1905—A delicate velvetlike finish in warm, exquisite shades of autumn foliage.
CORONA ANIMALS 1905—Figures of animals for both indoor and outdoor use. These were in natural colors ranging from 4½ to 43 inches in height, including dogs from dachshund to Great Danes in their natural sizes.
CORONA WARE 1904—The decoration of this ware resembles the many varieties of bronze wares in form and decoration.
CYRANO 1898—Sgraffito designs with incisions filled with clay in the manner of lace. Very similar to Weller's Turada.
DELFT 1904—Old Holland bucket shapes ornamented with Dutch scenes in shades of blue.
FEROZA 1902—Ware with iridescent glaze. Similar to Weller's Sicardo.
GUNMETAL WARE 1905—Ware with a glaze resembling the rich, dull surface of gunmetal with decorations etched in delicate designs.
HENRI DEUX 1905—An inlaid process

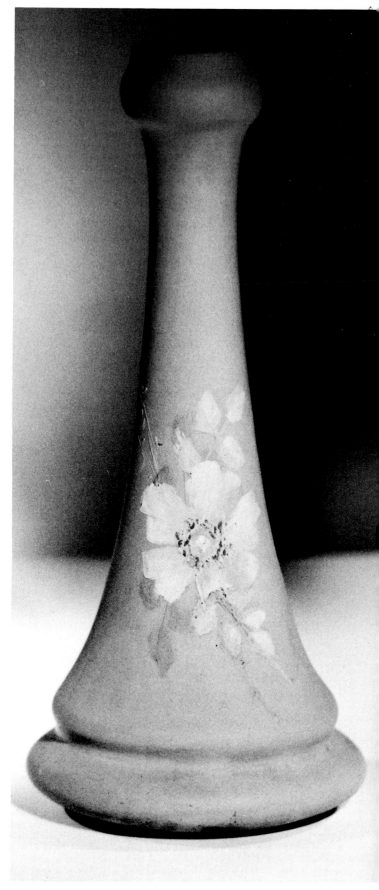

"Matt" vase. Pastel colors, 13½ in. high. Orren photo

similar to some French pottery and Stallmacher Teplitz, Austria.

LOTUS 1900—Under-the-glaze slip painting. Similar to Weller's Eocean.

MATT UTOPIAN 1905—Soft matt finish ware with slip decoration. Usually found in light colors.

MISSION 1903—Western landscapes and churches applied by hand with a splashed effect. Each piece was fitted with a wooden stand.

OPALESCE INLAID 1905—This ware has a background in solid colors of green or other light shades. Wavy lines are traced in gold, silver, or bronze with floral decorations inlaid in colors and outlined in black. This ware was made to duplicate to a certain extent the Italian Vermiculated designed ware of the sixteenth century.

OPALESCE UTOPIAN 1905—This ware was coated with gold, then overlaid with small coraline-like beads with slip decoration on one side.

RED FLAME 1905—Embossed flower decoration with red glaze.

RUSTIC 1904—Rustic looking or as if decorated with trees and stumps.

SOUDANEZE 1907—Ebony black ware with pastel color inlaid slip decoration.

SUNBURST 1906—A Utopian-type ware with a high-gloss glaze with the background sponged on. Similar to Weller's Aurelian.

UTOPIAN 1896—High-glaze brown ware with under-the-glaze slip painting. Similar to Weller's Louwelsa, Rookwood's standard brown ware, and Roseville's Rozane brown ware.

VENETIAN 1904—This ware features a metallic glaze with iridescence intensified by depressions or elevations on the surface.

WEDGWOOD JASPERWARE 1903—Very similar to the English Jasperware and Radford's Jasperware.

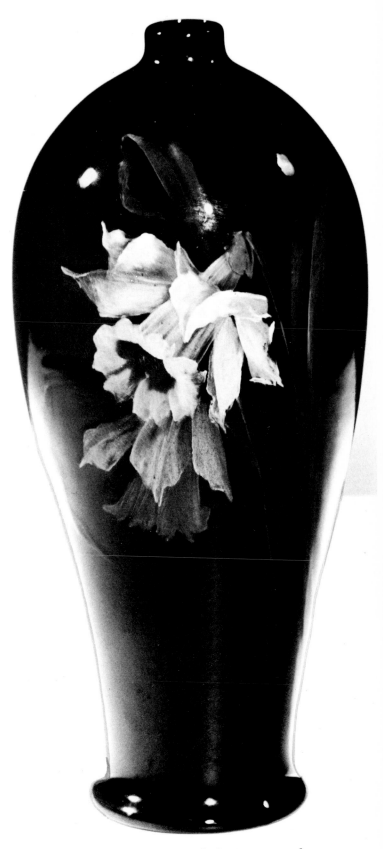

"Utopian" vase. Dark brown to yellow, signed "Dolores Harvey," 11 in. high. Orren photo

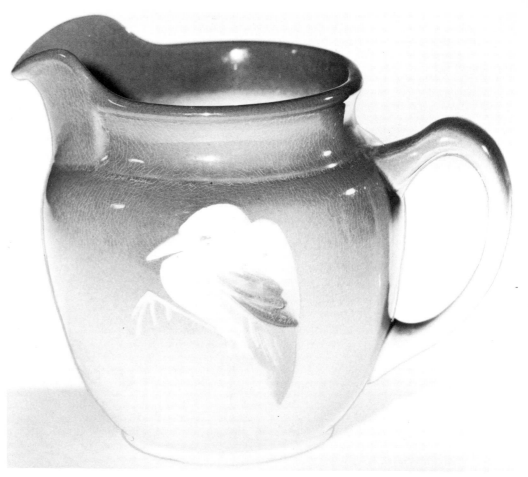

"Lotus" pitcher. Dark gray to light gray, 6½-in. high. Author's collection; Orren photo

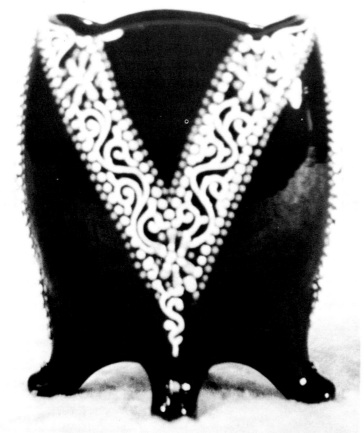

"Cryano" vase. Dark blue shaded with white decoration, not marked, 6 in. high. Fox photo

J. B. Owens Pottery
marks:

impressed on the base of each item

J.B. Owens OWENS
UTOPIAN UTOPIAN
1031 214

OWENS ART owens
UTOPIAN UTOPIAN
1129 1060

OWENS FEROZA HENRI
 DEUX

UTOPIAN MISSION OWENS
J.B. OWENS 123

"Lotus" vase. Light blue-gray with pink and green decoration, matt glaze, marked "Owens Lotus," 5 in. high. Knight photo

Artist names and monograms:

Estelle Beardsley	𝕯𝕭	Lillian Bloomer	ℒ𝓑	Cecil Excel	C℮
Edith Bell	E B	Cora Davis	C.D.	Charles Gray	G
Fanny Bell	F B	W. Denny	WD	Martha E. Gray	M.G.
A. F. Best	𝔅	Harrie Eberlein	HE	Delores Harvey	D.H.
Cecilia Bloomer	𝕭	Hattie Eberlein	HE	Albert Haubrich	A Haubrich

Owens Pottery

Artist names and monograms:

Roy Hook	Miss Oshe	Will H. Stemm
H. Hoskins	Mary L. Peirce	Mary Fauntleroy Stevens
Harry Larzelere	Harry Robinson	Mae Timberlake
A. V. Lewis	Hattie M. Ross	Sarah Timberlake
Cora McCandless	R. Lillian Shoemaker	Arthur Williams
Carrie McDonald	Ida Steele	

Paul Revere Pottery
1906—1942

Paul Revere Pottery was established in Boston, Massachusetts, in 1906 by a group of philanthropists which included Mrs. James J. Storrow, who was also a member of the Board of Managers of the North Bennett Street Industrial School of Boston's North End. These sympathetic people were endeavoring to establish better social and industrial conditions among the underprivileged young girls who were no longer compelled to go to school, but rather were forced to take up some type of work in order to survive. They felt that pleasant conditions could exist in a shop as well as in a home, and that a life of drudgery was not necessarily all these working girls had to look forward to. The art of pottery was undertaken as the object lesson, and thus began the Paul Revere Pottery.

Edith Brown, who had served as librarian at the North End Boston Library and had also supervised a group of high-school girls in an educational program, was first director and designer, assisted by Edith Guerrier. This group of underpriviliged girls became known as "The Saturday Evening Girls." The small operation of pottery-making was started in the basement of an old dwelling. In 1912 Mrs. Storrow purchased, for this operation, a brick house at 18 Hull Street in Boston, under the shadow of the Old North Church, where Paul Revere's signal lanterns had been hung. This location was also opposite Copps Hill Burying Ground, where the green turf and ancient elms watch over the resting places of some of Boston's first citizens.

At this new location, the Pottery was equipped with a substantial kiln and all the other materials that were essential for production. The club grew rapidly until the membership included some two hundred girls. This group continued to be known as "The Saturday Evening Girls."

The ware became famous and a substantial amount of it was sold both locally and abroad. However, the experiment never became really profitable. Mrs. Storrow found it necessary to continue contributing funds in order to keep the Pottery in operation.

In 1915 the plant was moved to a new building on Nottingham Hill in Brighton, Massachusetts. At this new location, thirty girls were employed regularly. The pottery continued to sell, but the financial condition remained unaltered and could not be placed on a paying basis. Edith Brown died in 1932. Without her guiding influence, the Pottery foundered and, in 1942, its doors were finally closed. Mrs. Storrow died in 1944.

Paul Revere pottery was made in all sorts of tableware and accessories, as well as "baby ware" that was very popular. Doll heads were also made but never placed on the market. The wares were mostly hand decorated in mineral colors; however, the sgraffito method along with the molded type was also used. The designs used in decorating were mostly natural, such as flowers, trees, chickens, rabbits, boats, and a galloping horse with a rider. Stylized designs were sometimes used.

The colors used on Paul Revere pottery were varied: eggshell lined with green or other colors; gunmetal gray lined with such colors as yellow, brown, red, and shades of green and blue. Articles were also finished in monochrome tints.

This ware was sold in gift shops as well as the showrooms at the Pottery. A system was devised to mark the wares, but the workers became careless and much of it was sold without markings. A paper label as well as an impressed mark was used, showing a galloping horse with a rider. The letters PRP were both impressed and painted in color on the base. Some pieces included the artist's monogram but no

records were made available as to the identity of these artists.

Although this small industry was not a profitable one, it did prove that some success could be accomplished along with attractive working conditions and agreeable surroundings, which was one step ahead for the "working girl."

Group of Paul Revere Pottery as pictured in an article appearing in December 1913 issue of "The Craftsman." Johnson photo

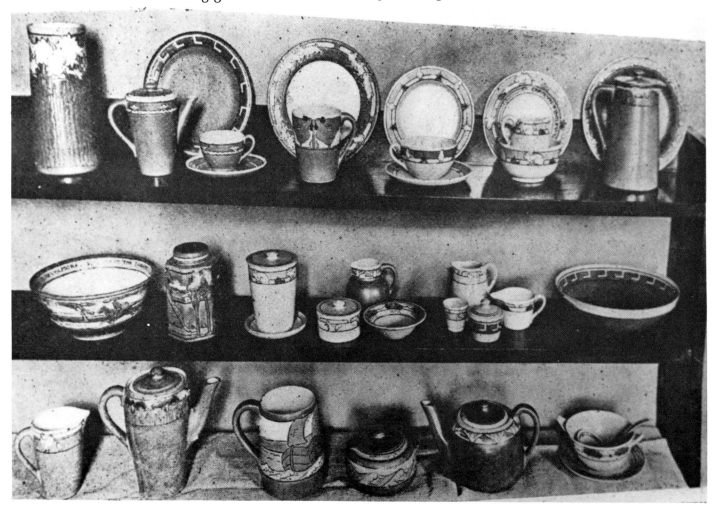

Paul Revere Pottery

marks:

P. R·P
1940

Painted

Impressed

Pauline Pottery
1883—1909

The Pauline Pottery had its beginning in 1880 in Chicago, Illinois, when Mrs. Pauline Jacobus visited a display of ceramic art work by Sarah Bernhardt, the French actress. Being deeply impressed by what she saw, she became determined to work in ceramics herself. Mrs. Jacobus was also encouraged by her husband, Oscar I. Jacobus, who insisted that she go to Cincinnati to study under the supervision of Maria Longworth Nichols at the Rookwood Pottery, which was just getting under way itself. Upon her return to Chicago, she organized a class in ceramics, importing the clays from the Ohio Valley. The initial wares that were made were sent to the Rookwood Pottery for firing, which proved to be a difficult and inconvenient procedure. This inconvenience forced Mrs. Jacobus to have a small kiln built locally. Thereafter she continued to make art ware with much success. She named the company "Pauline Pottery," a name she continued to use until the closing days.

Mrs. Jacobus was continually searching for a suitable clay nearer her home than the Ohio Valley. Just such a bed of clay was soon discovered in Edgerton, Wisconsin. An old home was purchased near the clay bed and the Pauline Pottery was moved to this location in 1888. Mr. Jacobus resigned his position as a member of the Chicago Board of Trade and founded a separate plant for making commercial wares, such as porous cups for batteries for the Bell Telephone Company.

The business began to flourish and soon the firm was employing over thirty five people. Two men who were added to the crew were Thorwald P. A. Samson and Louis Ipson. Both of these men were experienced potters who had migrated from Denmark. Mr. Ipson was an experienced molder and Samson was both artist and modeler, however, these two men only remained at the Pottery for about a year, at which time they departed to organize a new establishment in Edgerton, called the "American Art Clay Works". At their plant they created figures and busts, some in terra cotta, using the local red clay.

After the death of Mr. Jacobus in 1893, business began to decrease partly due to the invention of the dry cell battery, and consequently, the Jacobus enterprises failed, and were placed in control of the stockholders. The Pottery was then incorporated using the name Edgerton Pottery Company. This undertaking also failed, and in early 1902, was dismantled. Most of the remaining equipment and material was sold to the public. Mrs. Jacobus purchased the kiln and the remaining unused clay for her own use. She employed a brickmason to assist in dismantling the kiln, brick by brick, and then rebuild it in the backyard of the family residence. She utilized the basement of her home and a small building at the back of the house to do the potting, glazing and decorating. She continued making Pauline pottery until 1909, when the Jacobus home was totally destroyed by fire. She resided for a short time with a daughter and son-in-law, Jenny and John Coons. Her last days were spent in the Masonic Home in Dousman, Wisconsin, where she died in 1930.

The earliest ware, with a yellow background, was decorated with underglaze blue painting. Later, a glaze was developed with a shaded background with underglaze slip painting, similar to Rookwood's standard glaze. The backgrounds were varied, other than the yellow and brown. Some Pauline was made in dark green shaded to dark blue, giving the effect of the vivid colors of peacock feathers. A marine blue, shaded to cool gray, was a refreshing combination. On occasion, even three tints were used—green to blue to a glowing rose pink. The Pauline creations are often crazed and were not always

waterproof which resulted in some pieces being discolored. Pieces of Pauline pottery are characterized by a thin black outline around the designs. The forms seem to emulate every style, such as English, French, German, Chinese, Japanese, and even the simple shapes of plain American crockery. Pauline was made in vases, bowls, pitchers, tableware, and statuettes. A most popular item was the teaset.

Among agents and outlets for Pauline Pottery was Tiffany's in New York, Marshall Field's in Chicago and Kimball's of Boston. Pauline pottery is on display at the Neville Museum in Green Bay, Wisconsin, and the Wisconsin State Historical Society in Madison.

Most Pauline pottery is marked on the base and is often signed by the artist.

Pauline chocolate pot. Shaded from a soft gray-brown to light rust, yellow flowers accented with gold, marked, 8½-in. high. Collection of Mr. and Mrs. George M. Rydings; Gilbert photo

Pauline Pottery
marks:

Impressed

Stamped

Stamped

Stamped

PAULINE POTTERY

Impressed

Stamped

Pauline Pottery

Pauline Pottery cookie jar. Yellow with blue outline decoration. Middleton collection, Wisconsin State Historical Society Museum. Madison, Wisconsin. Sketched by David Thompson.

4 in. statuette in unglazed white; marked "Edgerton Art Clay." Sketched by David Thompson.

Pennsbury Pottery
1950—1971

In historical Bucks County, just three miles west of Morrisville, Pennsylvania, on Tyburne road, the Pennsbury Pottery was founded (1950) under the guidance of Henry Below. He was aided in this venture by his wife and their son, Earnest Below.

Henry Below was in charge of designing some of the shapes and also managing the business office, while his wife, who was a gifted creative artist, was one of the decorators. Earnest Below became general manager of the Pottery. Earnest had experience in ceramic engineering as he had been employed by the Stangl Pottery for twenty one years. He brought along with him a handful of workers from the Stangl organization and they subsequently began operations. Although work was started with only a crew of eight, eventually, housewives and young girls were taught the trade, and in time, some of them were used in the decorating department. By the closing years, a crew of between forty and fifty were employed.

The first line to be introduced was the birds. These are very similar to those that were produced by the Stangl Company, in detail, coloring, shapes and glazes. This line included several varieties of the American Eagle, hen and rooster sets, and various other small birds. These birds are marked by hand "Pennsbury Pottery" and usually the name of the bird portrayed, is also included in the marking.

The wares designed at Pennsbury are reminiscent of a carving technique that was used at the Stangl Pottery. Most designs were created by using the sgraffito method of carving an outline of the patterns and then painting the designs in soothing complimentary tints, by hand, and then covering the entire article with a smear glaze in a light brown or tan tone that accents the supple colors of the hand work. This blend is the distinguishing characteristic of the Pennsbury creations.

Many of these charming articles are decorated with early Pennsylvania Dutch motifs along with figures of Amish people, combined with witty sayings---for instance, as is shown on the Amish Head oil and vinegar bottles. The Amish man vinegar bottle says, "Vee Get Too Soon Old", and the Amish lady oil bottle says, "Undt Too Late Schmart".

Mrs. Henry Below is credited with creating most of these folk art designs, depicting scenes indigenous to folklore of the area. Many pieces are nostalgic, such as--"The Barber Shop Quartet" and plaques with early steam engines and the like. These wares were made in plates, plaques, pitchers, mugs, candle sticks, vinegar and oil bottles, ash trays, lamps, tiles and others, too numerous to mention. Some of the most popular pattern designs appearing on these pieces are the "Red Rooster", "Black Rooster", Pennsylvania Dutch "Hex Ware", "American Eagle" and "Sweet Adeline" (Barber Shop Quartet).

A line of commemorative merchandise was made available in quantities to their customers. These included Fraternal Organizations, Churches, Electrolux, Railroads, Historic Fallsington etc. Articles made for these people were plaques, ash trays, plates, mugs or any specialty items that might be requested. Scenic serving dishes were designed for the final running of the last steam engine that was operated by the Reading Railroad. The tray that pictured the engine, was made in limited numbers, and these were given away to the passengers as a souvenir.

One of the most rare articles produced was a plate designed for Walt Disney when he attended the opening of the Walt Disney School in Levittown, Pennsylvania. Only one Christmas plate was created and it is dated 1970.

Pennsbury is a strong earthenware body, fired at a high temperature. Several

different clays were utilized, mixed with flint and other materials. These clays were mostly imported from Tennessee and Georgia.

In the spring of 1971, the Pennsbury Pottery closed their doors and the remaining stock was disposed of at public auction. A short time later, the pottery was completely destroyed by fire, including all the machinery and all the molds.

Practically every piece of pottery was marked on the bottom by hand in script.

↑ *Pennsbury Pottery mug; 4¾ inches. Author's collection*

← *Pennsbury; mug, 4½ in. high. Marked in script. Author's collection*

Pennsbury Pottery. Vinegar and oil bottles; 7" high. Ash tray; 5". All pieces collection of Joyce Smalley ↓

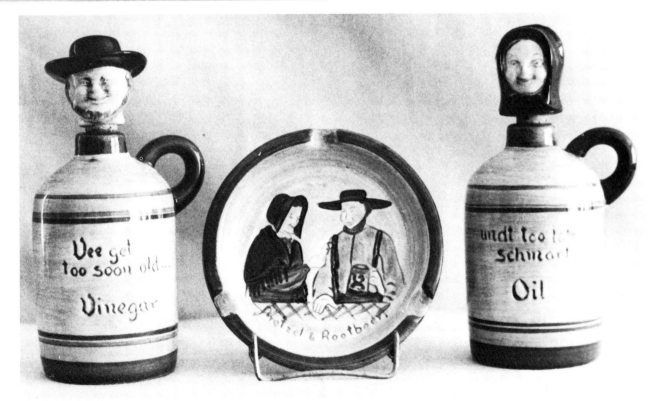

Pennsbury Pottery. 8" plate. Author's collection

Pennsbury Pottery. 10" plate. Author's collection

Pennsbury Pottery. Plate; 11". Amish People. Collection of Joyce Smalley

Pennsbury
Marks:

103
BLUE BIRD
PENNSBURY
POTTERY

Hand printed on Birds

Pennsbury Pottery
Morrisville Pa.

Printed or incised by hand

Pennsbury
Pottery

Printed or incised by hand

Peters and Reed
1897—1921
Zane Pottery
1921—1941

In the Ohio Valley, with its fine clays, more potteries flourished than anywhere else in the United States. New potteries sprang up every few months between 1880 and 1915. Many men who worked at the Weller, Rookwood, and other large factories in this area aspired to become industrialists rather than just ordinary workmen. Two such men were John Peters and Adam Reed. When Sam Weller stopped making flowerpots in 1897, when his art ware became popular, Peters and Reed decided to try their hand at capturing some of Weller's flowerpot business. A building was rented, with an option to buy, at the old Clark Stoneware plant on Linden Avenue in South Zanesville, Ohio. Their anticipated wealth was not accomplished over night; however, they were beginning to prosper. When the option came due, in 1898, circumstances put them in no position to buy the building, and George Young purchased it for his Roseville Pottery, where it remained until it closed in 1954.

Peters and Reed purchased another building, in the same general location—the old South Zanesville Stoneware Company. The company was incorporated in 1901, as Peters and Reed. Almost immediately they did well selling garden ware and flowerpots. Soon they were ready to invade the art-pottery field. When Frank Ferrel left Weller about 1905, Peters and Reed hired him as designer and salesman. Ferrel had designed a Pinecone pattern while at Weller which was not accepted and the samples were destroyed. He renewed this pattern for Peters and Reed and it subsequently became a profitable seller. This new line was made of reddish brown clay with raised designs, sprayed with green paint which was then wiped from the embossings and backgrounds. It was also made in designs other than the Pinecone, and labeled "Moss Aztec." Other art lines

were created and all continued to sell readily. After his short tenure of two years with Peters and Reed, Ferrel migrated to the Owens Pottery. In 1917 he was employed by the Roseville Pottery.

In 1920 Harry S. McClelland bought Peters' stock; in 1921 the name was changed to Zane Pottery Company. When Reed died, McClelland became sole owner. The factory was enlarged and more art lines were added to the production. At this time, a fine Ohio artist, C. W. Chilcote, was in charge of designing and Ernest Murray was ceramist.

The Moss Aztec line continued to sell quite well and was in production until the Zane Company changed from the reddish brown clay to white clay in 1926.

The company continued to prosper and, at peak production, the annual sales amounted to approximately one half million dollars.

When Harry S. McClelland died in 1931, his wife, Mrs. Mabel Hall McClelland, became president and she retained Zane Pottery for another decade. She then retired and sold the plant to Lawton Gonder, who operated it as Gonder Ceramic Arts from 1941 to 1957.

Patterns or line names:

CHROMAL WARE—Scenic decoration in semigloss finish.

CRYSTALINE WARE—Hard semimatt glaze. Orange and green.

DRIP LINE—Covered with one glaze, with second glaze dripping irregularly from top.

GARDEN WARE—Graystone until Weller had this name copyrighted, then changed to Stonetex.

GRAYSTONE—See Garden Ware.

LANSUN—Matt finish. Sunset scenes in various colors.

MONTENE WARE—Rich copper bronze color.

MOSS AZTEC—Reddish brown clay with wiped-on green. Various designs include the Pinecone.

PERECO WARE—Solid color matt glaze in blue, green, and orange.

PERSIAN WARE—Allover stylized flowers and leaves.

POWDER BLUE LINE—Solid blue matt finish.

SHEEN WARE—Four colors in matt glaze. Herringbone pattern and others.

STONETEX—See Garden Ware.

Peters and Reed

Zane Pottery

mark:

ZZPO

ZANEWARE
MADE IN USA

1921-1941

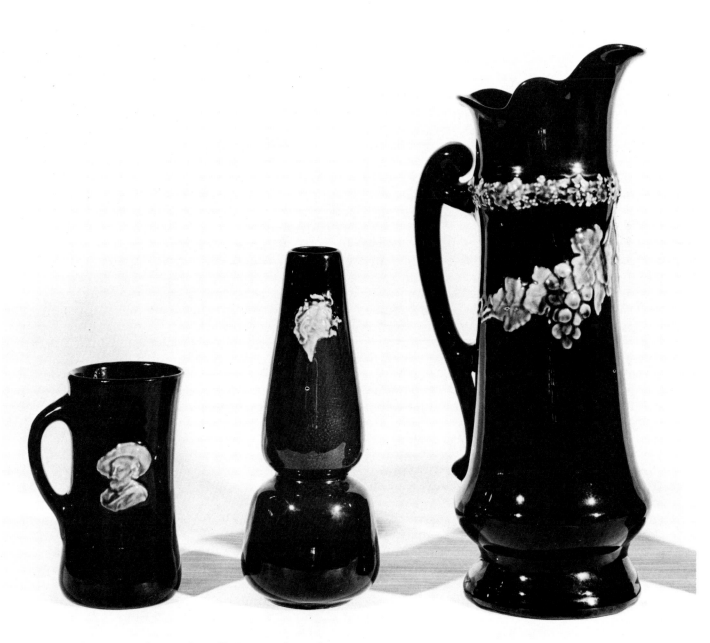

Peters and Reed; All brown [dark] with sprigged on decoration covered with amber high gloss glaze. Left to right: mug-5½ in. high. Vase-8½ in. high. Pitcher-14 in. high. Knight photo

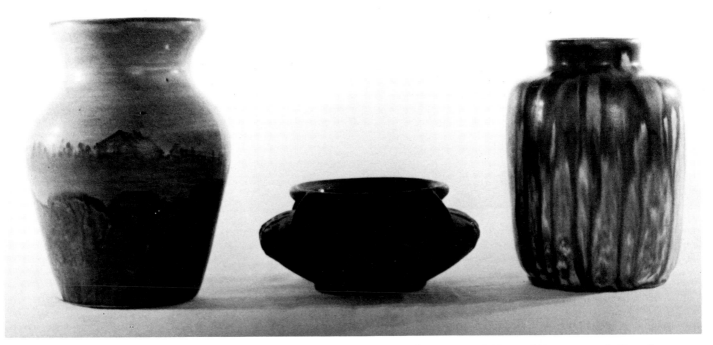

A group of Zane [Peters and Reed] vases. Left to right: *"Chromal," 6 in. high; "Moss Aztec" marked "Zane," 2½-in. high; "Drip Line," 5½ in. high. Johnson photo*

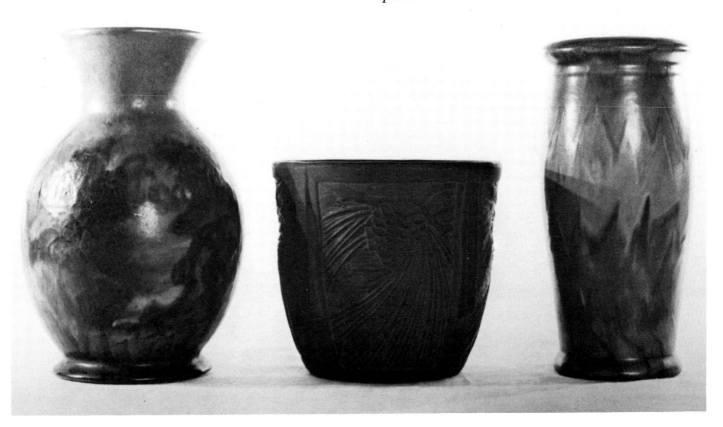

Peters and Reed pottery. Left to right: *"Chromal," 8 in. high; "Moss Aztec," brown and green, 5½ in. high; "Sheen Ware," shades of brown, gray, and green, 8 in. high. Collection of Andy Anderson; Johnson photo*

Pigeon Forge Pottery
1947—

Pigeon Forge Pottery is located at Pigeon Forge, Tennessee, in the Great Smokey Mountains, about six miles from Gatlinburg, Tennessee. It had its beginning when Douglas Ferguson and Ernest Wilson were both employed by the Tennessee Valley Authority (TVA) Ceramic Research Laboratory at Morris, Tennessee.

Mr. Wilson was an expert ceramist in his own right and Ferguson soon developed a big interest in the ceramic arts himself, and became so engrossed, he studied the ceramics of England, France, Italy, Japan and every other country that afforded available information.

Douglas Ferguson, a native of the Southern Mountains, was born in Burnsville, North Carolina. He attended Mars Hill College where he was a Pre-Med student and studied Art as a second interest. He was acclaimed a fine and talented artist and received several awards for his work. He was sought after for commission work for everything from ash trays to architectual decorations.

Mr. Ferguson was a close observer of the native wild life and flowers that were abundant in the Great Smokey Mountains. His close scrutiny led to the discovery of the clays which resulted in the pottery being located at Pigeon Forge, where these clays were available. A type of wasp, a member of the Sphecidea family, that is commonly called dirt or mud Dauber. They generally build their nests of clay in long tunnel like tubes, which are usually located on walls, rocks, old buildings and the like---Ferguson and Wilson tested some of these nests, they had discovered in an old mill, on the Little Pigeon River, and found them (Daubers) to have used the identical clays that potters search for.

In the Pigeon Forge Pottery brochure, it states that the company continues to run tests on these structures in order to locate different excellent clays in the surrounding area. The discovery of these clays led to the Pottery being established (1947) in an old tobacco barn in Pigeon Forge. In 1957, when the old barn was destroyed by fire, a new facility was constructed at the same location.

The clay is a rich red color after it has been fired, and has henceforth been referred to as "Pigeon Red". Glazes are produced from the native minerals that are found in the Smokies. Mr. Ferguson's vast knowledge of chemistry was quite instrumental in his perfecting a wide range of glazes. Pieces are fine-crafted and some are hand decorated with slip (liquid clay) in delicate detail. These pieces are usually brown with a matt glaze. Other articles are molded, while still others are wheel thrown or hand formed. Ferguson usually constructs the original piece and when he is fully satisfied with the creation, he then advises the factory to place it into production. All pottery is fired to an extremely high temperature, which results in a very hard stone ware type pottery. One of the most popular decors used is the dogwood.

Various pieces are created, such as---vases, animal objects, bowls, pitchers, sugar and creamers, tea pots, wall pockets, table ware and a fine line of miniatures.

Most of the products are marked with the full name stamped or incised on the base, however, at times, only parts of the mark is visable, a consequence of not having been stamped properly.

Pigeon Forge sugar and creamer;
3½". Brown matt glaze lined in yellow.
Pitcher; 7". Brown matt glaze lined in
yellow. Collection of the author

Pigeon Forge Pottery

The
Pigeon Forge
POTTERY
Pigeon Forge
Tenn.

Stamped or incised

Pisgah Forest Pottery
1926—

The Pisgah Forest Pottery is located in Arden, North Carolina, near Ashville, in the shadow of the colorful majestic Mount Pisgah.

The Pottery had its beginning in 1896 when Andrew Stephen, along with his wife Nellie and their son Walter Benjamin, settled in Shelby County in western Tennessee. Andrew Stephen was a native of Scotland and a stone mason by trade. He and his son began working in the masonry trade and soon discovered the native clays were of an unusual light color and were excellent for potting.

Mrs. Nellie Stephen was a gifted artist in her own right, who had drawn illustrations for the children's pages of a magazine called *"The Youth's companion"*, a publication that was very popular in the late 1800s. Prior to moving to Tennessee, the Stephens resided in a sod house in Chadron, Nebraska. At this location, she observed the lives and customs of the Sioux Indians, and later in Tennessee, she painted Indian scenes from memory...some of these were shown and won a prize at the Centennial in Nashville.

Walter B. (1876 — 1961) worked along with his mother and learned from her. They tested clays and glazes and constructed a small kiln and a kick wheel and began making figures, boxes, and vases. This first small Pottery was called, by an Indian name, "Nonconnah"; when translated means "long stream" Mrs. Stephen began using a pate-sur-pate technique utilizing a light colored porcelain applied to a pottery body. This style is very reminescent of Wedgwood's Jasper Ware, however, Wedgwood is sprigged on and the Stephen's ware is applied layer by layer. The designs are not as finely detailed as the English ware. Later at Pisgah Forest, Walter developed this into a more refined ware, but it was never as exact in detail as the English Jasper.

In 1913, after the demise of his parents (1910), Walter settled in the North Carolina Mountains and began a pottery business in partnership with C. P. Ryman, an enterprise which lasted only three years. After the partnership was dissolved, Walter Stephen purchased and built his home on the property where the Pottery is presently located. Between 1920 and 1926 he worked in the construction business, but continued experimenting and creating some pieces of pottery. By 1926, he began to operate his Pisgah Forest Pottery full time, making a fine high fired vitrified ware.

Included in the ware made here was the improved version of the earlier Jasper ware type. These pieces are decorated with scenes in white on a dark blue matt, dark green matt, medium brown and others. The scenes depicted are of American pioneer life, including the covered wagon with figures of people, buffalo hunting scenes, cabins, square dancers, fiddlers and other musicians, pine trees and several others. Some of these have the name Stephen or W. B. Stephen incorporated (slip trailed) in the design on a strip beneath the scene on the face of the article.

Another type of ware created are the pieces covered in a crystalline glaze. Often two or three colors were employed; for example, a silver blue shaded to cream lined in pink. These crystalline pieces are of special interest to collectors. Stephen developed a line of various colored glazes, including a beautiful crackled turquoise blue, ivory, several shades of green, a wine purple shade (similar to the color of an egg plant), shades of pink, and oftentimes combining the tints shading from one color to another, such as purple to turquoise. Some pieces are mottled (with specks) using two colors. Most are lined in a different tinted glaze.

Pisgah Forest was produced in classic

shaped vases, pitchers, teapots, mugs, candle sticks, cups and saucers, cream and sugars and various miniature pieces.

Stephen took great pride in his work as every article was hand made and practically every piece was marked and dated, some included his name. These dated articles, especially those baring his name, are the most sought after. Prior to 1926, the ware did not include the Pisgah Forest name but are marked only with the name Stephen or W. B. Stephen.

After Stephen's death in 1961, the firm continued to operate part time under the direction of Tom Case and Grady Ledbetter. They carried on, producing the turquoise and other glazes, but all jasper type ware and crystalline glazes were discontinued.

Pisgah Forest; vase, 6½ in. high. Turquoise lined in pink-1950. Author's collection

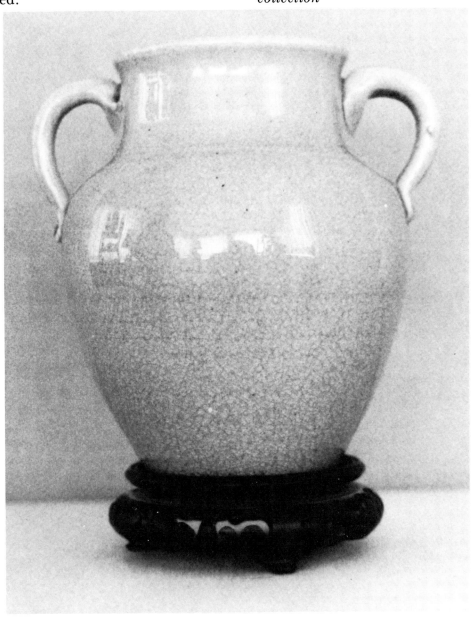

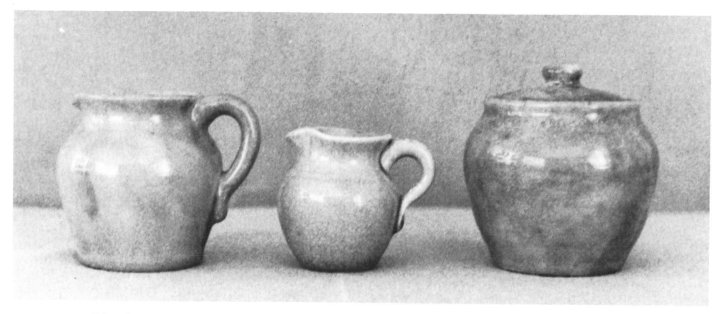

*Pisgah Forest Pottery, creamer &
sugar.* Center: *miniature creamer, tur-
quoise, signed W. B. Stephen 1930.*
Author's collection

Pisgah Forest Pottery

The sketches shown are of some classic
shapes that have been seen most often, with
the jasper-cameo work and the crystalline
glazes. The mugs seem to be the most pre-
valent decorated with the scenes.

Pisgah Forest Pottery
Marks:

All above marks impressed or embossed.
Used in Arden, N. C. from 1926 to present.
After 1961 the date was omitted.

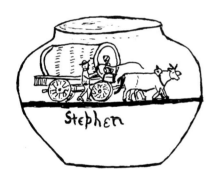

Stephen in cameo on pieces similar to
above.

Pisgah Forest Pottery

All marks raised on the base

Nonconnah

The Nonconnah pottery mark was used in
Tennessee from 1901 to 1910. (Shelby County
near Memphis)

From 1913 to 1916 the mark was used at
Skyland, North Carolina, during the Stephen-
Ryman enterprise.

A. Radford and Company
1891—1912

In the latter part of the nineteenth century, when the peoples of Europe were migrating to this land of opportunity, many day-laborers aspired to become American businessmen. From England, where potteries and glassworks flourished, came talented artists who were destined to gain fame and fortune in the United States. One such artist was Albert Radford, who was born in Staffordshire, England, on November 10, 1862.

Albert Radford arrived in this country aboard the *Hanoverian* on September 10, 1882. He was soon employed by the Haynes Pottery in Baltimore, Maryland where he met and married Ellen Hackney. Approximately three years later, his parents, Mr. and Mrs. Edward Radford, arrived in the United States.

In September 1886 the Radfords moved to Trenton, New Jersey, where Albert took a position with the Eagle Pottery. In 1889, while working at the Eagle Pottery, he won a bronze medal at the Philadelphia Exposition. The actual award was a bronze medal or thirty-five dollars in cash, but which one he accepted is not known.

Albert Radford built his first Pottery in Broadway, Virginia, where the initial kiln was drawn March 19, 1891. About 1893 Radford moved to Tiffin, Ohio, where he erected a Pottery with one kiln on the back of his property. It was at Tiffin that Radford created his finest art pottery. This ware, which is known as "Radford Jasper," is very similar to the Wedgwood type made in England. Radford's Jasper was decorated with the "sprigged-on" decoration, a skill he acquired while working for English potteries. According to Fred W. Radford, Albert's grandson, every piece of Radford Jasper made at Tiffin, Ohio, was created by his grandfather personally. No one else in the United States, at that time, possessed the skill to produce this type of ware with the cameo-type decoration. This ware was fired at an extremely high temperature, exceeding well over 2450 degrees Fahrenheit. The cameo-type decorations were first modeled and then a mold was made in plaster of Paris or some other suitable material. Then, when firm enough to handle, they were stuck (sprigged on) to the wet unfired clay body and then fired. The slightest contact was a firm commitment, as the cameos could not be moved after the initial contact. The background colors of this ware, made at Tiffin, were royal blue, light blue, olive green, and dove gray. These were decorated with white figures and other subjects in white. The forms are very reminiscent of the English Wedgwood. Lucky indeed, is the collector who has a specimen of this Tiffin Radford in his collection, for it is very rare.

Radford moved from Tiffin to Zanesville, Ohio, about 1898, where he was known to have been employed by Weller as a modeler. He also worked for the Zanesville Art Pottery as foreman of the art department. Here, a ware was made called "La Moro," which is very similar to Weller's Louwelsa. Radford also is known to have worked for the Owens Pottery. Some of the early specimens of Peters and Reed are decorated with sprigged-on cameos and garlands of flowers against a dark brown background, then coverd with a gloss glaze. The high glaze tends to hide the fine detailed workmanship of the cameo work. We feel it almost a certainty that Radford did these fine pieces.

According to family records and dates involved, the Pottery Radford built in Zanesville was constructed for the Arc-En-Ceil Company. Evidently there was some sort of agreement that Radford would turn over the buildings to them as soon as the new Radford Pottery, then under constructtion at Clarksburg, Virginia, was

completed. In the latter part of 1903 Radford moved to his new location and the contract with the Arc-En-Ceil Company was fulfilled.

The ware made in Zanesville was a fine vitrified ware decorated with the classic cameo-relief figures in white. This ware was often further ornamented with an overlay of contrasting colored clay, resembling tree bark or orange peel, either in matt or semimatt finish. This type of decoration was usually done in brown, black, tan, green, or gray with contrasting backgrounds in lighter shades of pink, blue, green, dove gray, and tan. Small pieces did not have the bark decoration and some larger articles, such as tankard pitchers and mugs, were made without the bark.

The formula for making this ware differed completely from the ware made at Tiffin. The Zanesville Radford ware was fired at 2250 degrees Fahrenheit, a much lower temperature than the Tiffin ware. The Zanesville Jasper was never marked with the name Radford, but each bears an incised number which was assigned to each different model. All Radford that was made at Zanesville is of the bisque type and is vitrified. In other words, it is of such hardness that it will hold water without the use of a surface glaze to make it waterproof.

The Radford Pottery at Clarksburg, Virginia, began operations in the fall of 1903. Albert Haubrich, who had been a decorator for Weller, was given the position of manager of the decorating department. Haubrich had also worked for the Owens Pottery and was considered quite a talented artist. The Radford Pottery was in operation for only a few months when disaster struck. Albert Radford suffered a heart attack and died August 4, 1904, at the age of 41.

The types of ware produced at Clarksburg were called "Ruko," "Radora," and "Thera." The Ruko is a duplication of Weller's Louwelsa and has the name Ruko impressed in the base. Radora is a green matt-glaze ware that was created by Albert Edward Radford (Albert's son) who at one time had been employed by the Roseville Pottery. His talents had been utilized there in the glaze-mixing department. The exact description of Thera is unknown, but is thought to be one of the brown-ware type.

Radford had planned to make the Jasperware at the Clarksburg plant but, due to his early death, it was never produced at this location.

Radford was succeeded by W. J. Owen, a salesman who worked for the J. B. Owens Pottery in Zanesville, and he in turn was succeeded by O. C. Applegate. The plant ceased production of art pottery about 1912 and failed shortly afterwards. Albert Haubrick, a former Weller artist was manager of the decorating department.

Albert Edward Radford, a son of Albert Radford, was born in Trenton, New Jersey, in 1887 and during his life has worked in American potteries for almost fifty years. He is the seventh generation of Radford potters. Fred W. Radford, a son of Albert Edward and grandson of Albert, is the eighth generation of potters, for he is, in a manner, carrying on the tradition. In his spare time he is making reproductions of the Jasper ware, of the type made in Zanesville by his grandfather. These are molded from the original pieces, using the original formula. The results are beautiful works of art made by a gifted craftsman and will enhance any collection of American art pottery. All pieces are and will be properly marked. The mark is impressed with a die and shows the following: "An A. Radford Reproduction by F. Radford." The article bears the original number with the sequence of production beginning with 001 and the month and year, 6 69. Mr. Radford states that positively no numbers will be duplicated. The reproductions are somewhat smaller than the originals due to shrinkage in the kiln. Production of these will be limited since Radford cannot possibly produce more than five or six, at the most, in any one week, and he doesn't know how long he will continue this project.

Under the management of John Lessell, the Radford company became the Arc-En-Ceil Pottery (1903—05).

Arc-En-Ceil pottery is noted for the gold luster glaze. It was made in pitchers, vases, dresser bottles, small decorated items, and the like.

Between 1905 and 1907 the factory operated as the Brighton Pottery.

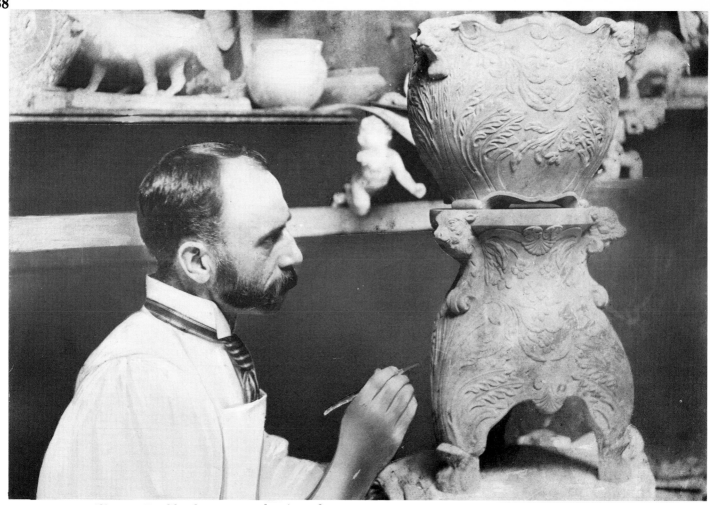

Albert Radford at work in the modeling room of the S. A. Weller Pottery, Zanesville, Ohio. Courtesy of Fred W. Radford

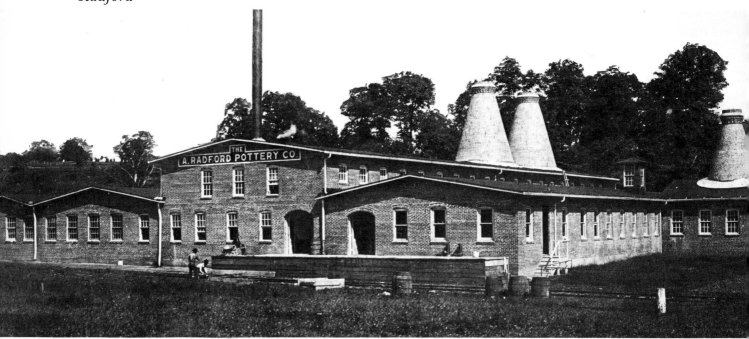

The A. Radford Pottery Company, Clarksburg, West Virginia, in 1904. Courtesy of Fred W. Radford

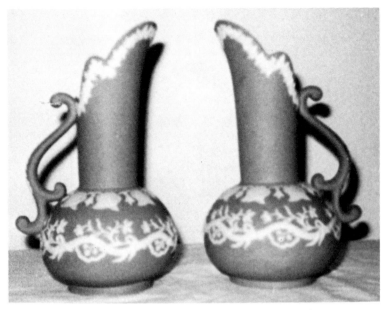

↑ *Matched pitchers; made at Tiffin, Ohio. 8½ in. high. Light blue ground, white applied decoration; unmarked. Collection of Fred Radford; Fred Radford photo*

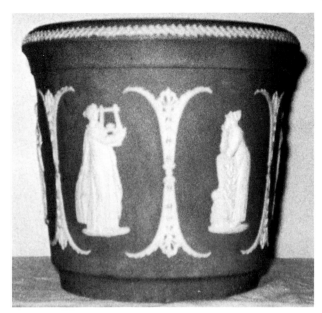

↑ *Jardinere-made at Tiffin, Ohio; 9¾ diameter-8¼ in. high. Light blue ground with sprigged on decoration. Marked "Radford-Jasper". Collection of Fred Radford; Fred Radford photo*

↑ *Chamber pot; made at Broadway, Virginia—1891. 9 in. diameter, 5¼ in. high. Gold trimmed. Collection of Fred Radford; Fred Radford photo*

Left to right: "La Moro" a product of Zanesville Art Pottery. 2 in. shaded brown to yellow and green-yellow flowers, marked "La Moro". 7 in. green shaded to yellow with flowers in red marked "La Moro"-signed AE. Author's collection; Knight photo ↓

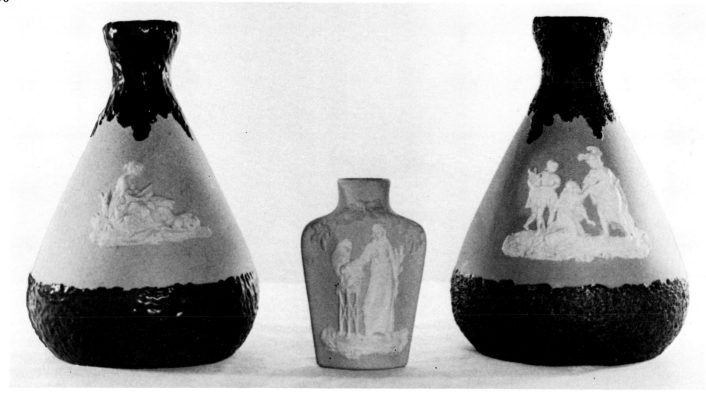

Radford pottery vases. Left to right: *Blue with dark brown glazed "bark" and white figures, no. 18, 6½ in. high; light blue with white figures, no. 55, 3½ in. high] beige with dark brown matt "bark" and white figures, no. 18, 6½ in. high. Johnson photo*

2 pieces of Radford "Tiffin-Jasper" that have been made into a lamp. Upper vase: 6½ in. high, light blue ground; unmarked. Lower vase: 5¾ in. high. light blue, marked "Radford Jasper." Collection of Fred Radford; Fred Radford photo

A. Radford and Company

Arc-En-Ceil Mark
Stamped in ink

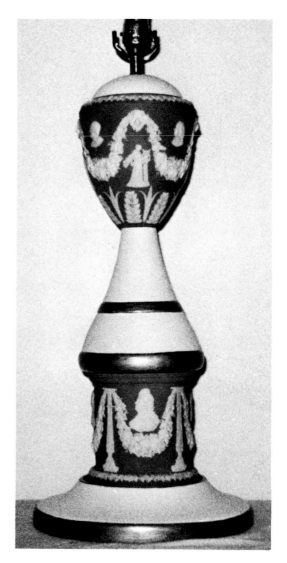

Red Wing
1878—1967

The Red Wing Potteries Inc. was located in Red Wing, Minnesota, in the beautiful Hiawatha Valley, the home of several historic Indian tribes. These included the Indian chiefs of the Dakota tribes, whose symbol was "KOO-POO-HOO-SHA", when translated means "Wings of the Wild Swan dyed red". It is said that one or more of the Dakota chiefs are buried atop Barn Bluff, a Red Wing landmark. An army engineer, Major Long, proposed the town be named Red Wing, for the last Red Wing chief whose name was "Tatanka-mani" (walking buffalo), consequently, the city was named Red Wing.

The roots of the pottery date back to 1861 when a German immigrant, Joseph Pohl, settled on a farm near Red Wing where the clays were excellent for potting. He began working in an old abandoned schoolhouse making utilitarian wares, such as; crocks and churns, for sale to the local citizens.

In 1868, William Philleo established a small pottery, where he made a line of crockery, until the building was destroyed by fire, in 1870. After rebuilding and purchasing new equipment, he remained in business for only a few months.

In 1868, David Hallem, who had been employed by Mr. Philleo, began operating a stoneware pottery at his home in Red Wing. This venture was not successful and was eventually purchased by a group of concerned citizens and they formed a corporation under the name Red Wing Stoneware Company (1878). Mr. Hallem was hired to supervise the operation and this venture proved to be successful. Subsequently, Red Wing Stoneware Company was recognized as one of the leading producers of stoneware in the United States. Soon two competitors entered the field, The Minnesota Stoneware Company (1883) and The North Star Stoneware Company (1892). After about four years,

the North Star Company ceased operations.

In the early 1900s, the Red Wing Stoneware Company and the Minnesota Stoneware were both destroyed by fire. After constructing new plants, these two companies merged, and the name was changed to Red Wing Union Stoneware Company. They introduced a pottery line in addition to the stoneware and eventually, began to create an art ware. The first decorative ware is characterized by a rough rustic finish, stained in green on light brown, glazed on the inside and decorated with geometric designs, figures of women, animals, birds, leaves, cattails and many more. About 1930, they began to introduce a fine line of art pottery with fine smooth glazes and classical forms. All types of ware was designed---vases, some molded in high relief, flower arrangers with figural flower holders (frogs) and figurines. The figurines created at Red Wing are one of their most charming items. One of the designers of these was artist Belle Kogan. Some of the figures have the letter "B" before the Red Wing mark, designating its creator, however, not all figures have the prefix letter. The figurines documented thus far are:

#1122—Tom Sawyer type lad holding an apple behind him, apparently for the teacher.
#1307—Bird
#1308—Oriental Goddess
#1309—Oriental Man
#1310—Half Man and Half Beast (Satyr)
#1350—Man standing by a fire plug holding a bouquet of flowers behind him.
#B1414—Cowgirl
#B1415—Cowboy
#B1416—Dancing Girl
#B1417—Man playing an accordion

Red Wing also produced a fine line of dinnerware, however, the local clays were not suitable for this ware, and had to be imported from other states.

The glazes on the art ware are soft velvety matt, semi-matt and gloss in every hue imaginable. One of the most attractive aspects of these products are the use of the different colored glazes used to decorate a single article. One shade was used on the outside and lined with a different color, such as; white with a blue lining, brown lined with orange, gray lined in pink and others.

One of the most popular lines is the soft ivory matt glaze with brown sprayed on and then lightly rubbed off, leaving color in the recesses. This method was used on Art Deco figurals in bowls and also the raised designs of fruits and flowers.

The name of the Pottery was changed in 1936, from Red Wing Union Stoneware to Red wing Potteries Inc. During the 1930s, Red Wing contracted to produce pottery items for George Rumrill, a marketing agent in Little Rock, Arkansas.

These items are marked Rum Rill. George Rumrill was a talented artist and created the designs for the strikingly beautiful pieces made for him at Red Wing. In 1938, George Rumrill ceased buying his wares from Red Wing and contracted with the Florence Pottery in Mt. Gilead, Ohio to create pottery from his designs. An interesting sidelight is that Lawton Gonder, of the Gonder Pottery of Zanesville, Ohio, was general manager of the Florence plant. After the Florence Pottery burned October 16th, 1941, Rumrill began to acquire his wares from the Shawnee Pottery of Zanesville, Ohio. All Rum Rill pottery made at Potteries other than Red Wing usually include "made in U S A," in the mark.

Red Wing discontinued the manufacture of stoneware in 1946 or 1947. They began to have labor trouble in the 1960s, and with their business dwindling, they were forced to cease operations, in August 1967. The remaining stock was sold, piece by piece, at a salesroom across the street from the Pottery.

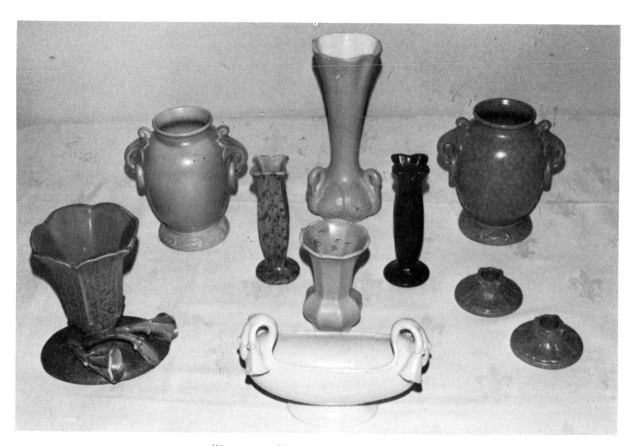

"Rum Rill" made at Red Wing.
Author's collection

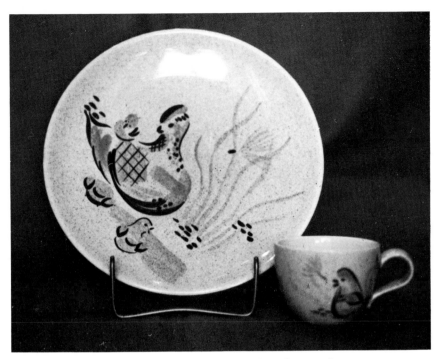

Red Wing dinner ware in the Bob White pattern. Author's collection

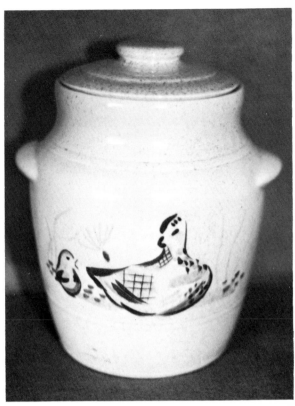

Red Wing Pottery, cookie jar. Collection of Rena & Bryce London

Red Wing ivory rubbed in brown. Author's collection

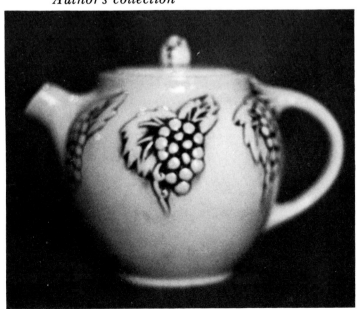

Red Wing; pitcher, 6½ in. high, heavy blue matt, hand marked #737. Author's collection

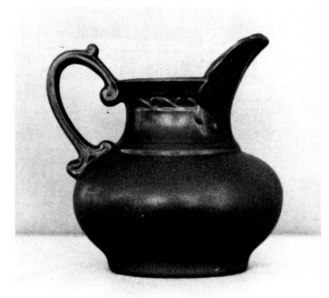

Red Wing

Marks:

RED WING
ART
POTTERY

Stamped in black
on the early ware

Red Wing

737

Incised by hand

RED WING

1122

RED WING USA

Impressed

616

RUM RILL

Impressed or
incised by hand

Paper label

REDWING
STONEWARE

Used between 1878—1892

Rookwood Pottery
1880—1960

Prior to the Centennial at Philadelphia, in 1876, a group of women residing in Cincinnati, Ohio, were experimenting with different clays and glazes. Although they were considered amateurs in their decorating abilities, they did place their finished products on display at the Centennial. One of these women was Maria Longworth Nichols (Storer). This group was quite impressed by the other exhibits, especially those of the Japanese and the French. On their return home, they began experimenting more extensively with the different clays and glazes, and also with underglaze decoration. Mrs. Nichols, along with Miss M. Louise McLaughlin of the Pottery Club of Cincinnati, set up studios at the Frederick Dallas (white-ware) Pottery, whose output was mostly graniteware. Neither woman was satisfied with her progress at the Dallas Pottery; furthermore, heat from the kilns was too intense for Mrs. Nichols' experiments and destroyed all the colors except cobalt blue and black. What she actually desired and needed was a pottery of her own, where she could control the firing of the vessels and be free to test all clays and all glazes.

Her father, Joseph Longworth, a man of considerable wealth and also a patron of the arts, purchased an old abandoned schoolhouse for his daughter. Mr. Longworth was the son of Nicholas Longworth who, at one time, owned most of downtown Cincinnati. The schoolhouse was converted into a pottery and the first kiln was drawn on Thanksgiving Day 1880.

Mrs. Nichols named the Pottery after her father's estate, which was heavily wooded and well inhabited by rooks. Mrs. Nichols hired Joseph Bailey, Jr., the son of Joseph Bailey with whom she had worked at the Dallas Pottery, as superintendent as well as chemist-artist. She had great confidence in the elder Bailey and hoped he would be a guiding force behind his son. So

it was, and after the death of Mr. Dallas, the senior Bailey also joined the Rookwood forces. E. P. Cranch was employed as handyman and artist, and the first Rookwood plaques can be accredited to him. Some of the earliest Rookwood pieces were not decorated by regularly employed Rookwood artists, but were blanks sold to artists, some of whom were members of the Cincinnati Pottery Club. The first paid artist to work for Rookwood was Albert Valentien (1881), who had previously been associated with the Wheatley Pottery. He was followed shortly by Matt Daly, from Matt Morgan Pottery, and by Laura Fry, William P. McDonald, and Kataro Shirayamadani. The very earliest Rookwood pottery was somewhat like the stoneware-type pottery, decorated with modeled designs or carved decoration on gray, cream, or other light-colored clays, with the color in the design. The appearance of the glaze was similar to that of salt glaze or smear glazes. Another type, known as "Limoge" decoration, was an undeglaze decoration on both dark brown and light color clay with the decoration in color, further embellished with gold over the glaze, very reminiscent of Matt Morgan pottery. No doubt this was Matt Daly's contribution to the early wares.

The clays used were entirely American, mostly from the Ohio Valley. These native clays inclined the color quality toward the yellows, reds, and browns. The blend of browns and yellows on the background with subjects painted in slip colors of yellow, red, and green in the manner of oil painting, then covered with a transparent glaze, is recognized as the "standard" glazed Rookwood. This is a rich, luxuriant style of ware, oftentimes decorated with portraits, animals, fish, fruit, and native flowers of every variety. This glaze was perfected by Laura Fry, who had this method patented March 5, 1889 (Patent

No. 399,029). T. J. Wheatley had patented a similar method in 1880. Miss Fry's process differs in that the background is air brushed.

In 1883 W. W. Taylor assumed the active direction of the Pottery as partner to Mrs. Nichols. Taylor was neither artist nor potter, but was a good businessman and under his guidance the Pottery soon began to prosper and outside assistance was no longer necessary.

Maria's husband, Mr. Nichols, died in 1885 and the following year she married Bellamy Storer. When Mrs. Storer retired in 1890, she transferred all her interests to Mr. Taylor, who became president and held that position until his death in 1913. He in turn bequeathed his stock in the company to the trustees for the continuation of the "freedom of expression" policy, which had given Rookwood its unusual character as an art industry. Mr. Taylor was followed by J. H. Jest as president and J. D. Wareham as vice-president.

The number of artists was increasing steadily, most of them coming from the Art Academy of Cincinnati. However, there were exceptions, notable among them being James Bromfield of England, who was never listed as a Rookwood artist, but was responsible for the teasets with the little blue pirate ships, first made in the 1880s, then again in the early 1920s. The first of the "Blue Sailing Pirate Ships" on white background bore no factory mark, and the decoration was over the glaze. When this pattern was revived, it was marked with the RP monogram, but no flame marks added. Each was marked with a letter and a number, with the slip painting under the glaze. They were made for three to four years.

Other decorators not from America were Kataro Shirayamadani and E. H. Asano, both migrating from Japan. Asano is known for his work in metals. Kataro Shirayamadani worked for Rookwood from 1887 to 1948, with the exception of about ten years when he had gone back to Japan. He was a guiding influence and his work definitely added an Oriental flavor to Rookwood pottery. The Rookwood artists never worked from patterns but each was allowed freedom to express his own individual feelings. Each was permitted to choose the glaze he desired, at any time, or try to develop new ones.

About 1884 the "Tiger Eye" was developed quite by accident. The glaze on this ware has an aventurine effect, which is very subtle, illusive, and very difficult to see. The glaze was developed within the kiln and the aventurine effect formula has always remained a mystery. Evidently the proper ingredients, plus the exact exposure to the heat, was important since the effect varies, sometimes appearing only on one side or in spots deep within the glaze. Tiger Eye was revived several years later; however, this later type contains more of the goldstone-appearing crystals. Under normal conditions, this aventurine effect is not noticeable and one must examine it under strong light before realizing it is Tiger Eye. This line is often undecorated and not artist signed.

Karl Langenbeck was hired by Taylor as Rookwood's first chemist. He later was known as America's first pottery chemist. His tenure with Rookwood was but one year—January till December of 1885. After severing connections with Rookwood, in 1886 he formed the Avon Pottery of Cincinnati, where he remained about one and one half years. From Avon he went to Weller and then to Owens in Zanesville, Ohio. In 1895, Karl Langenbeck was the author of a book, *Chemistry of Pottery*.

In 1892, Rookwood erected a new factory. The new building crowned the summit of Mount Adams, one of Cincinnati's many hills. It commanded beautiful views in every direction—of the river, the city, its suburbs, and a large garden of flowers grown on the premises. A beautiful display room was also included where much pottery was sold to visitors. The factory was enlarged in 1899 and again in 1904.

In 1893, the "Iris" line was introduced. This was created by changing the background colors of the standard brown ware to pastel hues, decorated with the same style of slip painting, covered with a gloss glaze. The light background afforded the artists a wider command of color. These background tints were shaded from light to dark or bicolor, from gray to pink, and the like. About this same period, the "Aerial Blue" was introduced. This line has a solid grayish white background trimmed with blue decorations under a gloss glaze. Also in this period, another

type of decoration, known as "Sea Green," was introduced. It is characterized by a rich green shaded background, usually decorated with light-colored subjects, covered with a green glaze. This ware is generally marked with an incised "G," along with the other marks.

In 1900 Rookwood employed 35 to 40 decorators, each with freedom to create or use any decoration he might choose. Rookwood always encouraged the artists to improve techniques and sent many of the decorators abroad to study, paying all or a portion of their expenses. Artus Van Briggle was one of these decorators, spending over two years in Paris. After his return to Rookwood in 1896 he created a new variety of matt-glaze decoration. Before it could become a full reality and put into production, Van Briggle was forced to resign because of ill health. During the period he was testing these new glazes, he modeled one of his art nouveau-type figures for Mrs. Storer and covered it with this new type of matt glaze. This is believed to be the only piece he modeled for Rookwood. It is very possible some of these may have been reproduced later by Rookwood. This type of matt glaze was then further developed by Stanley Burt.

Three different types of ware were treated with this matt finish. One, called "Painted Matt," was broadly painted with decorations of both naturalistic and stylized subjects. The second, known as "Incised Matt," was executed by using the sgraffito method with a matt finish. The third line, known as "Modeled Matt," was modeled in bas-relief or high relief, then covered with the matt finish. These pieces, dated between 1900 and 1905, are marked with the letter "Z," along with the size letter appearing on the base.

In 1904 a new variation of the matt glaze was introduced. This type is called "Vellum." It was pronounced by experts at the St. Louis Exposition as the only ceramic novelty at the Exposition. Vellum is a soft transparent matt glaze that was developed within the kiln at the same time as the decoration, without any other treatment to give it this soft texture. Previously, the matt glazes were heavy and the objects had to be broadly painted or modeled. This made it impossible to produce subjects in detail, such as appeared on the slip painting on the standard and other gloss glazes. Vellum afforded the artists a much greater variety of decoration, such as beautiful scenes, including snow scenes, sunsets, marine life, and a wide assortment of flowers. This ware was also decorated in the same style as some of the earlier matt (incised and modeled). Most of the Rookwood plaques are Vellum. Many of these plaques, with the title of each written on the back, came with fitted wooden frames. These plaques are artist signed, sometimes on the obverse, sometimes on the reverse. This particular type of decoration is quite easy to recognize as a "V" appears along with the other marks, occasionally impressed with a die, and at other times incised by hand.

In 1910 Rookwood celebrated its thirtieth anniversary by bringing out still another matt-glaze line known as "Ombroso." This finish was generally used on modeled objects, such as large bookends and paperweights. The finish is not easy to describe; however, it appears somewhat like Vellum but has no identifying marks. The colors seem to have burned out more and to have run slightly, especially the pastel shades. Ombroso is generally found in monochrome colors.

In 1915 Rookwood introduced "Porcelain." This is a very hard, vitreous-like pottery, usually termed "soft porcelain" or "semiporcelain." Porcelain was made in all sorts of flower-arranging bowls, vases, figurines for use as flower frogs, and paperweights. The glazes used were both high gloss and matt finish. This ware was expensive to produce, as many pieces cracked or damaged severely in the firing; consequently, the line was discontinued after a short time. This ware is easily identified by the letter "P" along with the other company marks on the base.

About 1920 Porcelain was replaced by "Jewel Porcelain." This is also a vitreous pottery that is translucent when held to a very strong light. It was made till the closing days and was covered with various glazes and decorations. The Jewel Porcelain was occasionally used in the commercial lines, cast in molds.

Years of experimenting and creative effort on the part of the chemist and artist brought about new glazes. Some of these were the "Butterfat," a soft, smooth monochrome matt glaze, and a "Wax

Matt" glaze similar to the Butterfat except that it has bicolor backgrounds with soft waxy surfaces, at times having a curdled effect. The designs have a fuzzy or runny appearance. Practically all decorated pieces are artist signed. The Wax Matt glaze was the result of combined experiments of John D. Wareham and Stanley Burt, Wareham having conceived the idea for this glaze while visiting an exhibit of pottery in Paris. Jewel Porcelain is often decorated with this Wax Matt glaze.

Some of the earliest pieces of Rookwood are further embellished with metals, such as silver overlay or silver deposit. Others are fitted with silver stoppers or lids embossed with designs matching the painted decoration. Some pieces were adorned with other metals. E. H. Asano, a Japanese who came to America with Shirayamadani, when the latter returned from a trip to Japan, worked at Rookwood experimenting with silver and other metals. Asano spent some time teaching Mrs. Storer the art of working with these metals. Occasionally an article will be found marked EHA. Shirayamadani supposedly perfected a method of electrodeposit; however, most of the silver work was hallmarked by silver companies.

Although Rookwood was known primarily for small art objects (vases and the like), the company produced ornamental commercial lines such as tiles, outdoor garden ware, panels, and so forth. Clement J. Barnhorn, a sculptor and associate of the artist Frank Duveneck (1848—1919), a portrait painter and sculptor, made many designs for panels and beautiful fountains made at Rookwood. Complete murals were designed in tiles, some composed of hundreds of pieces.

Early in the 1900s, Rookwood began to produce ornamental wares cast in molds. The production of these wares increased in volume as the years passed. Since these molded pieces were less expensive to produce, they were made by the dozens in such forms as pleasing classic vases, paperweights, bookends, ashtrays, teasets, candlesticks, and bowls. These molded items were covered with a variety of colors and glazes. Although they were commercial pieces, they were marked with all the factory marks on the base, but never artist signed. The only exception to this was when the sculptor signed the master mold. The signature actually appears to be molded rather than incised by hand or stamped with a die. This type of signature usually will be found on bookends or other heavy modeled specimens. The objects made in molds should not be referred to as "signed Rookwood," but should be rightly called "marked Rookwood." The term "signed" should be reserved for the artist-signed pieces only, which were never duplicated. The commercial lines were molded in different styles. Some were the modeled type with flowers, rooks, and other designs in bas-relief, while others were molded in the style of the early incised-matt technique. Many of these "cast in a mold" pieces were the Jewel Porcelain variety.

Rookwood hand-decorated vases were considered a quality work of art from the inception. These were often displayed on teakwood bases and sold in exclusive stores everywhere. These vases were comparatively expensive from the very beginning as Rookwood advertised no duplicates were ever made. Later, when a larger volume of commercial ware was placed on the market, the Rookwood advertisement read, in effect, "No duplications are ever made of artist-signed ware."

At the time the hand decorated pieces were made, they were priced according to the popularity, ability, and salary of the artist. Works of Valentien, Daly, Nourse, Shirayamadani, Steinle, Coyne, Diers, and several other early artists commanded a higher price than some of the newer or junior artists. At the present time, these earlier artist-signed pieces still continue to bring a higher price. One must realize, however, that all artists, despite the length of their tenure with Rookwood, did do some inferior work. One must not judge a specimen by the signature alone, but quality should also be of primary concern. Many of the later decorator's subjects were just as well executed as the early masters, and the works of these later artists should be given due consideration, for many indeed were very talented.

Mrs. Storer, a widow again in 1922, lived to the age of eighty-three. In her later years she resided in Paris with her daughter, who had married a French nobleman. Mrs. Storer passed away in

1932.

In 1934 J. D. Wareham succeeded J. H. Jest as president of the company. Wareham had been working for Rookwood for many years, first as decorator and later as head of the decorating department, and holding the post of vice-president since 1914. When Wareham became president, the Rookwood Company was in deep financial difficulty. The equipment was practically obsolete and the depression years had taken its toll of the business. Although he tried every way and means to keep the operation on a paying basis, it was almost impossible to accomplish any real security. It became one struggle after another. In 1954 Mr. Wareham passed away.

In 1959 the Rookwood Company was sold to the Herschede Hall Clock Company and in 1960 was moved to Starksville, Mississippi. Pottery was made here from time to time, but was never of the quality of the original ware. This later ware did not appeal to the public and, consequently, operations ceased in the summer of 1967. This ware was marked with the company mark and was correctly dated. Due to the fact that the Starksville, Mississippi (Rookwood) ware was made such a short period of time, collectors are ardently searching for these pieces. These items are covered with matt and jewel glazes in a variety of colors, including orange, shades of blue, shades of green, black with a misty white accent, and an off white matt. Included in the Starksville line are vases, mugs, paper weights, (in the form of birds and animals), ash trays, candle holders, bowls, sugar and creamers, and vases that were drilled with the necessary holes for lamps.

Although Rookwood made fine quality pottery for many years it does not mean that the company did not also make inferior pieces, as did all potteries from time to time. You will notice that on some Rookwood there is an "X" scratched in the base. This usually indicates the piece was a "second" and was not allowed to be sold at the top quality price, however, the "X" did not always indicate a "second". The Rookwood management was constantly striving to increase business by attempting new methods of merchandising, however, despite all efforts, the salesroom became over stocked. In order to alliviate this problem, a certain amount of perfect pieces were removed and placed in the "seconds" room. These were incised with an "X" and reduced in price where they sold more readily. Even though the "X" mark does not always mean a "second", the collector should evaluate the article by close scrutiny. One might find a piece of Rookwood of actual inferior quality and wonder why this piece was not marked with an "X." Such pieces were total rejects and were not allowed to be sold under any circumstances, but were given, at the rate of twelve pieces a year, to the employees for their own use. Every three months, these were distributed—three pieces to each employee. The company used the system of "drawing by lot number." As the years went by, however, these inferior pieces and rejects found their way into the salable market; consequently, every now and then, one will show up.

From the very beginning, the Rookwood Company was proud and rightly so. Plaques with slogans or mottoes could be found hanging in several spots around the pottery. The wording of these slogans or mottoes went something like: "The World's Exclusive Producers of Jewel Porcelain," "There is no Rookwood without the Rookwood Mark," and "America's Contribution to the Fine Arts of the World."

It may be interesting to note that Charles A. Lindbergh was presented a fabulous Rookwood vase valued at several hundred dollars. This vase, signed by Sarah Sax, is now on display in a St. Louis Museum along with Lindbergh's other trophies.

The Rookwood Company received numerous honors at different expositions. We will not list them all; however, a few are worth mentioning.

FIRST PRIZE—Pottery decorated and modeled for underglaze slip painting. Pennsylvania Museum, Philadelphia. 1888.
GOLD MEDAL—First Prize. For faience. Exhibition of American Art Industry. Philadelphia. 1889.
HIGHEST AWARDS—World's Columbian Exposition. Chicago. 1893.
GOLD MEDAL—Pan-American Exposition. Buffalo. 1901.
TWO GRAND PRIZES—Louisiana Purchase Exposition. St. Louis. 1904.

GOLD MEDAL—Jamestown Tercentennial Exposition. 1907.
GRAND PRIZE—Alaska, Yukon and Pacific Exposition. Seattle. 1911.

Rookwood also received several other high awards in countries outside the United States and one will find specimens of this fine art in many of the museums around the world. Probably no other American product received such enormous acclaim as did Rookwood.

From the very outset, every piece was marked and dated and hand-decorated pieces were artist signed. No other pottery marked its products as religiously as did Rookwood. Frequently, the type of clay and glaze used were indicated by symbols on the base. It has been said that the artists were fined if they failed to sign their own creations. The actual systematic dating of the pottery started in 1886, and every piece made thereafter bears the date. The letter "P" with the reversed "R" was used for the monogram in 1886. Each succeeding year, up to and including 1900, a flame point was added to this monogram. In 1901 Roman numerals were added below the monogram for 1900 (for instance, in 1903 III would appear below the monogram). This system of dating was used until the closing days. From time to time, one will notice esoteric marks on Rookwood. What these meant was unknown to the public, as they were generally put on experimental pieces only.

Letters denoting the type of clay used were stamped on the base of each of the earlier pieces, below the company mark. These were as follows: G, Ginger; O, Olive; R, Red; S, Sage Green; W, White; and Y, Yellow; all these indicated the color of the clay. There is, however, one exception. One will at times find the letter "S" below the regular company mark. This was a "Special" piece created by the artist and was one of a kind. This "S" should not be confused with the "S" for Sage Green, since Sage Green clay is an extremely pale olive drab. In the event that a special piece was made with Sage Green clay, the letter "S" would appear twice. These special pieces are extremely rare and were generally made for VIPs. When the letter "S" precedes the pattern number, it indicates it was made from a sketch.

Also appearing below the regular factory mark are numbers denoting the pattern design and shape. These numbers were kept on record at the factory. Accompanying these numbers were the size letters, ranging from "A" to "F." The letter "A" denotes the largest size made of the vase or vessel, and the letter "F" the smallest. All wares were not made in all sizes, perhaps in only three or four. It must be noted here that all wares marked with an "A" were not all the same size but, instead, the largest one made in that particular line. When no size letter appears along with the pattern number, it is an indication that this particular piece was made in only one size. The letter "T" preceeding the pattern number indicates a new shape was being tested. If the letter "X" both precedes and follows the pattern number, it indicates a trial glaze.

The Rookwood Pottery issued a brochure or booklet at intervals, especially when a new line was introduced. These contained a brief history of the company and a list of the artist's names and monograms.

Rookwood Pottery line names and descriptions:

AERIAL BLUE—Solid white with a gray cast background, with blue decorations under a transparent gloss glaze.

IRIS—This is the same technique as the Standard Glaze ware except the backgrounds are light colors. Similar to Weller's Eocean and Etna, Owens' Lotus and Roseville's Rozane Royal (light).

JEWEL PORCELAIN—A semiporcelain body which replaced the more costly Porcelain. Jewel Porcelain was used from 1920 until the closing days, covered with various glazes. The artist-signed pieces are often covered with the Wax Matt glaze. This type ware is translucent when held to a strong light.

LIMOGE WARE—This line is generally to be found in the earliest pieces. An underglaze decoration on dark red or light clay under a transparent gloss glaze. Further embellished with gold, similar to Matt Morgan.

MATT GLAZES—A soft smooth surface distinguished by the absence of gloss.

A. Butter Fat Glaze—A soft matt glaze with a monochrome background. Hand painted similar to Wax Matt.

B. Incised Matt—Sgraffito type. The

designs are scratched into the surface of the ware with a tool in the same manner as Weller's second-line Dickens Ware.

C. Modeled Matt—The subjects are modeled in bas or high relief and covered with a matt glaze.

D. Painted Matt—The subjects are broadly painted in natural or stylized designs, then covered with a matt glaze.

E. Wax Matt—A waxy surface with a bicolored background distinguished by the runny and fuzzy decoration having a curdled effect in the glaze. This glaze is generally applied to the Jewel Porcelain ware.

OMBROSO—Similar to Vellum but with no identifying marks. Usually covers heavy modeled pieces such as bookends, paperweights, figures, etc. Generally in monochrome shades, with a semigloss glaze.

PORCELAIN—A semiporcelain body covered in a variety of glazes. Always marked "P" on the base along with the other marks.

SEA GREEN—Shaded green backgrounds, some being quite dark. It is distinguished by a gloss green transparent glaze, marked "G."

STANDARD GLAZE—Dark rich shaded brown and yellow colors with underglaze slip paintings of flowers, fruits, and portraits. This is the line most often encountered and recognized as Rookwood. It was duplicated by Weller's Louwelsa, Owens' utopian, and Roseville's Rozane Royal (dark).

TIGER EYE—An aventurine effect deep within the glaze. The goldstonelike crystals are subtle, illusive, and very difficult to detect under normal lighting conditions. Tiger Eye is seldom decorated or artist signed.

VELLUM—A soft transparent matt glaze developed within the kiln at the same time as the decoration. It is always marked "V" along with the other marks. Vellum is also decorated in modeled, incised, and painted styles. The scenic Vellums are considered very rare. Most plaques are of the Vellum type.

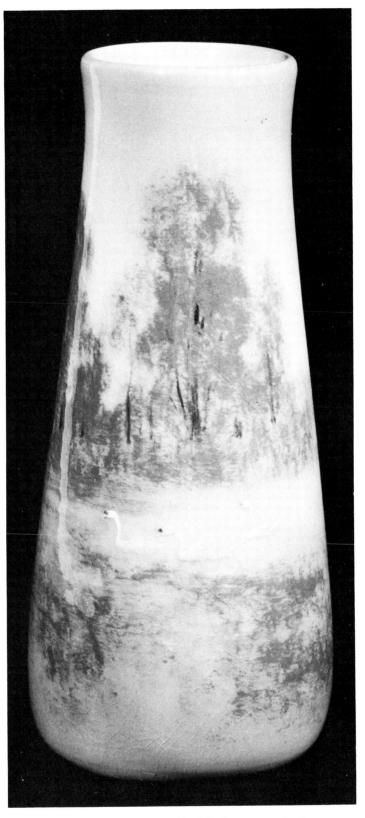

Rare scenic vase. "Iris" glaze, marked, signed by Kataro Shirayamadani, dated 1909, 8½ in. high. Knight photo

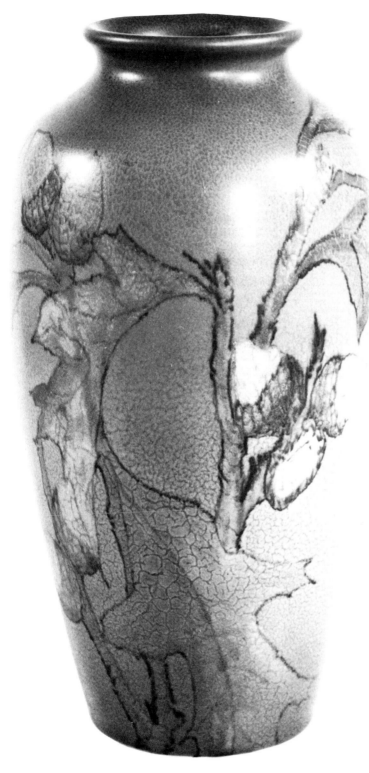

"Wax Matt" vase. Browns, greens, and reds, signed "LNL"—Elizabeth N. Lincoln, 1929, 10½ in. high. Knight photo

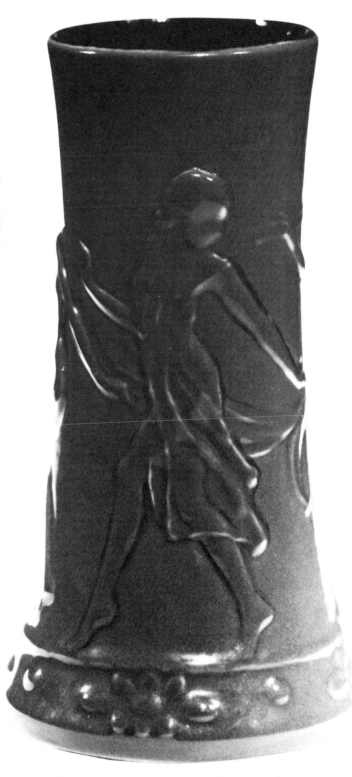

Vase sculptured and signed by Louise Abel. Maroon, 1921, 11 in. high. Author's collection; Orren photo

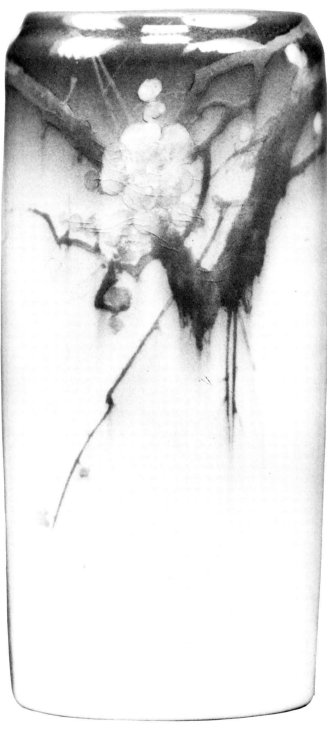

Rookwood vase. Shaded light to dark rose-beige with pink apple blossoms on a branch, "Iris" glaze, signed "I.B."—Irene Bishop, dated 1906, 6 1/8-in. high. Collection of A. C. Revi

Rookwood vase. Turquoise shading to rose-beige at top, glaze contains small pieces of mica; marked with an esoteric mark indicating a trial glaze, dated 1932, 7 in. high. Knight photo

"Standard" glaze brown ware. Left to right: Jug [7½ in. high] with ear of corn, 1903, signed "CCL"—Clara C. Lindeman; cup [2½ in. high] and saucer [4½ in. diameter] with holly leaves and berries, 1897, signed "Sara Sax"; jug [5½ in. high] with ear of corn, 1897, signed "Sallie Toohey." Knight photo

Assorted commercial molded vases. All have company marks and dates, but are not signed by the artists; all matt finish. Left to right, top row: Brown, 1923, 6½ in.; "Vellum," blue, 1909, 3½ in.; pink on green, 1935, 5 in. Bottom row: Green, 1921, 6¾ in.; lavender, 1926, 9 in.; brown, 1911, 7½ in.

"Blue Sailing Pirate Ships" sugar and creamer. Center: "Iris" vase, pale pink to green, signed "Carrie Steinle," 1906, 5½ in. high. Knight photo

Rookwood signed vases. Left to right, top row: "Wax Matt," green shaded to yellow, "Sallie E. Coyne," 1929, 7½-in.; "Modeled Matt," red decorated in green, *"Sallie Toohey," 1904, 6 in.; "Painted Matt," green, "C. S. Todd," 1911, 7½-in. Bottom row: "Butter Fat" glaze, green trimmed in various colors, "M. H. McDonald," 1930, 6 in., "Etched Matt," blue-green with turkey decoration, "W. E. Hentschel," 1911, 8½-in.; "Butter Fat" glaze, blue background with green and red decoration, "Jens Jensen," 1931, 6 in.*

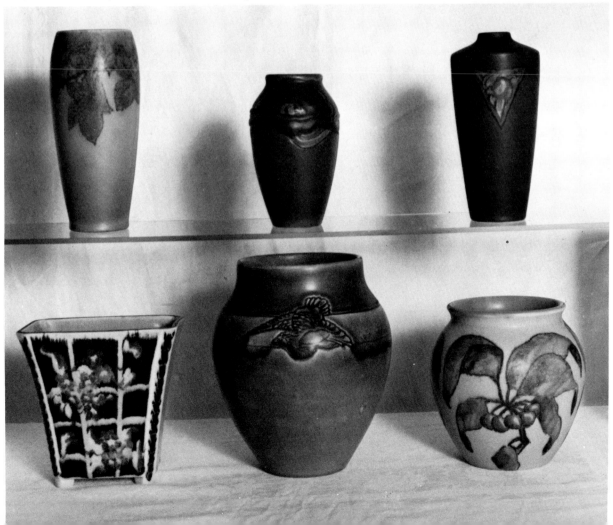

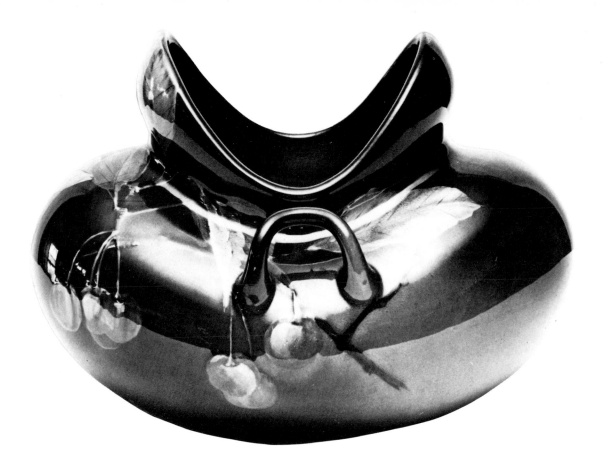

↑ *Standard glaze brown ware. Red cherries and green leaves, 1893, signed "Mary Nourse," 5½ in. high, 8½ in. across. Knight photo*

Rookwood "standard" glaze brown ware. Green foliage and red berries, 1890, signed "Amelia B. Sprague," 4 in. high, 7 in. across. Knight photo ↓

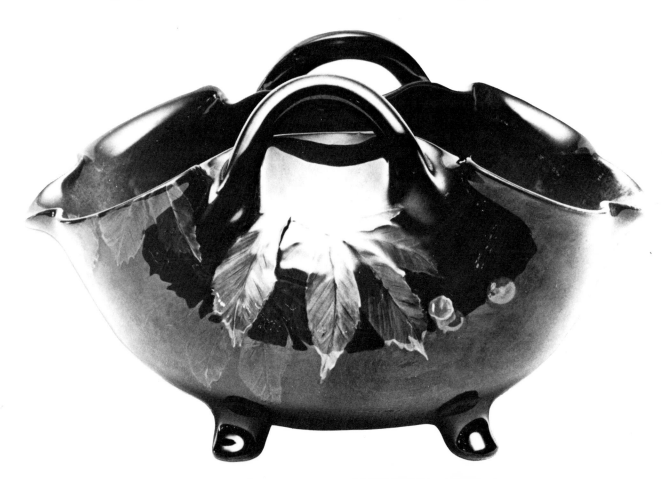

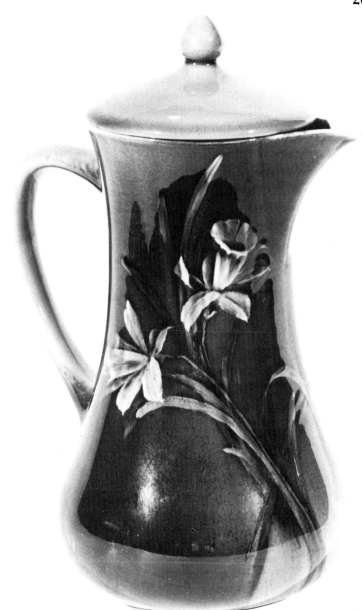

Chocolate pot. "Standard" glaze with →
yellow flowers, handle, and lid, marked,
signed "ABS"—Amelia B. Sprague, dated
1890, 9 in. high. Knight photo

Rookwood pottery. Inkwell, "stand-
ard" glaze with yellow flowers, marked,
signed by Carrie Steinle on both lid and
insert, dated 1900, 4¼ in. by 9¼ in.
Knight photo

↓

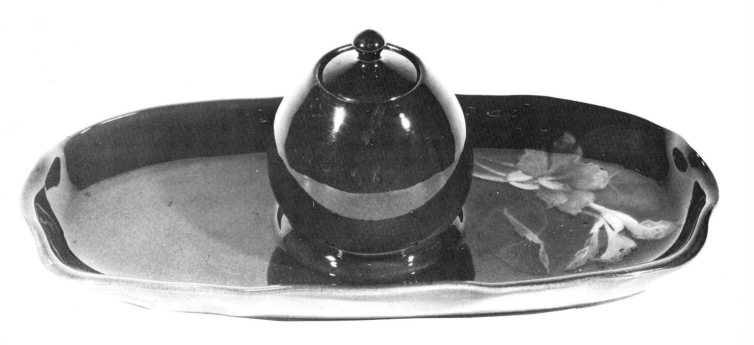

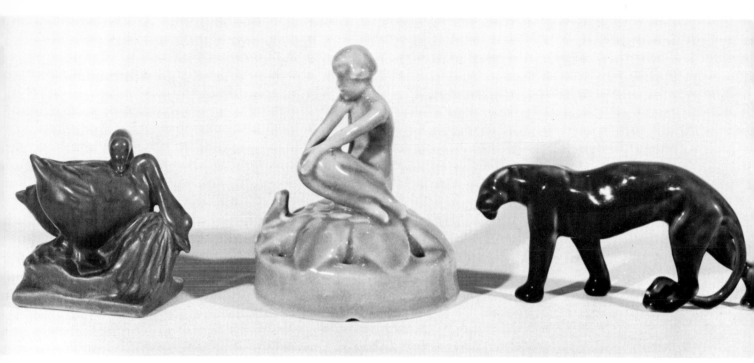

Rookwood Pottery. Left to right: Geese paperweight, brownish gray, marked "Porcelain," dated 1916, 3½ in. high; flower frog, high-gloss turquoise glaze, dated 1922, 5 in. high; cheetah, dark green, gloss glaze, marked with monogram with fourteen flames, but missing the Roman numerals which usually appear on late figural pieces, ca. 1930, 3 in. high, 6 in. long. Knight photo

Modeled "Ombroso." Ivory signed by Louise Able, dated 1926. Knight photo

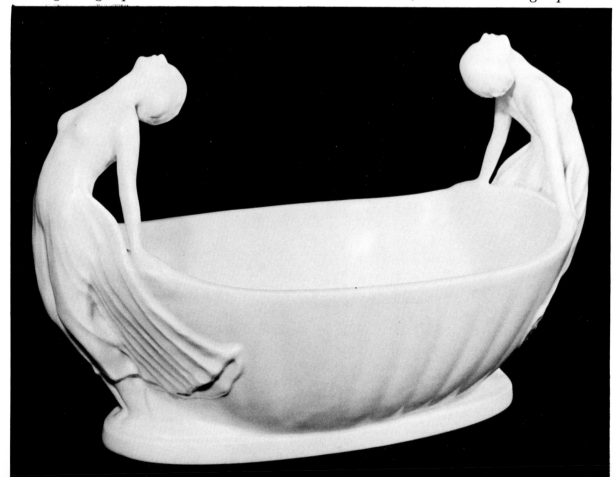

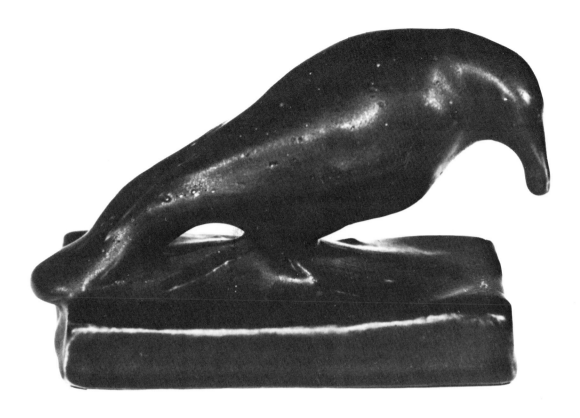

"Vellum" black rook, 1909, 3 in. high. Orren photo

Rookwood Pottery. Left to right: *White ship paperweight, 1928, 3½ in. high; figure marked "Porcelain," high gloss, 1918, 6 in. high; geese paperweight, 1930, 4 in. high. Knight photo*

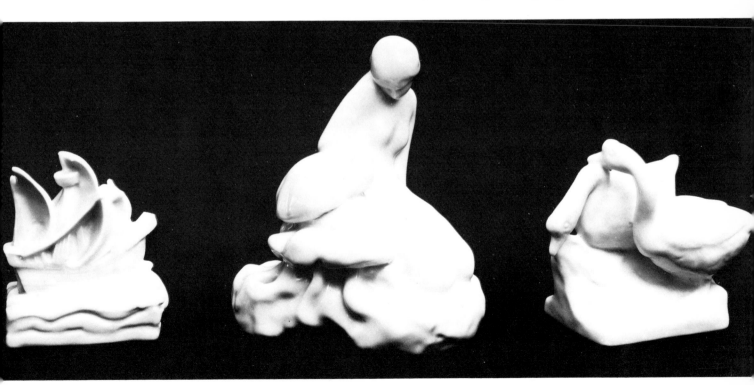

210

↑ *"Ombroso" book ends. Pale pink and brown, master mold signed by William McDonald, 7 in. high. Author's collection; Johnson photo*

Rookwood tray. White mermaids on turquoise sea shell, marked "Porcelain," dated 1915, weight 5 pounds, 9½-in. diameter. Knight photo ↓

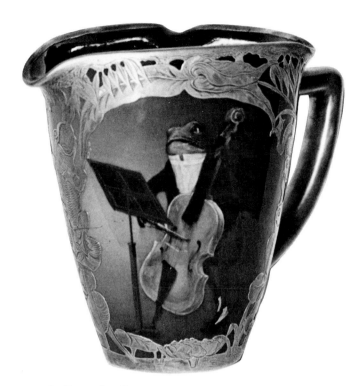

Both sides of Rookwood "standard glaze" brown ware pitcher with frogs, 1898, brown and yellow, silver overlay, signed "Wm. P. McDonald," 8 in. high. Collection of Joe Loadholtz; Loveland photo

"Standard glaze" plaque, 1894. Pottery portion signed "Bruce Horsfall," 8 by 10 in. Collection of Joe Loadholtz; Loveland photo

"Standard" glaze brown ware stein signed by Grace Young, 1899, portrait of "Turning Eagle, Sioux," silver lid with dinosaur or lizard thumb lift, brown and yellow, 8 in. high. Collection of Joe Loadholtz, Loveland photo

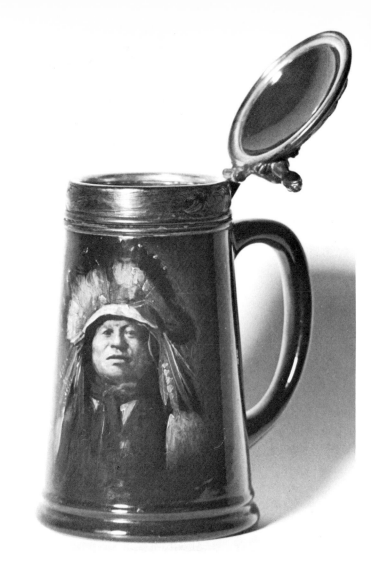

"Standard" glaze brown ware. Left to right: Covered jar, dated 1895, signed "Sallie Toohey," 7 in. high; jug dated 1897, signed "Sallie Toohey," 9½-in. high; mug with sterling silver cap, dated 1895, signed "Bruce Horsfall," 7 in. high. Fox photo

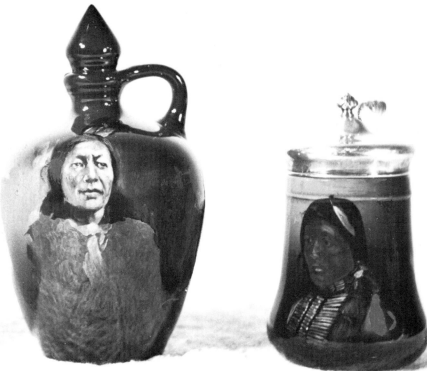

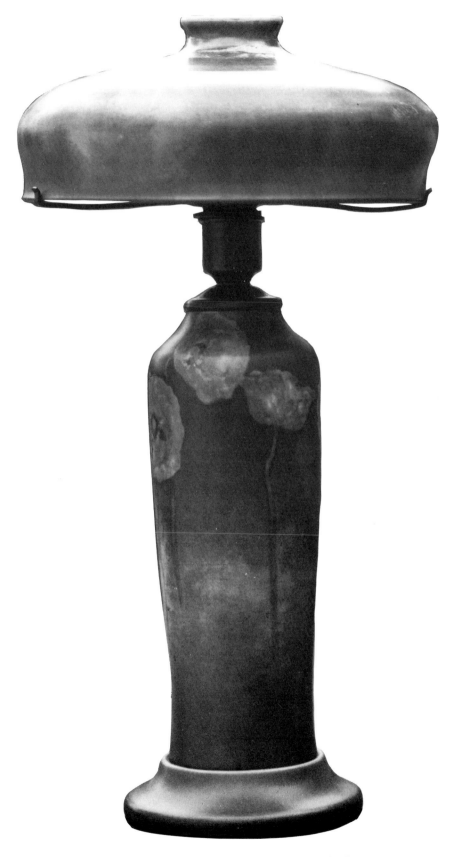

Electric lamp. Green with pink flowers, painted matt, signed by Harriett E. Wilcox, dated 1903, 23 in. high, shade 13 in. diameter. Jarrett photo

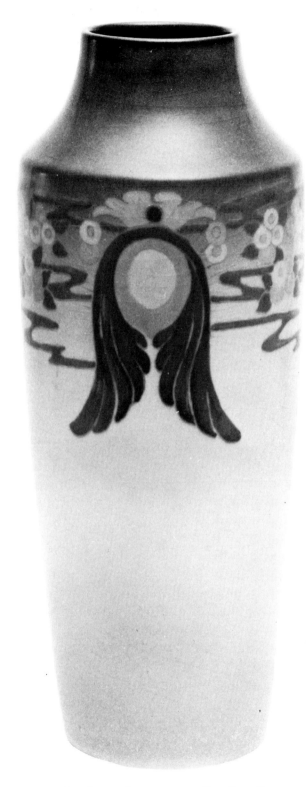

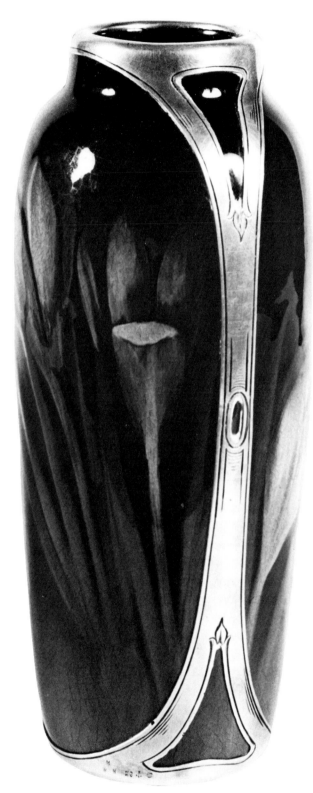

Rookwood pottery. "Vellum" vase, gray to pink with blue decoration, signed "Margaret Helen McDonald," 1920, 11 in. high. Knight photo

Rookwood pottery. "Standard" glaze brown ware with light brown foliage, silver overlay, 1905, signed "LNL"—Elizabeth N. Lincoln, 7 in. high. Knight photo

Rookwood incised vase. Matt finish, blue and mauve, signed "Fannie Auckland, 1882," 11 in. high. Collection of Joe Loadholtz; Loveland photo

7" high—shaded light and dark brown. Decoration—garland of rose-colored flowers with greenish-yellow leaves. Dated 1911—signed "C. S. T. [Charles S. Todd]. Matt glaze. Collection of A. Christian Revi

Rookwood vase. Brown figures in raised slip on turquoise background, marked "special," signed by Jens Jensen, dated 1934, 6 in. high. Knight photo

Vase with Limoges-type decoration. Rose-beige background with foliage in autumn hues, accented with gold over the glaze, marked "Rookwood 1882" with anchor mark, signed "MLN"—Marie Longworth Nichols, 10 in. high. Collection of R. E. and F. G. O'Brien, Jr.; Knight photo

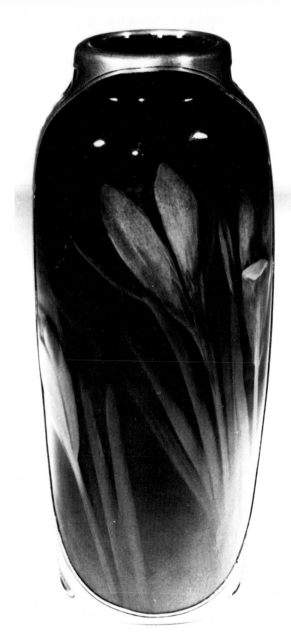

Rookwood; Brownware-7 in. high, silver overlay. 1905-Elizabeth N. Lincoln

Rookwood Pottery Company catalog, ca. 1961. Starkville, Mississippi.

Rookwood Pottery is available in glazes listed below:

EGM—*Emerald Green Mat*
MG—*Moon Glow-Midnight Blue background, Misty White accent*
TE—*Tiger Eye Green*
o—Orange
CBM—*Cerulean Blue Matt*

218

1881 Mug, 7½" high

6064 Paperweight, 4" long

6514 Vase, 4" high

2556 Vase or 2556-L Lamp Base 8½" high

1880 Mug, 7" high

7158 Vase or 7158-L Lamp Base 19½" high

6777 Vase or 6777-L Lamp Base 12" high

6937 Plate, 13¾" diam.

2816 Set — Cup and Saucer 4½" diam. Cap. 2 cups

1236 Vase or 1236-L Lamp Base 13½" high

7201 Bowl, 7½" diam.

7165 Ash Tray, 9½" long

6870 Vase, 12" high

2545 Vase, 7½" high

778 Vase, 10" high

2691 Vase, 7" high

2989 Vase, 7" high

6773 Vase, 9¼" high

7098 Vase, 11" high

6893 Vase, 9½" high

7185 Ash Tray, 8½" diam.

Rookwood Pottery Company catalog, 1961

219

Rookwood artists and their monograms.
This list is probably not complete. Notice that
some decorators used more than one mark.

Edward Abel	*E.A.*	
Louise Abel	Ⓐ	Ⓐ
Howard Altman	*HA*	
Lenore Asbury	*LA.*	*L.A*
Fannie Auckland	*Fʌ*	
Constance A. Baker	*CAB.*	
Elizabeth Barrett	*Ɛb*	
Irene Bishop	*J.B.*	
Caroline Bonsall	*C.F.B.*	
A. M. Bookprinter	*AMB*	*ⱭB*
Elizabeth W. Brain	*EⱮB*	
Alfred Brennan	*AB*	
W. H. Breuer	*W H B*	*B*
Arthur P. Conant	Ⓖ	
Patti M. Conant	Ⓟ︎Ⓒ︎	
Daniel Cook	*·D·C·*	
Catherine Covalenco	*C C*	

Sallie E. Coyne	*S.E.C.*	*SE*
Cathrine Crabtree	*(𝒸*	
E. Berthan I. Cranch	*E.B.I.C.*	
Edward P. Cranch	*EPC*	*EPG*
Cora Crofton	*℮*	
Matt A. Daly	*MAD*	*MD.*
Virginia B. Demarest	*VBD*	
Mary Grace Denzler	*⌐GD*	
Charles John Dibowski	*C J·D·*	
Edward Diers	*ED.*	
Cecil A. Duell	*CAD*	*C·A·D·*
Lorinda Epply	*Ŀ*	*Ŀ*
Henry Francois Farney	*Ⱶ*	
Rose Fechheimer	*R.f.*	*R*
Edith R. Felten	*E R.F*	
Kate Field	*K.F.*	
Emma D. Foermeyer	*E.D.F.*	

Rookwood Pottery

Artists names and monograms:

Mattie Foglesong	ΠF	Jens Jensen		
Laura A. Fry		Katherine Jones	KJ	
Lois Furukawa	LF	Florence Kebler	F.E.K.	
Arthur Goetting	AG	Mary Virginia Keenan	MK	
Katharine de Golter	K·G·	Flora King	FK	
Grace M. Hall	G.H	Ora King		
Lena E. Hanscom	L.E.H.	William Klemm	WK.	
Janet Harris	JH	Charles Klinger		
W. E. Hentschel	VEH NEH	F. D. Koehler	K	
Katherine Hickman	JH	Sturgis Laurence	S.L.	
Orville B. Hicks	Hicks	Eliza C. Lawrence	ECL	
N. J. Hirschfeld	N.J.H	Kay Ley	LEY	
Alice Belle Holabird	A.B.H.	Elizabeth N. Lincoln	LNL	
Loretta Holtkamp	LH	Clara C. Lindeman	CCL	
Bruce Horsfall	B—	Laura E. Lindeman	L.E.L. LEL	
Hattie Horton	H.H.	Elizabeth N. Lingenfelter	L.N.L.	
Albert Humphreys	A.H.	Tom Lunt	TOM	
E. T. Hurley	E.T.H.	Helen M. Lyons	HML.	

Rookwood Pottery

Artists names and monograms:

Artist	Monogram	Artist	Monogram
Sadie Markland	*S.M.*	O. Geneva Reed	*O.G.R*
Kate C. Matchette	*K.C.M.*	Wilhelmine Rehm	*WR*
Elizabeth F. McDermott	*EFM*	Martin Rettig	*MR*
Margaret Helen McDonald	*MHM* *(MH)*	Fred Rothenbusch	*R* *R.*
William P. McDonald	*(WMc)* *WPM^cD* *W&D*	Jane Sacksteder	*vSv*
Charles J. McLaughlin	*JM*	Sara Sax	*S.S.* *A* *S*
Earl Menzel	*EM*	Virginia Scalf	*V.S.*
Marianna Mitchell	*M*	Carl Schmidt	*S* *(S)*
Clara Chipman Newton	*C.N* *#*	Adeliza D. Sehon	*A.D.S.*
Edith Noonan	*EN.* *E.N.*	David W. Seyler	*DWS*
Elizabeth Nourse	*E.N.*	Kataro Shirayamadani	*KS →*
Mary Nourse	*M.N.*	Marion H. Smalley	*M·H·S·*
Mary L. Perkins	*MP* *M.L.P.* *M*	Amelia B. Sprague	*ABS* *$*
Pauline Peters	*P*	Carolyn Stegner	*S*
Agnes Pitman	*AP*	Carrie Steinle	*C.F.S.* *CS* *C.S.*
Albert F. Pons	*R*	Maria Longworth Storer	*MLS* *M·L·N* *M.L.N.* *R.P.C·O*
Wesley Pullman	*WP*	Harriet R. Strafer	*H.R·S.*
Marie Rauchfuss	*MR.*	H. Pabodie Stuntz	*$*

Rookwood Pottery

Artists names and monograms:

Jeannette Swing		F. W. Vreeland	
Mary L. Taylor		John D. Wareham	
Vera Tischler		Harriet Wenderoth	
Charles S. Todd		Harriet E. Wilcox	
Sallie Toohey		Edith L. Wildman	
Albert R. Valentien		Alice Willitts	
Anna M. Valentien		Delia Workum	
Artus Van Briggle		Grace Young	
Leona Van Briggle		Clotilda Zanetta	
Katherine Van Horne		Josephine E. Zettel	

A sketch of the famous RP mark created
by Wm. P. McDonald

Rookwood Pottery
marks:

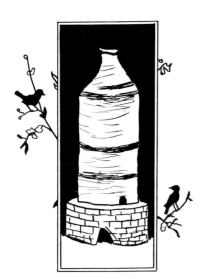

1886 1890

1901

Another factory mark was a sketch of a kiln with two rooks.

Underglaze mark printed in black was used during the first two years of operation. This trade mark was designed by H. F. Farny and was also used as Rookwood's first letterhead.

Impressed with the date. Some pieces with this mark also had the monogram of the artist.

Still another mark used was the name and address of the factory and the date in an impressed oval.

Name of the pottery and date. Also the name of the artist, either incised or painted.

R. P. C. O.

"Rookwood Pottery, Cincinnati, Ohio." The artist's monogram was included with these letters.

Used in 1882. Impressed letters on a raised ribbon. This mark was used only on a special commercial item.

Used in 1882. Impressed letters on a raised ribbon.

In relief with the date. Some pieces with this mark also had the monogram of the artist.

This mark was used from 1882 until 1886, the date being changed each year.

In 1883, the name Rookwood and date were used, either alone or with a small kiln impressed.

The Rookwood Pottery, Cincinnati, Ohio. View overlooking the river.

Roseville Pottery
1892—1954

The year 1890 was a depression year and the Youngs, Anna and George, were struggling desperately to get along financially. George Young was born in Washington County, Ohio, on February 24, 1863, and spent a portion of his early years as a schoolteacher. Later, he made an attempt at selling Singer Sewing Machines while Anna was trying her luck at selling millinery. Neither venture appeared to be very successful; consequently, George relinquished his position with Singer. He decided there was more demand for pottery and therefore made an investment in a pottery in Roseville, Muskingum County, Ohio, just eleven miles south of Zanesville.

The perfect clays of the Muskingum Valley, along with the plentiful supply of natural gas and coal, were inducive to potting. Potteries sprang up by the score in the area, some of them growing to be of great importance. One of the most productive and best known, worldwide, was George Young's "Roseville."

On January 4, 1892, the firm was incorporated. George Young was elected secretary and general manager, C. F. Allison, president, J. F. Weaver, manager, and Thomas Brown, treasurer. The company began prospering almost immediately; and in 1895 they acquired a new plant in Roseville and expanded the manufacturing of stoneware.

In 1898 the company moved to Zanesville, purchasing the Clark Stoneware Company on Linden Avenue. Peters and Reed were operating a pottery at this location but were forced to move to a new plant. A year later, in 1899, Young built a three-story building on this site. The company continued to operate under the name "Roseville." By 1900 Young was ready to capture some of the profits claimed by other Ohio potters.

Ross C. Purdy, an artist, was hired to develop an art line. He created a line with a high-gloss glaze, with under-the-glaze slip painting, which was named "Rozane Royal." Some of these were dark while others were in pastel colors. These subjects on clay are oftentimes as bold as oil paintings, other times as pale as water colors. The dark was very similar to Weller's Louwelsa, Rookwood's standard glaze ware, and Owens' Utopian. One must look for the mark before becoming positive just which company manufactured it. Since the artists migrated from one pottery to another, you will find some Rozane Royal pieces signed by artists whose names will also appear on other Ohio pottery.

In 1900 Roseville hired John J. Herold, who had worked for both Weller and Owens, to take over as art director and designer. Herold was responsible for the "Rozane Mongol," with its difficult-to-produce, dark red crystalline glaze. This is a solid red glaze and, on occasion, is found with a silver overlay. His exhibits won first prize at the St. Louis Exposition in 1904. In 1908 Herold left the Roseville Pottery to organize the Herold China Company at Golden, Colorado. Later this firm became the Coors Porcelain Company.

In 1901 the Roseville Company acquired a fourth plant, the old Mosaic Tile Company auxiliary at Muskingum Avenue and Harrison Street in Zanesville. Cookware was made in this plant, which kept four kilns operating and approximately fifty men employed. By 1905 the company had 350 people on its payroll with an annual output of five hundred thousand dollars in merchandise.

Young employed all available talent. In 1902 Christian Neilson, who was born in Denmark in 1870, worked at the Roseville Pottery. Neilson had studied sculpture at the Royal Academy of Art at Copenhagen before coming to the United States in 1891. In 1894 he went with the American

Encaustic Tiling Company in Zanesville, but remained there only a short time. He then migrated to Roseville where he remained until 1906. He was responsible for the "Egypto" figures and some of the "Della Robbia" patterns that pictured seventy-five different designs in the catalog.

Frederick Hurten Rhead was a guiding influence at Roseville from 1903 until 1908, at which time his brother, Harry W. Rhead, became art director. Frederick Hurten was a son of Frederick Alfred Rhead, who was employed by Weller during this same period. Perhaps this explains why Rozane Mara and other Rozane lines were copies of Weller lines. By 1911 Frederick Hurten Rhead had migrated to California, where he aided in organizing the Arequipa Pottery for patients in a tuberculosis sanatorium.

Rozane became popular and sold well. Every time Weller or other Ohio potteries would produce a new line, Young would produce a comparable one. When Weller introduced his Dickens Ware, Young introduced not one, but three, similar lines. "Rozane Woodland" 1905, and "Rozane Fugi" in 1906, and "Della Robbia" in 1906. All these lines are the sgraffito type. In 1904 the "Mongol" pattern was introduced as well as a beautiful line named "Olympic." This line was decorated with Grecian figures in white, on a dark red background, outlined in black. The decoration was not hand done but apparently a printed technique was used. This pattern is extremely rare, perhaps the rarest of the Roseville lines.

Weller then introduced his Sicardo, which was supposed to be a secret process. Young retaliated with "Rozane Mara," which was an iridescent metallic line and more varied in color than Sicardo. Mara had the deep reds and purples, and also came in a pearl white with pastel designs as changeable as a seashell. it was quite elegant with the predetermined design developed within the iridescence. Practically all Mara is unsigned and consequently is often mistaken for unsigned Sicardo. Roseville also added a Japanese influence to the art lines by hiring Gazo Foudji, formerly of Paris. He was given his own studio where he perfected Rozane Woodland and Rozane Fugi. These lines were decorated in the sgraffito method with the designs covered with a gloss glaze, with a soft matt-finished background. These were usually done in russet autumn hues.

Although Young introduced a new line every time his competitors did, he did not make his lines in as vast a quantity as did the other potters. Some lines were never in mass production, just a few being made on special order. Some pieces were further embellished with silver overlay.

Harry W. Rhead, an Englishman, succeeded Herold as art director in 1908. It was he who, in 1914, developed the "Pauleo" line, named for Young's daughter Leota and his daughter-in-law Pauline. In going through the material on the Roseville Pottery at the Ohio Historical Society in Columbus, the formula for Pauleo was made available. It denoted two types. Type one entailed covering the ware with a red metallic luster glaze. Type two described a finish with a marbleized cover. The entire recipe was given for making both these lines. Although every piece we have seen in type two has been yellow, it is possible that other colors also exist.

Rhead also designed several popular lines that were less expensive and more widely distributed. He created a line called "Donatello," with frolicking cherubs in panels separated by trees. Each piece is fluted at both top and bottom. Colors are light green and tan against a white background. Donatello was a great favorite with the public and was constantly in demand. This line was made for a decade and was produced in as many as a hundred different shapes and sizes, thus becoming one of Roseville's successful lines.

By 1910 Young had closed the two plants in Roseville, but had retained the two in Zanesville. The Linden plant was busy making the art lines while the Muskingum Avenue plant produced the commercial lines. In 1917 the Muskingum plant burned and all operations moved to the Linden site. At about this time (1919), Russell T. Young became director, succeeding his father, and George Krause, a native of Germany, became technical supervisor. Frank Ferrel took Rhead's position as art director.

During the Ferrel period. Roseville pottery was developed at the rate of two or more patterns each year. The "Dogwood" was a popular line among his first floral designs. His most popular line was

"Pinecone," which he developed when he worked for Weller, although Weller had rejected this particular line as being a poor gamble. Later, Ferrel redesigned the Pinecone pattern for Peters and Reed and named it Moss Aztec. Still later, he redesigned it once again and called it Pinecone, which became the most popular line ever designed at Roseville. It was made in seventy-five different shapes and sizes and came in an array of colors—brown, blue, and green. The Pinecone pattern sold well for fifteen years and consequently was a contributing factor in the company achieving a million-dollar-a-year business.

In 1932 Mrs. Anna Young became president of the Roseville Pottery, following her son. Most people who traveled Route 40, near the western part of Zanesville, in the 1930s and early 1940s will remember well the tearoom and the showrooms Mrs. Young had built. It was a most popular resting place for the weary traveler. After Mrs. Young's death in 1938, her son-in-law, F. S. Clement, became president and served until 1945; he was followed by his son-in-law, Robert Windisch, who held the office until Roseville closed in 1954.

In the waning years, to reduce the cost of production, and in an attempt to stimulate sales, Roseville turned to a glossy glaze instead of the traditional matt finish. The transition was called "Wincraft." Although it was quite artistic, it did not please the public, consequently, sales began to decline. The Pinecone pattern, along with other patterns that had previously sold well, was included in the Wincraft line.

In 1952 Roseville developed a fancy oven-proof tableware called "Raymor." This line came in covered casserole and serving dishes with ultra-modern shapes. This also proved unsuccessful and the company failed. Operations were closed down and the plant was sold to the Mosaic Tile Company. One might place part of the blame for failure on the tremendous increase in the manufacture of plastic articles during this period. Plastics could be purchased at a much lower price and had the added convenience of being almost unbreakable.

The Roseville Company enjoyed a long and productive life. During the late period of operation, Roseville made vast quantities of pottery, including a variety of colors and sizes in pitchers, vases, baskets, bowls, teasets, and all sorts of vessels for making flower arrangements. Practically all department stores and catalog houses sold Roseville. Incidentally, it may be interesting to note that the S & H Green Stamp Centers redeemed stamps for Roseville pottery during the late period.

"Rozane Egypto" vase. Lush green, marked with a wafer, 12¼ in. high. Knight photo

"Pauleo" vases. Left to right: *First-line "Pauleo," red metallic glaze, unmarked; second-line "Pauleo," yellow marble-ized cover, marked in wafer. Collection of Dr. and Mrs. Gordon Gifford; Mesre photo*

WINCRAFT

by Roseville

ZANESVILLE, OHIO

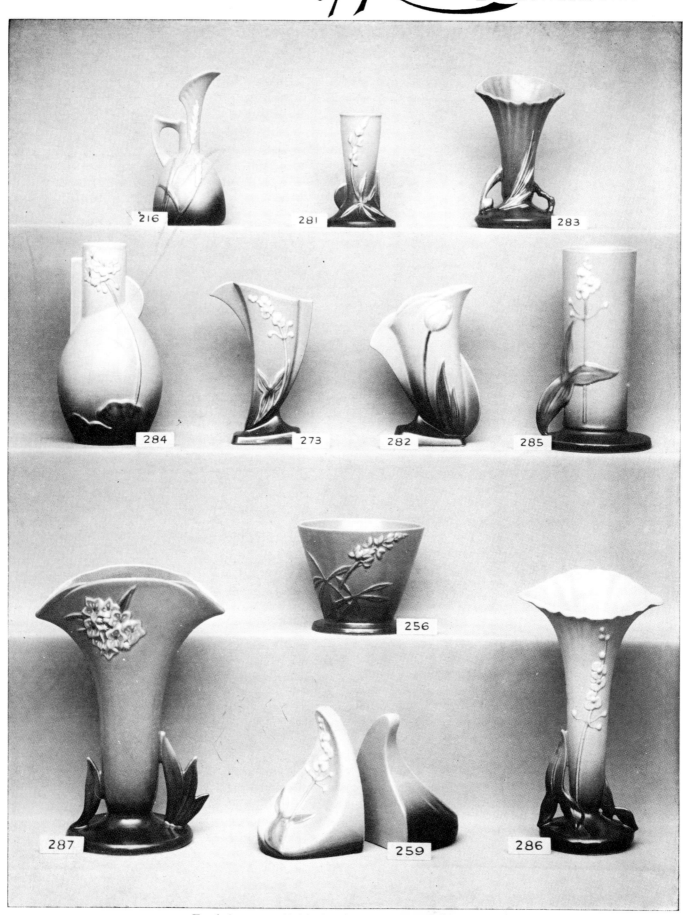

Each item available in three distinctive colors:
Apricot—Azure Blue—Chartreuse

WINCRAFT

by *Roseville*

ZANESVILLE, OHIO

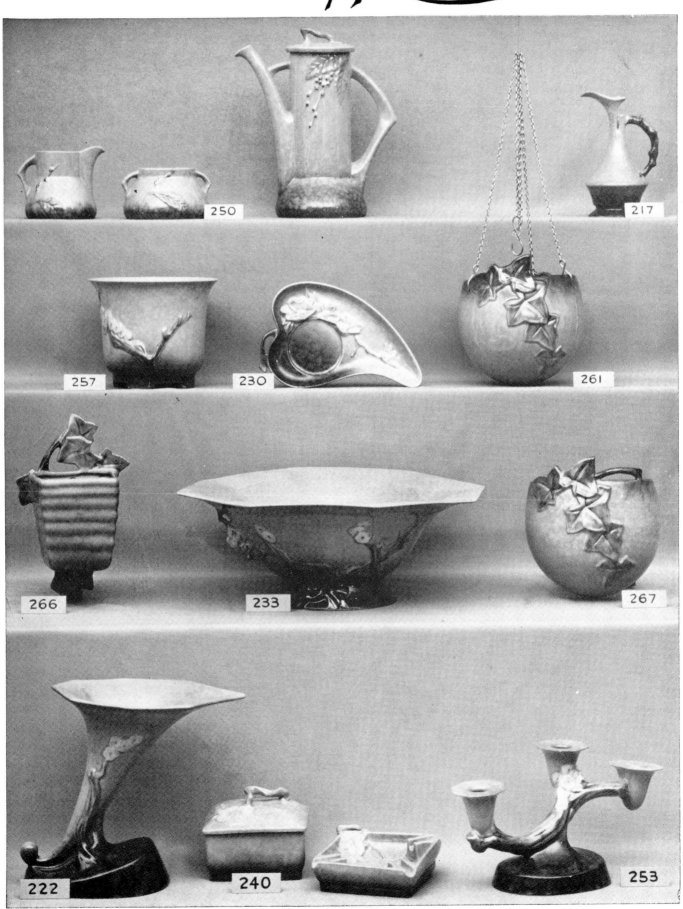

250 217

257 230 261

266 233 267

222 240 253

Each item available in three distinctive colors:
Apricot—Azure Blue—Chartreuse

WINCRAFT

by Roseville

ZANESVILLE, OHIO

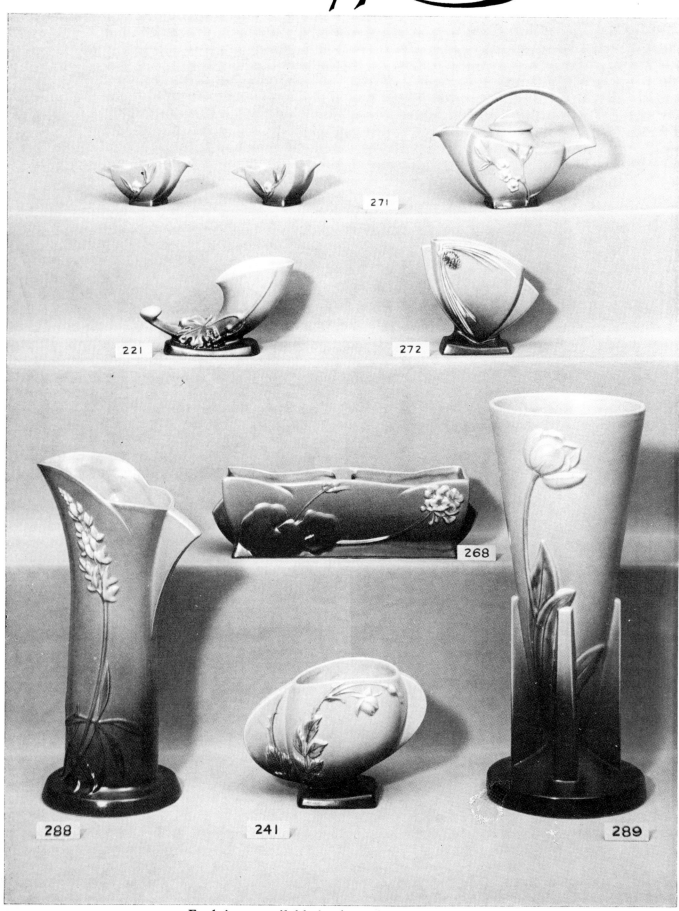

Each item available in three distinctive colors:
Apricot—Azure Blue—Chartreuse

WINCRAFT

by Roseville

ZANESVILLE, OHIO

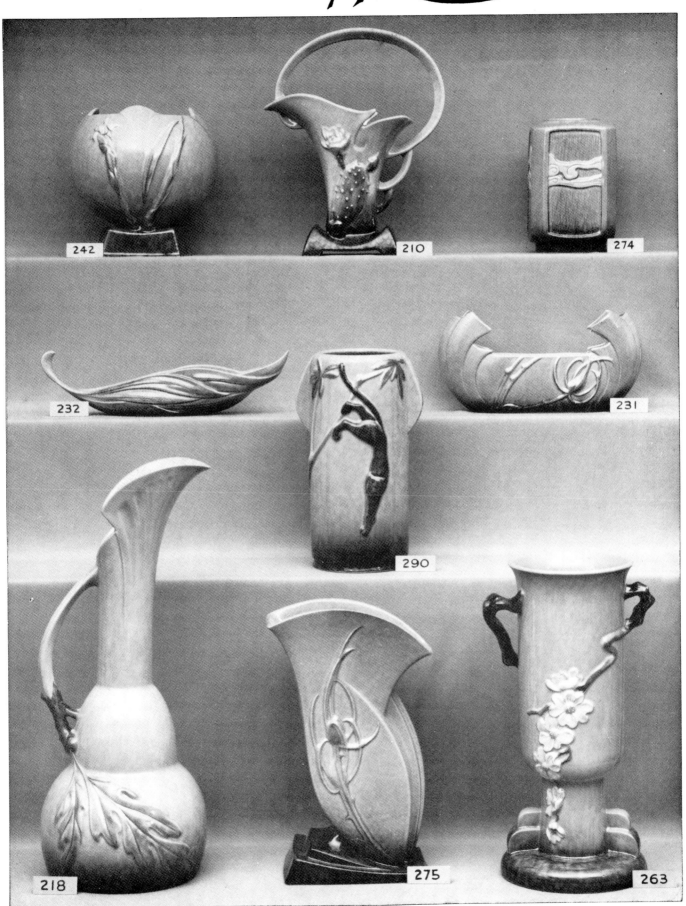

242 210 274

232 290 231

218 275 263

Each item available in three distinctive colors:

Apricot—Azure Blue—Chartreuse

WINCRAFT

by Roseville

ZANESVILLE, OHIO

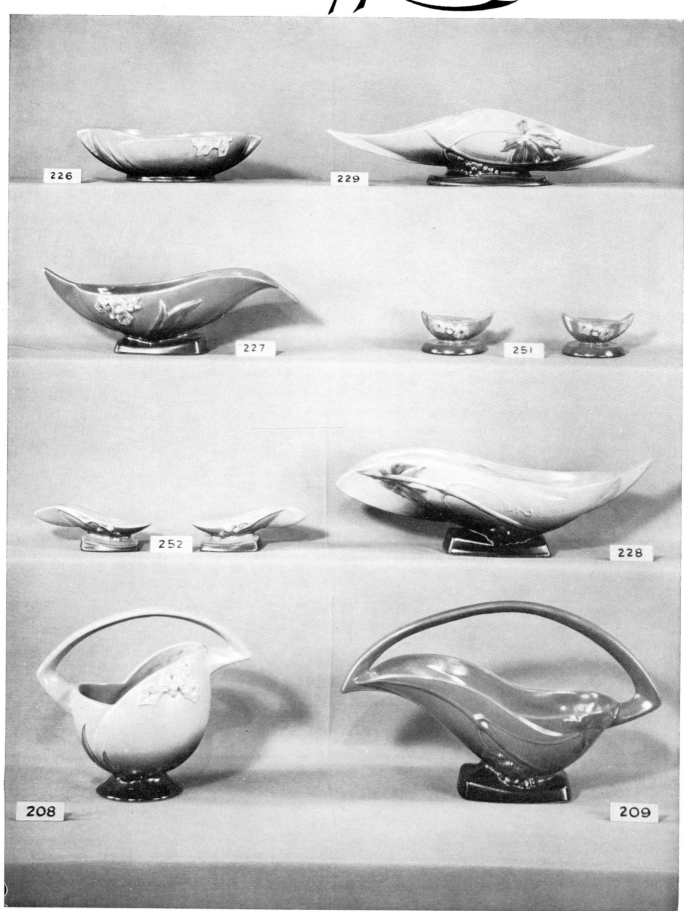

226

229

227

251

252

228

208

209

Each item available in three distinctive colors:
Apricot—Azure Blue—Chartreuse

Rozane Mara 5 in. high. Circa 1904. Blue and green against red background. Orren Photo

Rosecraft vintage: 6 in. high. Circa 1925. Black with blue grapes and tan leaves. Orren Photo

Signed "Rozane Woodland" vases. Wafer with line name, brown iris on light tan background, 9 in. and 6½ in. high. Johnson photo

Roseville vases. Left to right: "Donatello" with high glaze, light green with tan background in band, 8 in. high; "Mock Orange" [marked] green, 9 in. high; "Ixia," as shown in catalog, tan shaded with cream, 7½ in. high. Johnson photo

Group of "Rozane Fugi" vases, tan and brown trimmed in blue and brown. Left: Unmarked. Center: Two vases as pictured in Rozane catalog. Right: Marked "Fugiyama" in green on base. Collection of Dr. and Mrs. Gordon Gifford; Mesre photo

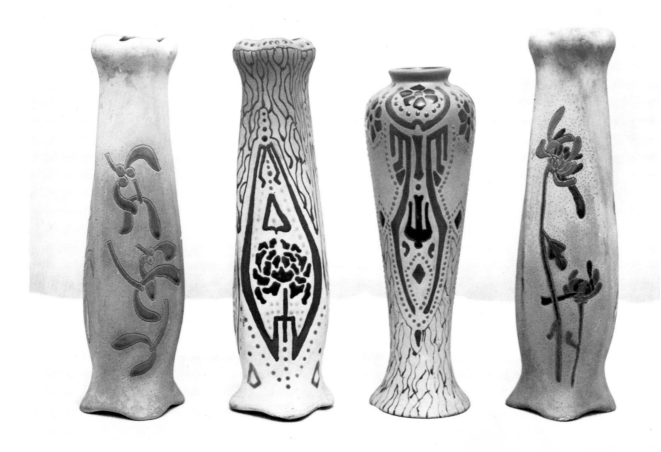

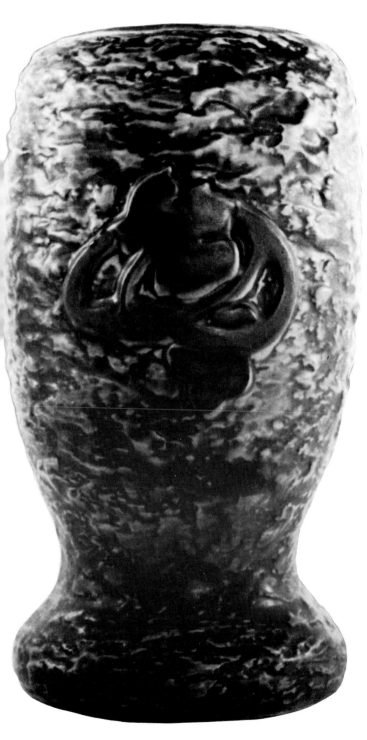

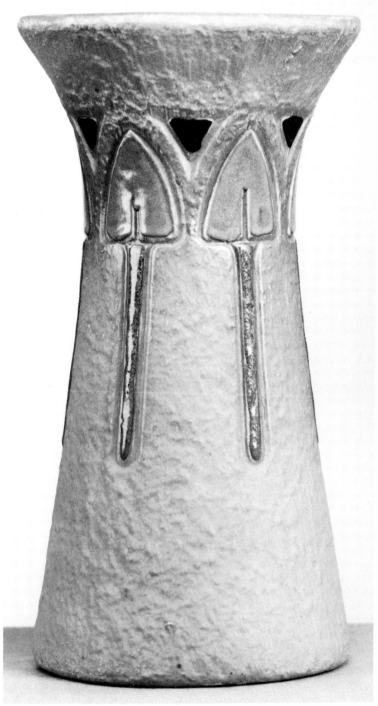

"Imperial I" vase. Pattern as shown in catalog, mottled browns, paper label, 12 in. high. Author's collection; Johnson photo

Roseville Mostique: vase-11½ in. high. Rough grey background with green, blue, and yellow decoration. Green lining. Photo by Poist's Studio

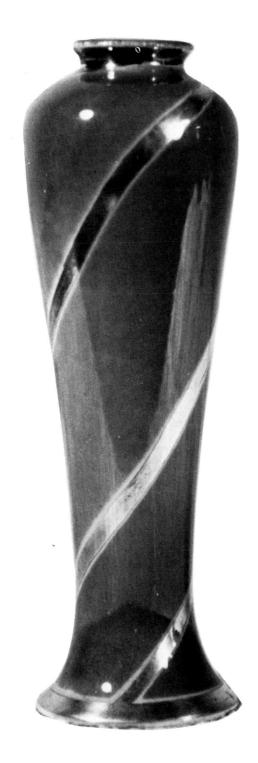

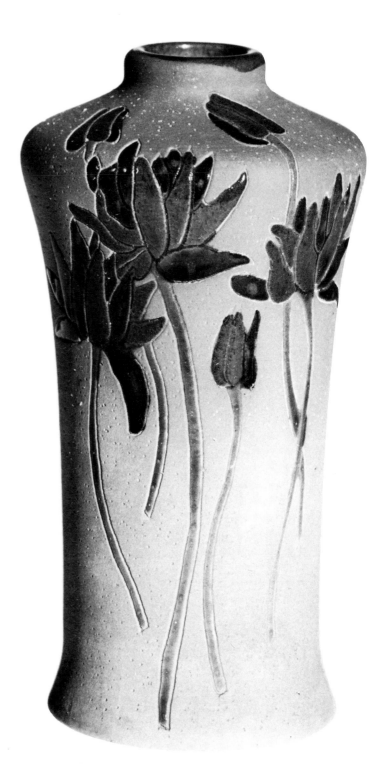

Silver overlay. Marked in wafer "Rozane Ware Mongol," 10 in. high. Fox photo

Rozane Woodland: 6½ in. high. Circa 1904. Buff color background. Dark brown flowers and stems.

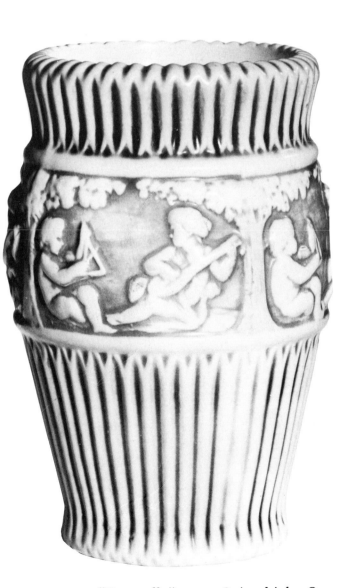

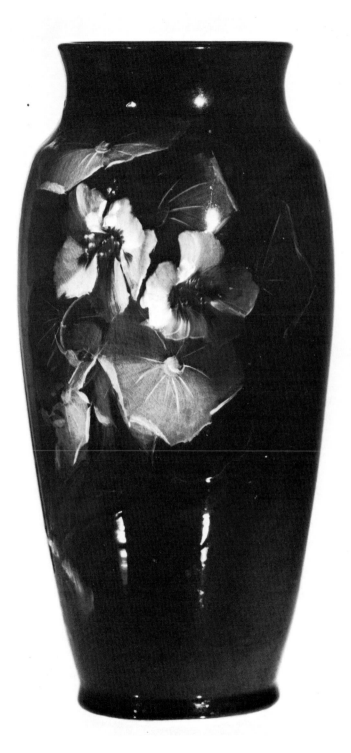

"Donatello" vase, 8 in. high. Orren photo

Marked "Rozane Royal" vase. Signed by artist, "M. Myers," dark brown with yellow shadings and orange flowers, ca. 1900, 12½ in. high. Orren photo

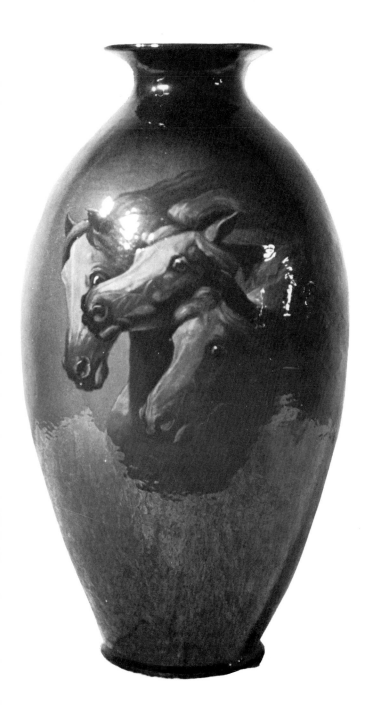

"Mayfair" vase. Green lined in chartreuse, ca. 1952, 9 in. high. Orren photo

Marked "Rozane" vase. Signed "AD" —Anthony Dunlavy, brown with yellow, 20 in. high. Fox photo

Marked "Rozane" pitcher. Brown to yellow, 5 in. high

Roseville Magnolia line: Cast in a mold, 9 in. to top of handle. Circa 1940- brown shading to green. Matt finish. Orren photo

Marked "Rozane" vase. Yellow roses on brown, signed "Josephine Imlay," 5½ in. high. Orren photo

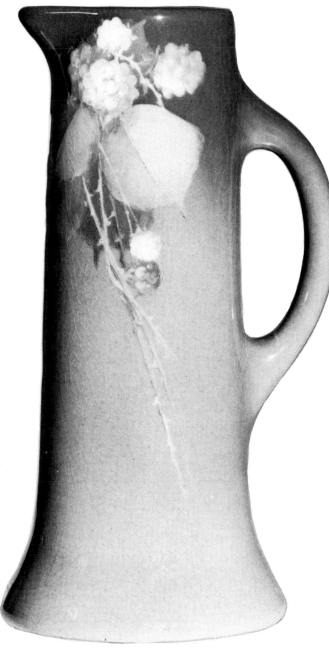

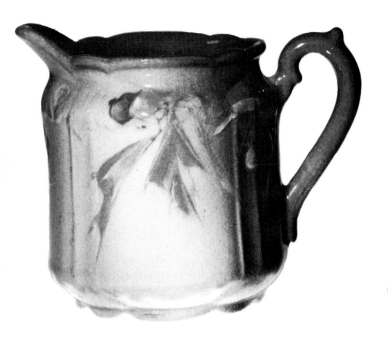

"Rozane Royal" creamer. Slip decorated in blue, marked "RPCo," signed by Grace Young, ca. 1900, 3½-in. high. Author's collection; Orren photo

"Rozane Royal" pitcher. Teal blue shaded dark to light with pink and yellow berries, signed by M. Myers, ca. 1900, 10½ in. high. Knight photo

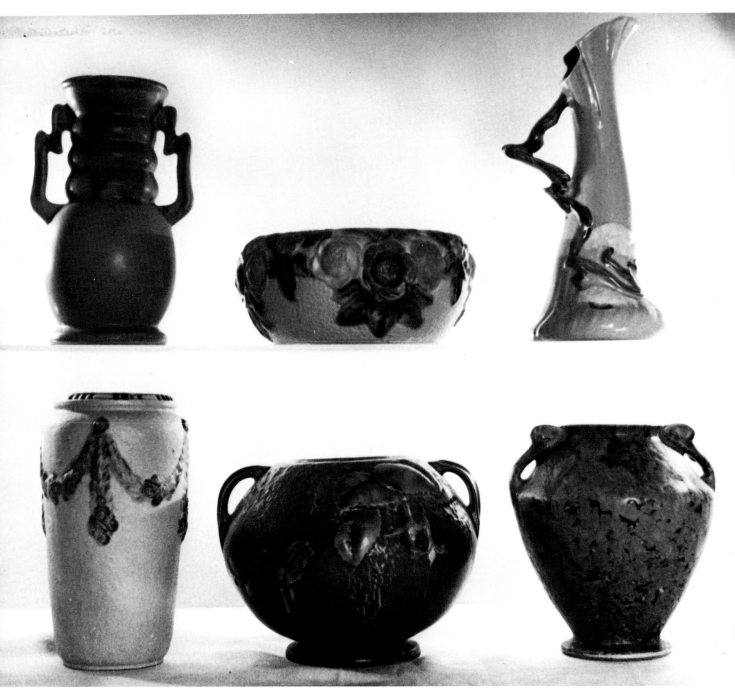

Roseville vases. Left to right, top row: "Carnelian," *as pictured in catalog, black-embossed paper label, 8 in. high, "Rozane," cream with red and blue flowers, marked in circle with pattern name, 3½-in. high; "Ming Tree," turquoise, embossed mark, 11 in. high.* Bottom row: "La Rose," *as pictured in catalog, white with red roses and green leaves, marked "R," with "v, 8½-in. high; "Fuchsia," blue with red flowers, early paper label, 6 in. high; "Imperial II," as pictured in catalog, pink mottled on blue, "Rv," 7 in. high. Johnson photo*

244

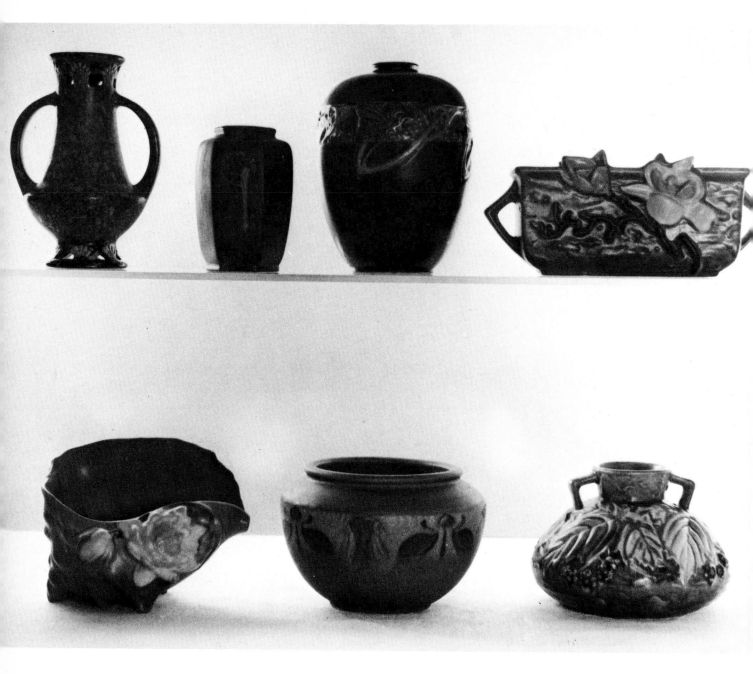

Roseville vases. Left to right, top row: "Ferrella," mottled tan and brown, early black-on-black label, 6 in. high; "Rose-craft Hexagon," dark green glaze with white decoration, marked "R" with "v," 4 in. high; "Rosecraft Vintage," black glaze with natural color grapes, marked "R" with "v," 6 in. high; "Magnolia," tan and brown with white flowers, embossed mark, 3 in. high by 6 in. long. Bottom row: "Water Lily," blue with white flower, embossed mark, 5 in. high; "Victorian Art Pottery," as pictured in catalog, blue on blue, marked "R" with "v," 4¼-in. high; "Blackberry," rustic colors with blackber-ries, early paper label, 5 in. high. Johnson photo

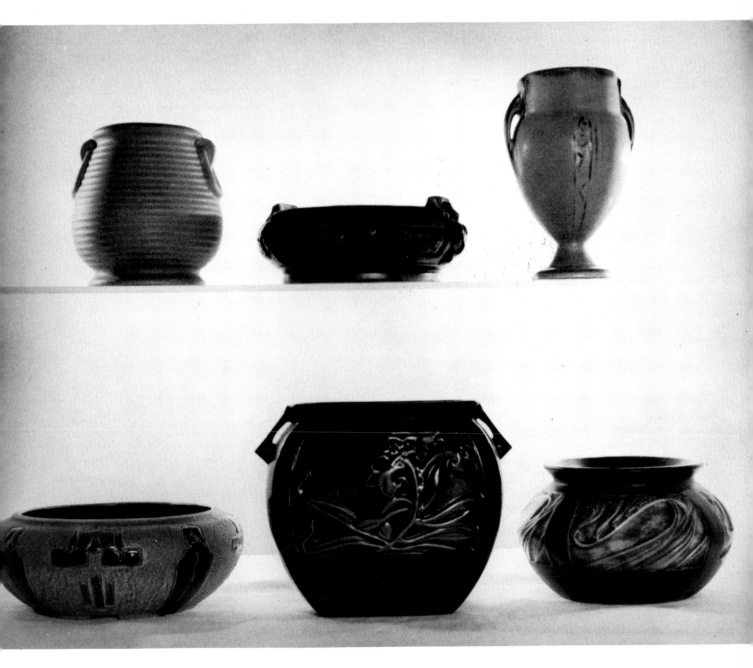

Roseville vases. Left to right, top row: Coors pottery, Denver [designed by J. J. Herold after leaving Roseville], rich rose-tan lined in bright turquoise, 5 in. high; "Florentine," rustic colors, 3 in. high; "Moderne," turquoise trimmed in gold, incised mark, 6½ in. high. Bottom row: "Mostique," green and red on ivory background, 3 in. high, 8 in. diameter; "Panel," brown with vivid orange decoration, 6 in. high; "Panel," green with white decoration, 4½ in. high. *Johnson photo*

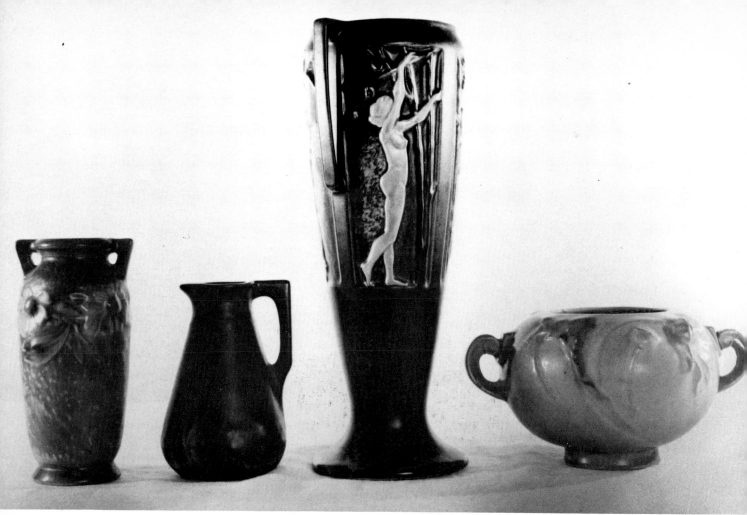

Roseville vases. Left to right: "Dahl-rose," tan with yellow, black embossed paper label, 6 in. high; "Rozane Egypto," dark green, marked with wafer with title below, 5 in. high; "Silhouette," dark green with white figures, 11½-in. high; "Poppy," blue with white flowers, 4½-in. high. Collection of Andy Anderson; Johnson photo

Roseville Pinecone design. Left to right: Blue vase, 6" high with incised mark. Green vase, 8" high with incised mark. Blue vase, 5¼ inches high with paper label

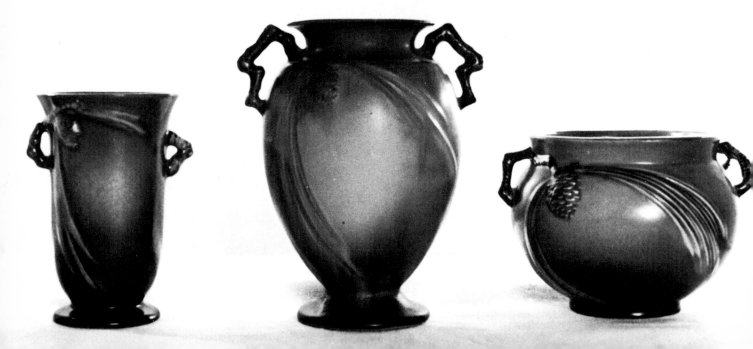

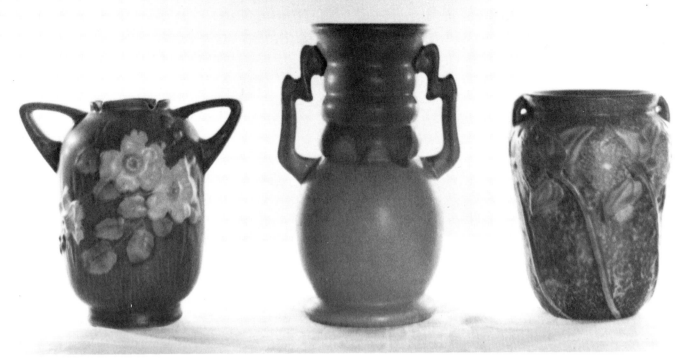

Roseville vases. Left to right: *"White Rose," tan, embossed mark, 6 in. high; "Carnelian," green with tan drippings, paper label, 8 in. high; "Sunflower," tan with yellow flowers, paper label, 6 in. high. Johnson photo*

Roseville vases. Left to right: *"Morning Glory," white background with purple and yellow flowers, early paper label, 8½-in. high; "Wisteria," blue, tan mottled background with natural color flowers, marked "R," 8 in. high; "Gardenia," silver gray shaded in pink, embossed mark, 8½ in. high. Johnson photo*

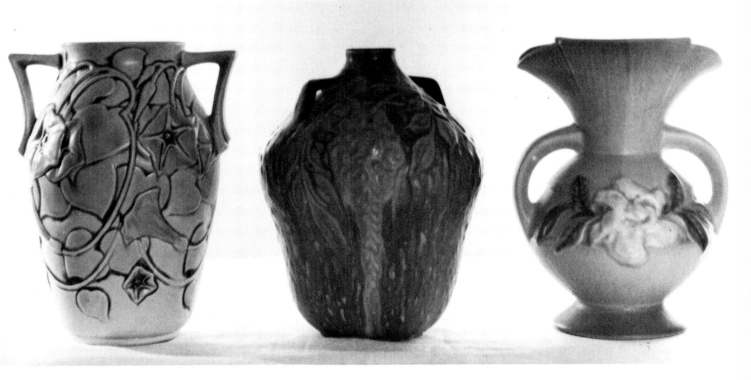

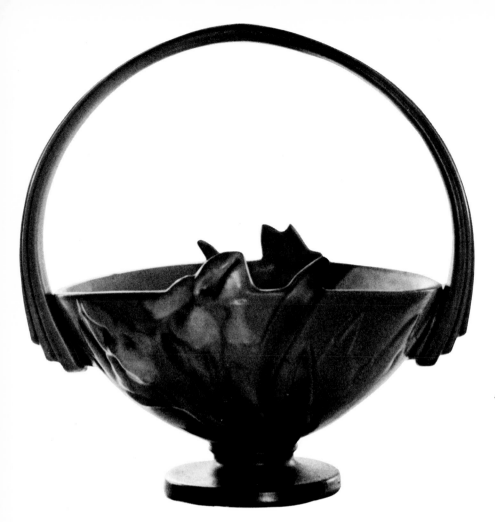

"Iris" basket. Blue, em-bossed mark, 4 in. high. Johnson photo

"Clemana" vase. Light green, 8 in. high. Johnson photo

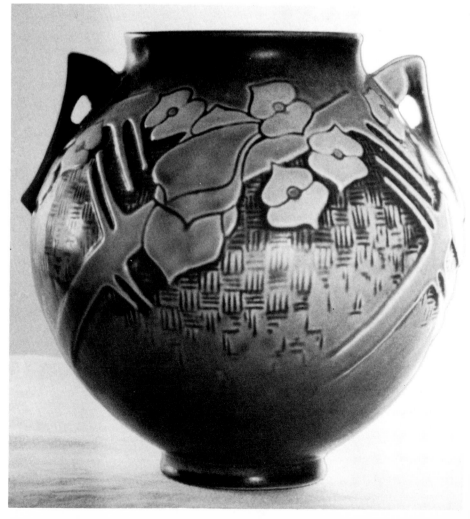

"Carnelian" bowl. Blue and pink, marked "v" in loop of "R," 4½ in. high, 7 in. by 9½ in. Orren photo

Dogwood I: 8½ in. high. Circa 1918. Dark green with brown handle. Orren Photo

"Olympic" vase. Dark red background, marked on base [stamped], "Rozane Olympic Pottery" and "Turyclea Discovers Ulysses," 11 in. high. Fox photo

"Baneda" vase. Pink with blue band, paper label, ca. 1933, 4¼ in. high. Orren photo

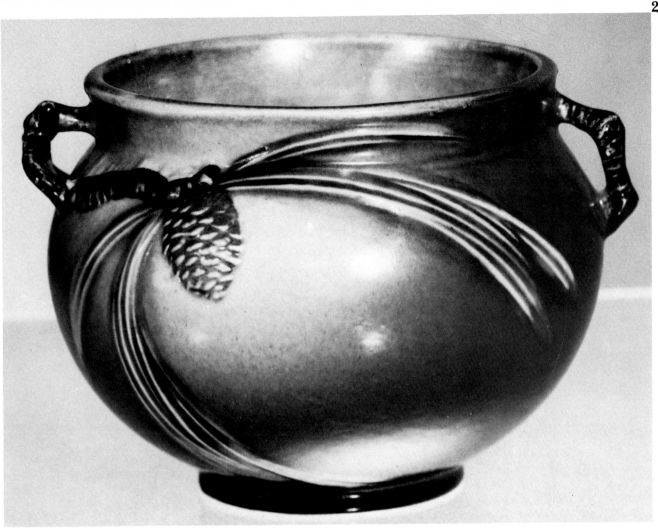

*Pinecone-blue 5 in. high. Circa 1920.
Brown twig handles and cones*

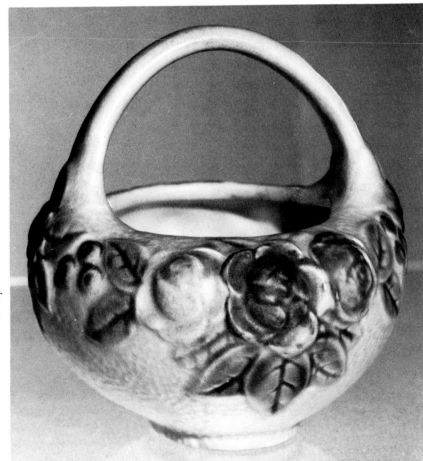

*Rozane: Basket-6½ in. high to top of
handle. Circa 1910-pink, yellow and blue
roses on white. Orren Photo*

Roseville Pottery line names, with approximate dates of presentation, and descriptions:

APPLE BLOSSOM 1948—Natural spring-like apple blossoms with the brown stems curling to form handles.

AZTEC 1916—Slip-decorated ware similar to Newcomb pottery.

BANEDA 1933—Band around center of vessel with cherries and small flowers. Solid background color.

BITTERSWEET 1940s—Natural blossoms with stem handles. Various background colors.

BLACKBERRY 1933—Natural blackberries on a very soft matt finish. Various background colors.

BLEEDING HEART 1938—Natural blossoms on various background colors.

BLUE WARE 1910—Similar to Weller's Blue Louwelsa.

BUSH BERRY 1948—Hollylike leaves and berries. Various background colors.

CAMEO 1920—Similar to Donatello with dogs and classical figures in the bands.

CARNELIAN 1910-15—One glaze running down over another. Classical style in various colors.

CHERRY BLOSSOM 1933—Natural blossoms on various background colors.

CLEMANA 1934—Stylized blossoms on basket-weave background. Various colors.

CLEMATIS 1944—Natural blossoms on various background colors.

COLUMBINE 1940s—Natural flowers on various bicolor background colors, usually shaded from one to another, such as brown to green.

CORINTHIAN 1923—Similar to Donatello with flowers in the bands. Ribbed.

COSMOS 1940—Natural blossoms. Various background colors.

CRYSTALIS (ROZANE) 1906—A crystallized glaze resembling ice on a window pane. Salt crystals. Various colors.

DAHLROSE 1924-28—Daisylike band of flowers around top with mottled background. Various colors.

DAWN 1937—Spiderlike flowers against solid-color background.

DELLA ROBBIA (ROZANE) 1906—Incised designs with allover high-gloss glaze. Made in 75 different patterns. Similar to Weller's Dickens Ware with high-gloss glaze.

DOGWOOD I 1916-18—Natural flowers. Various background colors.

DOGWOOD II 1928—Similar to Dogwood I except has the later mark and detail not as sharp.

DONATELLO 1915—Light green fluted top and bottom with a band of frolicking cherubs in panels separated by trees. Background color in the panels light brown.

EARLAM 1930—Similar to Weller's Golbrogreen.

EGYPTO (ROZANE) 1905—Shape and decoration resembling old Egyptian art. Finish is shades of soft green matt.

FALLINE 1933—Stylized designs with triangles around top rim and peapodshape designs near the bottom. Various background colors.

FERRELLA 1930—Mottled glaze with small flowers in a line around the rim. Reticulated. Various background colors.

FLORENTINE 1924-28—Panels of flowers with cascades of fruit and leaves between the panels. Various background colors.

FOXGLOVE 1940s—Natural flowers. Various background colors.

FREESIA 1945—Natural flowers. Various background colors.

FUCHSIA 1939—Natural flowers. Various background colors.

FUGI (ROZANE) 1906—Same technique as Rozane Woodland. Sometimes trimmed with dots and studs and wavy lines. Matt-finished background. Detailed decorations are in high gloss.

FUTURA 1924—Extreme art deco shapes, some with flowers added to the angular designs.

GARDENIA 1940s—Natural flowers. Various background colors.

GREMO 1920s—Solid-color matt-finish background shading from red to yellow to green.

HOLLAND 1915—Dutch boy and girl on light-colored stoneware-type pottery.

HOLLY 1915—Natural leaves and berries. Various background colors.

IMPERIAL I 1916-19—Pretzel-shaped flowers and swirled leaves on heavy rough background. Various colors.

IMPERIAL II 1924-28—A splotched glaze ware. Pink over blue.

IRIS 1938—Natural flower. Various background colors.

IVORY 1930s—A classic figure with dog in a band circling the vessel. Also ivory color

in other lines such as Donatello. Background all ivory.

IXIA 1930s—Natural flowers. Various background colors.

JONQUIL 1931—Natural flowers. Various background colors.

JUVENILE 1915—Children's plates and other dishes in light backgrounds with decal decor.

LA ROSE 1924-28—Cream-color background draped with leaves and roses.

LAUREL 1934—Natural laurel leaves with berries in panels with three lines between. Various background colors.

LOMBARDY 1924-28—Panels ending in scallops near the top with square odd feet. Various background colors.

LOTUS 1950s—Natural flowers. Various background colors.

LUFFA 1934—Poison-ivy-type leaves stacked one over the other. All of the ware is covered with these leaves.

MAGNOLIA 1943—Natural flowers. Various background colors.

MARA (ROZANE) 1905—Iridescent line very similar to Weller's Sicardo. One noticeable difference is that Mara is decorated with damask-type design in a repeat pattern developed within the glaze.

MATT GREEN 1910—Heavy dark green matt glaze. Solid color.

MING TREE 1949—Natural-type ming-tree decoration. Solid colors of white, blue, and green. High-gloss glaze.

MOCK ORANGE 1950—Floral. Various background colors. "Mock Orange" included in the mark.

MODERNE 1930s—Classic shapes. Teal-blue matt-glaze background trimmed with touches of gold.

MONGOL (ROZANE) 1904—A beautiful deep rich solid red without decorations. Resembles Chinese lacquer. Occasionally trimmed with silver deposit. See text.

MONTICELLO 1931—A matt-glaze ware with small white crosslike designs with keyhole-shape designs between the crosses. Various dark background colors.

MORNING GLORY 1935—Stylized flowers covering the ware on light colored matt glaze.

MOSS 1930s—Moss background with five-pointed leaves. Matt finish. Various background colors.

MOSTIQUE 1915—Pebbled background with stylized designs in high-gloss glaze. Various background colors, usually in gray or tan.

NORMANDY 1924-28—Fluted similar to Donatello with grapes and leaves in a circle at the top.

NURSERY 1920s—Children's dishes decorated in nursery-rhyme motifs. Light color.

OLYMPIC (ROZANE) 1905—Dark red background decorated with white Grecian figures outlined in black; similar to a ware made in England by the F & R Pratt Company, Fenton. See text.

ORIAN 1935—Chinese shapes in bright colors with high-gloss glaze. Allover geometric-design pattern.

PANEL 1920s—Various flowers in panels. Various glazes and backgrounds.

PAULEO (ROZANE) 1914—See text.

PEONY 1940s—Natural flowers. Various background colors.

PERSIAN 1915—Persian-type decoration on light-colored matt background.

PINECONE—Natural design of pinecones and leaves. Made for several years. See text.

POPPY 1930s—Natural flowers. Various background colors.

PRIMROSE 1930s—Natural flowers. Various background colors.

ROSECRAFT 1915—A plain classic shape with luster glaze. no decoration.

ROSECRAFT HEXAGON 1924-28—Hexagon shape with small white bleeding-heart-type decoration. Dark matt glaze.

ROSECRAFT VINTAGE 1916-28—A band with grapes and leaves around shoulder. Dark matt glaze.

ROZANE I 1917—Roses on stippled light background. Marked "Rozane" in center, along with the mark "Roseville Pottery."

ROZANE II 1940s—Various solid colors with molded seashells.

ROZANE MATT 1920s—Similar to Weller's Hudson pattern.

ROZANE ROYAL, DARK Early 1900s—Similar to Rookwood's standard brown ware and Weller's Louwelsa.

ROZANE ROYAL, LIGHT Early 1900s—Similar to Rookwood's Iris line and Weller's Eocean.

RUSSCO 1940s—Octagon shape with ribbons running up and down. Matt finish with a slight iridescence. Stacked handles. Various solid colors.

SAVONA 1924-28—Ribbed three-quarters of the way down from top. Grapes and leaves around shoulder.

SILHOUETTE 1950s—An art nouveau figure in panels. Various colors.

STEIN SETS early 1900s—Tankard and six mugs. Decorated with monks, elk heads, Dutch figures, eagles, and other subjects.

SUNFLOWER 1930s—A "mum"-type sunflower on various background colors.

SYLVAN 1918—Molded owls and leaves on rough barklike background.

TEASEL 1930s—Natural floral design on various background colors.

THORN APPLE 1930s—A thistle-type bloom on one side and fruit on the other. Various background colors.

TOPEO 1934—Snaillike ear handles on two sides. Modeled background. Various colors.

TUSCANY 1924-28—Solid color grapes and leaves molded to body. Various colors.

VELMOS 1916-19—Small red moss roses and green leaves incised on light matt-finish background.

VELMOSS 1934—Three leaves molded in relief with three stripes around center. Solid color.

VOLPATO 1918-23—Similar to Donatello with band of fruits and flowers.

WATER LILY 1940s—Natural flowers. Various background colors.

WHITE ROSE 1940s—Group of small white roses on various background colors.

WINCRAFT late 1940s—Various early designs, such as Pinecone and Bush Berry, included with gloss glaze.

WINDSOR 1930s—Edges impressed in box-type design with stylized flowers on sides. Various solid colors.

WISTERIA 1933—Natural flowers. Various background colors.

WOODLAND (ROZANE) 1905—Sgraffito technique with the decoration painted, with high-gloss glaze in autumn colors. Matt-finish background. Similar to Rozane Fugi. Also see text.

ZEPHYR LILY 1940s—Natural floral design. Various background colors.

The Roseville Company adopted a regular system of marking their wares. Paper labels alone were used on some pieces, expecially in the early and middle periods. Many of these labels have long since gone the way of all paper labels, which accounts for many pieces turning up unmarked. The name "Rozane" was dropped about 1917, but during the period Rozane Royal was made, no definite records were kept of the artist's signatures, although much of it is artist signed.

Roseville Pottery

Early period marks: 1900—1918

[During the first period, the marks were not consistent. Some pieces were marked with raised disks; on some, the line name appeared in a ribbon under the disk. Other pieces carried marks impressed or stamped in dark color; while still others bore no mark at all, having only paper labels.]

ROZANE
POTTERY

Stamped in black on Olympic line. Also includes title of decoration

Raised disks with raised lettering

ROZANE
RPCO

ROZANE
67-B
RPCO

RPCO RVPCO ROZANE
RPC

Impressed Impressed All impressed

Roseville Pottery

marks:

ROSEVILLE ROZANE POTTERY

Stamped on
Rozane Pattern

Jugiyama

Stamped on Rozane Fugi

ROSEVILLE Pottery

Earliest paper label. Dark with dark letter-
ing. Embossed. Does not include the R with the
V in the loop

Middle period marks, 1918—35:

During this period many pieces were unmarked
except with paper labels. Some patterns may appear
marked two ways. For instance, the Donatello line
is found marked in three ways: paper label, the RV
mark, or the Donatello line name.

DONATELLO RVPCO

Impressed

R

Printed

R

Printed

ROSEVILLE POTTERY R

Paper label. Black on silver. Includes
the RV mark

*Roseville
858-8"*

Incised with pattern number and size

Late period marks, 1935—54:

These marks are in high relief with "U. S. A."
added. Also bears the pattern number and size
in inches.

*Roseville
U.S.A.
858-8"*

*R USA
138-4"*

On small pieces

*Roseville
USA
934-10"
Mock Orange*

Pattern number and size.
Line name added

*156
raymor
by Roseville
USA*

Circa 1952

*Roseville
USA
1 BK-8"*

Appears on
baskets

Roseville Pottery

A partial list of artist names and monograms
found on Rozane ware:

V. Adams	VA	M. Myers	m-m
Jenny Burgoon		Grace Neff	
Anthony Dunlavy	AD	Hester Pillsbury	HP
Charles Duvall		Lois Rhead	
Frank Ferrel	F.F.	Frederick Hurten Rhead	
Gazo Foudji		Helen Smith	
Gussie Gerwick	G	F. Steel	
W. Hall		Tot Steel	₮
Madge Hurst	MH	R. Tate	
Josephine Imlay	J. I.	Mae Timberlake	M T
Mignon Martineau		Sarah Timberlake	S.T.
L. McGrath		Arthur Williams	AH
Lillie Mitchell	L M		

Southern Potteries Inc.
1920—1957
Blue Ridge Line

The Southern Potteries Incorporated was issued a charter on April 8th, 1920 with E. J. Owens as president and Ted Owens as vice president. The Pottery actually had its beginning in 1917 when E. J. Owens and son Ted migrated from Minerva, Ohio to the small town of Erwin, Tennessee, located in the picturesque valley near the crest of the Appalachian Mountains.

Mr. Owens engaged a group of well experienced potters from the bustling Ohio pottery district to commence operation of the Clinchfield Pottery. The enterprise being brand new, the company provided homes for over three dozen families who made the move to the new location. At the outset, the new Clinchfield Pottery manufactured dinnerware using only decals for the decoration. After two or three years of moderate business, the Pottery was sold to Charles W. Foreman who had formally been associated with Mr. Owens in the Ohio pottery district, at the Owens China Company.

Mr. Foreman introduced the technique of hand painting under the glaze with a myriad of bright colors on intricate shaped dinnerware, and soon "Blue Ridge", as it was named, became very popular. During peak production, the firm employed over one thousand people. "Blue Ridge" was distributed in many fine stores across the country, including showrooms in the Chicago Merchandise Mart. Advertisements appeared in several magazines, including *"House Beautiful", "The American Home"* and *"Better Homes and Gardens".* From the early 1940s to the mid 1950s, the "Blue Ridge" line was sold by Montgomery Wards and Sears Roebuck. During the latter part of this period, imports from foreign countries began to intrude into the ceramic market and their wares could be purchased at a more moderate price. The quality was high, especially the dinnerware, which seemed to

be more chip and crack resistant, consequently, business at Southern Potteries began to dwindle as it did in so many American Potteries. At this point in time, the stockholders voted to close the plant and the Southern Potteries was liquidated in 1957. The remaining merchandise was disposed of at a reduced price to customers who had previously ordered and/or advertised their products.

About 1945, a line of art ware was implemented. The most talented artists were allowed to create and sign their own innovations. These pieces are fine examples of American Folk Art and are highly prized by collectors. Pieces that have been found thus far are plates depicting cabins, old mill houses, birds, large turkey platters with various scenes with both hens and gobblers, and other wild life. A few of the artists that have been documented are Nelsene Q. Calhoun, Mae Garland (Hice), Ruby S. Hart, Frances Kyker (Treadway) and Lena Watts.

Production consisted mostly of dinnerware, however, many specialty items were also produced in fanciful shapes, including chocolate pots, vases, pitchers, tea pots, candy boxes, cigarette boxes with matching trays and "Toby" type jugs. These Tobys include the "American Indian" (6¾"), "Daniel Boone" (6"), "Paul Revere" (6¼") and a "Pioneer Woman" in a polk bonnet (6½"). The names are impressed on each of these with the exception of the Indian. A few copies of these have been made from the old molds by the Cash family (Ray and Pauline) at the Clinchfield Artware Pottery in Erwin, Tennessee, who acquired some of their molds when the Southern Potteries liquidated. These Tobys are somewhat larger, of different material, and are marked with Cash family logo instead of the Blue Ridge mark. Incidently, the Clinchfield Artware Pottery should not be confused with the

earlier Clinchfield Pottery.

In the dinnerware line, a very popular pattern among many, is the "French Peasant", an almost exact copy of the prestigious "Quimper" ware. Not all pieces in the Southern Potteries line are marked, however, it is much lighter in weight and thinner than the French ware. As was the case in many pieces of pottery, the wares did escape markings, in spite of the fact that Southern Potteries tried to mark everything, as they did maintain a separate department for marking their merchandise.

After observing the gay bright clear colors of the hand-painted Blue Ridge, it soon becomes recognizable on sight. No two pieces are exactly alike, although the artists worked from specified patterns. Each one would add a bud, a leaf, a stem, a tendril or some extra flowers according to their own taste and mood. Some of the pieces are almost entirely covered with designs, while others are small and dainty. These variations in design and the bold bright colors are the real rcognizable traits and appeal of the hand painted Blue Ridge ware.

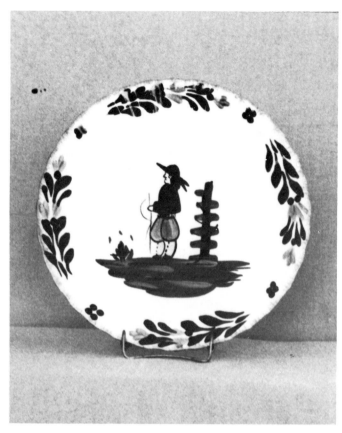

Blue Ridge line. French Peasant plate; 9". Author's collection

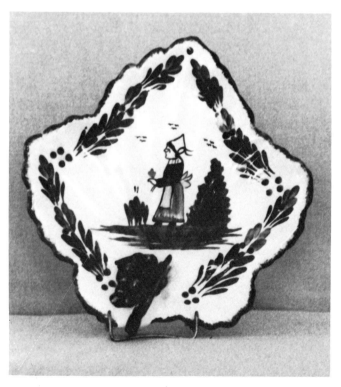

Blue Ridge line. French Peasant relish plate, 10". Author's collection

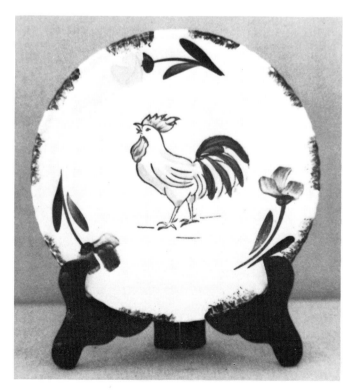

Blue Ridge; plate, 6 in. high. Phyllis Larson collection

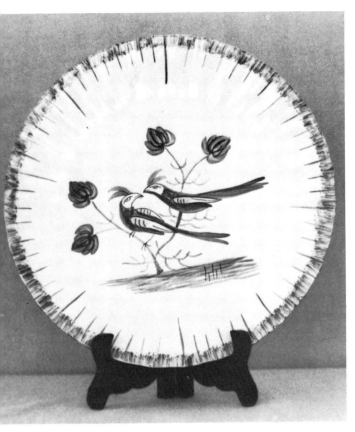

Blue Ridge; plate, 10 in. high.
Author's collection

Blue Ridge line. "Chick Pitcher"; 6".
Author's collection

Blue Ridge line. "American Indian"
jug; 6¾". Author's collection

Blue Ridge line. Profile…"American
Indian"; 6¾". Note tomahawk handle.
Author's collection

Southern Potteries. Léft: *Spiral pitcher; 7".* Right: *Betsy Jug; 8¾".* *London collection*

Southern Potteries Inc.
Blue Ridge Line

Blue Ridge
China
Hand Painted
Underglaze
Southern Potteries Inc
MADE IN U.SA.

Blue Ridge
Hand Painted
Underglaze
Southern Potteries Inc.
MADE IN U.S.A
10 C

All marks stamped

Tiffany Pottery
1905—1918

Tiffany Art Ware, including pottery, cannot be reflected upon without remembering its originator, Louis Comfort Tiffany, a man who became one of America's foremost designers, and a leading figure who influenced the art world with his magnificent glass windows, leaded lamp shades, entrancingly beautiful favrile glass and other executed forms of art..However, few people know of the opportunities he gave so many others through the Louis C. Tiffany Foundation.. an inducement for young artists, of every medium, to develop their individuality, although he did not always understand or agree with them. The many world-wide honors given him in recognition of his achievements were not only for his artistry, but also for a man whose friendship and sincerity was felt by all who knew him.

Born February 18, 1848, Louis C. Tiffany was the son of Charles L. Tiffany, founder of one of the world's leading jewelry and silver firms. By rights, he could have taken over the directorship of this firm. Instead, encouraged by his father, he chose the field of art.

Due to an endless inquisitiveness, he wished to probe every available field of artistic expression. Instead of confining himself to one medium, he expressed himself in many. Tiffany was an extraordinary colorist; as it was color he loved, he related it not only to canvas, but to all fields of art in which he participated.

He studied in New York with George Inness, one of America's most famous landscape artists, and later, in Paris with Leon Bailly. During a tour of Europe, he was introduced to the art nouveau school of art, in which such men as Emile Galle' and Eugene Rousseau were working in pottery and glass. This period of travel time took him all over the Continent and to north Africa where he was especially influenced by Islamic art; later apparent in his works.

In 1870, at the age of twenty-two, he was elected to membership in the Century Club and in 1871, became an associate member of the National Academy of Design. In 1880, he became a full academician. He was also a leader in the early modern school of painters---the ash-can and impressionistic. About this same time (1879), he began working with John LaFarge, experimenting in chemistry of glass, and formed the Louis C. Tiffany Company and Associated Artists. A few years later, these partnerships were dissolved and Tiffany organized the Tiffany glass and Decorating Company (1892), and Tiffany Furnaces at Corona, Long Island (1893). These were known as the Tiffany Studios.

After the death of his father in 1902, L. C. Tiffany became Vice President of the Tiffany & Company jewelry firm. He moved the Tiffany Studios, which incidently was never connected with the jewelry firm, to 45th and Madison Avenue in New York City. It was at this location that the greatest number of leaded lamp shades were produced. These lamp shades were used on all types of lamp bases made of pottery, porcelain and metal. Prior to 1905, the ceramic bases were purchased from other potteries, including Grueby Faience, Boston, Massachusetts and Lenox China of Trenton, New Jersey.

In 1905, Tiffany organized his own ceramic department and began manufacturing a variety of lamp bases as well as vases and bowls. Mr. Albert Southwick of Tiffany's pottery department and Mr. Frank G. Holmes of Lenox Incorporated, vied in producing the most original designs in this ware. Tiffany Favrile Pottery was individually designed and handmade in a variety of shapes and glazes. Some articles were moulded and some hand turned on the potter's wheel. A

teakwood type base was made of pottery and decorated to match some of the vases. Tiffany Favrile pottery was never decorated with painted designs, but the colors were impregnated into the clays and glazes. Some pieces were biscuit finished without the use of any kind of glaze. The earliest products were a deep ivory color, occasionally sponged with brown. This ware was known as "Ivory Favrile Pottery". Later, all tones of soft green were used; some were mat finished, while others were gloss glazed...with both smooth and rough surfaces. Tiffany Favrile pottery is decorated with natural appearing floral designs with some in the free flowing art nouveau style. There are few articles that were decorated with flowers moulded of natural clay and then applied.

Tiffany also created a ware using a pottery base clad with a skin-tight layer of bronze; a product very similar to Clewell Art ware. The interior of this Bronze pottery, as it was called, is covered with a gloss glaze.

Tiffany's pottery did not sell as readily as his other wares. Perhaps this was due to the advertising of this ware, since it was not given as prominent a place as was his fancy glass and leaded lamps. However, Tiffany pottery does have merit and each example is unique. During the period Favrile pottery was being manufactured, Mr. Tiffany visited the Studios about twice a week. Although there was little demand for this product, the people in charge concealed this fact from him, hoping perhaps, the demand for it would increase.

Tiffany Favrile pottery is always marked, incised on the base with the L. C. T. monogram---usually interwoven, which is generally referred to as the "Cipher" mark. The mark on the Bronze ware is impressed with a die.

Examples of all kinds of art pottery were displayed in Tiffany's fabulous home, Laurelton Hall, at Oyster Bay, Long Island. His home, like his works of art, expressed his love of nature. Here on 600 acres of magnificently landscaped grounds reposed the 84 room house in its Mission-Moorish style. It was elegant and crammed from wall to wall and floor to ceiling with hundreds of art objects. Later, by giving his home for a place of practical study of art, plus an endowment of one million dollars for continuing operation, he be-

lieved he had laid his plans for helping needy students of the future. Regretfully, increasing costs and taxes soon were larger than the fund provided and the multimillion dollar estate was sold, in 1950, for a fraction of its real value. In 1957, a worse disaster struck and the home was totally destroyed by fire. Fortunately however, in 1946, the contents of Laurelton Hall had been sold at auction at the Park-Bernet Galleries in New York.

At the time of Tiffany's death, January 17, 1933, at almost eighty five years of age, public taste had changed and his work was not accepted as fine art by most art critics and collectors. Nevertheless, in recent years, there has been renewed appreciation for the Tiffany Studio products; including Favrile pottery, one of the most scarce items.

Louis Comfort Tiffany, a great American, lives on today not only through the objects that came from his studios but also through the work of the artists who have been encouraged by the practical assistance he made possible through the Tiffany scholarships.

All types of glazes were employed on Tiffany pottery, including a soft matt, a rough-finished matt, a gloss finish, and the bronze and gold luster type, including the iridescent ware. The forms or shapes were very reminiscent of the Rookwood, Grueby, and other excellent wares of the same period.

Tiffany pottery is always marked with the Tiffany monogram in the base of each piece.

Tiffany marks:

Incised in the base

A cipher of interweaving letters was one type of monogram used by the Tiffany Studios for the signature (L. C. T.) on his pottery.

The "Cipher" mark is sometimes mistaken for an oriental mark. Generally when a particular metal was affixed to Tiffany pottery for the base, a full signature was impressed in the base.

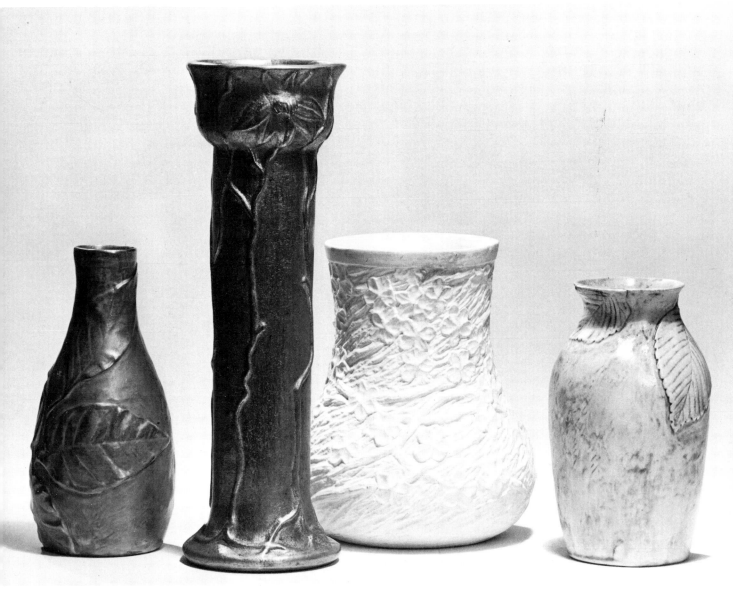

"Favrile" pottery vases. Left to right: "Gold Lustre" glaze with relief design of large leaves, signed with "L. C. T." cipher in base, 5 in. high; "Bronze Pottery," silver-plated copper exterior and mottled green glazed interior, relief decoration of flowers, leaves, and vines, impressed "L. C. Tiffany—Favrile—Bronze Pottery—B. P. 313," on copper base, 8¼ in. high; unglazed buff-colored vase with molded relief of flowers, leaves, and vines, signed with "L. C. T." cipher, 5 1/8 in. high; buff and tan, molded relief of leaves. Signed "L. C. T." 4¾ in. high. Collection of Mr. and Mrs. R. L. Suppes; Brooks photo

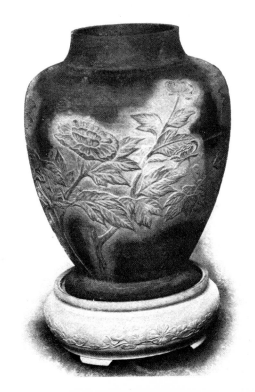

Tiffany ware; Ivory Favrile pottery. Photo shown in 1907 Bayview Magazine

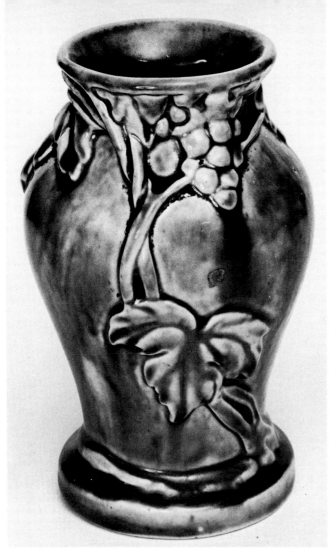

↑ *Tiffany; mottled green and yellow glazed pottery vase, incised "LCT" in base. Height 5 inches. Collection of A. Christian Revi; Knight photo*

Tiffany pottery vase. Hand thrown, pale green, signed with Tiffany monogram, 5 in. high. Collection of Bill
↓ *Runyon; Johnson photo*

Mottled buff and green glazed pottery vase; incised "LCT" in base. Calla lilies and leaves in relief. Height 13 inches. Collection of A. Christian Revi; Knight photo

Van Briggle Pottery
1901—

The Van Briggle Pottery was established in 1901 by Artus Van Briggle in the shadow of Pikes Peak, where the colors of the beautiful sunsets and the countryside are captured in Colorado's clay. Here, in Colorado Springs, Van Briggle pottery continues to be made and sold. The company has never employed any agents, nor is its ware sold in retail stores. All purchases are made directly at the factory. Visitors are invited to make a tour of the plant and watch the artists at work, the plant being open daily except Sunday. The only process the public is not allowed to see is the glazing which, after all these years, is still a carefully guarded secret.

Artus Van Briggle was born in Felicity, Ohio, on March 21, 1869. As a lad of seventeen, he became quite interested in art pottery and, in spite of poor health, went to Cincinnati, Ohio, to study under Karl Langenbeck, of the Avon Pottery (1886). His tenure with the Avon Pottery was short and he joined Rookwood a year later (1887), when the Avon Pottery closed. By 1894 he had become quite an accomplished artist and had already been given the title of senior artist at Rookwood, and had been provided with his own private studio. The Rookwood Company, taking notice of his fine talent, sent him to Paris, France, for additional study, paying a portion of his expenses. There he met Anne Lawrence Gregory, to whom he became engaged in 1895 and whom he married June 12, 1902.

Van Briggle returned from Europe in the summer of 1896 and remained at Rookwood for another three years. During this period his efforts were turned toward perfecting a matt-type finish which was adopted by Rookwood. Throughout his tenure with Rookwood he was considered one of their finest artists. However, because of ill health and on orders from his doctor, he was forced to seek a new climate. This separation from Rookwood took Van Briggle to Colorado Springs, where he opened his own Pottery. The experience he gained while with Rookwood and in his studies abroad gave him the knowledge he needed for his own factory. Rookwood was not pleased with his departure as they had invested quite a substantial sum of money toward his education in the field of ceramics. Notwithstanding Rookwood's displeasure, Mrs. Storer remained his friend and advisor and contributed the necessary funds to open his first studio Pottery in 1899, with full operation commencing in 1901.

Anne Lawrence Gregory Van Briggle was born in Plattsburg, New York, on July 11, 1868. At the time she met Artus she was studying painting in the Beaux Arts in Paris. In the Pottery today hangs a portrait of Artus Van Briggle which was painted by Anne during this period. She was quite a talented artist in her own right. She worked hand-in-hand with Artus and created many of the early pieces, as well as the later Van Briggle.

Artus Van Briggle died July 4, 1904, leaving his widow to carry on the pottery business. During the five-year period that he personally operated his own factory he took more awards than any other American potter of that era. Some of the awards that were won during these early days were at the St. Louis Exposition of 1904, at the Lewis and Clark Centennial of 1905, and at the Arts and Crafts Exhibition of Boston. It is interesting to note that Van Briggle pottery may be found among the permanent collections of the Louvre, Paris, the South Kensington Museum, London, the Smithsonian Institution, Washington, D.C., and several other important museums around the world.

As a brave young widow, Anne continued experimenting with the Colorado clays, and the Pottery progressed rapidly.

In 1907 a beautiful building, designed by a Holland Dutch architect, Nicholas Van den Arend, was erected at 300 West Uintah Street. This was, indeed, a fitting memorial to Artus Van Briggle. The mammoth kilns were built at tremendous cost and were in full operation until the fall of 1968, when the Uintah Street plant ceased operations. All facilities were transferred to the 21st Street plant where accessibility to the interstate highway was more advantageous.

In 1908 Anne Van Briggle was married to E. A. Ritter, a mining engineer. She remained as art director at the Pottery, always actively creating, until 1923. She died November 15, 1929.

The potters developed and introduced two new glazes as a tribute to Mrs. Ritter. One was "Jet Black" with a mirror finish. The other was "Honey Gold," also with a gloss glaze, capturing the colors of autumn leaves.

Early Chinese potters, and their secret of wonderful glazing, became famous centuries before pottery was made in the Western world. Their secrets were lost with them, to be born again in Van Briggle pottery. In China's centuries of history, the emperors selected certain colors in pottery as their favorites. For instance the Ming dynasty was the patron turquoise blue, whose delicate tints defied every effort of imitation for more than 500 years. This color was successfully obtained by Artus Van Briggle. The American innovation of this finish is highlighted by spots of royal blue, brushed or sprayed on over the turquoise in beautiful shaded work. This color, known as "Turquoise Ming," is still in production. Another is the maroon red, brushed with a dark blue-green, known as "Persian Rose," which is no longer in production. This is a copy of old Persian, deep rouge-tinted pottery. Another color was a light "off-white" shade known as "Moon Glo." In the early Van Briggle, other colors will be found, such as dark blue, dark brown, dark green, yellow, and lavender, as well as the colors that are used today.

Van Briggle pottery was made in many types of vases, tableware, lamps, paperweights, bookends, and small bric-a-brac, all with molded designs. However, the outstanding and most beautiful pieces are the modeled or sculptured art nouveau figures, some of which are quite large. The details of the human figures often suggest the emergence from water, the effect being very artistic. In some instances, these figures are used as "flower frogs" in large bowls. Perhaps the two most important Van Briggle figures are "Lorelei" and "Despondency," the latter being that of a man. Both figures have received recognition in the art nouveau field. Also made by the Van Briggle Pottery were the small molded animals in various colors.

From the very beginning, Van Briggle ware was marked with the double "A" in a square, and the Company still claims there is no such thing as an unmarked piece of Van Briggle. The marks that accompanied the combined "A" marks were changed from time to time.

It has previously been believed the Roman numerals appearing on the earliest wares had been assigned to Anne, Bangs and Artus respectively, however, it has since been proven to be erroneous. These Roman numerals were used on the earliest wares to indicate the type of clay being utilized. The Roman numeral II indicated the type of clay used in 1901. The year 1902 they employed both numbers II and III. 1903 they used the number III and the pattern number was also included. In 1904 the number V was applied along with other marks. Various other Roman numerals were used until 1907. No item has been seen with Roman numeral number I. Arabic numerals appearing in a circle are the mark of the person who finished the article. Beginning in 1902, each item had a designated pattern number.

At the outset...1900 to 1907, all pieces included the yearly date. From 1908 to 1911, the dates were deleted. In 1912, Van Briggle resumed the yearly dating practice until late 1918. During the years 1919 and 1920, only a few articles were dated. Pieces made during these years were glazed with a heavy glaze that partially covered the bottom. Articles from 1922 to 1929 included "U.S.A." together with the regular double "A" mark. Since 1930, only a standard white clay has been used, consequently, any article on dark clay was made prior to 1930. After 1920, "Colorado Springs", incised in script, was added to the mark...at times abbreviated according to the size of the article. The numbers beside the Van Briggle mark do not

indicate the date but are the Company pattern numbers, or numbers used by the people who finished the item. No dates have been included on Van Briggle pieces since 1921.

During the 1950s and 1960s, a line with a gloss glaze was introduced. This line is incised on the base "Anna Van Briggle" or just "Anna Van" with or without the use of the joined "A" mark. This has lead some collectors to believe this denotes an early creation by Anne, however, she never spelled her name using an "A" as the final letter in her name. No products were made under the direction and/or by Anne Van Briggle after 1912.

The Van Briggle Pottery continues to produce copies of the early designs including the popular figures. A few new items have been added to the line, including a large owl and various small animal figures. The glaze most often applied to these is "Ming Turquoise", however, the splotches of blue on these figures is a much lighter color tone than was used on the older wares.

The Van Briggle Company claims there are no "seconds" in the pottery line. Any piece not coming up to standard is completely destroyed.

Since Artus Van Briggle was among the first Americans to think of art as a contributor to the economy of the nation, the continued importance of the Pottery he founded justifies his confidence in the financial success of industry with high artistic standards.

Blue vase with three Indian heads; 11½ in. high. Orren photo

"Turquoise Ming." Figure 9 in. high, bowl 15 by 10 in. Johnson photo

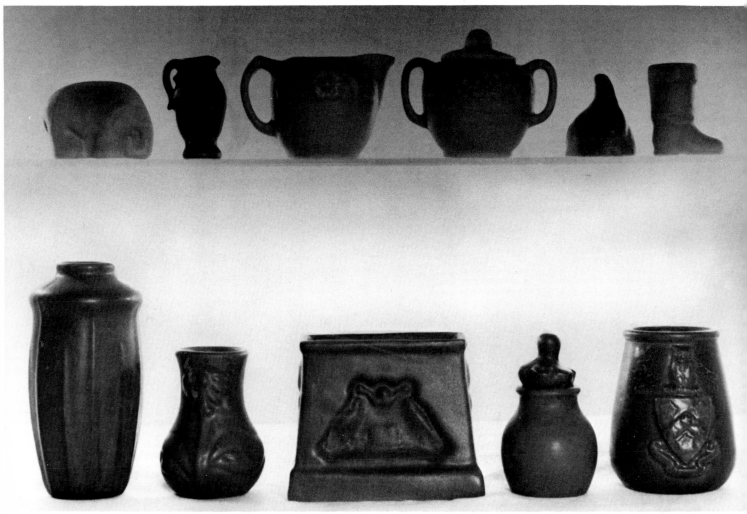

Van Briggle ware. Top row, left to right: *"Turquoise Ming" elephant, 2¼-in. high; "Persian Rose" handled vase, 3 in. high; "Turquoise Ming" sugar and creamer, 3 in. high; rabbit, green, 2½-in. high; "Turquoise Ming" boot, 2¾-in. high. Bottom row: vase, brown, 6½-in. high;* "Persian Rose" vase, blue flowers, 4 in. high. "Persian Rose" card holder, blue birds, dated ca. 1909, 4½ in. high; "Persian Rose" covered jar, dated 1915, 4½-in. high; handled mug, dark blue, dated 1916, 4½ in. high. Johnson photo

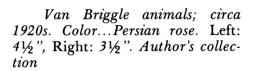

Van Briggle animals; circa 1920s. Color...Persian rose. Left: 4½", Right: 3½". Author's collection

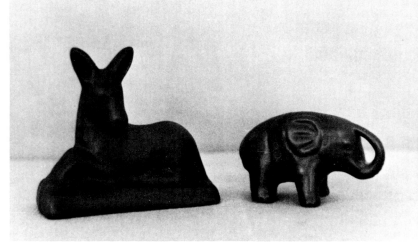

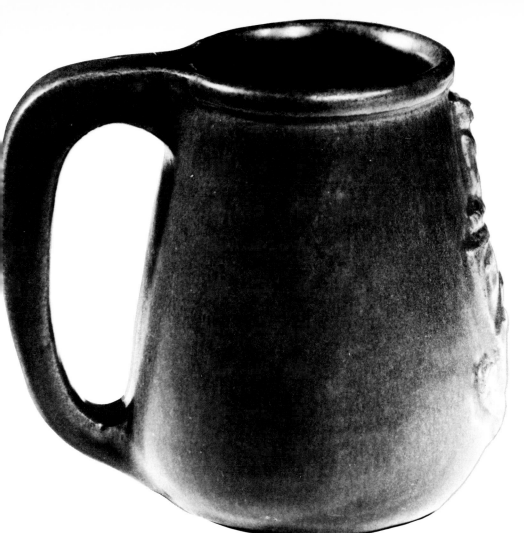

Van Briggle Pottery. Left: Mug, shades of brown and green, marked "Van Briggle 1902," 4½ in. high. Right: plaque, shades of brown, green and blue, marked "Van Briggle 1903," 8½ in. diameter. Collection of R. E. and F. G. O'Brien Jr.; Knight photo

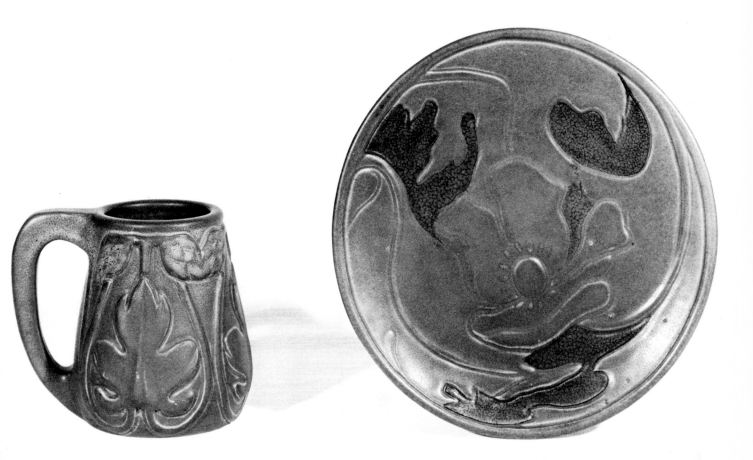

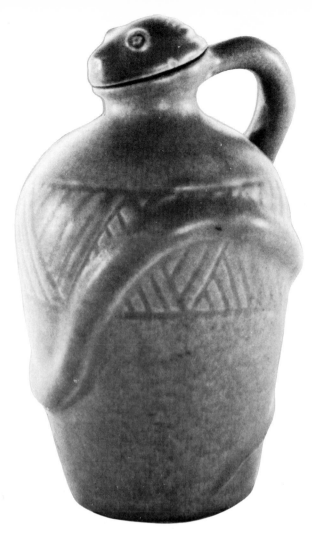

Green jug. Dated "1902", 7 in. high. Collection of Andy Anderson; Johnson photo

Van Briggle Pottery

The marks found on Van Briggle pottery are incised by hand on the base of each piece:

Early period: 1901-1920

VAN BRIGGLE
1902

1918

USA was added between 1922 to 1929

VAN BRIGGLE
U.S.A.

Late period: 1920 to the present

VAN BRIGGLE
Colo Spgs
original

VAN BRIGGLE
Colo. SPGS.

Vernon Kilns
1931—1958

In July 1931, Mr. Faye G. Bennison (1883—1974) purchased the Poxon China Company in Vernon, California, which had been operated by the Poxon family since 1916. He immediately changed the name to Vernon Kilns. Mr. Bennison was a creative patriotic man with a love of history and the personalities and places that were involved.

The Vernon pottery is unique in that most pieces are pictorals depicting memorable events. These include American presidents, famous personalities, patriots, nostalgic bits of history and places of interest over the entire country.

Mr. Bennison attended Morgan Park Academy at Morgan Park, Illinois and later attended a Columbia affiliate in New York, called the Bond Institute of Mercantile Training. For a time after his marriage to Mildred in 1910, he operated a dry goods store in Cedar Falls, Iowa. In 1921, he sold the store and migrated to California with his wife and three daughters. He gained employment as general manager and vice president of a glass and bottle factory that later was purchased by Owens-Illinois glass Company.

In the late 1930s, a new department was established at Vernon Kilns with Mr. Gale Turnbull (1889—) as supervisor. He was a well known artist involved in painting and engraving, whose creations were on exhibit in the Brooklyn Museum in New York and other museums. Mr. Bennison, using his pursuasive personality, was able to employ famous and gifted artists and allowed them the freedom to originate designs using their own ideas.

In the early 1940s, Vernon Kilns entered into a contract with the Walt Disney Studios to use the Walt Disney designs for vases, tableware, figurines, memorabilia and the like. Many of the figurines were reproductions of actual models that were used in the Disney animated film "Fantasia". These figures were hand painted and required so much time to complete that they proved too costly to produce in vast quantities, consequently, they were discontinued in a short time. The Vernon Kilns extremely rare "Baby Weems" was modeled after the figure of Baby Weems that appeared in the full length animated film "The Reluctant Dragon". Other charming copies of animated cartoon figures were "Dumbo the Elephant" and "Timothy Mouse". These figures were only in production for approximately eighteen months. All of the Disney figures are stamped in black on the bottom---"Vernon Kilns USA, Designed by Walt Disney" and dated 1940 or 1941.

The vases and bowls were cast in molds with the figures of "Tinkerbell" and others in high relief. Disney also created designs from "Fantasia" on several sets of dinnerware. They also made, in limited numbers, figurines of famous Hollywood movie stars, and these are extremely uncommon.

Rockwell Kent (1882—1971) created several exciting designs for Vernon Kilns. Mr. Kent was a celebrated artist, lecturer and explorer, having explored the Artic and Greenland. One of his most colorful patterns was "Salamina", named for his cherished housekeeper, about whom he had earlier written a book, titled "Salamina". He designed two other very interesting lines; "Moby Dick" and "Our America"; the latter depicting typical scenes and activities as seen across America. These included oil fields, The Statue of Liberty, The grand Canyon, harvest scenes and many others. Actually, there were over thirty five of these scenes in all. The "Moby Dick" pattern portrays ships and scenes from the thrilling story of the sea, "Moby Dick" by Herman Melville, and is one of the most sought after by collectors.

Don Blanding (1894—1957) was another well known artist, illustrator, lecturer, author and world traveler. He was also known as the Hawaiian poet, as he lived among the people for a period of time and wrote books of poetry about the natives and the Islands, and illustrated them himself. When he wasn't traveling, he kept a studio in California where he accomplished his designs for Vernon Kilns. One of his writings was *"Leaves from a Grass House"*. Most of his designs were reminescent of the exotic flowers and the terrain of the Islands.

Mr. Cavett was a young talented artist who took temporary leave from his position at Vernon Kilns to join the paratroopers during World War II, but was killed while in training. He is credited with the designs of the so called "Bit Plates". These plates depict graphic scenes of Americana all over the United States, and came in a series of eight, which included the "Old South", "Old New England", the "Old West", the "Old Northwest", the "Old Southwest" and the "Old Middlewest". The bit plates depicting the California Missions came in a series of sixteen. Two of these portrayed "San Juan Capistrano" and "San Gabriel".

Many other well known artists worked on different lines at Vernon Kilns. These included Paul Davidson who designed many commissioned pieces. May and Vieve Hamilton, sisters who were listed in Who's Who in American Art---Vol I-III; Sharon Merrill was known for art deco designs. Allen F. Brewer Jr. known for his equestrian series. Orpha Klinker, who worked on the State and University commemorative plates, was listed in Who's Who in American Art in 1962.

In the mid 1950s, business began to dwindle due to booming imports and high labor costs, consequently, the plant was sold in 1958. Practically every article is marked and some are artist signed. The commemorative plates usually have some facts about the subjects printed on the reverse.

When the Pottery closed in 1958, the trade name was purchased by Metlox Pottery of California. Their pottery line called Vernon Ware is marked with two words, "Vernon Ware" and should not be confused with Vernon Kilns, as it is spelled as one word, "Vernonware".

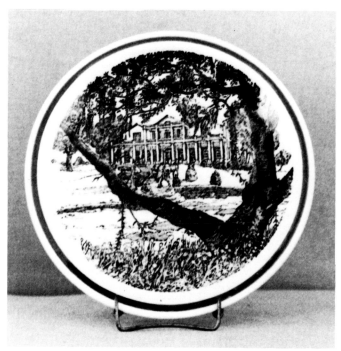

Vernon Kiln, 8½" "Bit Plate", signed by Cavett, bits of the old south, "A Southern Mansion". Author's collection

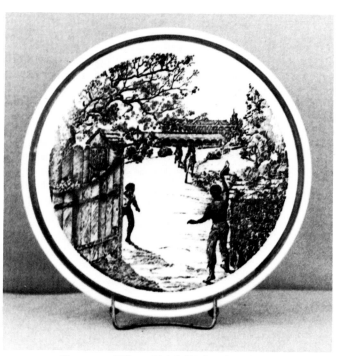

Vernon Kiln, 8½" "Bit Plate", signed by Cavett, "Off to the Hunt", Bits of the old South. Author's collection

Vernon Kilns Pottery; 16 inch commemorative plate. Turquoise with dark blue border. Don Goodwin collection; Rocky Joe Denton photo

Vernon Kilns Pottery; Hawaiian flower plates by Don Blanding. "Lei Lani" pattern. Left to right: 9½ inches, 10½ inches, 12 inches, and 16½ inches. Don Goodwin collection; Rocky Joe Denton photo

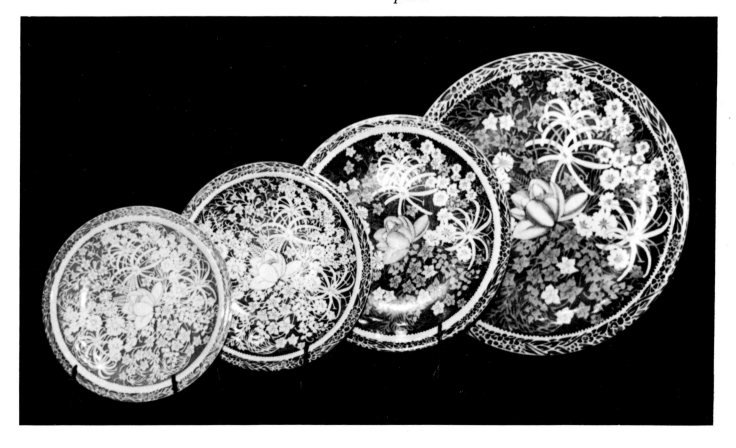

274

Vernon Kilns Pottery; Top left: 8½ inch "French Opera Reproduction" series. Top right: 8½ inch "Music Masters" series. Ignace Jan Paderewski, Polish pianist and composer. Center: train plate, 10½ inches. "The Emma Sweeney". Bottom left: 9½ inches. "Our America" series by Rockwell Kent. Draw bridge in downtown Chicago. Lower right: 9½ inch "Moby Dick" series by Rockwell Kent. Don Goodwin collection; Rocky Joe Denton photo

Vernon Kilns Pottery; Left: "Bits of Old New England" plate, 12 inches. ["Tapping for Sugar"] Right: "Salamina" plate, 12¼ inches by Rockwell Kent.

Bottom: Walt Disney, 9½ inch plate. "Fantasia" line. "Fairyland" pattern. Don Goodwin collection; Rocky Joe Denton photo

Vernon Kilns Pottery; Sitting "Dumbo"-5". "Dumbo"-wearing clown hat-5½" inches. Blue with pink trim. Disney creations. Don Goodwin collection; Rocky Joe Denton photo

Vernon Kilns Pottery; bowl, 5½ inches tall, 8½ inches wide. Designed by Jane Bennison [Howell] Green glaze. Don Goodwin collection; Rocky Joe Denton photo

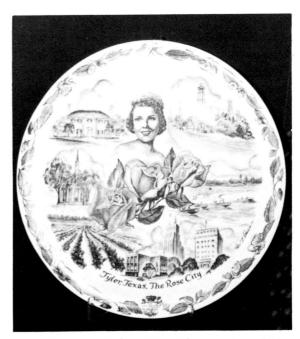

Vernon Kiln; 10" plate, signed by Paul Davidson. Author's collection

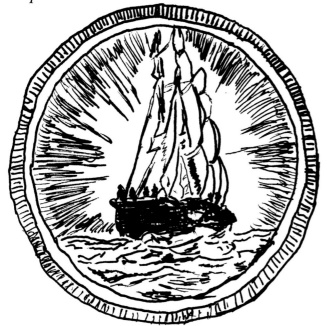

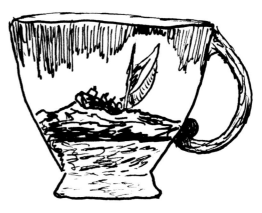

Sketches of Rockwell Kent's "Moby Dick"

Vernon Kilns Pottery

All marks imprinted:

MOBY DICK
Designed by
Rockwell Kent
VERNON KILNS
MADE IN USA

HAWAIIAN FLOWERS
Designed by
Aloha
Ton Blanding
VERNON KILNS
MADE IN USA

SALAMINA
Designed by
Rockwell Kent
VERNON KILNS
MADE IN USA

Bits of the Old South
"A SOUTHERN Mansion"
Designed Copyrighted
AND ENGRAVED BY
VERNON KILNS
U.SA

DESIGNED BY
WALT DISNEY
Copyright 1940
VERNON KILNS
MADE IN USA

Hand Painted by
VERNON KILNS
U.S.A.

DISNEY
COPYRIGHTED
1941

VERNON
KILNS
USA

Marks on Baby Weems feet

Vernon Kilns Pottery; ceramic display sign showing the mark applied to Vernon Ware made by Metlox Potteries. Don Goodwin collection; Rocky Joe Denton photo

Weller Pottery
1872—1948

From just plain paint-covered clay flower-pots, which Samuel A. Weller made and sold from house to house, grew one of the largest potteries in America. Weller was a poor country boy who was born in Muskingum County, Ohio. His life could be considered a "rags to riches" story. During his boyhood he worked at the Bluebird Potteries, near his home, where he learned the art of "throwing a pot" on the potter's wheel. In 1872 he set up his own small, unpretentious shop in Fulton-ham, Ohio, and there worked every minute until he could get a wagonload of his paint-covered flowerpots ready for market. The same horse that helped furnish power to run the machinery used in making the stoneware and flowerpots also drew the wagon in which these wares were hauled to the purchaser.

Weller was a supersalesman and a still better businessman, for he had advanced far enough by 1882 to open his first factory, on Pierce Street in Zanesville. Numerous potteries thrived in Zanesville, which was often referred to as "Clay City." Weller continued to prosper. In 1890 he built a three-story building at Putnam commons, on Cemetery Drive, which was thereafter referred to as the Putnam Plant. Here, some sixty workers were employed.

In 1895 Weller purchased the Lon-huda Pottery in Steubenville, Ohio; with the purchase came W. A. Long and his process for making "Lonhuda," an under-the--glaze slip-decorated ware. Weller immediately entered the art-pottery field and began making the hand-decorated Lonhuda-type pottery. Since the name "Lonhuda" belonged to Mr. Long and could not be used by Weller, the new ware was called "Louwelsa," incorporating Weller's name with that of his daughter, Louise—"Lou" from Louise and "wel" from Weller, and "sa," Weller's initials. Louwelsa is a beautiful ware in delicate

harmonizing shades of brown and yellow, with velvety shadows and shimmering highlights. It was very popular in the twenty-three years it was made (1895-1918), and over five hundred different items were produced during these years. The rarest and most sought-after pieces of Louwelsa are portraits and pictures of birds, fish, and animals. Other rarities are pieces trimmed with silver overlay and silver deposit. These were extremely scarce in the early days, and even more so today. Louwelsa ware can also be found in a shaded royal blue, which is indeed a rarity.

W. A. Long remained less than a year at the Weller Pottery and was succeeded as art director by Charles Babcock Upjohn. Upjohn worked for Weller for about a decade (1895-1905), and then retired. Later he became Professor of Art at Columbia University, a post he occupied for twenty-five years.

During his tenure with Weller potter-ies, Upjohn created the now-famous "Dickens Ware." In the late 1800s Doulton of England was making an exquisite line of figurines, tableware, and accessories de-picting characters from the Charles Dick-ens stories. These lines were selling well in England and also in America. Weller, being an alert businessman, decided to "hop on the bandwagon" and commis-sioned Upjohn to create a line called "Dickens Ware." Weller jokingly said, "If Dickens can create a character named Sam Weller, the least I can do is name a line after him." Upjohn immediately began ex-perimenting to find a suitable ware to bear this name. He changed the background color on the Louwelsa-type lines to solid colors of dark blue, dark green, and a light chocolate brown; on some pieces the colors were shaded from dark to light. Some of these first-line items will be found with "Trial-D" incised on the inside.

In a matter of months Upjohn

introduced the "second-line" Dickens Ware, which was destined to become the most sought after by collectors of American art pottery today. Pieces signed by Upjohn are highly treasured. Much of his work was very well executed and gave the effect of being three dimensional. This ware was decorated by the sgraffito method, being incised with a sharp tool by hand, with the background sprayed or brushed, and the colors blended together in beautiful shadow work. The subjects were slip painted with natural colors, then covered with a glaze. The glazes used on the second line varied from a soft matt to a high-gloss finish. The soft matt and semi-gloss are the glazes most often encountered. The pieces with the high-gloss finish are indeed very rare. A dark, reddish brown clay was usually used in the second-line Dickens Ware; however, on occasion, a light-colored clay was used.

The colors most often seen in the second-line Dickens Ware are rich chocolate browns shaded to a blue-green or turquoise. Oftentimes the rich brown alone was used, and sometimes the blue-green or turquoise was used alone, blended from dark to light. It was also made in other colors, such as a beautiful true royal blue, shaded from light to dark. One of the rarest colors is the pink, a peach pink with shadings of bluish gray. Another rare color is the white. It is quite possible that other colors were used, but these are all the author has seen. The exact number of years the second line was made has not yet been established; a good estimate might be a decade.

The third-line Dickens Ware, which was introduced about 1904 or 1905, was a high-glaze pottery with under-the-glaze slip painting. The background is dark, shading to light, very similar to Weller's "Eocean." The glaze on this line is clear. This is, by and large, the rarest of the Dickens Ware by Weller. The obverse has a Dickens character slip painted under a high-gloss glaze. On the reverse side is a raised disk bearing the name of the character and the story in which he appeared. The disks were molded by Gordon Mull and applied to various pieces. When these disks appear alone, the ware is sometimes referred to as "Cameo" Dickens; however, it is part of the third-line Dickens Ware. At times two disks will appear on the reverse side of a slip-decorated piece; one with the Charles Dickens cameo and the other with the title.

The subjects appearing on Dickens Ware are not always taken from the Charles Dickens tales. Some are portraits of Indians, with the Indian's name, such as "Fox Tail," "Daring Fox," or "White Cloud," appearing on the piece. Some are people at play, such as golfers or men playing checkers, garbed in costumes of the period. Tavern scenes are found on many pieces. One of the most common subjects is a monk, either in full figure or bust. Birds, fish, and other natural subjects can be added to this list. It was rumored that one artist, Levi Burgess, was paid one dollar for each Indian portrait he created on Dickens Ware pieces. Other Weller artists also created very fine Indian portraits, and these too are eagerly sought after by collectors.

The name "Dickens Ware" appears on almost all pieces of the first and second lines; however, the third line is marked only "Weller" on the base.

Most collectors of American art pottery are generally concerned with the ornate hand-decorated ware of the art nouveau and post-art nouveau periods (1890 to the early 1930s). A pamphlet published by the Weller Pottery in 1905 contained this statement. "Our factory has increased in size until today it stands the largest pottery in the world, covering over 300,000 feet of floor space." At this time, Weller had originated more than twenty different styles of ware, including the "Sicardo." Mr. Weller, who was always searching for new talent and new ideas, imported two Frenchmen to create a line of iridescent pottery. Jacques Sicard and his assistant, Henri Gellie, were making a beautiful metallic lusterware for the Clement Massier Pottery at Golfe Juan, France. Weller induced them to come to America to fashion a line of similar ware for his company. Arriving in this country sometime during 1901, they began making a metallic luster pottery with floral and geometric designs developed within the glaze. The colors for the most part are beautiful dark rich hues, blending from one shade to another. They consist of dark rich wine red, bright green, and peacock blue. Occasionally the reds and blues are used one over the other, giving an illusion

of vivid purple. Each piece is highlighted with a gold or silver sheen. The inside shows a deep rose, evidently the first coat of glaze used on Sicardo. Sicardo follows closely in form the elegant classic shapes of the iridescent glass of the art nouveau period. Some items have molded designs in the body and some are reticulated. Sicardo was made mostly in ornamental vessels—vases, bowls, bonbon dishes, candlesticks, umbrella stands, jardinieres, plaques, and jewel boxes. The sizes in Sicardo ware are varied, some are as small as two inches, while others are as much as thirty inches in height.

This excellent line of art pottery was named after its creator by adding the letter "O" to his surname. Sicardo was a sensation from the very beginning and added prestige to the Weller art wares. It was very costly to produce, and due to the high cost of production, Weller claimed this line never made his factory any money. Some pieces reportedly were priced for upwards of three hundred dollars, being sold in exclusive jewelry stores, including Tiffany's.

The method used in making Sicardo was a laborious and time-consuming process. It was a difficult ware to produce and many pieces were damaged in the process or in the kiln and hence had to be discarded. The glaze was heavy and ran badly. There are pinpoint holes, craters, and thick spots (called bubbles) on many pieces. There is also evidence that the "stilts," on the base, had to be broken off on some articles. ("Stilts" are small pins or fins made of clay used to raise the wares from the floor of the saggers, thus preventing the glaze from sticking to the shelves. The stilts were usually in groups of three. If they happened to stick to the ware, they were removed with a gentle tap. The scars are often visible on pieces with a heavy glaze.) The excess glaze on the bottoms was then polished down on a grinding wheel to make smooth resting surfaces for the vessels. The glaze was a difficult one to fire as the colors seem to have burned out easily. The surface on some Sicardo pieces that were not exposed to the heat evenly have light spots and streaks, while others have a rather sickly green appearance and seem to have lost all of their vivid colors completely.

Sicard and Gellie created an air of secrecy and mystery about the making of Sicardo, and it was rumored they worked behind locked doors conversing in a French-Swiss dialect so that no one could understand what they were saying, if they were overheard by someone who understood the French language. It was also rumored that Weller requested his other artists to obtain the formula for the making of Sicardo, by unorthodox means if necessary. However, the artists were unable to discover any of the processes. Sicard and Gellie managed to be convincing and imparted an air of secrecy about Sicardo which continues to intrigue people today. Although these two men endeavored to keep it a secret the process was not a complete mystery, since a similar line was developed by other potteries, including Tiffany, Roseville, and Owens. It must be understood that these other potteries did not use the exact process for the making of this lusterware, but that the end results were almost a duplication.

Sicard was proud of his product and claimed that every piece was signed. The signature consists of the name "Sicard" or "Sicardo," along with the name "Weller," no matter how insignificant the item. Most pieces are signed on the surface of the vessels near the bottom; some others were signed near the center, with "Sicard" or "Sicardo" on one side and "Weller" on the other side. Occasionally a piece will be marked with the impressed "Weller," or just "W" on the base. Pieces made by Sicard on special order were signed "J. Sicard," without the name Weller. Two techniques were used in the signing: in one method, the signature was worked in with the predetermined design and became part of the decoration; in the other method, the name was scratched in over the design before the final firing. On close observation the iridescence in the scratched signature is clearly visible.

The clay used in Sicardo was usually light in color; however, some of the earlier pieces are made of a dark reddish brown clay of the same type used on the second-line Dickens Ware.

Sicard, a bachelor, returned to his native France in 1907, where he operated a small pottery until his death in 1923. Gellie remained in America for a longer period of time; then he also returned, with his wife and two sons, to his homeland. He died in

1917, after being wounded in the Battle of Verdun in World War I. Mrs. Christiana Gellie, after their return to France, continued to correspond for several years with the many friends they had made in America.

Weller Sicardo was made for approximately seven years and is quite scarce today. It is considered by most collectors and students of American art pottery to be the most renowned line ever made at the Weller Pottery.

In 1903 Sam Weller built the Weller Theater and decorated it extensively with Weller pottery. Even the box office was adorned with Dickens Ware; in the lobby were a pair of large Sicardo vases.

Frederick Alfred Rhead followed Upjohn as art director, a position he held from 1905 till 1920. Rhead was an Englishman who had worked for several potteries in England, including Minton, where he decorated the beautiful "Pate sur Pate" in the style of L. Solon. He and his brother, G. W. Rhead, were co-authors of the book *Staffordshire Pots and Potters,* published in 1906.

By 1905 Weller Pottery had grown to a mammoth institution, sprawling over four acres of ground, having 600 employees, and operating twenty-three kilns with 300,000 feet of floor space. Twenty-two different lines had already been introduced to the public and three railroad boxcars of goods were shipped each day to the purchasers. The company, at this time, was definitely enjoying a thriving business, with an encouraging future ahead.

The various Weller lines seem to have been created by trial and error. The first line, the "Louwelsa" ware, was a duplication of Rookwood's standard glaze brown ware, with the high-gloss glaze. The "Aurelian" ware was merely Louwelsa, with a changed background. This background was sponged-on splashed effects, which appears somewhat like a distant forest fire, with the slip painting under the same standard glaze as Louwelsa. Later, the background colors of Louwelsa were changed from browns to shaded pastel colors of pink, blue, green, and gray. This afforded the artists a greater range of color for the under-the-glaze painting. These lines were called "Eocean," "Auroro," "Etna," "Floretta," and "Rochelle."

The following description of Eocean

and third-line Dickens Ware was given by Marcus Benjamin in his article, *"American Art Pottery,"* published in 1907.

The name Eocean is applied to those wares which are of light body and have the background colors blended with an atomizer. Pale and delicate blues, grays and green color effects are the characteristics of this ware. The decorations are of flowers, fruits, and figures; sometimes the latter are in relief affording a pleasing effect, and when characters from the works of Charles Dickens are presented the ware takes its name from the great novelist and is called Dickensware.

The Weller artists were constantly developing new decorations and glazes. When Rookwood introduced the Vellum glaze in 1904, Weller retaliated with a similar matt-glaze line called "Dresden." This line contained a Dutch mill scene using, at times, Dutch boy and girl figures in blue on blue, with a touch of green blended into the light blue background. At this same time, another etched line was introduced, in the style of the second-line Dickens Ware. This was labeled "Etched Matt." Floretta also came "etched" in the same manner. Perhaps other lines were also further decorated in the sgraffito method. "Turada" and "Jap Birdimal" lines are the sgraffito type, with the incisions inlaid with designs standing out in relief from the surface of the vessel.

In 1904 another line, "L'Art Nouveau," was introduced. Most L'Art Nouveau pieces have a soft velvetlike finish; however, some have a semigloss or gloss glaze. Decorations on this line are the traditional misty flowing figures of the period. Most L'Art Nouveau pieces are pastel, but occasionally pieces will be found with a dark brown high glaze.

During the period directly after World War I, Weller felt the need for manufacturing a less expensive line of ware. It was then that the molded lines were introduced. One of the most prolific artists to model designs for these lines was Rudolph Lorber, a native of Mettlach, Germany. Lorber worked in the Putnam Plant studio, under the supervision of Ed Pickens, a brother of Mrs. S. A. Weller.

The able potter who turned the shapes was Aloysius J. Schwerber. Many talented artists worked at the Putnam studio, including Karl Kappes, who became famous for his "Paintings in Oils."

Most of the molded patterns were created strictly from American scenes, flowers, and wildlife. One day, while riding on a train, Lorber was inspired by the wooded scenes, which gave him the idea for the "Forest" line. This line was well received by the public and similar lines were created, for example, a line decorated with owls, foxes, logs, and other rustic-type woody subjects, called "Woodcraft." Beautiful figures of nudes, birds, frogs, butterflies, and other subjects were used as ornaments in flower-arranging bowls. This is the "Muskota" line. Included in this line is the Tom Sawyer type "fisher boy."

Lorber also created the "Zona" line, which consisted of red apples on a light background, with a gloss glaze. The Gladding McBean Company, of California, purchased the rights to use the design for their wares. This company is still in operation, making this pattern which is known as their "Franciscan Apple" pattern. After the rights were sold, the name "Zona" was applied to other decorated lines with high glaze, such as the "Zona Baby Ware." From time to time the old patterns that had sold well would be introduced again under a new name, except that minor changes would be made in color, glaze, and so forth.

In 1920 Weller purchased the old Zanesville Art Pottery on Ceramic Avenue, this becoming plant No. 3. In 1924 it was remodeled and enlarged to a huge three-story building at a cost of $150,000.

John Lessell, who was already known as an expert in the field of metallic luster glazes, became art director in 1920. He had previously worked for the Owens Company. Lessell created the "LaSa," "Lamar," "Marengo," and other luster and metallic glazed ware. He also perfected a Chinese red line, called "Chengtu." At that time, only a very few artists were capable of working with luster glazes, Arthur "Art" Wagner being one of them. Mr. Wagner, a colorful and extremely alert gentleman, as of 1969 was still decorating pottery at the location that once housed the Weller showrooms and continued to work part time

until his death in 1977. From 1930 to 1942 the showrooms were open and managed by Walter J. Gitter. This building as of 1969 houses the "Pottery Queen" and is located on the "Old Pike" (Route 40). The structure has not been changed to any great degree except for the removal from the face of the building of the tiles that spelled the name "Weller." Inside is a fine display of old Weller, including an Aurelian vase seven feet tall and valued at several thousand dollars. The vase is signed by Frank Ferrel and dated 1903.

Art Wagner was born December 24, 1899, near Marietta, in Washington County, Ohio. He was endowed with a natural talent and claims he never had an art lesson. He moved to Zanesville in 1907 and started his career with Weller in 1920 under the supervision of Lessell, who became both friend and teacher. He quickly learned the art of luster painting and worked on the second metallic luster line named "LaSa." (The first line made in this category was Weller's Sicardo, made several years earlier.) According to Wagner, the LaSa line was a very difficult ware to make and had to be fired six times. The first firing was the application of the white glaze; the second included an application of a certain type oil, dusting with lampblack, and the scratching of designs into this, and then fired at 1250 to 1310 degrees F. The third stage was a coating of bright gold, brushed on and fired. The fourth firing was for the addition of the luster for the colored background. The fifth firing came when the lining was added; and the sixth and final firing was the black luster for the ground and trees. LaSa is signed "LaSa Weller," in script, near the bottom of the vase or vessel, oftentimes near the base of a tree. The signature is rather evasive and difficult to find.

Only three people made the Lamar line: John Lessell, Henry Weigelt, and Art Wagner. Lamar was very difficult to make as it had to be handled swiftly. The glaze was colorless when applied and great care had to be taken so as not to overlap since it would fade out completely where the overlap occurred. Lamar entailed three separate firings: The first a layer of carmine, brushed on and fired. The second, a spray coat of carmine, fired on; and the third and final, the black luster

handpainted decoration of trees, and the like, fired on. Mr. Wagner made the statement, "I've been using these lusters for such a long time, that I can tell by smell what color it is without looking at the label on the bottle." Lamar was never marked except by the use of a paper label.

S.A. Weller died in 1925 and was succeeded as president by his nephew, Harry Weller. Lessell was replaced by Henry Fuchs, who became head of the decorating studio. Henry Weigelt remained along with other decorators who had for many years worked at the Weller plants. Rudolph Lorber continued as modeler, as did Dorothy England. She created many of the fine late patterns, including the Ollas Water Bottle which was made in the shape of a gourd with a stemmed lid and trimmed in various colors. The bottle was quite thick and porous, allowing a small amount of moisture, just enough to keep the outside of it damp, to seep through. The circulation of air around the outer surface supposedly kept the water cool. An underliner, a plate on which the bottle rested to hold any drippings from the bottle, was made to accompany the bottle. These bottles were very popular and sold by the thousands. After her marriage to Frank Laughead in 1938, Dorothy England continued to work, creating many other fine designs, but, for some reason or other, some of these never went into production. She still has in her collection many specimens of her beautiful work.

At the beginning of the 1929 depression there was less demand for pottery, especially the costly hand-decorated ware, competition became keener, and business began to wane. The Weller firm adjusted somewhat by closing two of the plants and moving all operations to the Ceramic Avenue building.

Weller made enormous amounts of utility ware, such as baking dishes and custard cups. After prohibition was repealed, in the 1930s Weller sold tons of beer mugs. Harry Weller was fatally injured in 1932 in an automobile accident and the position of president was turned over, in succession, to Sam Weller's sons-in-law: Frederick Grant, then Irvin Smith, and finally Walter M. Hughes.

The Weller Company managed to survive until World War II when money became more plentiful and potteries could sell their ware extensively. After the war, competition became even greater, with emphasis on foreign imports that were cheaper and were favored by the public. By 1945 the Weller Pottery was in financial difficulty and space in the building was leased to the Essex Wire Company of Detroit, Michigan. In 1947 the Essex Company bought the controlling stock; in 1948 the Pottery was closed.

During the fifty years that art pottery was manufactured by Weller, many different patterns were made and each was given a specific name. Former Weller employees claim that Walter Gitter, sales manager, chose some of the names from Pullman cars as the trains passed through the city. Other names were given by the creators and artists; still others were named because of the special type of glaze or design. The following line names and descriptions have been gleaned from records, catalogs, and important collections.

Photograph of Samuel A. Weller

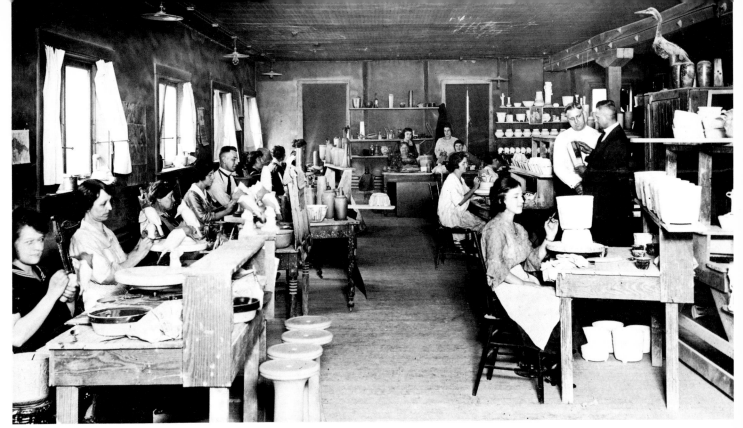

Decorating room at Weller's Putnam Plant during 1920s. Men standing are Walter Gitter in white, Ed Pickens in dark coat, holding a "Pictorial" vase.

Rudolph Lorber, modeler for Weller Pottery, ca. 1920.

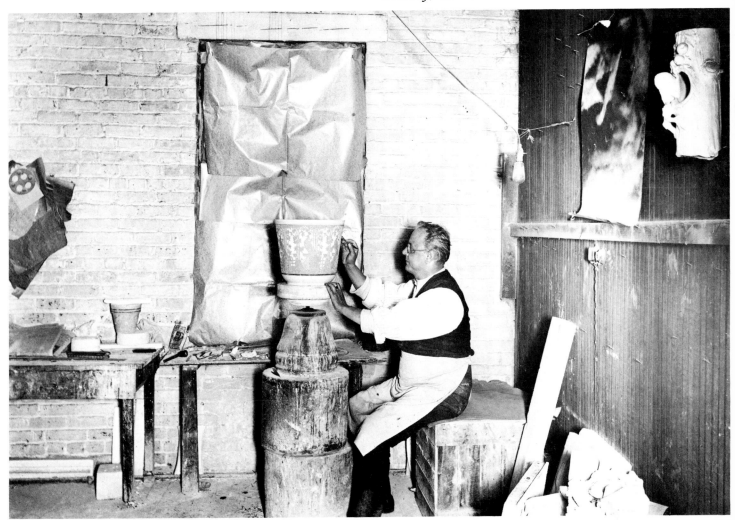

Weller Pottery line names and description.

ALVIN—Rustic type with small apples entwined on vinelike limbs. Matt finish. Middle period.

ANSONIA—Hand turned with horizontal ridges in pastel colors. Middle period. Matt. Marked "handmade."

ARCOLA—Light background with applied grapes entwined on vines. Matt finish. Middle period.

ARDSLEY—Cattails among leaves with water lilies at the bottom. Matt finish. Middle period.

ATLANTIC—Heavy and crude burnt-wood type. Matt finish. Middle period.

ATLAS—Star-shaped top. Various colors. Semigloss. Late period.

AURELIAN—Duplicate of Louwelsa except for the background which has been sponged on and gives the illusion of a distant forest fire. High-gloss brown ware. Early period.

AURORO—Splotched pastel colors under high-gloss glaze. Slip decorated with flowers, fish, and other subjects. Early period.

BALDIN—Realistic apples on branches. Rustic. Matt finish. Middle period.

BARCELONA—Handmade with horizontal ridges with stenciled dark decoration. Yellow with pink stripe close to the base. Matt finish. Middle period.

BEDFORD MATT—Green, heavy glaze, matt finish. Middle period.

BLUE DECORATED—Same as blue Louwelsa except it is marked only "Weller." High-gloss glaze. Early period.

BLUE DRAPERY—Dark blue background. Draped with clusters of roses. Matt finish. Middle period.

BLUE WARE—Classic embossed figures on dark blue background. Matt finish. Middle period.

BLO'RED—Similar to Greenbriar. Red over blue. High-gloss glaze. Middle period.

BO-MARBLO—Lightweight pottery with tree-of-life design. Various colors. Luster glaze. Middle period.

BONITO—Cream color with hand decoration in mineral paints. Somewhat like Majolica. Matt finish. Middle period.

BOUQUET—Dogwood blossoms with matt finish. Various colors. Late period.

BRETON—Band of roses alternating with smaller flowers around the center. Mottled top and bottom. Matt finish. Middle period.

BRIGHTON—Figurines of bluebirds, peacocks, ducks, parrots, etc. Natural colors under a high-gloss glaze. Middle period.

BRONZE WARE—Similar to Sicardo without the predetermined designs. Middle period.

BURNT WOOD—Tan color with dark brown band at top and bottom. Etched designs. Appears like real burnt wood. Middle period.

CAMEO—White flowers and leaves on various background colors. Late period.

CHASE—Fox hunter and dogs embossed in white on various background colors. Matt finish. Middle period.

CHELSEA—Band of flowers similar to Roseville's Donatello. Matt finish. Middle period.

CHENGTU—Chinese orange-red glaze. Solid color. Semi-gloss. Middle period.

CLARMONT—This ware has a double handle with similated notches. The designs at the top of the vessel differs from those at the bottom. The top has a continuous row of twirling circles, whereas the bottom section has a continuous row of berries or grapes hanging on a swirling vine. Only dark monochrome backgrounds have been seen by the author.

CLASSIC—Solid color with lattice work at the top dotted with small flowers; some pieces reticulated. Middle period.

CLAYWOOD—Similar to Burnt Wood. Panels separated by dark bands to match top and bottom. Matt finish. Middle period.

CLINTON IVORY—Various cream-colored patterns with rubbed-on brown. Matt finish. Middle period.

COMET—Stars scattered irregularly on white or pastel shades. Matt finish. Late period.

COPPERTONE—Bright green over brown similar to copper ore. Decorated with frogs, fish, and other natural subjects. Semi-gloss. Middle period.

CORNISH—Slightly mottled background with various-colored berries on long stem. Large leaves at the top. Base color is varied. Semi-gloss finish. Middle period.

CRYSTALLINE—Rows of stacked leaves. Various background colors. Semi-gloss finish. Late period.

DARSIE—Twisted cord with tassels wound around the body of the vessel. Various

colors. Matt finish. Late period.

DELSA—Flowers and leaves with leaves turned out to make the handles. Various colors. Matt finish. Late period.

DELTA—Slip decorated under the glaze. Blue on blue. Hudson-type decoration. Matt finish. Middle period.

DICKENS WARE—First line. Under-glaze slip painting on brown, green, or blue background. Always marked "Dickens Ware."

DICKENS WARE—Second line. Sgraffito-type decoration with blended shaded backgrounds. Usually found in a matt finish; however, can also be found with a high-gloss finish. The latter is a rarity. Decorations include outdoor scenes with people, tavern scenes, Indian portraits, birds and fish, and a most common decor, the bust of a monk. Always marked "Dickens Ware."

DICKENS WARE—Third line. Under-glaze slip decoration that is similar to Weller's Eocean except that the decor used are characters from the tales of Charles Dickens. Marked "Weller" in a rectangular frame on the base. Oftentimes a number accompanies the name.

DORLAND—Three-fold drape with scalloped top with beaded handles. Various colors. Matt finish. Late period.

DRESDEN—Dutch mill scene with occasional Dutch boy and girl. Color is blue, slip painted. Matt finish. Early period.

ECLAIR—Applied roses on plain white glazed body. No piping. Middle period.

ELDORA—Band of flowers at the top and ribbing at the bottom. Various colors. Matt finish. Middle period.

EOCEAN—Decorated with under-the-glaze slip painting. Pastel color. High-gloss glaze. Early period.

EOCEAN ROSE—Same as Eocean except the color goes from gray to pale pink. Also early period.

ETCHED MATT—Comparable to second-line Dickens Ware, except that light clay is used. Incised portrait of a woman with windblown hair. Matt finish. Early period.

ETHEL—Profile of Ethel Weller, in a circle, sniffing a rose. Cream color. Matt finish. Circa 1915.

ETNA—Similar to Eocean in looks except the design is molded in low relief and then color applied. High-gloss. Early period.

EUCLID—Plain matt finish; traditional Weller shapes. Middle period.

EVERGREEN—Solid turquoise green with soft matt finish with a white lining. Late period.

FAIRFIELD—Appearance similar to that of Roseville's Donatello with cherubs at the top and fluted at the bottom. Matt finish. Middle period.

FLEMISH—Small birds molded in relief with clusters of roses. Large birds along with other subjects were also used. Matt finish. Middle period.

FLORAL—Flowers on a ribbed background in pastel colors. Semi-gloss finish. Late period.

FLORALA—Cast flowers in square panels on cream background. Matt finish. Middle period.

FLORENZO—Ivory background with green edge. Ribbed or paneled with a grouping of flowers at the base. Matt finish. Middle period.

FLORETTA—Under-glaze decorated flowers and fruit cast in low relief. Brown and pastel colors both were used for the background. High-gloss glaze. Early period. The fruit was occasionally incised in the manner of second-line Dickens Ware.

FOREST—Rustic molded forest scene. Matt finish. Middle period.

GLENDALE—Birds in their natural habitat. Rustic. Birds with nests and eggs. Matt finish. Middle period.

GOLBROGREEN—Bi-color shaded gold to green with brown where the two colors meet. Semi-matt finish. Middle period.

GOLD-GREEN—Utility ware trimmed with gold decoration. High-gloss glaze. Middle period.

GRAYSTONE—Outdoor line. Stoneware.

GREENBRIAR—Handmade ware. Bright green under-glaze with very pale flowing pink over-glaze. Marbleized by adding maroon streaks. Horizontal ribbing around body. High gloss glaze. Middle period.

GREORA—Similar to Coppertone except the background in bi-color orange shaded to green splashed over with brighter green. The mixture of colors give the appearance of bronze color instead of orange. Semi-gloss finish. Middle period.

HOBART—Girls and swans in solid pastel colors. Matt finish. Middle period.

HUDSON—Matt finish with under-glaze slip painting. Probably made in all periods.

HUDSON (GLAZED)—Under-glaze slip painting. High-gloss glaze. Middle period.

HUNTER—Brown with under-the-glaze slip decoration of ducks, butterflies, and probably other outdoor subjects. Signed only "Hunter." High-gloss glaze. Early period.

INDIAN—Indian-type. Middle period.

IVORIS—Ivory colored in Oriental shapes. Semi-gloss. Late period.

IVORY—Ivory colored, various patterns with rubbed-on brown. Matt finish. Middle period.

JAP BIRDIMAL—The outlines of the design on this ware are first incised with a tool and then inlaid with slip that was squeezed from a tube or heavily painted on with a brush. The designs are then colored and covered with a high-gloss glaze. Early period.

JET BLACK—Solid black background with matt finish. Late period.

JEWEL—Similar to the Etna line except that it has molded jewels. High-gloss glaze. Middle period; possibly early period.

JUNEAU—Stark white background with soft matt. Late period.

KITCHEN-GEM—Brown utility ware. Late period.

KNIFEWOOD—Rustic-appearing molded dogs, swans, and other subjects to give the effect of carving. Matt finish. Middle period.

LAMAR—A metallic luster ware in a deep raspberry red decorated with black luster scenery. Never marked except with a paper label.

L'ART NOUVEAU—Molded line with figures. Most of these are in pastel colors in matt finish. Occasionally this line is found in brown with semi- and high-gloss glaze. It is also sometimes signed "Art Nouveau." Early period.

LASA—A metallic luster ware decorated with outdoor scenes in gold, red, and green. Generally marked "Weller LaSa" near the bottom of the ware near the base of the trees. Signature is very illusive.

LAVONIA—Pastel pink shaded to blue-green or turquoise. This line denotes the color used on various molded designs. Matt finish. Middle period.

LIDO—Bi-color twisted-drape pattern without flowers. Various colors. Matt finish. Late period.

LORU—Octagon-shaped with molded leaf design shading from light to dark. Matt finish. Late period.

LOUELLA—Similar to Blue Drapery with slip decoration. Various colors. Matt finish. Middle period.

LOUWELSA—Under-glaze slip painting on brown shading to yellow. The blended backgrounds are very similar to Rookwood's standard glaze ware. Portraits and natural subjects are the usual decorations. Louwelsa may also be found in a shaded blue with a high-gloss glaze which can be considered rare. An extreme rarity is the Louwelsa ware in a pastel matt finish.

LUSTER—Plain metallic luster glaze without decoration. All colors. Middle period.

MALTA—Subjects from the Muskota and Brighton lines glazed in plain white. Semi-matt finish. Middle period.

MALVERN—Modeled background in various assorted colors with molded leaves and buds in very high relief. Matt finish. Middle period.

MANHATTAN—Stylized flowers and leaves on various background colors. Matt finish. Late period.

MARBLEIZED—Marbleized high-gloss glaze. Middle period.

MARENGO—Luster glaze in pastel colors with line drawings of trees. Middle period. Sometimes referred to as Lessell Ware. This line was never signed.

MARVO—Molded fern and leaf design on various background colors. Matt finish. Middle period.

MI-FLO—Horizontal ribbed with stair-step effect. Various background colors with flowers in relief. Semi-matt. Late period.

MIRROR BLACK—Solid color black with mirror-like glaze. Middle period.

MONOCHROME—Solid color semi-gloss glaze. Middle period.

MUSKOTA—Birds, figures, frogs, etc., with rustic bases and matt finish. These were made for use in flower arranging bowls. These pieces usually have holes for flower stems.

NARONA—Roman classic figures rubbed-in brown on cream-color background. Matt finish. Middle period.

NEISKA—Mottled various background colors on Ivoris shapes. Matt finish. Late period.

NOVAL—White background piped in black with applied roses or fruit. High-gloss glaze. Middle period.

NOVELTY LINE—Various colors. Objects such as ashtrays with figures of monkeys, pigs, dogs, wolves, kangaroos, etc. Also tableware including tumblers with faces. Semi-gloss glaze. Middle period.

OAK LEAF—Molded oak leaves on one side and acorns on the other, with various background colors. Matt finish. Late period.

OLLAS WATER BOTTLE—Heavy gourd-shape water bottle with stemmed lid and an underplate. Common, ordinary paint was used to decorate upper portion, usually in red, green, or blue.

ORRIS—Similar to Greora except melon ribbed. Middle period.

PANELLA—Pansies in relief on various background colors. Matt finish. Late period.

PARAGON—All-over pattern of stylized flowers and leaves on various background colors. Semi-gloss finish. Late period.

PASTEL—Ultramodern shapes in pastel background colors. Matt finish. Late period.

PATRA—Rough orange-peel-like finish with stylized design at the bottom. Matt finish. Middle period.

PATRICIA—Matt finish. Swan handles. Various colors. Late period.

PEARL—Cream color draped with pearl-like beads. Matt finish. Middle period.

PICTORIAL—A line with underglaze slip painting similar to Hudson, depicting outdoor scenes or landscapes done in a very high relief. Colors are generally in pastels.

PIERRE—Utility kitchenware. Basket-weave pattern. Late period.

PINECONE—Stylized pinecone in panel similar to Claywood. Matt finish. Middle period.

PUMILA—Panels of lily leaves flattened to make an eight-scallop top. Various colors including coppertone. Matt finish. Middle period.

RAGENDA—Design features a sash draped in folds with the ends looped; same color as background. Middle period.

RAYDENCE—Upper half ribbed; band of flowers around lower half; large flower with group of small ones in between. Matt finish. Middle period.

ROBA—Draped design with flowers and leaves. Various colors. Matt finish. Late period.

ROCHELLE—Eocean line renamed.

Marked only "Weller." Middle period. High-gloss glaze.

ROMA—Cream color, trimmed with garlands of flowers. Occasionally has medallions. Matt finish. Middle period.

ROMA CAMEO—Cameo in high relief with garlands of flowers and leaves. Cream-colored background. Matt finish. Middle period.

ROSEMONT—Bright colors on dark background of birds and flowers, etc. High-gloss glaze. Middle period.

RUDLOR—Floral design on spiral ribbed body. Beaded-type handles. Various colors. Flowers stand out in relief. Matt and semi-matt finish. Late period.

SABRINIAN—Seashell body with seahorse handle. Pastel colors. Matt finish. Middle period.

SELMA—Knifewood line with a high-gloss glaze. Occasionally with peacocks, butterflies, and daisies. Middle period.

SENIC—Late molded line with outdoor scenes. Pastel colors. Matt finish.

SICARDO—An iridescent glaze ware with a predetermined design worked into the glaze in brilliant colors of red, green, and blue. Some pieces occasionally will have a silver or gold sheen.

SILVERTONE—Molded flowers; over-all splotched with bluish pink glaze. Matt finish. Middle period.

SOFTONE—Three-fold drape design. Scallop top. Velvet-like finish. Various colors. Late period.

STELLAR—Hand slip decorated with blue stars in a "comet" design. White background. Matt finish. Middle period.

TEAKWOOD—Similar to Burnt Wood and Claywood except the colors are reversed in the design. White flowers and dark background. Matt finish. Middle period.

TEROSE—Utility ware. Pumpkin shape. Color is white. Matt finish. Middle period.

TING—Oriental shapes with ring handles. Semi-gloss finish. Late period.

TIVOLI—Cream-colored background with black piping at the top. Base looks like teakwood with a band of flowers. High glaze. Middle period.

TURADA—This ware is found with a lacelike pattern against a dark background of black, brown, or blue. The design is first incised and then inlaid with slip similar to the technique used on Jap Birdimal, with the exception that the designs are in much

higher relief. The lacelike design is always done in light-colored slip. High glaze.

TUTONE—Various colors with flowers and leaves in high relief. Modern looking. Matt finish. Middle period.

UNDERGLAZE BLUE—Similar to Coppertone except color is blue. Middle period.

VELVA—Similar to Ivoris except for a change in color. Late period.

VOILE—Small apple trees on light background. Matt finish. Middle period.

WARWICK—Modeled rustic background with trees and fruit. Matt finish. Middle period.

WILD ROSE—An open rose on a light background. Rose applied in the middle period. Rose is molded in late period. Matt finish.

WOODCRAFT—Rustic-type ware simulating the appearance of stumps, logs, and woody subjects. Some are adorned with owls, squirrels, dogs, and other outdoor animals.

WOOD ROSE—An oaken bucket with rose clusters or berries. Rustic. Matt finish. Middle period.

ZONA—Red apples with stems and leaves against a cream-colored background. A pitcher with a kingfisher bird and cattails was listed in the 1920 Weller catalog as Zona line.

ZONA BABY LINE—Weller baby dishes.

Weller "Dickens Ware" tobacco jars. Left to right: *Admiral, natural color face, blue collar and hat, trimmed with red, 7 in. high; Turk, dark brown face, turban green, red, and brown, 7 in. high; Chinaman, natural color face, brown color, 7 in. high. Collection of Dr. and Mrs. Gordon Gifford; Mesre photo*

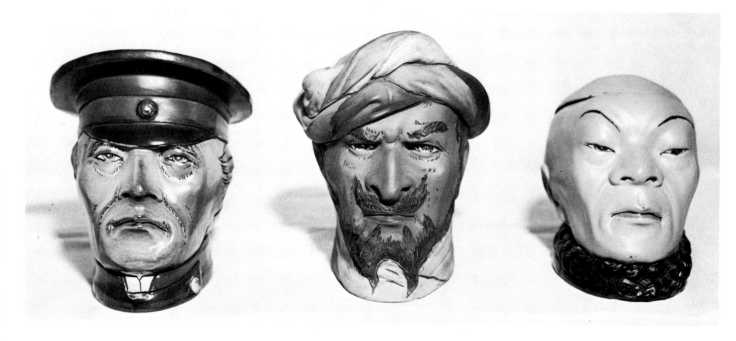

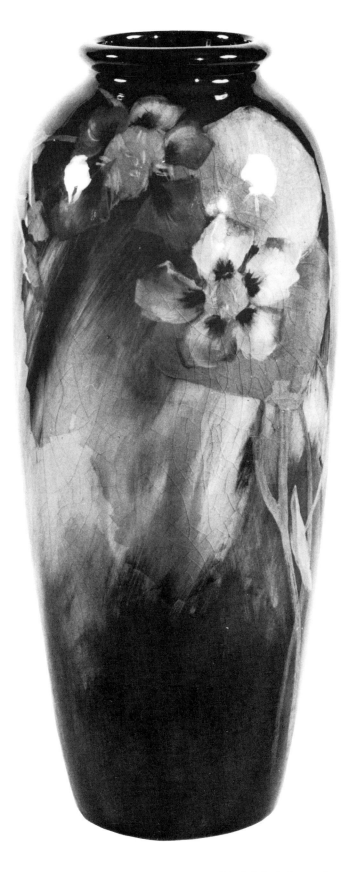

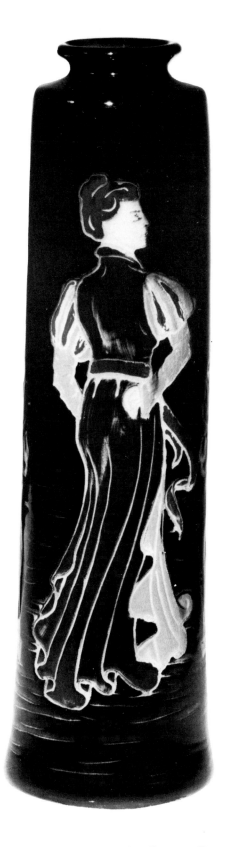

"Aurelian" vase. Multi bright colors, signed "Madge Hurst," 11½ in. high. Author's collection; Knight photo

"Dickens Ware" [2nd line] vase. Rare high-gloss glaze, deep cobalt blue with figure, in sgraffito, wearing a long blue and brown dress, ca. 1901, 14 in. high. Orren photo

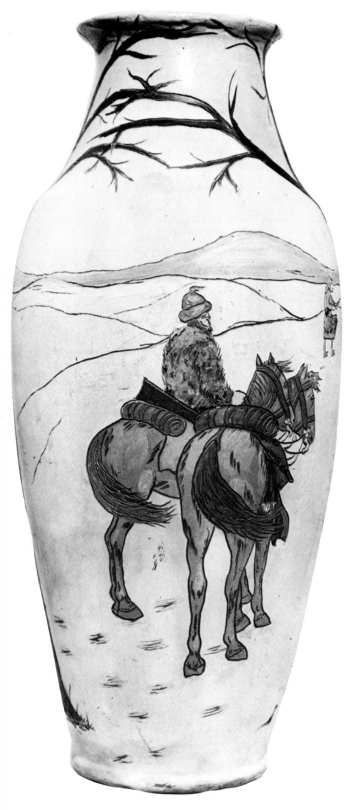

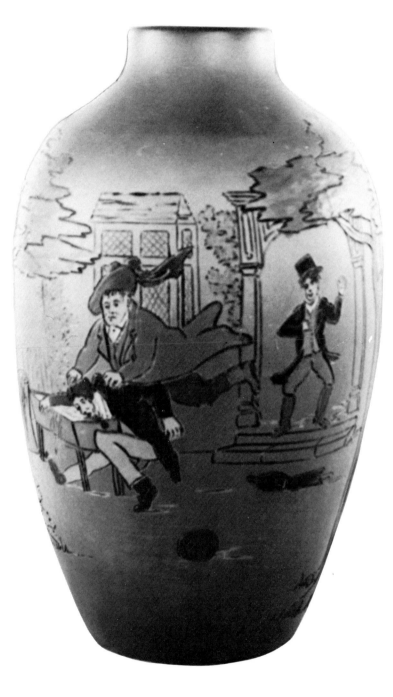

Rare white Weller "Dickens Ware"
[2nd line] vase, signed "E. L. Pickens."
Collection of Dr. and Mrs. Gordon
Gifford; Mesre photo

"Dickens Ware" [2nd line] vase.
Brown with shades of yellow, quotation on
reverse side from Pickwick Papers: *"It was*
a still more exciting spectacle to behold
Mr. Weller...immersing Mr. Stiggin's head
in a horse-trough full of water." Collection
of Andy Anderson; Johnson photo

Reverse of vase showing title disk in raised white slip. Author's collection; Orren photo

Very rare "Dickens Ware" [3rd line] vase. Dark gray shading to light gray, high clear glaze, under-the-slip painting in natural color, signed "Lillie Mitchell," marked "Weller" in raised frame with "15" in duplicate frame, ca. 1910, 7 inches high. Obverse of vase showing full-length figure of Sam Weller of Pickwick Papers. Orren photos

"Dickens Ware" [2nd line] vases. Left and right: Dark green and brown; center: royal blue with vicious dragon in yellow, 16 in. high. Johnson photo

Weller "Dickens Ware" [1st line] vase. Light impressed mark "Dickensware," incised "Trial-D" on bottom inside, 6¾ in. high. Knight photo

"Dickens Ware" [2nd line] pillow-shaped vase. Shaded turquoise, matt finish, signed "Upjohn," ca. 1901, 9½ in. high. Orren photo

Marked "Etched Matt" vase. Light green, 5½ in. high. Knight photo

"Dickens Ware" [2nd line] vase. Deep cobalt blue with trees, in sgraffito, in brown and light blue, rare glossy finish, ca. 1901, 14 in. high. Note Chinese influence. Orren photo

"Fox Tail" mug shaded from blue-green to brown, matt finish, signed "Anna Dautherty," ca. 1902, 5½ in. high. Author's collection; Orren photos

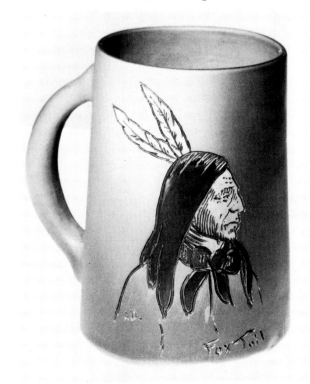

"Daring Fox" vase, shaded blue-green to chocolate brown, matt finish, signed "J. B.," ca. 1902, 7½ in. high. Author's collection; Orren photos

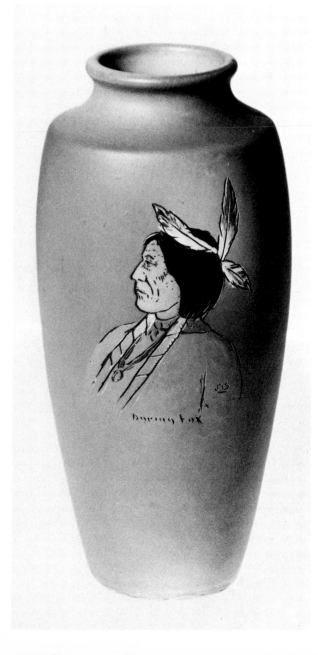

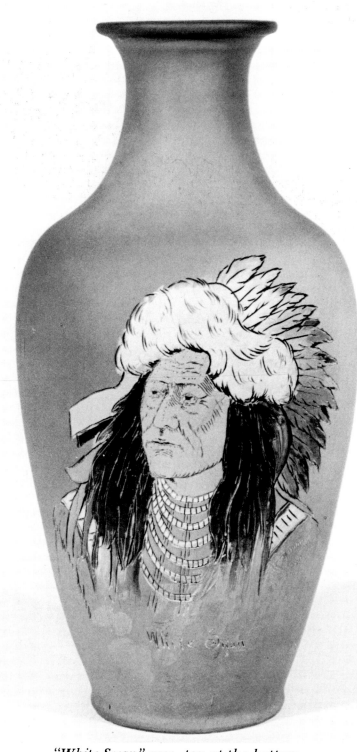

"White Swan" vase, tan at the bottom shading to turquoise at the top, white headdress and beads, impressed mark "Dickensware," signed by A. Dunlavy, dated 1901, 13½ in. high. Collection of Oma and Andy Anderson; Knight photo

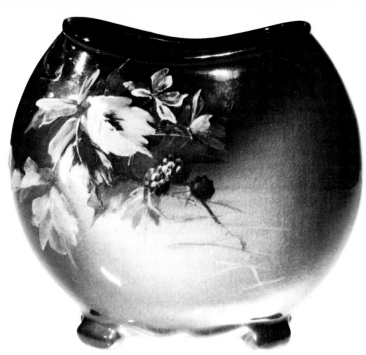

"Dickens Ware" [1st line] pillow-shaded vase. Dark green shading to light green, clear glaze, flowers in white, orange, and brown, signed "C. G.," ca. 1900, 7 in. high. Orren photo

Three-cornered vase, all chocolate brown, semi-matt glaze, signed "Hattie Mitchell," ca. 1902, 6½ in. high. Author's collection; Orren photos

Weller "Dickens Ware" [1st line] vase. Light brown lined in yellow, orange flowers and green leaves applied in heavy slip, impressed mark, 7½ in. high. Knight photo

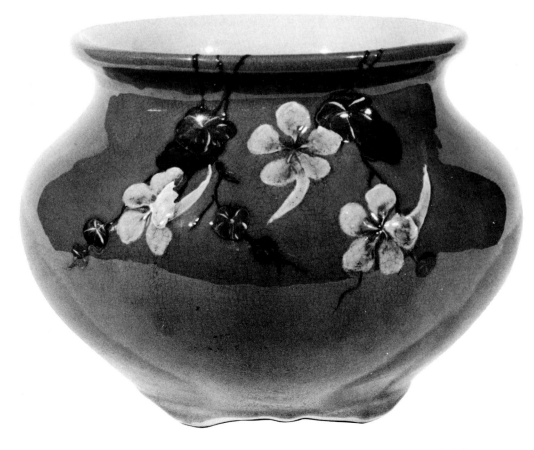

Weller "Auroro" vase. Pale pink and blue splotched background with goldfish, 8 in. high. Collection of Dr. and Mrs. Gordon Gifford; Mesre photo

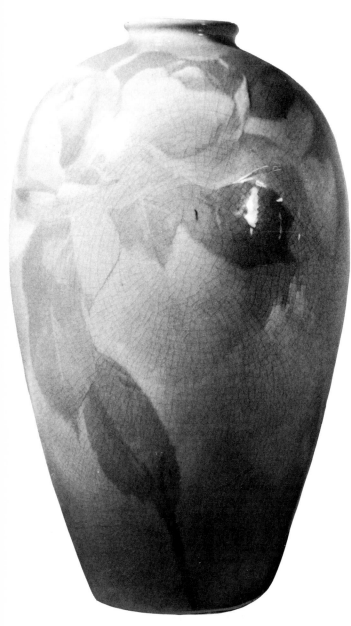

"Auroro" vase; pink and blue mottled background with pink flowers; incised "Auroro Weller" on base; 12 in. high. Fox photo

"Baldin" vases. No. 11 in catalog, natural apples on dark blue background [left] and rustic brown background [right], 10 in. high. Dr. Lori Larson collection; Orren photo

"Burnt Wood" vase, 8½ in. high. Collection of Joan Massey; Johnson photo

"Darsie" bowl and candlesticks. Turquoise, marked in script; bowl 5½ in. high, 16 in. long; candlesticks 3½ in. high. Knight photo

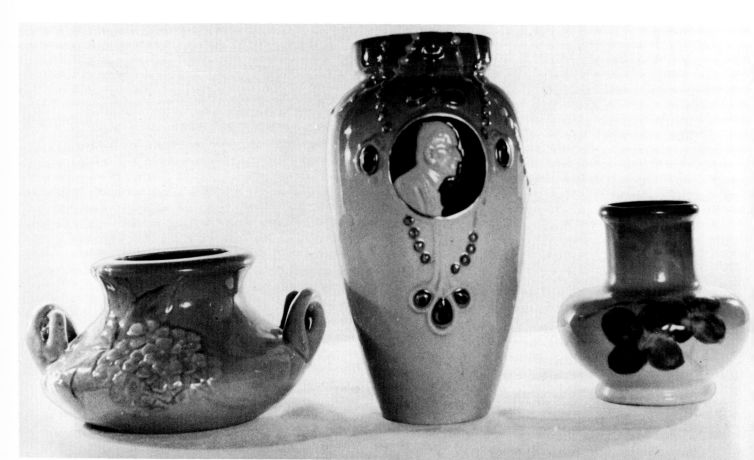

"Etna" vases. Gray shading to pale pink, all signed "Etna Weller." Johnson photo

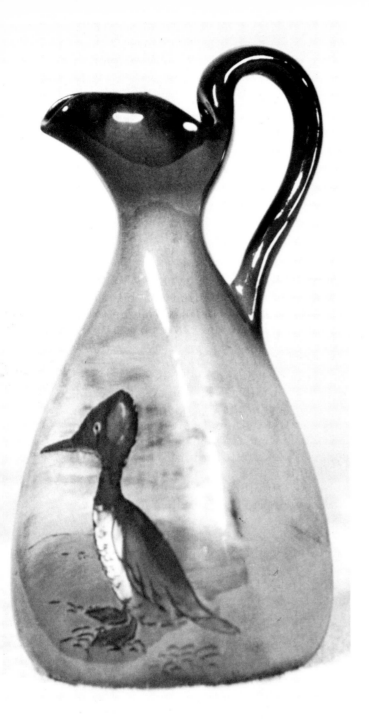

"Hunter" ewer, dark brown shaded to yellow, 5½ in. high. Fox photo

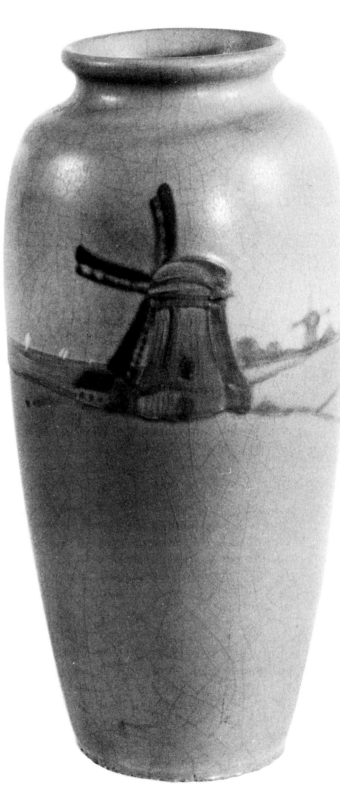

Weller; 9½ in. high Dresden vase- pale blue, marked-Matt Weller-J. L. B. Knight photo

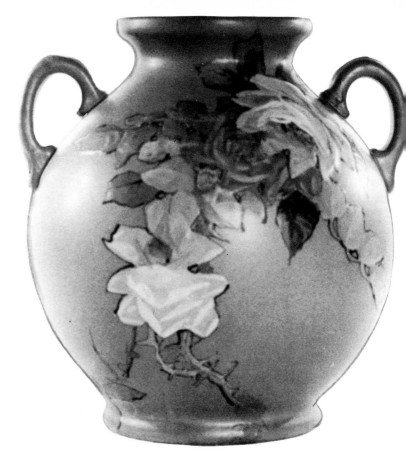

"Hudson" vase. Yellow roses on blue shading, signed "Pillsbury," 9½ in. high. Collection of Dr. Tom and Mary Ann Lamb; Johnson photo

Dark blue "Hudson" with pink, yellow, blue, and green decoration. Left to right: *9 in. high; 10½ in.; 13 in.; 10 in. Johnson photo*

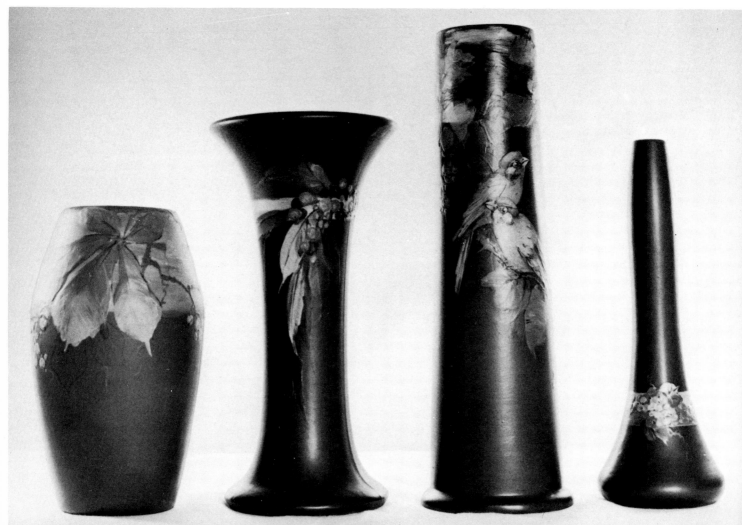

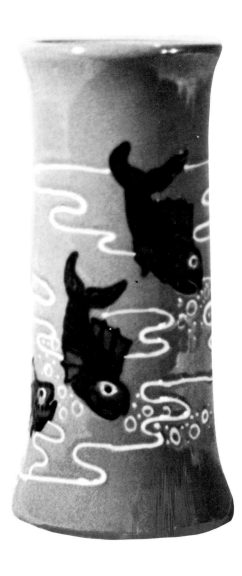

"Jap Birdimal" vase, light blue with black fish, 7 in. high. Fox photo

Three-handled vase. "Jap Birdimal," dark bluish-green background, marked "Weller Faience," signed "Rhead," 8 in. high. Collection of R. E. and F. G. O'Brien, Jr.; Knight photo

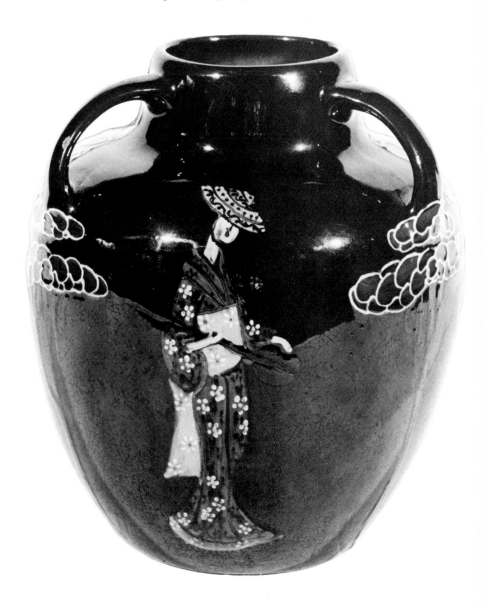

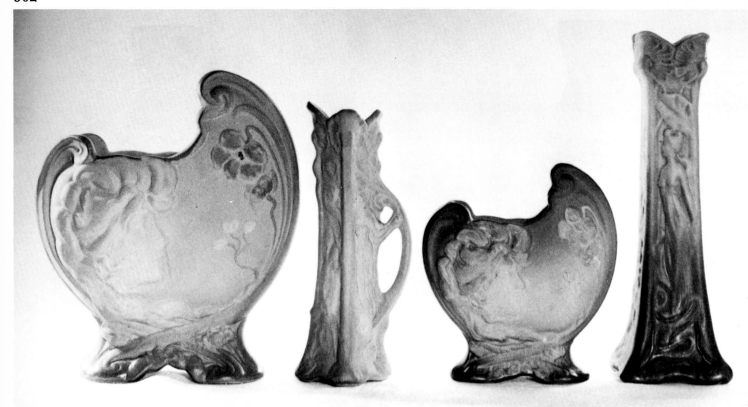

"L'Art Nouveau" vases. Pastel colors, group all marked. Left to right: Matt finish, 9 in. high; matt finish, 7½-in. high; matt finish, 6-in. high; semi-matt finish, 10 in. high. Johnson photo

"Lavonia" line. Shaded from pink to turquoise, paper labels, 11 in. high; the figure is listed in catalog as "Hobart" line when in monochrome color; candle holders, 5 in. high. Johnson photo

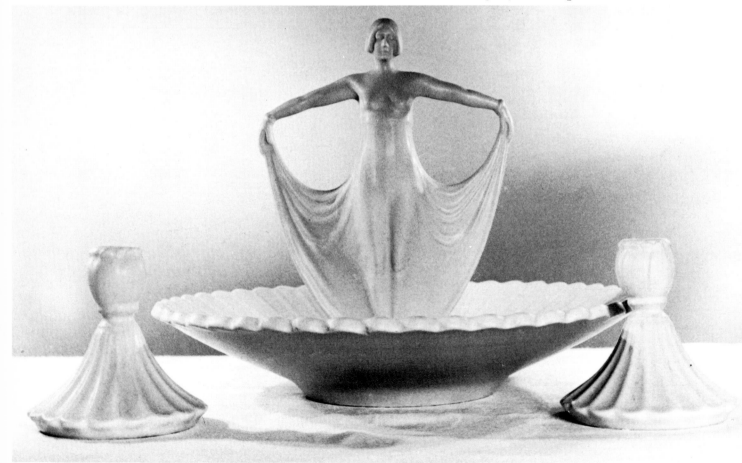

"Louwelsa." Left to right: *Vase, shaded brown to yellow with red flowers, marked "Louwelsa" in circle, 4½ in. high; vase, shaded brown to yellow with red flowers, marked, 3½ in. high; shaded from brown to green to yellow with yellow flowers, 2½ in. to top of handles; ash tray, shaded from brown to yellow, decorated with one live match and one burnt one, marked "Louwelsa," 1½ in. high; ewer, shades from yellow to brown, yellow and red flowers, marked "Louwelsa," signed "H. S.," 6 in. high. Knight photo*

Weller "Louwelsa" clock. Marked "Louwelsa," 10 in. high. Collection of R. E. and F. G. O'Brien, Jr.; Knight photo

"Louwelsa" vases. Left to right: *Brown and yellow shading with yellow flowers, marked, signed "S. Reid McLaughlin," 7 in. high; shaded from brown to green to yellow, red poppies, marked, 9¼ in. high; shades from pale yellow at base to dark brown at top, yellow flowers, marked, 10¼ in. high; shades from brown to green to yellow, red flowers, marked, 9¼ in. high. Knight photo*

"Louwelsa" pottery. Left to right: *Vase, shades from light yellow to dark brown, glaze contains aventurine crystals deep within the glaze similar to Rookwood "Tiger Eye," marked "Louwelsa Weller," signed by Elizabeth Blake, 6¼ in. high; pitcher, dark brown with hint of yellow under the spout, yellow pansies, marked, 5 in. high; vase, reddish brown at base shaded to dark brown at top with red rose, marked, 7 in. high. Knight photo*

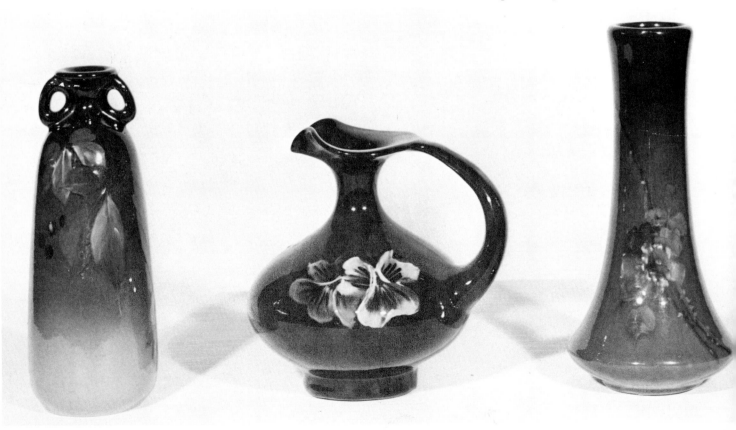

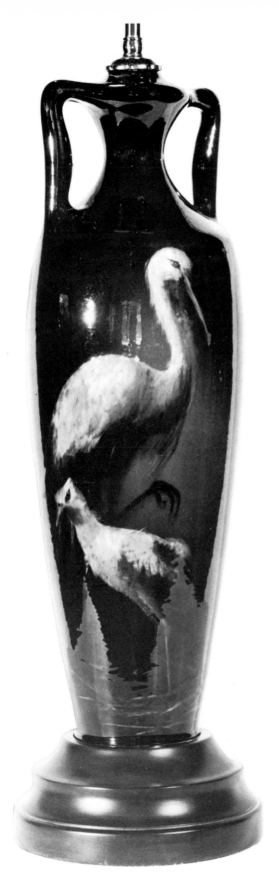

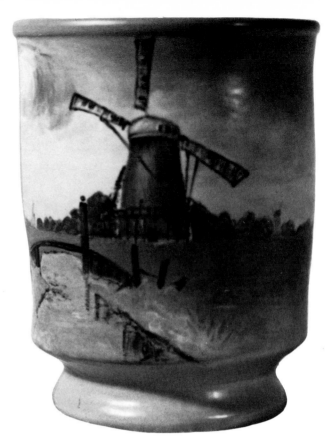

Weller "Pictorial" vase. Blue-gray decorated in natural colors, signed "Mc Laughlin," 9 in. high. Fox photo

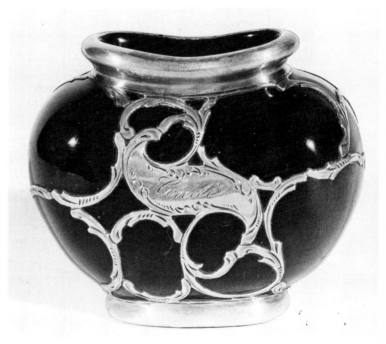

Weller "Louwelsa" electric lamp base. White birds on brown and yellow background, marked "Louwelsa Weller," signed "A. Haubrich 1901," 19 in. high. Author's collection; Knight photo

Marked "Louwelsa Weller," brown and yellow with silver overlay, 3 in. high. Knight photo

306

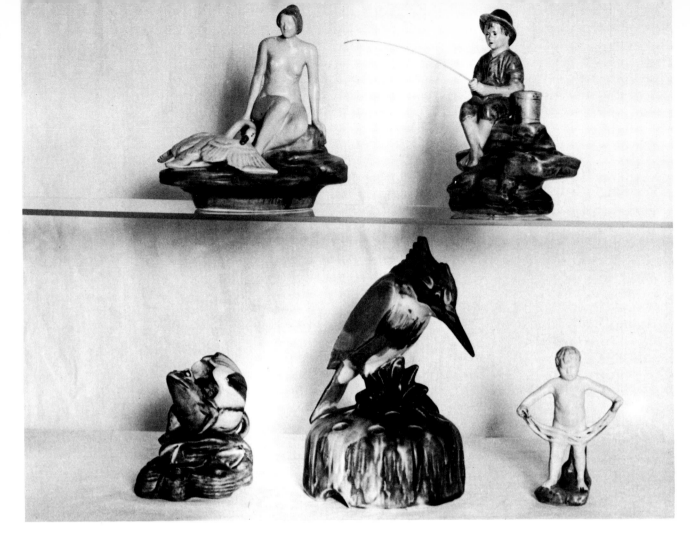

"Muskota" pottery, all in natural colors. Girl with swan, marked in block letters, 7 in. high; fishing boy, marked in block letters, 7½-in. high; frog in lily, marked in block letters, 5 in. high; kingfisher, ink stamped, 9 in. high; cherub, unmarked, 5½-in. high. Author's collection; Johnson photo

Weller pottery. Left to right: "Muskota" figure, 6½-in. high; turtle, marked "Weller" in block letters, 9½-in. long; rare shiny "Forest"-line covered teapot, marked in block letters, 6-in. high. Collection of R. E. and F. G. O'Brien, Jr.; Knight photo

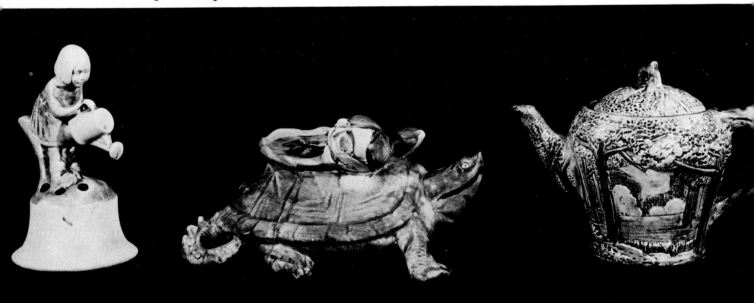

"Sicardo" vase. Green, 4¼ in. high. Orren photo

Green candlestick with highlights of wine red and blue, 8½ in. high

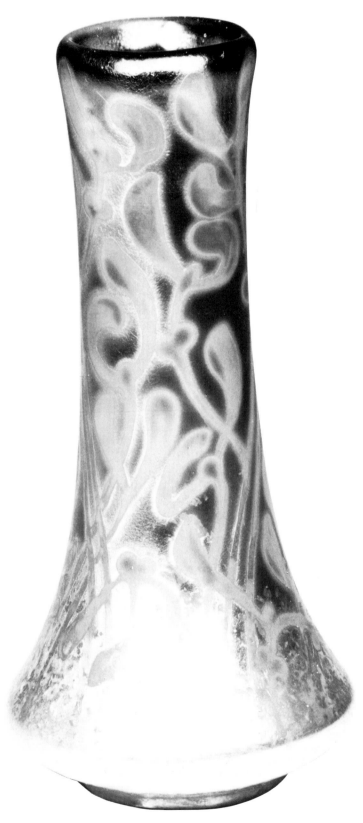
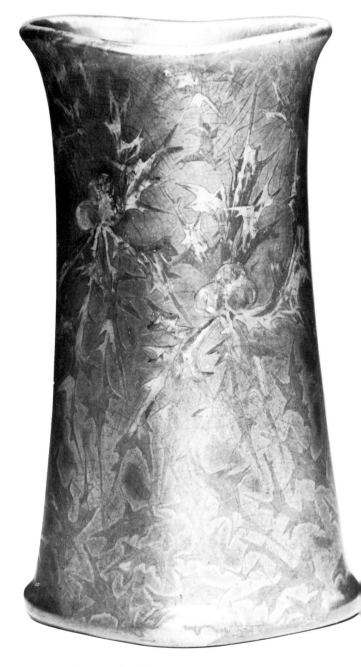

Weller "Sicardo" line. Left: Wine red vase with green, silver sheen, 7 in. high

Peacock blue with purple highlights and gold thistles, 10 in. high

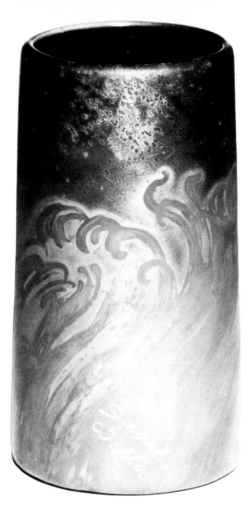

Vase, dark red at top, brilliant green at bottom, 5½ in. high. Note scratched signature "Sicard Weller." Orren photo

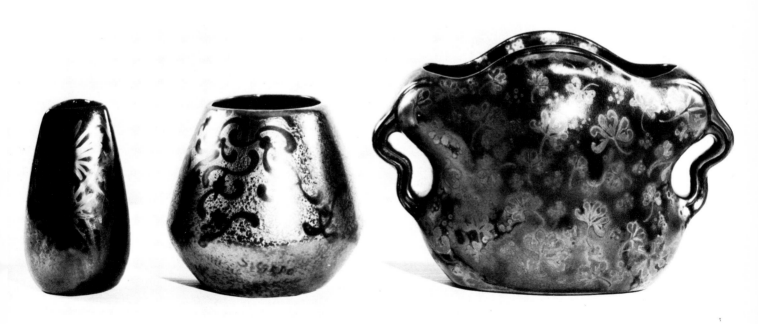

Weller Sicardo: Left; vase 4½ in. high-Reds and blues. Center; vase-silver sheen. Right; 2 handle vase 6½ in. high-Reds, blues and greens. Knight photo

Weller, Turada line; 6½ in. high. Dark brown shaded with yellow. White decoration with blue flowers, unmarked. Knight photo

"Turada" umbrella stand. Dark brown with golden yellow and blue trim, 21 in. high. Orren photo

Weller "Woodcraft" dogs. Collection of Dr. and Mrs. Gordon Gifford; Mesre photo

Weller "Woodcraft" pottery from middle period. Tree trunks, natural color, marked in block letters, 8½ and 9½ in. high; foxes, no. 26 in catalog, 5 in. high; log, no. 23 in catalog, natural colors, marked in block letters, 9½ in. long; owl, 7 in. high. Author's collection; Johnson photo

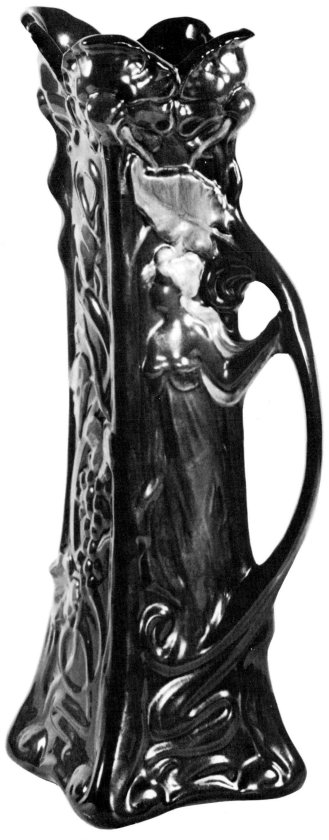

"L'Art Nouveau" vase. Brown, 13½ in. high. Collection of Andy Anderson; Knight photo

Signed Weller "Marbleized" vase. Black and white, very heavy, 8½-in. high. Author's collection; Knight photo

Weller figure. Brown clay with brown glaze and overglaze of white, signed script "Weller," 9 in. high. Knight photo

Weller pottery. Left to right, top row: Marked *"Floretta"* mug, gray shading to pink, 5¼ in. high; *"Muskota"* bird, natural color, 6 in. high; marked *"Floretta"* jug, dark brown with grapes, 6 in. high. Bottom row, left to right: *"Muskota"* bird, natural color, 9 in. high; *"Zona"* pitcher with kingfisher, 8½ in. high; *"Muskota"* bird, natural color, 8½ in. high. *Johnson photo*

Rare special Weller plaque. Terra-cotta colored matt glaze, Garden of Eden scene, marked in small block letters, 11 in. diameter. Knight photo

Weller pottery. Left to right, top row: *"Warwick"* vase, mottled dark red and brown with red and green fruit, 5 in. high; *"Flemish"* inkwell, no. 48 in catalog, cream with pink roses and blue birds, 4 in. high; *"Wood Rose"* candlestick with blue berries. Bottom row: *"Wood Rose"* bucket, 5 in. high; *"Knifewood"* jar, natural colors, 7 in. high; *"Coppertone"* vase, green over brown, 9 in. high. *Johnson photo*

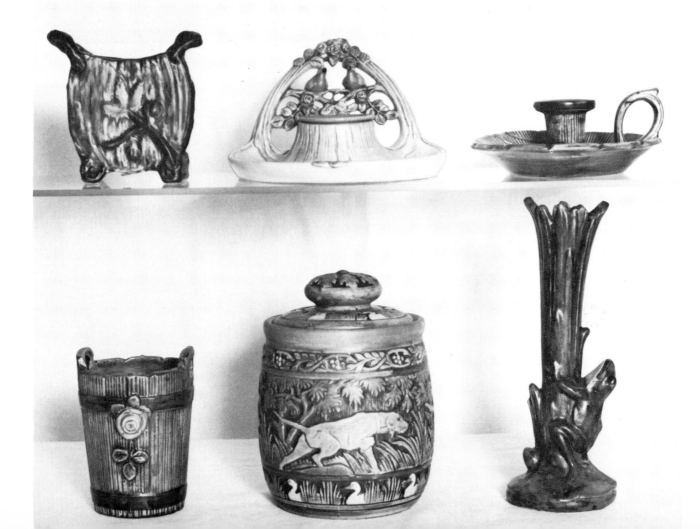



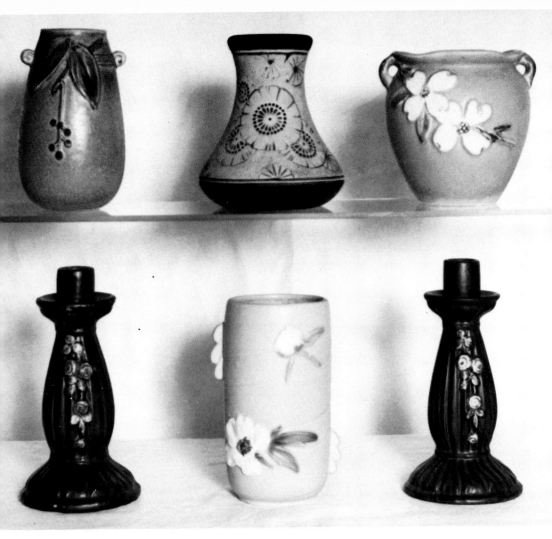

Weller pottery. Top row, left to right: *"Corn-ish"* vase, *blue back-ground with red and blue berries and green leaves, 6 in. high;* *"Burnt Wood"* vase, *rich tan with dark brown, lined with glossy brown glaze, 5½ in. high.* *"Bouquet"* vase, *blue-white blos-soms and green leaves, 5 in. high.* Bottom row, left to right: *"Blue Drap-ery"* candlesticks, *dark blue with pink roses, 8 in. high;* center: *"Rud-lor"* vase, *yellow with blossoms and green leaves, 6½ in. high.* *Johnson photo*

Weller pottery vas-es. Left to right, top row: *"Panella,"* *blue-white pansies, 5 in. high;* *"Roma,"* *no. 119 in cat-alog, cream with orange and green decoration, 4¼ in. high;* *"Roba,"* *white shaded to green, 6 in. high.* Bottom row: *"Loru,"* *blue, 9 in. high;* *"Tutone,"* *green on pink, 3 in. high;* *"Mal-vern,"* *8¼ in. high.* *Johnson photo*

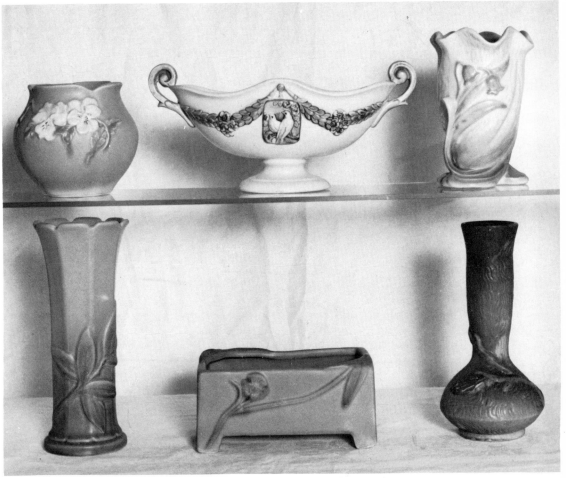

*Weller pottery.
Left to right, top row:
"Luster" compote in
blue, 4 in. high; "Oak
Leaf" vase, brown, 4
in. by 10 in.; "Para-
gon" vase, blue, 4½
in. high. Bottom row:
"Sabrinian" pitcher,
no. 11 in catalog,
mottled blue and
pink, 9 in. high;
"Warwick" vase;
"Pumila" vase, green
shaded to brown, 8 in.
high. Johnson photo*

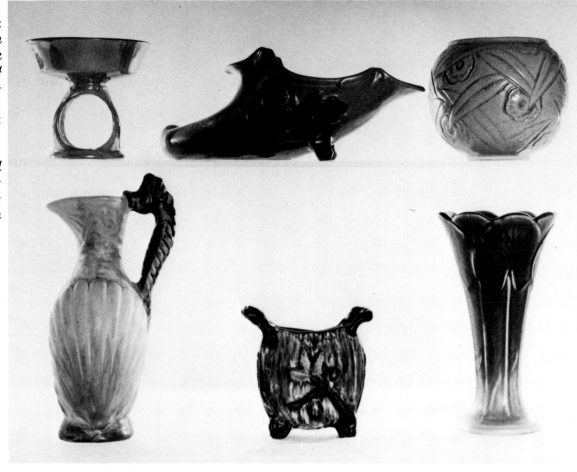

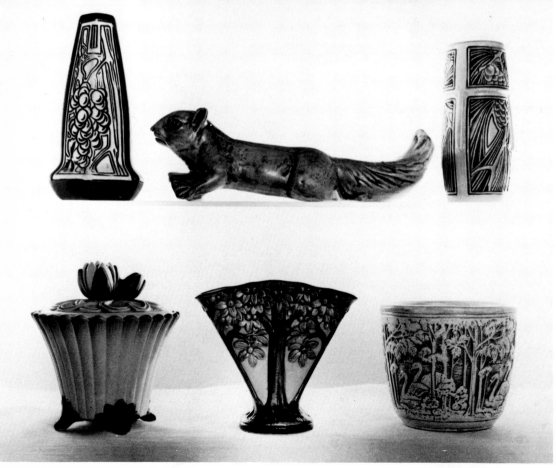

*Weller pottery. Top
row, left to right: "Clay-
wood" vase, designs in
panels, brown and tan, 8
in. high; "Woodcraft"
squirrel, natural color,
14½ in. long; "Pine-
cone" vase, pale green
with natural color pine
cones, 7 in. high. Bot-
tom row: "Florenzo" jar,
cream shaded to green, 7
in. high; "Voile" vase,
light tan background,
6¼ in. high; "Ivory"
jardiniere, light tan with
darker tan rubbed in,
5¼ in. high. Collection
of Andy Anderson; John-
son photo*

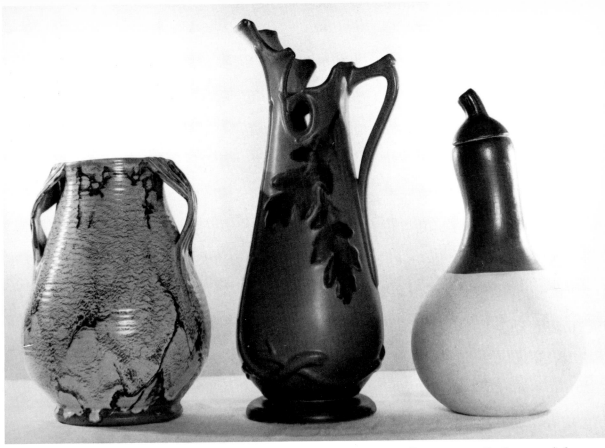

Weller ware. Left to right: *"Greenbriar" vase with paper label, no. 28 in catalog, pink over green, 9½ in. high; "Oak Leaf" vase, brown with natural leaves, 14 in. high; "Ollas Water Bottle," pale yellow with green top, 11½ in. high. Johnson photo*

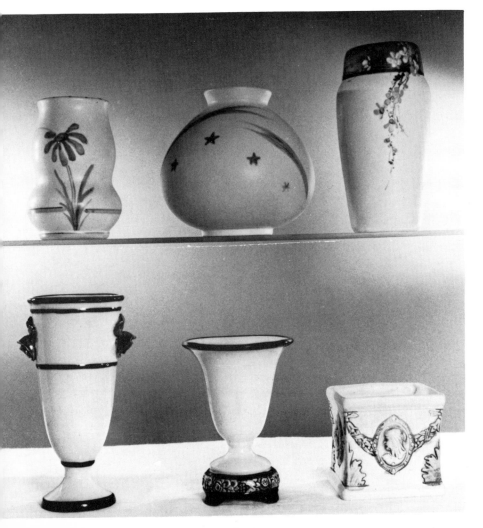

Weller pottery vases. Left to right, top row: *"Bonito," cream lined in green, blue flowers and green leaves, 5 in. high; "Stellar," white with blue stars, 5½ in. high; "Hudson," white with blue top, 7 in. high. Bottom row: "Noval," white piped in black, red roses, 7½ in. high; "Tivoli," no. 2 in catalog, cream piped in black, red roses, 5½ in. high; "Roma Cameo," cream with coral cameo, 3½ in. high. Johnson photo*

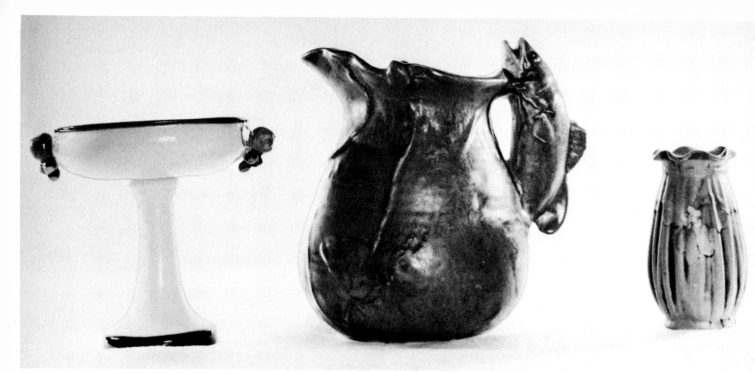

Weller ware. Left to right: *"Noval" compote, white piped in black with fruit handles, 6 in. high; "Coppertone" pitcher, paper label, 8 in. high; "Louella" vase, gray on gray, 5 in. high. Collection of Joan Massey; Johnson photo*

Weller vases. Left to right, top row: *"Indian" in tan, brown, and black, 4¼ in. high; "Hudson" in shaded blue flowers, signed "Dorothy Laughead," made after her marriage in 1938, 5½ in. high; "Barcelona" in yellow with dark blue decoration, 6 in. high. Bottom row: "Delsa" in green with white flowers on green stems and leaves, no. 12 in catalog, 9 in. high; silver deposit on mottled turquoise, signed in late period script, 9 in. high; "Forest" in rustic shades, 8½ in. high. Johnson photo*

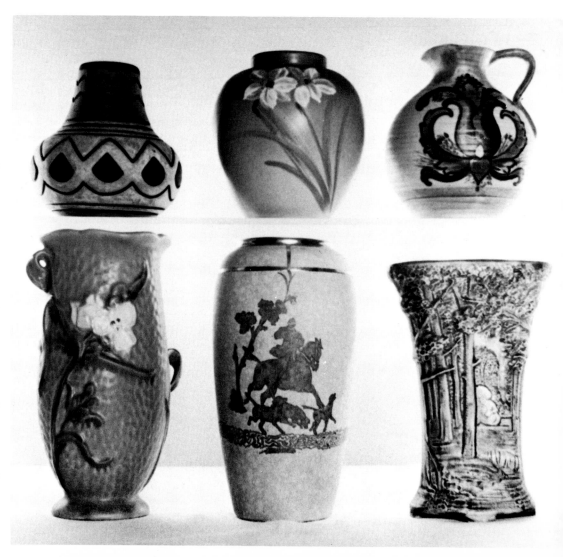

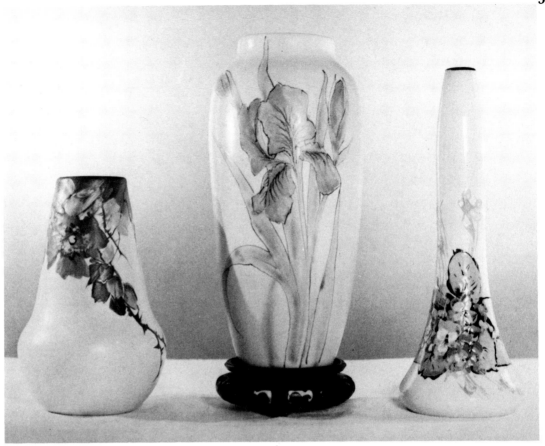

"Hudson" vases, left to right, white, signed "Eugene Roberts," 7½-in. high; white with blue iris, signed "Hester Pillsbury," 9½-in. high; white glazed with pink, blue, and gray decoration, catalog no. 53. Author's collection; Johnson photo

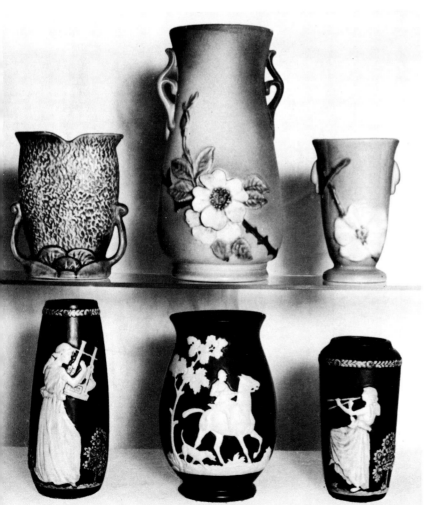

Weller vases. Left to right: "Patra," orange with bright colors at bottom, 6½ in. high; early "Wild Rose," orange shaded to cream, white applied rose, 11½ in. high; late "Wild Rose," green with white rose, 6½ in. high. Author's collection

Weller vases. Left and right: "Blue Ware," blue with light yellow figures, 8½ in. and 7 in. high. Center: "Chase," white on blue, 8¼ in. high. Author's collection; Johnson photos

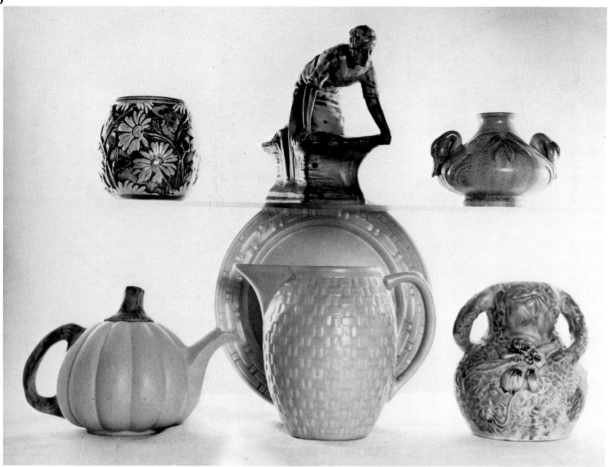

Weller pottery. Left to right, top row: *"Selma" vase,* same as *"Knifewood"* except for a high-gloss glaze, 5 in. high; *"Muskota"* line figure, rustic colors, 7 in. high; *"Patricia"* vase, yellow with green, 4 in. high. Bottom row: *"Terose"* teapot, no. 651 in catalog, 6 in. high; *"Pierre"* pitcher [7 in. high] and plate [10 in. diameter] in pink; *"Silvertone"* vase, splotched bluish pink, 7 in. high. Collection of Andy Anderson; Johnson photo

Weller pottery. Left to right, top row: *"Zona"* sugar and creamer, white with red apples, 3½ in. and 3 in. high; a *"Weller"* blank decorated in rich cream and gold, signed *"Raoul,"* not a Weller artist. Bottom row: *"Roma"* vase, cream with pink roses, 8 in. high; *"Hudson"* vase, white with black decoration, 7 in. high; *"Florenzo"* vase, cream shaded to green, pink flowers, 6 in. to top of handle. Johnson photo

Weller bowl. Pastel green and pink, hand-incised "Weller Matt," 8½ in. high. Knight photo

Weller pottery. Left to right: "Arcola" candlesticks, pink, 12 in. high; "Arcola" bowl, ivory, marked "Weller" in block letters, 13 in. diameter; "Etched Matt" vase, rust background, marked "Weller" in block letters, 10½-in. high. Collection of R. E. and F. G. OBrien, Jr.; Knight photo

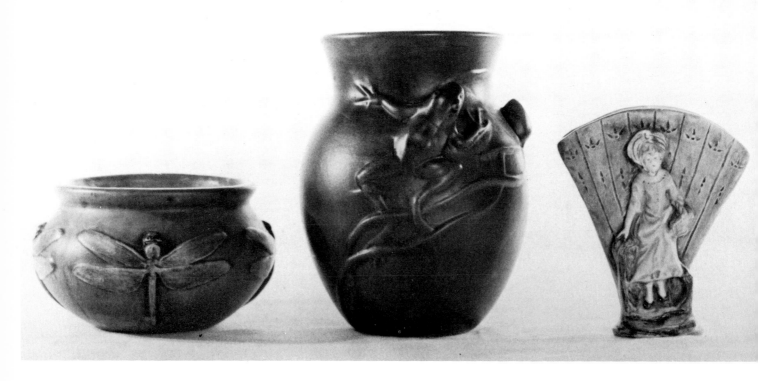

Weller ware. Left to right: "Modeled Matt" dragon fly, brown and tan, 3 in. high; "Modeled Matt" frog, gunmetal color 6½-in. high; trial piece modeled by Dorothy England [Laughead], white dress with natural colors on green background, signed "England," never put into production, 5 in. high. Collection of Andy Anderson; Johnson photo

Weller pottery. Left: "Ivory" planter, marked "Weller" in block letters, 7 in. by 10 in. Right: "Barcelona" bowl, paper label "Weller Barcelona Ware," 9 in. diameter. Collection of R. E. and F. G. O'Brien, Jr.; Knight photo

Weller vases. Left: *"Ragenda," dark red, 9½ in. high;* right: *"Classic," medium green, 5½ in. high. Johnson photo*

Weller vases. Left to right: *"Ethel," cream background with charcoal trim, block "Weller" mark, 9 in. high; "Alvin," light tan, paper label with line name 8¾ in. high; "Glendale," rustic colors, marked with block "Weller," signed by Hester W. Pillsbury, 6½ in. high; "Knifewood," rustic colors, unmarked, 10½ in. high. Collection of Andy Anderson; Knight photo*

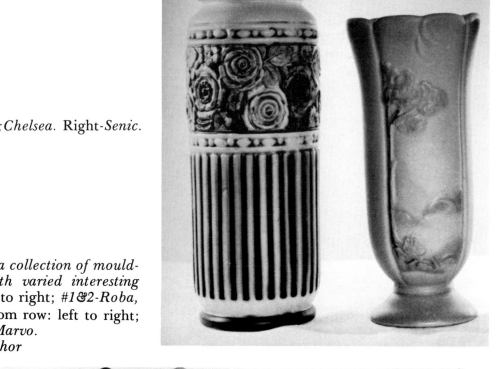

Weller; Left; *Chelsea.* Right-*Senic.*

*Weller Pottery; a collection of mould-
ed ware covered with varied interesting
glazes.* Top row: left to right; *#1&2-Roba,
#3-Zona pitcher* Bottom row: left to right;
#3&6-Glendale, #5-Marvo.
Collection of the author

Weller Pottery catalog, ca. 1919

Weller Pottery catalog, ca. 1919

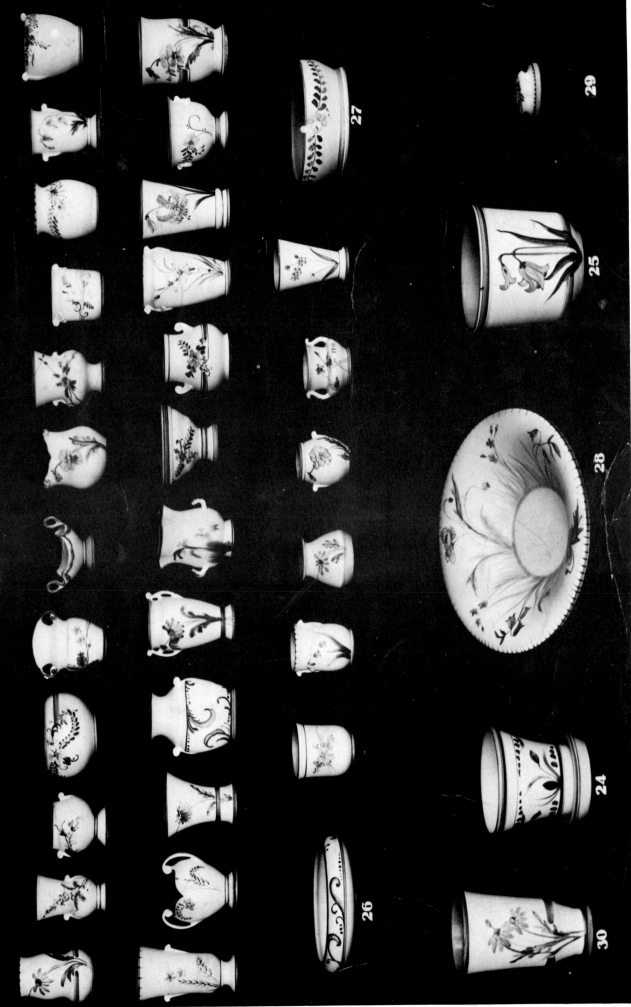

Weller Pottery catalog, ca. 1919 "Bonito" line

Weller catalog of "Bonito" line

329

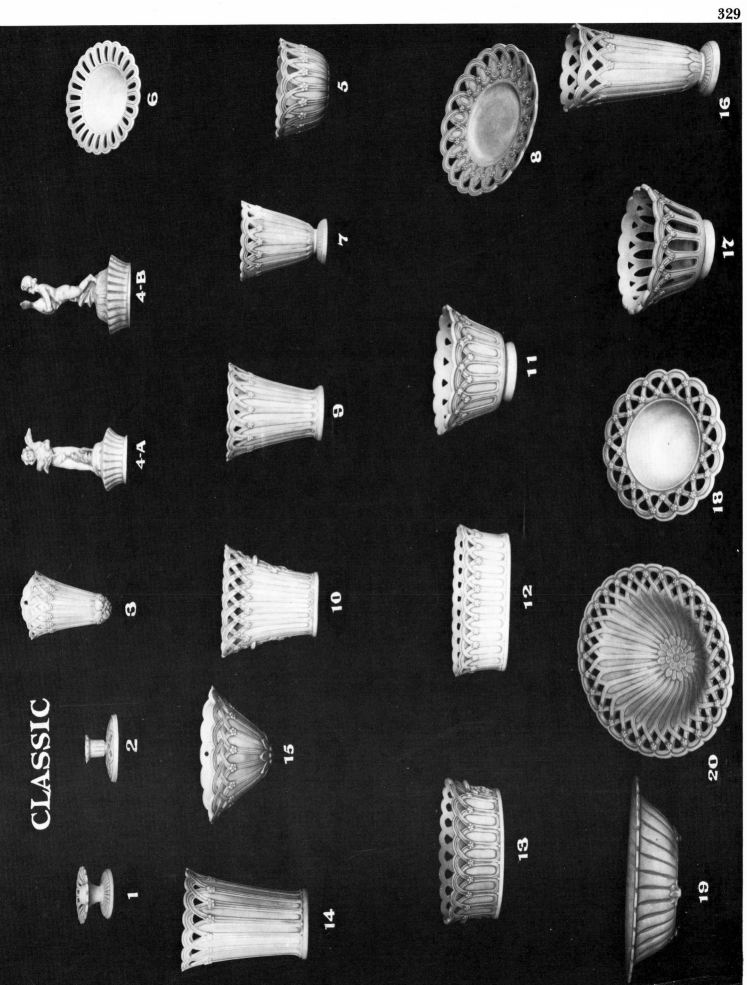

CLASSIC

Weller Pottery catalog, ca. 1919

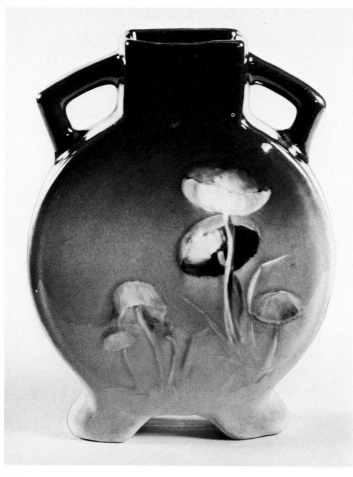

"Eocean" two-handled vase, flat-sided, pink and red flowers, 7½-in. high.

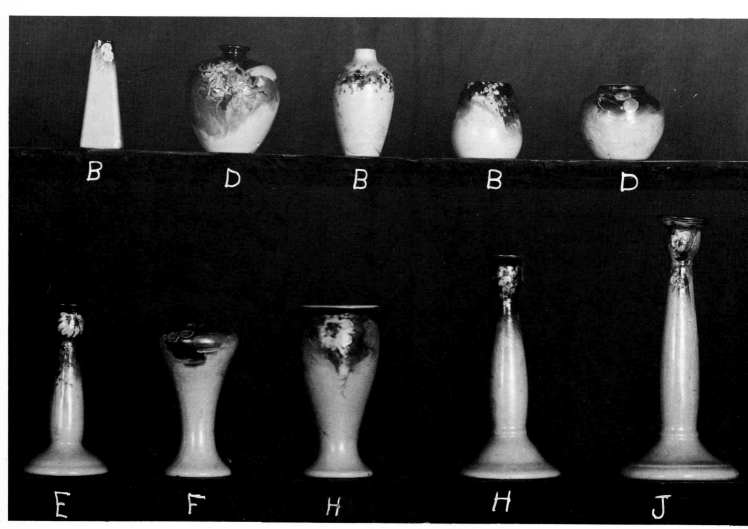

Weller catalog of Eocean Ware

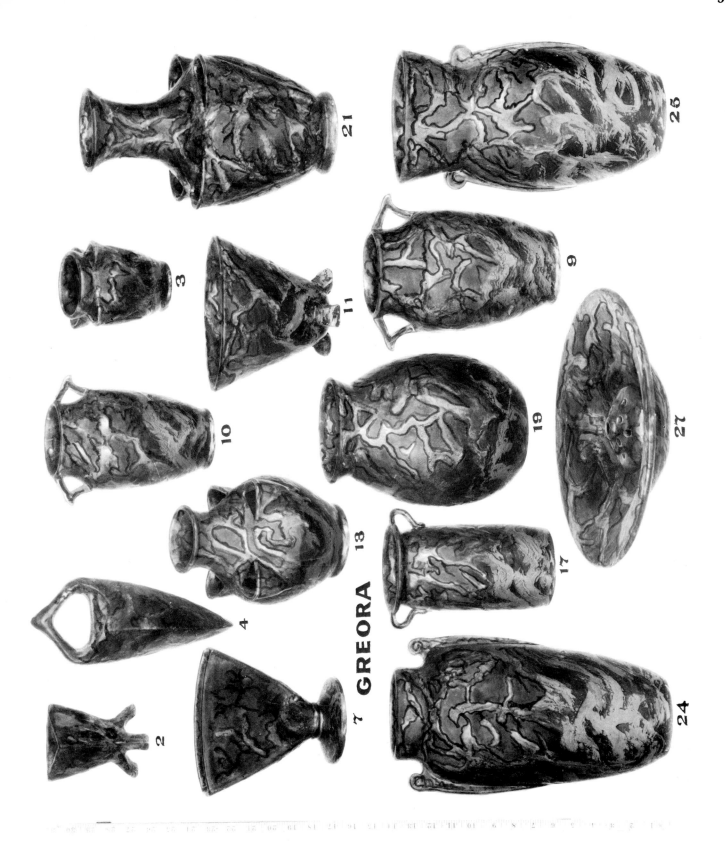

GREORA

Weller Pottery catalog, ca. 1919

332

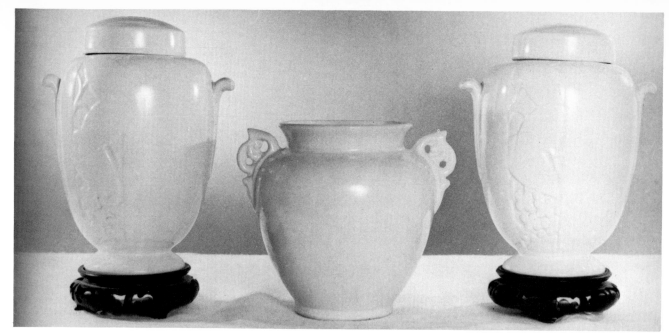

"Ivoris" ware, all with paper labels, covered jars 8½ in. high, vase 6 in. high. Collection of Phyllis Larson; Johnson photo

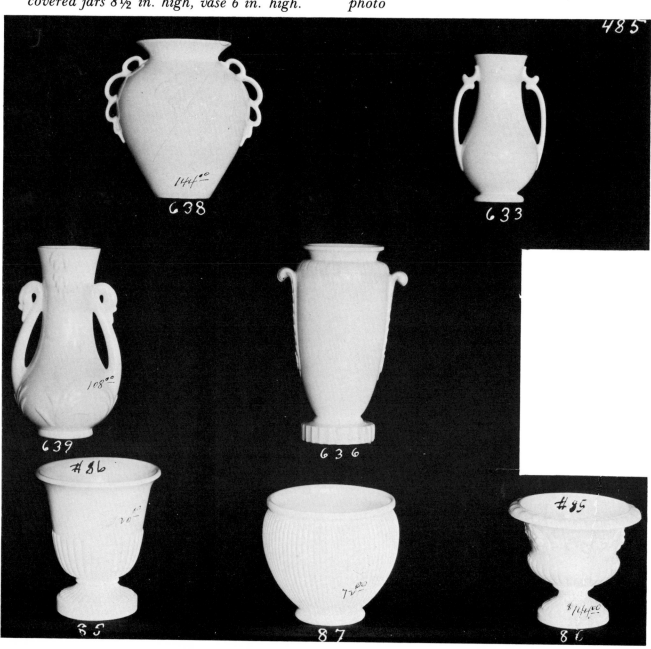

Weller catalog of Ivoris Ware

Weller Pottery catalog "Lasa" line

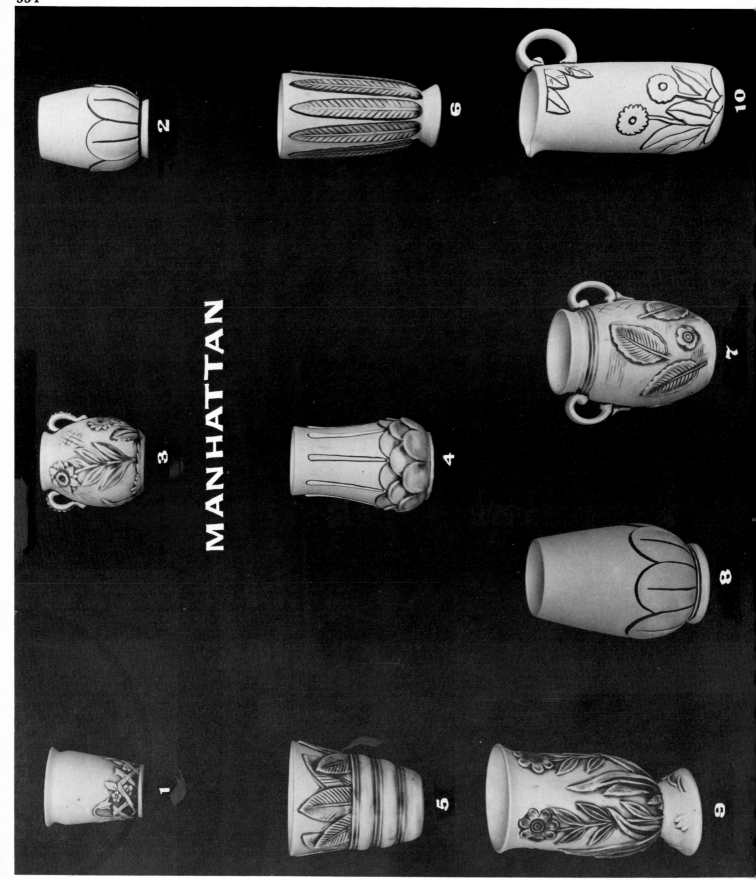

MANHATTAN

Weller Pottery catalog

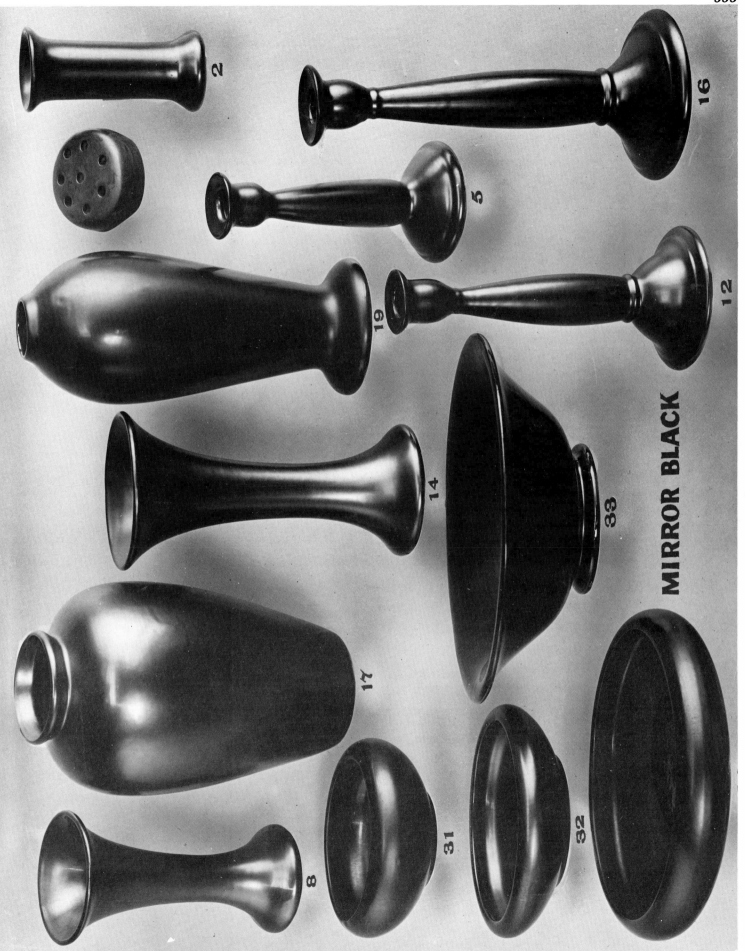

Weller Pottery catalog, ca. 1919

336

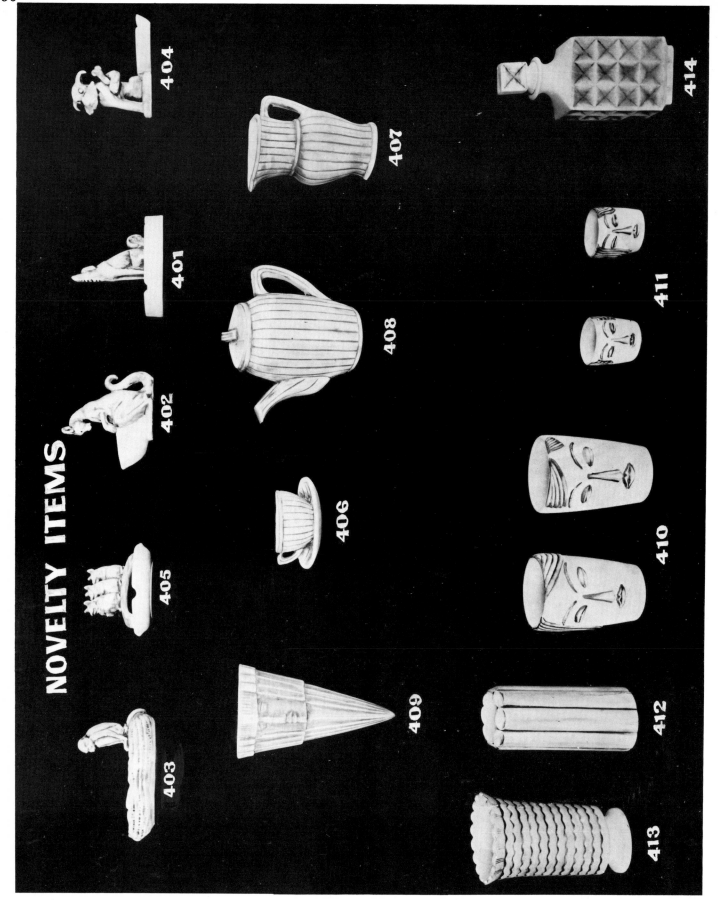

NOVELTY ITEMS

Weller Pottery catalog

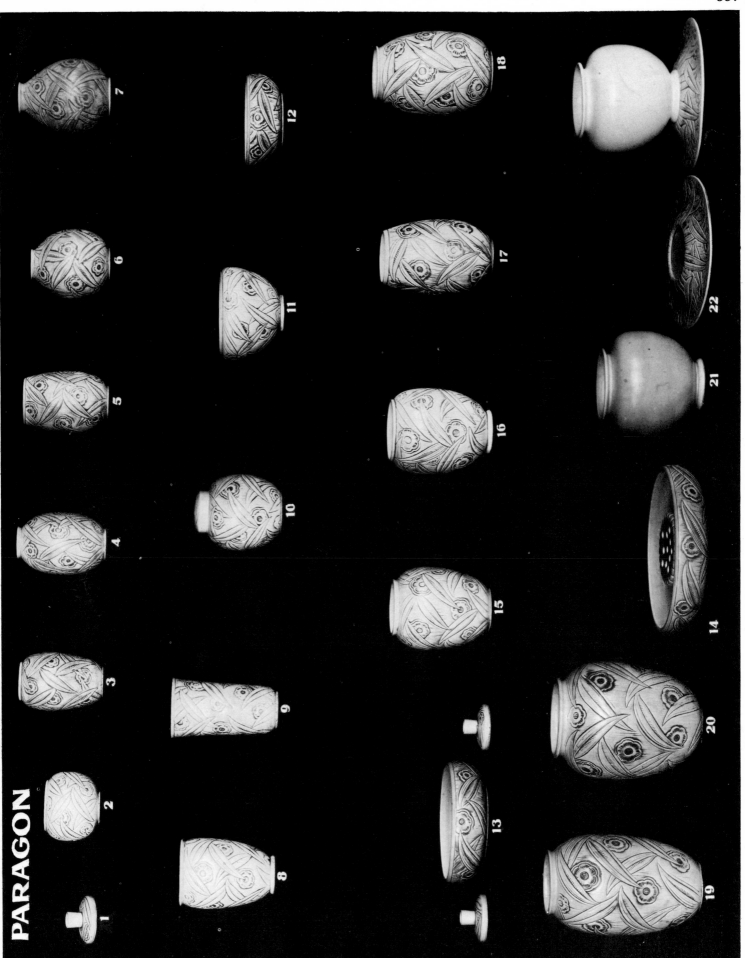

PARAGON

Weller Pottery catalog, ca. 1919

338

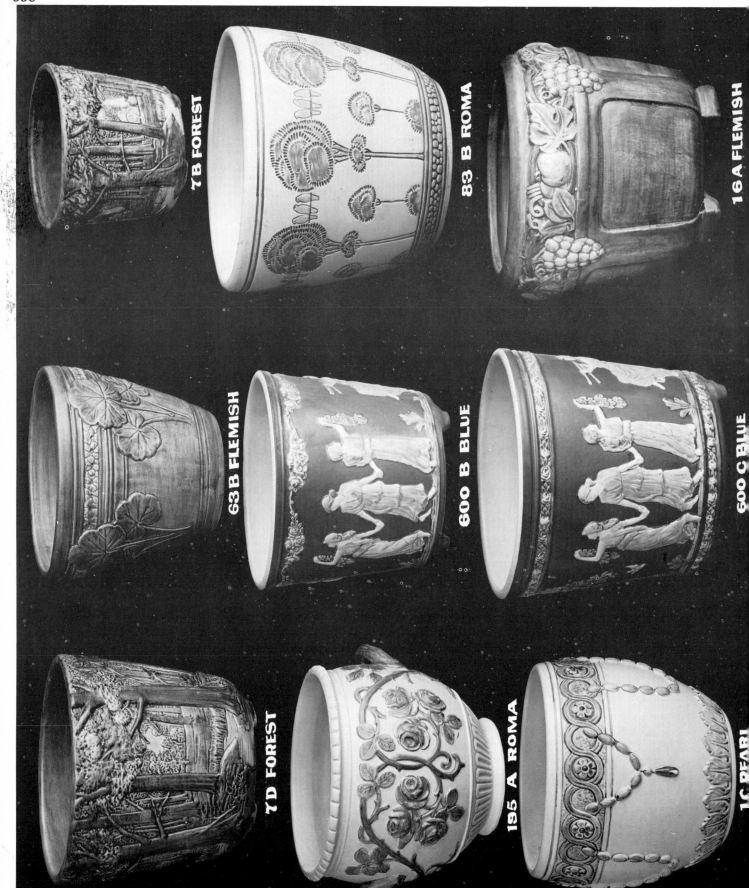

7B FOREST

83 B ROMA

16A FLEMISH

63 B FLEMISH

600 B BLUE

600 C BLUE

7D FOREST

195 A ROMA

1 C PEARL

Weller Pottery catalog, ca. 1919

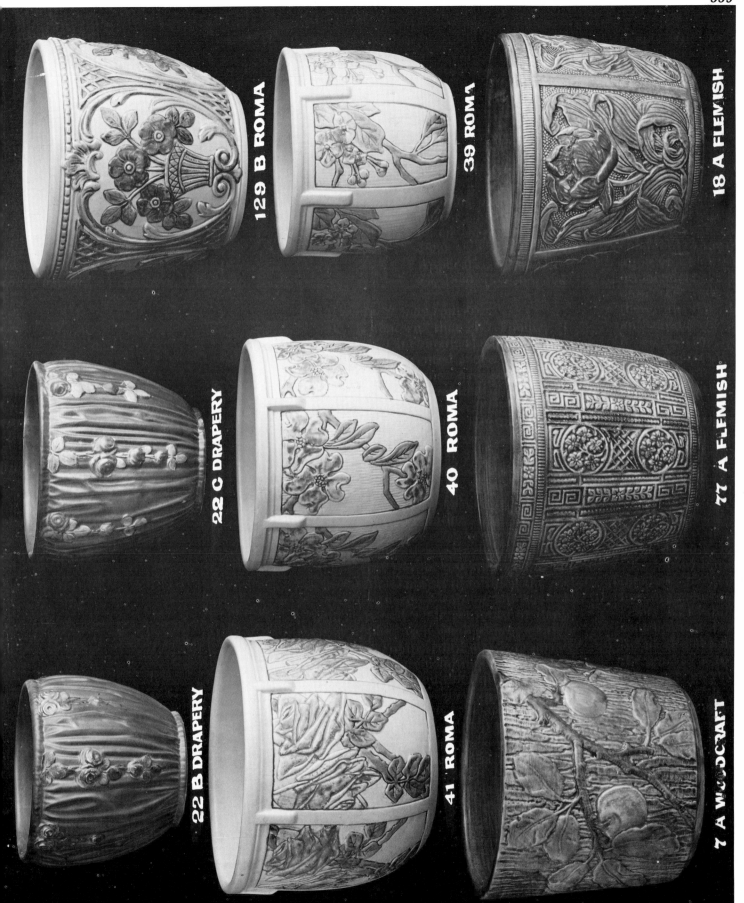

129 B ROMA

39 ROMA

18 A FLEMISH

22 C DRAPERY

40 ROMA

77 A FLEMISH

22 B DRAPERY

41 ROMA

7 A WOODCRAFT

Weller Pottery catalog, ca. 1919

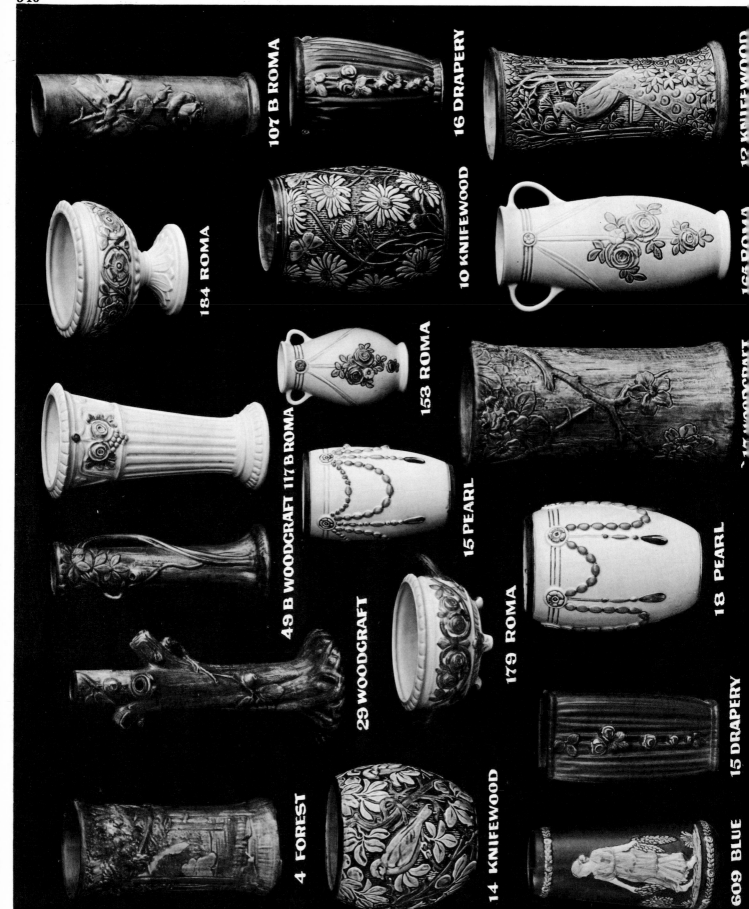

Weller Pottery catalog, ca. 1919

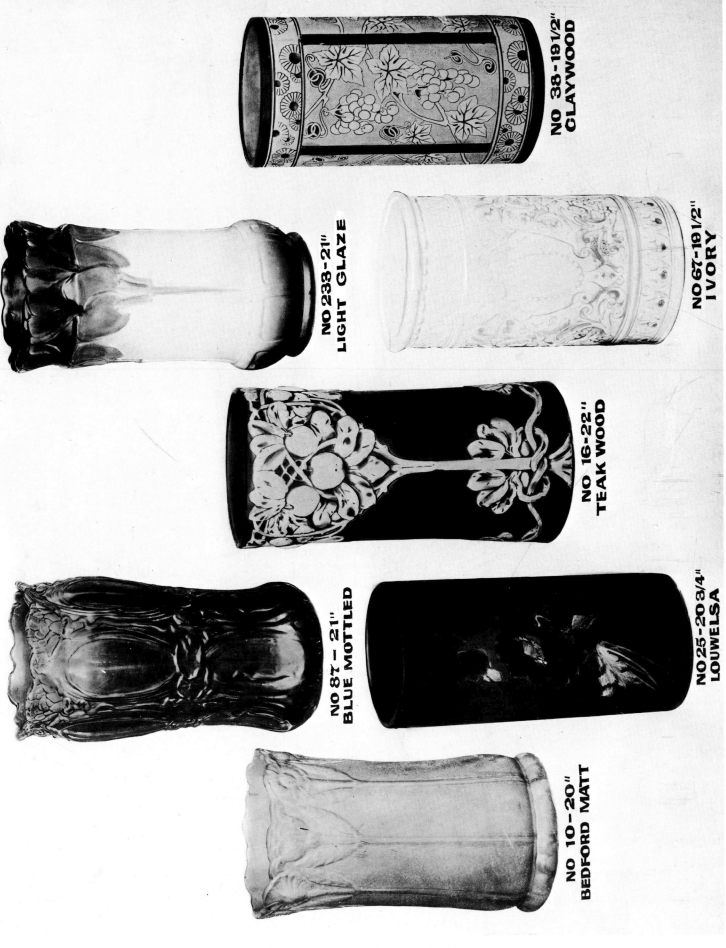

NO. 38 - 19 1/2"
CLAYWOOD

NO. 233 - 21"
LIGHT GLAZE

NO. 67 - 19 1/2"
IVORY

NO. 16 - 22"
TEAK WOOD

NO. 87 - 21"
BLUE MOTTLED

NO. 25 - 20 3/4"
LOUWELSA

NO. 10 - 20"
BEDFORD MATT

Weller Pottery catalog, ca. 1919

Weller Pottery catalog, ca. 1919

Weller Pottery catalog "Orris" ware

122

9.00

10.00

13.00

9.00

11

7—8

10

5—6

9

$19\frac{1}{2}$" Tell. r $11\frac{3}{4}$" Jan. 12.00
$17\frac{1}{2}$" " — 10" " 9.00

Weller Pottery. Flemish line. Priced

Weller Pottery

Weller artists and their monograms:
Some of the monograms were not available to this author.

Artist	Monogram	Artist	Monogram
Abel	*A BEL*	C. A. Dusenbery	*C. P.*
Virginia Adams	*VA*	Dorothy England (Laughead)	*DL*
M. Ansel	*MAnSEL*	Frank Ferrel	*F.F.*
Ruth Axline	*R*	Charles Fouts	*F*
Elizabeth Ayers	*EA*	Henry Fuchs	*H·FuCHS H*
A. Best	*AB*	M. Gibson	*m GiBSON*
Lizabeth Blake	*L·B·*	W. Gibson	*W GIBSON*
Levi J. Burgess	*L·J·B·*	Mary Gillie	*MG M.S.*
John Butterworth	*B B*	Charles Gray	*C.G.*
Sam Celli		William F. Hall	*WH WH*
Charles Chilcote	*C.C. c.c.chilcote*		
Laura Cline	*L C*	Delores Harvey	*D.H. H*
Anna Dautherty	*A·D·*	Albert Haubrich	*A.H.*
Frank Dedonatis	*E FODTIS*	Hood	
Charles John Dibowski	*C. J. D.*	Roy Hook	*RH*
Anthony Dunlavy	*AD*	Madge Hurst	*MH*

Josephine Imlay	J.I.	Fredrick Hurten Rhead	FR	
Karl Kappes	K·K·	Eugene Roberts	ER / ER	
L. Knaus	K	Hattie M. Ross	HMR	
Claude Leffler	C.L	Helen Smith	HS	
John Lessell	JL	Tot Steele	ST	
M. Lybarger	M. Lybarger	William Stemm	WS	
Sarah Reid McLaughlin		Sulcer	E SULCER	
Hattie Mitchell	HM	C. Minnie Terry		
Minnie Mitchell	MM	Mae Timberlake	MT	
Lillie Mitchell	LM	Sarah Timberlake	S.T.	
L. Morris	Morris	Naomi Truitt (Walch)	WALCH (married name)	
Gordon Mull		Arthur Wagner		
M. Myers	MM	Carl Weigelt	CW	
Lizzie Perone	LP	Carrie Wilbur	CW	
Mary Pierce	MP	Edna Wilbur	EW	
Edwin L. Pickens	E.LP	Albert Wilson	WILSON	
Hester W. Pillsbury	HP	Helen B. Windle	HW.	
Marie Rauchfuss	MR	Clotilda Marie Zanetta	CZ C3 M·Z·	

Weller Pottery

EARLY PERIOD MARKS (1895-1918):
During this period many of the marks.
included the line name along with the
company title.

Aurelian Weller

Eocean Weller

WELLER *DICKENS*

WELLER
ETCHED
MAT

MATT
WELLER

Eocean Rose Weller

Incised
(Appears on tobacco jars)

Incised on Dresden line

W

WELLER DICKENS
WARE

weller

Hunter
hunter

Incised

Incised on various pieces of hand-decorated
ware in different styles of handwriting.

WELLER
15

Raised frames with raised lettering
(Appears on third-line Dickens Ware)

TURADA
WELLER

WELLER
ETNA

DICKENSWARE
WELLER

WELLER

Impressed in very small lettering

Louwelsa marks impressed

MIDDLE PERIOD MARKS (1918-35):

Weller

Hand drawn on Barcelona using the color
of the swipe decoration

WELLER **WELLER**

Impressed in various sizes

Weller
Pottery

Weller
Hand Made

Weller

WELLER

Incised in fine line by hand

Stamped in dark lettering

Stamped in dark letters

Weller Pottery

LATE PERIOD MARKS (1935-48):

Weller Pottery *Weller* *Weller pottery*
SINCE 1872

Weller *Weller*
Pottery SINCE 1872

Impressed on all late-period Weller pieces. Also paper labels were used, designating the line name.

A white label with black lettering was used during the first part of the late period.

A black label with white lettering was used last.

T. J. Wheatley and Company
1880—1882
Wheatley Pottery Company
1903—1936

The T. J. Wheatley and Company was founded in April 1880 at 23 Hunt Street in Cincinnati, Ohio. Here, all the decorating and firing of the pottery was under the supervision of Wheatley, and was in operation about six months prior to the organization of the Rookwood Pottery.

In 1879, Wheatley was supervising a class at the Coultry Pottery where he was associated with M. Louise McLaughlin, both experimenting with the Haviland type decoration. This ware has a splotched background with the designs painted in slip, under the glaze. These early pieces are not as smooth in the background as the later Rookwood standard glaze, that was applied with an air brush. At this same period in time, Wheatley was also working at the Cincinnati Art Pottery, using the same technique. After some disagreement with that Company, he patented (1880) this relatively new process of decorating pottery, an under-the-glaze slip painting of scenes, flowers and other beautiful decorations. Wheatley, being among the first to use this strictly American innovation, was widely copied by other Potteries that were soon to be engaged in this highly competitive business. He also created a matt green, with the decoration in relief, very similar to the dark green pottery that was so popular at the turn of the century.

The T. J. Wheatley and Company prospered, and by the winter of 1880, had four employees. Huge amounts of pottery was ordered from the Wheatley Company, by the prestigeous Tiffany and Company.

The Pottery became a Corporation in December of 1880, however, business was suspended for a few months, following a fire, but was again operating by February, 1881. Wheatley was associated with the T. J. Wheatley and Company until the summer of 1882, at which time he opened a Pottery at the end of the Suspension Bridge, on the Covington, Kentucky side. This venture lasted less than two years, due to the devastating flood in 1884. He was known to have migrated to Zanesville, Ohio, where he worked at the Weller Pottery, commencing in 1897. What speculative business enterprise Wheatley participated in between 1884 and 1897 is not known.

With a new associate, Isaac Kahn, he returned to Cincinnati in 1903, where he again opened a business at 2430 Reading Road. This operation was named Wheatley Pottery Company and not to be confused with the earlier (1880) T. J. Wheatley and Company. A line of pottery was created here, with some designs in relief, glazed in dark green, yellow, blue and a unique finish with green splotches on black or dark blue. A line of garden and architectural ware was also produced. The Pottery burned in 1910, but was rebuilt and continued in business, with Wheatley as acting manager until his death in 1917. It is believed that no art ware was made after the fire.

Isaac Kahn succeeded Wheatley as manager of the Wheatley Pottery Company, and later, formed a Corporation (about 1920) with Kahn as president. During the next few years, the Corporation became affiliated with several tile Corporations, located in Ohio. The final ones were: "Cambridge Wheatley" and "Wheatley Tile and Pottery Company". These Corporations were dissolved legally in 1936.

The Wheatley Pottery Company was not very meticulous in their marking of their wares. Some bore only a paper label, however, the T. J. Wheatley and Company pieces are generally always carefully marked and sometimes dated.

The new process of decorating pottery was patented in 1880, the patent reading

350

as follows:

UNITED STATES PATENT OFFICE

————————

Thomas J. Wheatley, of Cincinnati, Ohio.

PROCESS OF PAINTING POTTERY

SPECIFICATION forming part of Letters Patent No. 232,791, dated September 28, 1880.
Application filed June 21, 1880. (Specimens)

To all whom it may concern:

Be it known that I, Thomas J. Wheatley, of Cincinnati, Hamilton County, Ohio, have invented a new and useful Improvement in the Art of Painting Pottery and other Ceramics, of which the following is a specification.

The object of my invention is to employ underglaze colors to pottery and other ceramics in such a manner as to cause the colors to become integral with the ware as soon as the latter is baked, thereby adding to the beauty and durability of the ornamentation and increasing the value of the ware, as hereinafter more fully described.

The first step in my improved art of ornamentation consists in forming the vessel or other piece of ware of any suitable plastic clay, and while yet moist or damp there is applied to it the background tint, which tint is composed of any appropriate oxide or undeglaze color mixed with white slip. The background tint thus prepared is applied to the damp piece with a brush, care being taken to give the article a thick uniform coating of said tint. The white slip employed in this process is the kind used in all potteries in manufacturing Parian ware or white delft, the slip being simply mixed with water until the desired consistency is obtained. While the background coat of tinted slip is yet damp the piece is decorated with landscapes, flowers, figures, animals, or other desired ornamentation, which decorations are applied with a brush or other convenient tool or implement. The appropriate oxide colors or other pigments used for these decorations are mixed with slip in any suitable proportions, and if the ornaments consist of a bunch of flowers or fruit or other simple group it is preferred to impaste the colors, so as to cause such a group to stand out in high relief after the piece is burned, which burning is effected by placing the article in an ordinary kiln heated to the proper temperature—say about two thousand degrees. After being baked a sufficient length of time, according to the size of the piece and the kind of clay of which it is composed, the article is then removed from the kiln or oven in the condition commonly known as "biscuit," an examination of which will show that the colored ornaments have been so thoroughly baked onto the ware as to become integral therewith. This biscuit is now dipped in any suitable glaze and then reheated, so as to give it the final or vitreous coating, which operation completes the process.

From the above description it will be apparent that the colored ornaments are so completely fused or burnt onto the substance of the ware as to become part of the material body of the same, and consequently they cannot scale off or be removed by any means short of the destruction of the vessel.

Finally, to define my invention more explicitly, it consists in baking tinted clay ornaments onto pottery or other ceramics.

I claim as my invention--------

The within described improvement in the art of painting ceramics, which improvement consists in mixing underglaze colors with slip or other suitable clay vehicle, then applying such tinted clays to the piece and baking or burning them onto the same so as to become integral with the substance of the ware, for the purpose specified.

In testimony of which invention I hereunto act my hand.

T. J. Wheatley.

Witness:
James H. Layman,
Geo. H. Kolker.

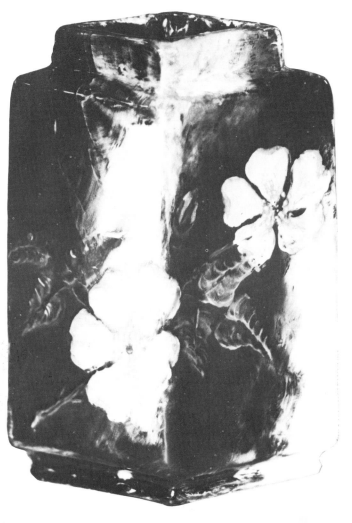

Wheatley vase. Shiny glaze, orange flowers on green and black, 1880, 6½-in. high.

Wheatley Pottery; Vase.. 5 5/8 in. high. Forest green glaze with applied rose in deep wine color. Patent Feb. 28, 1880. #36-T. J. WeCo. Artist signed.."W" under rose. Collection of Alice Kopp. Photo by Barry Brumfield

Wheatley Pottery

T. J. Wheatley and company pottery marks:

T. J. W. 60 *TJWheatley*

*TJ We 60
Pat sep 28
1880*

Incised by hand

Printed or impressed

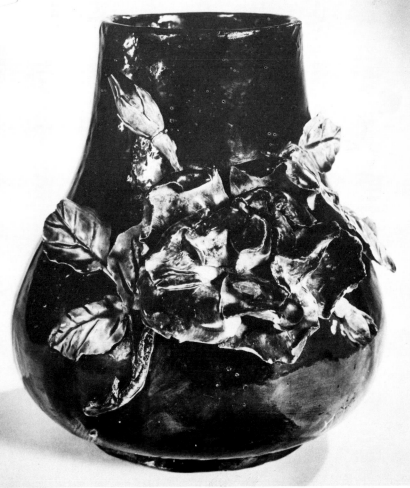

Pottery Tiles

Ornamental and souvenir tiles from American factories are still preserved and collected, long after the floor and wall tiles have been destroyed. Many tile companies made gift tiles for the customers. These included commemoratives, records of important dedications and conventions, and busts of presidents or other celebrities. These tiles and plaques are eagerly sought by today's American art pottery collectors. Art tiles to decorate homes and public buildings were made in a number of styles. Groups of tiles were placed together to compose these subjects. At times, only four tiles were used for a theme; at other times several hundred had to be used to compose an entire theme.

In addition to the regular tile manufacturing companies, tiles were also made by various important potteries—Rookwood, Weller, Tiffany, and others—along with their regular lines of ware. The majority of tile companies were engaged in business in the eastern half of the United States due to the proximity of an abundance of fine clay. In the western part of this country, especially California, only a few tile companies operated. The Western Art Tile Works started in 1905, but failed by 1910. Only two major companies were producing art tile in California in 1920. These were the Tropico Potteries and The American Encaustic Tiling Company.

IMPORTANT AMERICAN TILE COMPANIES WITH DATE AND PLACE OF ORIGIN

Alhambra Tile Company, 1892, Newport, Ky.

American Encaustic Tiling Company, 1875, Zanesville, Ohio.

Architectural Tiling Company, Inc., 1911, Keyport, N.J.

Atlantic Tile and Faience Company, 1910, Maurer, N. J.

Beaver Falls Art Tile Company, 1886, Beaver Falls, Pa.

C. Pardee Works, 1894, Perth Amboy, N.J.

Cambridge Art Tile Company, 1887, Covington, Ky.

Columbia Encaustic Tile Company, 1887, Anderson, Ind.

Enfield Pottery and Tile Works, 1906, Enfield, Pa.

Grueby Faience Company, 1891, Boston, Mass.

J. and J. G. Low Art Tile Works, 1879, Chelsea, Mass.

Matawan Tile Company, 1902, Matawan, N.J.

Moravian Pottery and Tile Works, 1899, Doylestown, Pa.

Mosaic Tile Company, 1894, Zanesville, Ohio.

Mueller Mosaic Tile Company, 1908, Trenton, N.J.

Old Bridge Enameled Brick and Tile Company, 1893, Old Bridge, N.J.

Olean Tile Company, 1913, Olean, N.Y.

Perth Amboy Tile Works, 1908, Perth Amboy, N.J.

Providential Tile Company, 1891, Trenton, N.J.

Robertson Art Tile Company, 1890, Morrisville, Pa.

Rookwood Pottery, 1880, Cincinnati, Ohio.

Star Encaustic Tiling Company, 1876, Pittsburgh, Pa.

Trent Tile Company, 1882, Trenton, N.J.

United States Encaustic Tile Works, 1877, Indianapolis, Ind.

United States Quarry Tile Company, 1913, Canton, Ohio.

Wenezel Tile Company, 1915, Trenton, N.J.

Wheatley Pottery Company, 1880, Cincinnati, Ohio.

Wheeling Tile Company, 1913, Wheeling, W. VA.

AMERICAN ENCAUSTIC TILING COMPANY, LTD.

The American Encaustic Tiling Company, better known as A. E. Tile, was organized in 1875 in Zanesville, Ohio. This company is perhaps the most important tile company in the history of ceramics in the United States. According to E. Stanley Wires, architect and foremost authority on tile, A. E. was the pioneer of floor and wall tile produced in this country.

Operations, begun in an old building on Hughes Street, had progressed far enough by 1879 to warrant the move to a more suitable location on Sharon Avenue. The company continued to prosper and by 1892, were moving into a modern new plant on Linden Avenue. Dedication of the new plant, attended by several thousand people who came from all over the country, was augmented by an address by William McKinley, who was then Governor of Ohio. Ceramic art works produced here were outstanding, and by the early 1920s A. E. Tile was the largest tile company in the entire world. Furthermore the company had acquired a beautifully decorated office building in New York City at 16 East 41st Street.

Some of the most important men in the field of ceramics were engaged by A. E. Tile, including Karl Langenbeck, chemist; Herman Mueller, modeler; Benedict Fischer, a financier who contributed to the organization of A. E. Tile; Harry Lillibridge; Emil Kohler; and George Stanbury. Also employed were Paul and Leon V. Solon, who were the sons of the noted English ceramist, L. M. Solon.

A. E. manufactured all sorts of decorative tile, including intaglio, embossed, unsurpassed decalcomanias, and beautiful underglaze handpainted panels. All types of architectural tiles were produced as well as a large variety of novelties and souvenir plaques or tiles. Some were only two and a half to three inches in size, small enough to tuck into a pocket or purse. These souvenir pieces depicted important events, dedications, conventions or just VIPs. Large quantities of the small tiles came with various colored backgrounds, in diverse techniques, and in different glazes. The earliest dated one that has been found was distributed at the dedication of the new A. E. Tile plant in 1892.

The depression years of the 1930s took its toll, including A. E. Tile; consequently the plant ceased operations about 1936.

American Encaustic Tiling Company marks:
 Many A. E. tiles were modeled and marked by Herman C. Mueller. These are prior to 1893.

A.E. TiLE Co.
LiMiTeD

ℋM A.E.T. Co.

AETCO FAIENCE

Block letters, impressed

Embossed

A. E. tile. Natural colors with yellow figure, titled, "There was a lady loved all swine," marked, 6 in. square. Knight photo

A. E. tile. Background of natural colors with brown female figure and blue boy, titled "Fortune and the Boy" marked, 6 in. square. Knight photo

A. E. tile. Delft blue, marked, 6 in. square. Knight photo

CAMBRIDGE ART TILE COMPANY

The Cambridge Art Tile Company was established in 1887 at Covington, Kenttucky. From the outset the Cambridge Company engaged some of the most talented artists available in the ceramic industry. One of these important artists was Clement J. Barnhorn, a celebrated sculptor from Cincinnati, Ohio. Also employed was Ferdinand Mersman, modeler, who had studied at the Academy of Fine Arts in Munich, Germany. Both of these outstanding artists were associated with the Rookwood Pottery at one time or another.

Items produced by the Cambridge Tile Company were handmade faience tiles, mantel facings, friezes, modeled plaques, and garden pottery.

The company eventually merged with Wheatley to become the Cambridge-Wheatley Company, producing a very high grade interior tile ware.

"King Lear" plaque made by Cambridge Art Tile Company. Sketched by David Thompson

Grueby faience decorative tile inserts

LOW ART TILE WORKS

The Low Art Tile Works was established at Chelsea, Massachusetts, by John Gardner Low in conjunction with his father, John Low. The first Low kiln was drawn on May 1, 1879.

John Gardner Low studied painting in Paris, France, under Thomas Couture from 1858 to 1861. On his return to the United States, he was employed by the Chelsea Keramic Art Works, where he learned the potting business from the Robertsons.

The Lows, ever progressive, were always experimenting with various techniques. They developed one technique referred to as the "natural" process of decoration. Leaves, grass, and flowers were used as the natural patterns pressed into the surface of each tile while the clay was still in plastic condition. On this impression, a sheet of thin tissue paper was applied, a second (soft) tile was laid on top with the tiles face to face, and then the whole was compressed. When the units were separated, one tile would have an embossed pattern.

The most important tiles made by Low were the "Plastic Sketches" or "Poems in Clay" as they were called. Some of these ingenious works of art were created by a talented young artist, Arthur Osborne. A certain portion of these tiles were as much as twenty-four to thirty inches in length. These were skillfully executed subjects such as pastoral scenes, animals and, the most stunning of all, the human faces and figures. In the high-relief subjects, the undercutting was hand done, after the designs were stamped in the press. The works executed by Osborne were marked "AO" or "A" in a circle.

Low manufactured such structural tiles as mantel facings, panels, modeled plaques, and friezes, and bric-a-brac trimmed in brass, including trinket boxes, inkstands, clock cases, and paperweights.

The decorative tiles created by Low were an important innovation to the architectural industry and increased the public demand for more colorful tiles.

J. and J. G. Low Art Tile plaque on display at the Smithsonian Institution. Sketched by David Thompson

Low Art Tile Works marks:
Many of these tiles bore the mark of Arthur Osborne, chief modeler prior to 1893.

AO

J & JG LOW
PATENT
ART TILE WORKS
CHELSEA MASS USA
COPYRIGHT 1881 BY
J & JG LOW

MORAVIAN POTTERY AND TILE WORKS

At the turn of the century, perhaps one of the most interesting and unique tile companies in America was the Moravian Pottery and Tile Works of Doylestown, Pennsylvania.

The guiding influence of the pottery was Dr. Henry C. Mercer who, at one time, was curator of the Museum of Archaeology at the University of Pennsylvania. He was also the author of a book on iron, entitled *The Bible in Iron,* published by the Bucks County Historical Society of Doylestown, Pennsylvania. Dr. Mercer began experimenting with art tiles about 1900, using the common red clay found in the vicinity of Doylestown. Realizing that the white uninteresting tiles were being outmoded, the Moravian Pottery produced beautiful colored tiles, some being as bright and as colorful as leaded glass windows, while others were soft matt finishes with subtle colored glazes. The designs on these tiles were reminiscent of the Pennsylvania Dutch patterns. A portion of these designs were copied from old Moravian iron-stove decorations and firebacks which were used in "Fonthill," Dr. Mercer's home in Doylestown. Still other designs were copied from a valuable collection of drawings gathered from the ruins of old English churches and presented to Dr. Mercer by Sir Hercules Read of the British Museum. Many medieval-type patterns were inspired by old designs found in France, Italy, and other countries. The American Indian was also used on some tiles for fireplaces.

The Moravian Pottery created some of the most important symbolic decorations for churches and museums in the United States and Canada.

MOSAIC TILE COMPANY

In 1894 the Mosaic Tile Company was founded in Zanesville, Ohio, by Herman Mueller, Karl Langenbeck, and William M. Shinnick, the latter being known for his contribution to the growth of the tile industry in the United States at the turn of the century. Both Mueller and Langenbeck were well experienced in the field of ceramics and left the American Encaustic Tiling Company to organize Mosaic Tile Company.

The Mosaic Company was an immediate success and on several occasions surpassed A. E. Tile to become the largest tile company in the world. During this era, when the tile business became highly competitive, these two companies vied for this title for several years—first one at the top and then the other. Mosaic manufactured all varieties of architectural tiles as well as numerous souvenir novelty items, including figures of people and animals. Many commemorative tiles and plaques were also created, depicting famous people and important events. These tiles or plaques were made in various sizes and with all types of elegant decorations including embossed, impressed, decalcomania, and one type with molded figures "sprigged on" similar to the Wedgwood Jasperware, with blue backgrounds and white figures. The souvenir pieces were made in a variety of shapes including round, square, oval, and hexagonal.

Mosaic developed a type of decorative tile in which the designs were created by sifting the powdered clay through stencils, then pushing it into the surface with tremendous pressure which gave the effect of mosaic design.

The Mosaic Tile Company in Zanesville ceased operations in 1967.

Moravian Pottery and Tile Works company marks:

Henry C. Mercer

Mosaic Tile Company marks:

Embossed Impressed

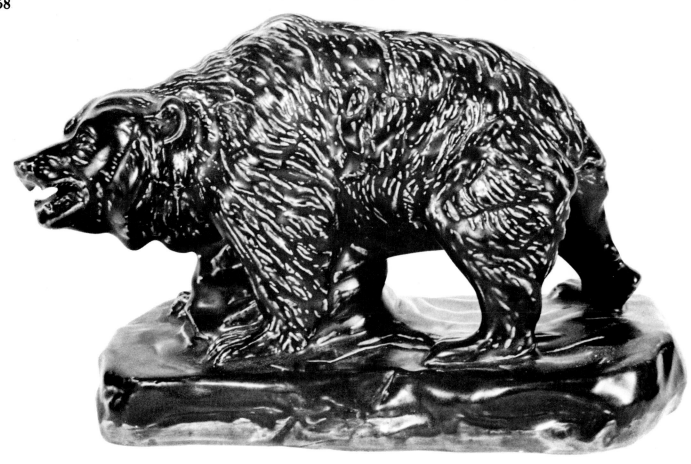

Mosaic Tile bear. Black glaze, mark-
ed, 6 in. high. Knight photo

Mosaic Tile Company. Delft blue,
marked, 6 in. square. Author's collection;
Knight photo

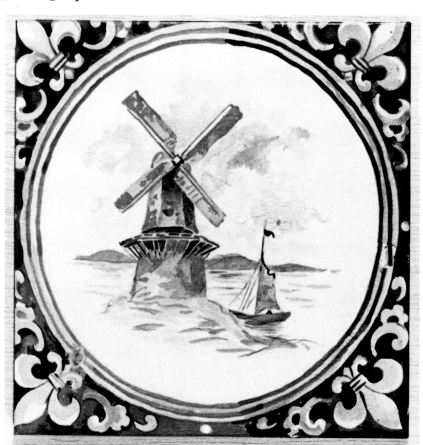

MUELLER MOSAIC TILE COMPANY

During the art nouveau period, the name of Herman C. Mueller was closely bound up in the history of American art pottery. He was one of the most talented ceramic artists in the United States during this era, having been trained in the Art School at Nuremberg, Germany.

For two decades prior to the organization of his own Pottery, Mueller had worked for several leading potteries in this country, including Matt Morgan, American Encaustic Tiling, National Tile, and Robertson Art Tile. He also assisted Karl Langenbeck in organizing the Mosaic Tile Company of Zanesville, Ohio.

In 1908 the Mueller Mosaic Tile Company was established in Trenton, New Jersey. The company produced some of the most beautiful and fascinating faience tiles in America. Some of these were classic art nouveau figures, while others depicted the "Jolly Monk," so popular at this period. The monk decor was widely used by the Weller Pottery in the second-line Dickens Ware and appeared on mugs, tankards, and all size vases. Another line of Mueller tiles depicted a variety of cunning antics by mischievous elves. Other products created were beautiful panels of faience tile and metal worked together.

Mueller Mosaic faience tile inserts. Sketched by David Thompson

OTHER TILE COMPANY MARKS

The Robertson Art Tile Company of
Morrisville, Pennsylvania. Operated by George
W. Robertson. Hugh C. Robertson (of Dedham
fame), did some of the modeling for the em-
bossed tile design

HCR Hugh C. Robertson

Star Encaustic Tiling Company of Pitts-
burgh, Pennsylvania; established, 1876

S. E. T.
Co.

Altman, Seymour and Violet. *The Book of Buffalo Pottery*. New York: Crown Publishers, 1969.

Arnst, Barbara M., ed., and Morris, Robert E. *Van Briggle Pottery, The Early Years*. Colorado Springs: Privately Published, the Colorado Art Center, 1975.

Barber, Edwin Atlee. *The Pottery and Porcelain of the United States*. 3rd ed. New York: G. P. Putnam's Sons, 1909.

Benjamin, Marcus. *American Art Pottery*. Washington D. C.: Privately published, 1907.

Boger, Louise Ade. *The Dictionary of World Pottery and Porcelain*. New York: Charles Scribner's Sons.

Bogue, Dorothy McGraw. *The Van Briggle Story*. Colorado Springs: Privately published, 1968.

Buxton, Virginia Hillway. *Roseville Pottery for Love or Money*. Tymbre Hill, 1977.

Charleston, Robert J., ed. *World Ceramics*. New York: Paul Hamlyn, 1968.

Coates, Pamela. *The Real McCoy*. Cherry Hill: Reynolds Publishing, 1971.

Cox, Warren E. *The Book of Pottery and Porcelain*. 2 vols., New York: Crown Publishers, 1944.

Cox, Susan N. *The Collector's Guide to Frankoma Pottery*. Privately published, 1979.

Evans, Paul. *Art Pottery of the United States*. New York: Charles Scribner's Sons, 1974.

Huxfords, Sharon and Bob. *The Encyclopedia of Brush McCoy Pottery*. Paducah: Schroeder Publishing Company, 1976.

Huxfords, Sharon and Bob. *The Encyclopedia of McCoy Pottery*. Paducah: Schroeder Publishing Company.

_____. *The Encyclopedia of Roseville Pottery*. Paducah: Schroeder Publishing Company, 1976.

_____. *The Encyclopedia of Roseville Pottery*. 2nd series. Paducah: Schroeder Publishing Company, 1980.

_____. *The Encyclopedia of Weller Pottery*. Paducah: Schroeder Publishing Company, 1979.

Johnson, Deb and Gini. *Beginner's Book of American Pottery*. Des Moines: Wallace Homestead Book Company.

Kircher, Edwin J. and Barbara, and Agranoff, Joseph. *Rookwood, Its Golden Era of Art Pottery*. Cincinnati: Privately printed.

Kovel, Ralph and Terry. *The Kovel's Collectors Guide to American Art Pottery*. New York: Crown Publishers, 1974.

Maddock's Sons, assisted by Barber, Edwin Atlee. *Pottery*. Limited ed. Thomas Maddock's Sons Company, 1910.

McClinton, Katherine Morrison. *Art Deco, A Guide for Collectors*. New York: Clarkson N. Potter Inc., 1972.

Mebane, John. *New Horizons in Collecting Cinderella Collectibles*. Cranbury: A. S. Barnes, 1968.

_____. *Collecting Nostalgia*. New Rochelle: Arlington House, 1972.

Nelson, Maxine Feek. *Versatile Vernon Kilns*. Costa Mesa: Rainbow Publications, 1978.

Newbound, Betty and Bill. *Southern Potteries Inc*. Paducah: Collector Books.

_____. *Blue Ridge Dinnerware*. Paducah: Collector Books, 1980.

Peck, Herbert. *The Book of Rookwood Pottery*. New York: Crown Publishers, 1970.

Purviance, Louise and Evan, and Schneider, Norris. *Zanesville Art Pottery in Color*. Leon: Mid-America, 1968.

_____. *Roseville Art Pottery in Color*. Des Moines: Wallace Homestead, 1970.

_____. *Weller Pottery in Color*. Des Moines: Wallace Homestead, 1970.

Ramsey, John. *American Potters and Pottery*. Clinton: 1939.

Ray, Marcia. *Collectible Ceramics*. New York: Crown Publishers, 1974.

Rehl, Norma. *The Collector's Hand Book of Stangl Pottery*. Privately printed, 1979.

Schneider, Norris F. *Zanesville Art Pottery*. Zanesville: Privately published, 1963.

Simon, Delores. *Red Wing Pottery with Rumrill*. Paducah: Schroeder Publishing.

Watkins, Lura Woodside. *Early New England Potters and Their Wares*. Cambridge: Achon Books, Reprint of 1950 edition.

Index of Lines and Patterns

A

Abino (Buffalo), 26
Aborigine (Owens), 164
Acorn (Cambridge), 41
Aerial Blue (Rookwood), 196, 200
Afro Girl (Frankoma), 64
Afro Man (Frankoma), 64
Al Capp's Dog Patch Cartoons
 (Imperial Porcelain), 95, 103
Alpine (Owens), 164
Alvin (Weller), 284, 323
American Eagle (Pennsbury), 174
Ansonia (Weller), 284
Antique Gold (Stangl), 74
Apple Blossom (Roseville), 252
Aqua Verde (Owens), 82, 164
Arcola (Weller), 284, 321
Ardsley (Weller), 284
Art Nouveau (Weller) see L'Art
 Nouveau, 116, 286, 302, 312
Art Vellum Ware (Owens), 164
Atlantic (Weller), 284
Atlas (Weller), 284
Aurelian (Weller), 128, 280, 281,
 284, 289
Auroro (Weller), 280, 284, 296
Azalea (Dedham), 45
Aztec (Roseville), 252

B

Baby Weems (Vernon Kilns),
 112, 271
Baldin (Weller), 284, 297
Baneda (Roseville), 250, 252
Barcelona (Weller), 284, 318, 322
Bedford Matt (Weller), 284
Bird in Orange Tree (Dedham), 44
Birds (Pennsbury), 106, 174
Birds (Stangl), 74, 101, 102
Bit Plates (Vernon Kilns), 272
Bittersweet (Roseville), 252
Blackberry (Roseville), 244, 252
Black Gold (Stangl), 74
Black Rooster (Pennsbury), 174
Bleeding Heart (Roseville), 252
Blo'red (Weller), 284
Blue Decorated (Weller), 124, 284
Blue Drapery (Weller), 284, 315
Blue Ridge (Southern Potteries),
 257–259
Blue Ridge Mountain Boys (Imperial
 Porcelain), 95, 114, 115
Blue Sailing Pirate Ships (Rookwood),
 196, 205
Blue Ware (Roseville), 252
 (Weller), 284, 319
Bo-Marblo (Weller), 284
Bonito (Weller), 284, 317, 328
Bouquet (Weller), 284, 315
Breakfast at the Three Pigeons
 (Buffalo decoration), 25
Breaking Cover (Buffalo decoration),
 25
Breton (Weller), 284
Brighton (Weller), 120, 284
Bronze Pottery (Tiffany), 263
Bronze Ware (Weller), 284
Brown Ware (Rookwood) see standard
 glaze, 22, 39, 109, 163, 201, 214,
 226, 280
Burntwood (Weller), 284, 297, 315
Bush Berry (Roseville), 252
Butter Fat (Rookwood) (glaze), 197,
 200
Butterfly (Dedham), 47

C

Cafe'-au-lait (Buffalo), 26
Calender Plates (Buffalo), 25
Cameo (Roseville), 252
 (Weller), 284
Cameo Dickens Ware (Weller), 278
Carnelian (Roseville), 32, 149, 243,
 247, 249, 252

Chase (Weller), 284, 319
Chelsea (Weller), 284, 324
Chengtu (Weller), 125, 281, 284
Cherry Blossom (Roseville), 252
Cerulean Blue Matt (Starkville
 Rookwood), 217
China Maid (pansy) (Cybis), 57
Christmas Cards (Frankoma), 65, 69
Christmas Plates (Buffalo), 26
 (Frankoma), 65–68
Chromal (Peters & Reed), 177
Claremont (Weller), 124, 284
Classic (Weller), 284, 323
Claywood (Weller), 284, 316
Clemana (Roseville), 248, 252
Clematis (Roseville), 252
Clinton Ivory (Weller), 284
Columbine (Roseville), 252
Comet (Weller), 284
Coppertone (Weller), 126, 284,
 314, 318
Corinthian (Roseville), 252
Cornish (Weller), 284, 315
Corona Animals (Owens), 164
Corona Ware (Owens), 164
Cosmos (Roseville), 252
Crystaline Ware (Peters & Reed),
 177
Crystalline (Weller), 284
Crystalis (Roseville), 252
Crystal Patina (Clifton), V, 129
Cyrano (Owens), 164, 165

D

Dahlrose (Roseville), 246, 252
Daring Fox (Weller design), 278,
 294
Darsie (Weller), 284, 298
Dawn (Roseville), 252
Deldare Ware (Buffalo), 24
Delft (Owens), 164
Della Robbia (Roseville), 111,
 227, 252
Della Robbia white glaze (Frankoma),
 65
Delsa (Weller), 285, 318
Delta (Weller), 285
Despondency (Van Briggle figure),
 266
Dickens Ware (Weller), 128, 129,
 277–280, 285, 288–295, 359
Dogwood (Roseville), 227
Dogwood I (Roseville), 249, 252
Dogwood II (Roseville), 252
Donatello (Roseville), 227, 236,
 239, 252
Dorland (Weller), 285
Dresden (Weller), 280, 285, 299
Drip Line (Peters & Reed), 177
Duck (Dedham), 42, 46

E

Earlam (Roseville), 252
Eclair (Weller), 285
Edgerton Art Clay (Pauline), 173
Egypto (Roseville), 227, 228, 246,
 252
Eldora (Weller), 285
Elephant Border (Dedham), 42,
 43
Emma Sweeney, The (Vernon Kilns),
 274
Emerald Deldare (Buffalo), 25
Emerald Green Matt (Starkville
 Rookwood), 217
Eocean (Weller), 120, 278, 280,
 285, 330
Eocean Rose (Weller), 285
Etched Matt (Rookwood), 205
 (Weller), 280, 285, 293, 321
Ethel (Weller), 285, 323
Etna (Weller), 280, 285, 298
Euclid (Weller), 285
Evergreen (Weller), 285

F

Fairfield (Weller), 285
Falline (Roseville), 252
Fallowfield Hunt (Buffalo
 decoration), 25
Fantasia (Vernon Kilns), 274
Favrile (Tiffany), 262, 263
Feroza (Owens), 164
Ferrella (Roseville), 244, 252
Flambe (Fulper), V, 103
Flemish (Weller), 120, 285, 314,
 344
Floral (Weller), 285
Florala (Weller), 285
Florentine (Roseville), 245, 252
Florenzo (Weller), 285, 316, 320
Floretta (Weller), 280, 285, 313
Forest (Weller), 281, 285, 306, 318
Fortune and the Boy (A. E. Tile),
 354
Foxglove (Roseville), 252
Fox Tail (Weller decoration), 278,
 293
Franciscan Apple (Gladding
 McGean), 281
Freesia (Roseville), 252
French Peasant (Southern Potteries),
 258
Fuchsia (Roseville), 243, 252
Fugi (Roseville), 227, 236, 252
Fugiyama (Roseville), 252
Futura (Roseville), 111, 252

G

Gardenia (Roseville), 247, 252
Garden of Eden (Weller plaque),
 314
Garden Ware (Peters & Reed), 177
Glendale (Weller), 285, 323, 324
Golbrogreen (Weller), 285
Gold-green (Weller), 285
Gold Lustre (Tiffany), 263
Granada Gold (Stangl), 74, 101
Grape (Dedham), 42, 46
Graystone (Peters & Reed), 177
 (Weller), 285
Greenbriar (Weller), 126, 285, 317
Green Matt (McCoy), 132
Gremo (Roseville), 252
Greora (Weller), 285
Guernsey (Cambridge), 41
Guernsey Cooking Ware (Cambridge),
 41
Gunmetal Ware (Owens), 164

H

Haviland (decoration), 349
Henri Deux (Owens), 164
Hobart (Weller), 285, 302
Holland (Roseville), 252
Holly (Roseville), 252
Honey Gold (Van Briggle), 266
Horse Chestnut (Dedham), 44
Hudson (Weller), 116, 117, 285,
 286, 300, 317–320
Hungarian (Cincinnati), 48
Hunter (Weller), 286, 299
Hunt Supper (Buffalo decoration),
 25
Hywood (Niloak), 159

I

Imperial I (Roseville), 237, 252
Imperial II (Roseville), 243, 252
Incised Matt (Rookwood), 110,
 197, 200
Indian (Weller), 286, 318
Indian, American (Moravian
 design), 357
Indian Ware (Clifton), 129
Iris (Dedham), 42, 47
 (Rookwood glaze), 22, 109,
 196, 200, 201
 (Roseville), 248, 252
Ivoris (Weller), 286, 332

Ivory (Roseville), 252
(Weller), 286, 316, 322
Ivory Colored Faience (Cincinnati), 48
Ivory Ware (Buffalo), 26
Ixia (Roseville), 236, 253

J

Jap Birdimal (Weller), 117, 124, 280, 286, 301
Jasper (Radford), 186
Jasper Ware (Pisgah Forest), 182
Jet Black (Van Briggle), 266
(Weller), 286
Jetwood (McCoy), 132
Jewel (McCoy), 132
(Weller), 286
Jewel Porcelain (Rookwood), 197, 200
Jonquil (Roseville), 253
Juneau (Weller), 286
Juvenile (Roseville), 253

K

Kezonta (Cincinnati), 48
Kitchen-Gem (Weller), 286
Knifewood (Weller), 286, 314, 320, 323
Krackle Kraft (McCoy), 132

L

Lady loved all swine (A. E. Tile title), 353
Lakeware (Cowan), 61
Lakewood Ware (Cowan), 60
Lamar (Weller), 125, 281, 286
La Moro (Zanesville), 186, 189
Lansun (Peters & Reed), 177
La Rose (Roseville), 243, 253
L'Art Nouveau (Weller), 280, 286, 302, 312
LaSa (Weller), 32, 113, 281, 286
Laurel (Roseville), 253
Lavonia (Weller), 286, 302
Le—Camark (Camark), 32, 33
Lei Lani (Vernon Kilns), 273
Lido (Weller), 286
Limoge-type decoration (Rookwood), 195, 200, 216
Lombardy (Roseville), 253
Lonhuda Line (Lonhuda), 129, 131
Lorelei (Van Briggle figure), 266
Loru (Weller), 286, 315
Lo'santi (McLaughlin), 140
Lotus (Owens), 165, 166
(Roseville), 253
Louella (Weller), 226, 286, 318
Louwelsa (Weller), 39, 116, 124, 129, 132, 163, 277, 280, 286, 303—305
Loy-Nel-Art (McCoy), 132, 137
Luffa (Roseville), 253
Luna Ware (Buffalo), 26
Luster (Weller), 120, 286, 316

M

Magnolia (Dedham), 42, 45
(Roseville), 241, 244, 253
Malta (Weller), 286
Malvern (Weller), 286, 315
Manhattan (Weller), 286
Mara (Roseville), 111, 227, 253
Marbleized (Weller), 286, 312
Marengo (Weller), 32, 125, 281, 286
Marvo (Weller), 286, 324
Matt (Owens), 129, 164
(Weller), 116, 321
Matt Green (Roseville), 253
Matt Utopian (Owens), 129, 164, 165
Mayfair (Roseville), 240
Mi-Flo (Weller), 286
Ming Tree (Roseville), 243, 253
Mirror Black (Weller), 286
Misfortune at Tulip Hall (Buffalo decoration), 27
Mission (Niloak), 159, 160
(Owens), 165
Moby Dick (Vernon Kilns), 271, 274, 275
Mock Orange (Roseville), 236, 253
Modeled Matt (Rookwood), 197, 201 (Weller), 322
Moderne (Roseville), 245, 253

Mongol (Roseville), 226, 238, 253
Monochrome (Weller), 286
Montene Ware (Peters & Reed), 177
Monticello (Roseville), 253
Mont Pelee (McCoy), 132
Moon Glo (Van Briggle), 266
Moon Glow (Starkville Rookwood), 217
Morning Glory (Roseville), 247, 253
Morning and Night (Dedham), 43, 97
Moss (Roseville), 253
Moss Aztec (Peters & Reed), 177, 178, 228
Mostique (Roseville), 237, 245, 253
Muskota (Weller), 281, 286, 306, 313, 320

N

Narona (Weller), 286
Navarre (McCoy), 138
Neiska (Weller), 286
Normandy (Roseville), 253
Noval (Weller), 286, 317, 318
Novelty Line (Weller), 287
Nursery (Roseville), 253

O

Oak Leaf (Weller), 287, 316, 317
Oakwood (Cambridge), 41
Ollas Water Bottle (Weller), 282, 287, 317
Olympia (McCoy), 132
Olympic (Roseville), 111, 227, 250, 253
Ombroso (Rookwood), 197, 201
Opalesce Inlaid (Owens), 165
Opalesce Utopian (Owens), 165
Orian (Roseville), 253
Orris (Weller); 287
Our America (Vernon Kilns), 271, 274
Oxblood (Chelsea), 42

P

Painted Matt (Rookwood), 197, 201
Panel (Roseville), 245, 253
Panella (Weller), 287, 315
Paragon (Weller), 287, 316
Pastel (Weller), 287
Patra (Weller), 287, 319
Patricia (Weller), 287, 320
Pauleo (Roseville), 227, 229, 253
Pearl (Weller), 287
Peony (Roseville), 253
Pennsylvania Dutch Hex Ware (Pennsbury), 174
Pereco Ware (Peters & Reed), 178
Persian (Roseville), 253
Persian Ware (Peters & Reed), 178
Persian Rose (Van Briggle), 266, 268
Pictorial (Weller), 116, 287, 305
Pierre (Weller), 287, 320
Pinecone (Peters & Reed), 177
(Roseville), 228, 246, 251, 253
(Weller), 287, 316
Plastic Sketches (Low), 356
Platina (Stangl), 74
Poems in Clay (Low), 356
Polar Bear (Dedham), 46
Poppy (Roseville), 246, 253
Porcelain (Rookwood), 197, 201, 210
Portland Blue (Cincinnati), 48
Portland Vase (Buffalo reissue), 26
Powder Blue Line (Peters & Reed), 178
Primrose (Roseville), 253
Pumila (Weller), 287, 316

R

Rabbit (Dedham border design), 42, 44
Radora (Radford), 187
Ragenda (Weller), 287, 323
Raydence (Weller), 287
Raymor (Roseville), 228
Red Flame (Owens), 165
Red Rooster (Pennsbury), 174
Redware (Chelsea), 42
Renaissance (McCoy), 132
Roba (Weller), 287, 315, 324
Robin's Egg Blue Ware (Clifton), 129

Rochelle (Weller), 280, 287
Roma (Weller), 287, 315, 320
Roma Cameo (Weller), 287, 317
Rosecraft (Roseville), 253
Rosecraft Hexagon (Roseville), 244, 253
Rosecraft Vintage (Roseville), 235, 244, 253
Rosemont (Weller), 120, 287
Rosewood (McCoy), 132
Rudlor (Weller), 287, 315
Ruko (Radford), 187
Rustic (Owens), 165
Royal Garden (Haeger), 88
Royal Haeger (Haeger), 87
Rozane (Roseville), 240, 242, 243, 251
Rozane I (Roseville), 253
Rozane II (Roseville), 253
Rozane Mara (Roseville), 235
Rozane Matt (Roseville), 253
Rozane Royal (Roseville), 111, 226, 239, 241, 253
Rozane Royal Dark (Roseville), 253
Rozane Royal Light (Roseville), 253
Russco (Roseville), 253

S

Sabrinian (Weller), 287, 316
Salamina (Vernon Kilns), 112, 271, 274
Sang de Boeuf (Chelsea), V, 42, 43
Sang de Chelsea (Chelsea), V
San Ildefonso Black on Black (Maria), 141, 144
Savona (Roseville), 253
Sea Green (Rookwood) glaze, 109, 197, 201
Selma (Weller), 287, 320
Senic (Weller), 287, 324
Sheen Ware (Peters & Reed), 178
Sicardo (Weller), 113, 125, 227, 278—280, 287, 307—309
Silhouette (Roseville), 246, 254
Silvertone (Weller), 124, 287, 320
Snuffy Smith Cartoon Characters (Imperial Porcelain), 95
Softone (Weller), 287
Soudaneze (Owens), 165
Standard glaze (Rookwood ware), 22, 39, 109, 163, 201, 214, 226, 280
Stein Sets (Roseville), 254
Stellar (Weller), 287, 317
Stonetex (Peters & Reed), 178
Sunburst (Owens), 165
Sunflower (Roseville), 247, 254
Swan (Dedham), 42, 45
Sweet Adeline (Pennsbury), 174
Sylvan (Roseville), 254

T

Teakwood (Weller), 287
Teasel (Roseville), 254
Teco Ware (Gates), 32, 82
Terose (Weller), 287, 320
Terra Rose (Stangl), 74
Terrhea (Cambridge), 39
The Dash (Buffalo), 25
The Death (Buffalo), 25
The Hunt Supper (Buffalo), 25
The Return (Buffalo), 25
The Start (Buffalo), 25
Thera (Radford), 187
Thorn Apple (Roseville), 254
Tiger Eye (Rookwood), 196, 201
Tiger Eye Green (Starkville Rookwood), 217
Ting (Weller), 287
Tivoli (Weller), 287, 317
Toby Jugs (Southern Potteries), 257, 259
Topeo (Roseville), 254
Tours of Dr. Syntax (Buffalo), 26
Turada (Weller), 280, 287, 310
Turkey (Dedham), 46
Turning Eagle, Sioux (Rookwood decoration), 212
Turquoise Ming (Van Briggle), 266—268
Turquoise Craquelle (Pisgah Forest), 106, 182
Tuscany (Roseville), 254
Tutone (Weller), 288, 315

U

Underglaze Blue (Weller), 288
Utopian (Owens), 39, 163, 165, 226

V

Vellum (Rookwood), 109, 110, 197,
201, 214, 280
Velmos (Roseville), 254
Velmoss (Roseville), 254
Velva (Weller), 288
Venetian (Owens), 165
Vernon Ware (Metlox), 272, 276
Vernonware (Vernon Kilns), 272
Victorian Art (Roseville), 244
Voile (Weller), 288, 316
Volcanic Ware (Dedham), V, 43
Volpato (Roseville), 254

W

Warwick (Weller), 288, 314, 316
Water Lily (Dedham), 42, 45
(Roseville), 244, 254
Wax Matt (Rookwood), 198, 201
Wedgwood Jasperware (Owens), 165
White Rose (Roseville), 247, 254
White Swan (Weller) Indian Decor,
294
Wild Rose (Weller), 288, 319
Wincraft (Roseville), 228, 230, 234,
254
Windsor (Roseville), 254
Wisteria (Roseville), 247, 254
Woodcraft (Weller), 281, 288, 311,
316

Woodland (Roseville), 111, 227,
235, 238, 254
Wood Rose (Weller), 288, 314

Y

Yellow Flambe (Fulper), 103
Ye Lion Inn (Buffalo), 25
Ye Olden Days (Buffalo), 25
Ye Olden Times (Buffalo), 25, 97
Ye Town Crier (Buffalo), 25
Ye Village Gossips (Buffalo), 25
Ye Village Street (Buffalo), 25

Z

Zephyr Lily (Roseville), 254
Zona (Weller), 281, 288, 313, 320,
324
Zona Baby Ware (Weller), 281, 288
Zuniart (McCoy), 132

Index of Pottery Locations

Abingdon Pottery, Abingdon,
Illinois, 9
American Art Clay Works, Edgerton,
Wisconsin, 171
Arc-En-Ceil, Zanesville, Ohio, 186, 187
Arequipa, Fairfax, California, 17
Avon Pottery, Cincinnati, Ohio, 22
Avon—Vance, Tiltonville, Ohio, 23
Wheeling, West Virginia, 23
Brush McCoy Pottery, Zanesville,
Ohio, 132
Brush Pottery, Roseville, Ohio, 132
Buffalo Pottery (Deldare), Buffalo,
New York, 24
Bybee Pottery, Madison County near
Lexington, Kentucky, 30
Camark Pottery, Camden, Arkansas, 32
Cambridge Art Pottery, Cambridge,
Ohio, 39
Chelsea Keramic Art Works, Chelsea,
Massachusettes, 42
Clifton Art Pottery, Trenton, New
Jersey, 129
Coors Porcelain Company, Golden,
Colorado, 226
Cincinnati Art Pottery, Cincinnati,
Ohio, 48
Clewell Art Ware, Canton, Ohio, 49
Cordey (Cybis), New York City,
New York, 51
Trenton, New Jersey, 51
Cowan Pottery, Cleveland, Ohio, 60
Rocky River, Ohio, 60
Dedham Pottery, Dedham, Massachu-
settes, 42
Edgerton Art Clay, Edgerton, Wiscon-
sin, 173
Frankoma Pottery, Sapulpa, Oklahoma,
63

Norman, Oklahoma, 63
Fulper Pottery, Flemington, New
Jersey, 73
Gates Pottery (Teco), Terra Cotta,
Illinois, 82
Gonder Pottery, Zanesville, Ohio, 177,
192
Grueby Pottery, Boston, Massachu-
settes, 84
Haeger Potteries, Inc., Dundee,
Illinois, 87
Imperial Porcelain Corporation, Zanes-
ville, Ohio, 95
Jugtown Pottery, Jugtown, North Carol-
ina, 126
Lonhuda Pottery, Steubenville, Ohio, 129
Denver, Colorado, 129
McCoy Pottery, Zanesville & Roseville,
Ohio, 132, 133
M. Louise McLaughlin Pottery, Cincinnati,
Ohio, 140
Maria Pottery, San Ildefonso, New Mexico,
141
Matt Morgan Pottery, Cincinnati, Ohio, 147
Muncie Pottery, Muncie, Indiana, 149
Newcomb Pottery, New Orleans, Louisiana,
151
Niloak Pottery, Benton, Arkansas, 159
Nonconnah Pottery, Shelby County near
Memphis, Tenn., 182, 185
Skyland, North Carolina, 185
J. B. Owens Pottery, Zanesville, Ohio, 163
Paul Revere Pottery, Boston & Brighton,
Massachusettes, 169
Pauline Pottery, Chicago, Illinois, 171
Edgerton, Wisconsin, 171
Pennsbury Pottery, Near Morrisville,
Pennsylvania, 174
Peters & Reed Pottery, Zanesville,

Ohio, 177
Pigeon Forge Pottery, Pigeon Forge,
Tennessee, 180
Pisgah Forest Pottery, Arden, North
Carolina, 182
A. Radford & Company, Tiffin &
Zanesville, Ohio, 186
Clarksburg, West Virginia, 187
Broadway, Virginia, 186
Red Wing Pottery, Red Wing,
Minnesota, 191
Rookwood Pottery, Cincinnati,
Ohio, 195
Rookwood Pottery (Starksville),
Starksville, Mississippi, 199
Roseville Pottery, Zanesville &
Roseville, Ohio, 226
Rum Rill Pottery, Little Rock,
Arkansas, 192
Southern Potteries, Erwin, Tennes-
see, 257
Stangl Pottery, Trenton, New Jersey, 74
Tiffany Pottery, Corona & New York
City, New York, 261
Van Briggle Pottery, Colorado
Springs, Colorado, 265
Vernon Kilns Pottery, Vernon,
California, 271
Weller Pottery, Zanesville, Ohio, 277
T. J. Wheatley Pottery, Cincinnati,
Ohio, 349
Zane Pottery, Zanesville, Ohio, 177
Zanesville Art Pottery, Zanesville,
Ohio, 186

General Index

A

Abel, -------------, 345
Abel, Edward, 220
Abel, Louise, 202, 208, 220
ABINGDON POTTERY, 9—16
Adams, Virginia, 256, 345
A. E. Tile Company, 22, 352—354,
357, 359
Aitkin, Russell. B., 60
Albert, F., 82
Aldin, Cecil Charles Windsor, 25,
28
Alfred University, IV, 60, 152
Alhambra Tile Company, 352

Allison, C. F., 226
Altman, Howard, 220
American Art Clay Works, 171
American Encaustic Tiling Company,
22, 227, 352—354, 357, 359
American Museum of Natural History,
142
American Steel Treating Company,
83
American Terra Cotta and Ceramic
Company, 82
American Terra Cotta Corporation,
82, 83
Anchor Pottery, 73, 74

Anderson, Elizabeth, 60
Anna, L., 29
Ansel, M., 345
Applegate, O. C., 187
Arc-En-Ceil Pottery, 186, 187
Architectural Tiling Company, Inc.,
352
Arend, Nicholas Van den, 266
AREQUIPA POTTERY, 17—21
Arequipa Pottery, 227
Art Academy of Cincinnati, 196
Artist, list of--
Abingdon, 15
Buffalo, 29

Cowan, 61
Grueby, 86
Lonhuda, 131
Matt Morgan, 148
Newcomb, 157, 158
Owens, 167, 168
Rookwood, 220–223
Roseville, 256
Weller, 345–346
Arts and Crafts Exhibition of
 Boston, 265
Art Pottery, definition of, IV, V,
 141
Asano, E. H., 196, 198
Asbury, Lenore, 220
Atlantic Tile and Faience Company,
 352
Atcheley, Whitney, 61
Auckland, Fannie, 215, 220
AVON POTTERY, 22–23
Avon Pottery, 163, 196, 265
Axline, Ruth, 345
Ayers, Elizabeth, 345
B
Baggs, Arthur, 60, 61
Bailey, Henrietta, 154–157
Bailey, Joseph, 140, 195
Bailey, Joseph Jr., 195
Bailly, Leon, 261
Baker, Constance A., 109, 220
Baker, Mary F., 157
Ball, H., 29, 97
Bangs, Harry, 266
Barber, Edwin Atlee, V
Barnhorn, Clement J., 198, 354
Barrett, Elizabeth, 220
Bartlett, Gladys, 157
Beardsley, Estelle, 167
Beatty, G., 29
Beaver Falls Tile Company, 352
Bell, Edith, 167
Bell, Fanny, 167
Below, Earnest, 174
Below, Henry, 174
Below, Mrs. -------, 174
Benham, Charles, 149
Benjamin, Marcus, IV, 280
Benson, Marie, 157
Bennison, Jane, 275
Bennison, Faye G., 271
Berks, L., 29
Bernhardt, Sarah, 171
Berry, George A. Jr., 82
Best, A. F., 167
Bibles in Iron, The, 357
Biddle, H., 29
Biddle, M., 29
Bidwell, George E., 9
Bidwell, Raymond E., 9, 10
Bigelow, Kennerd and Company
 (retailers), 17
Binns, Charles F., IV, 60
Bishop, Irene, 203, 220
Blake, Elizabeth or Lizabeth,
 304, 345
Blanding, Don, 272, 273
Blazys, Alexander, 61
Bloomer, Cecilia, 167
Bloomer, Lillian, 167
Bluebird Potteries, 277
Blue Eagle, Acee, 63
Bogatay, Paul, 61
Bonsall, Caroline, 220
Bookprinter, A. M., 220
Boston Museum of Fine Arts, 42
Bown, Louis H., 24
Brain, Elizabeth W., 220
Brastoff, Sascha, 88
Brennan, Alfred, 220
Breuer, W. H., 220
Brewer, Allen F. Jr., 272
Briggs Manufacturing Company, 9
Brighton Pottery, 187
Brodway, Dr. C. F., 9
Broel, E., 29
Broel, M., 29
Bromfield, James, 196
Bron, M., 29
Broome I., School of Industrial
 Arts, IV
Brown, Brenda A., 88

Brown, Edith, 169
Brown, Dr. Philip King, 17
Brown, Thomas, 226
Bruchman, Helmut, 88
Brush, George S., 132
Brush McCoy Pottery, 132
Brush Pottery, 132
BUFFALO POTTERY, 24–29
Burgess, Levi J., 278, 345
Burgoon, Jenny, 256
Burt, Stanley, 197, 198
Busbee, Jacques, 126
Busbee, Juliana, 126
Butler, Mary W., 157
Butterworth, John, 345
BYBEE POTTERY, 30–31
C
Caird, K., 29
Calender Plates (Buffalo), 24, 25
Calhoun, Nelsene Q., 112, 257
CAMARK POTTERY, 32–38
Camark Pottery, 159
CAMBRIDGE ART POTTERY,
 39–41
Cambridge Art Tile Company, 352,
 354
Cambridge–Wheatley Company,
 349, 354
Capp, Al, 95
Carnes, J., 32
Case, Tom, 183
Cash, Ray and Pauline, 257
Catalogs, Company,
 (Rookwood), 218–219
 (Roseville), 230–234
 (Weller), 332–344
Cavett, -------, 272
Celli, Sam, 345
Chalaron, Corinne, 157
CHELSEA KERAMIC ART WORKS,
 42–47
Chemistry of Pottery, 22, 196
Cezanne -------, 51
Chicago, Great Fire of, 87
Chilcote, Charles C., 345
Christmas Cards (Frankoma), 65
Christmas Plates (Buffalo), 26
 (Frankoma), 65–68
 (Pennsbury), 174
CINCINNATI ART POTTERY, 48
Cincinnati Art Pottery, 349
Clark Stoneware Company, 177, 226
Clement, F. S., 228
Clement Massier Pottery, 278
CLEWELL ART WARE, 49–50
Clewell Art Ware, 262
Clewell, Charles Walter, 49
Cleveland Museum of Art, 60, 127
Clifton Art Pottery, 129, 130
Clinchfield Artware Pottery, 257
Clinchfield Pottery, 257
Cline, Laura, 345
Cobb, Arline, VI, 9, 15
Cobb, Lura Milburn, V
Cocke, Frances H., 157
Colman, Duke, 33
Columbia Art Tile Company, 354
Columbia University, 277
Combe, William, 26
Conant, Arthur P., 220
Conant, Patti M., 220
Cook, Daniel, 220
Coons, Jenny, 171
Coons, John, 171
Coors Porcelain Company, 226, 245
CORDEY (Cybis), 51–59
Cornelison, Eli, 30
Cornelison, Ernest, 30
Cornelison, Mrs. -------, 30
Cornelison, Walter, 30
Coultry Pottery, 140, 349
Covalenco, Catherine, 220
Couture, Thomas, 356
Cowan, R. Guy, 60
COWAN POTTERY, 60–62
Cox, Dr. Paul, 152
Coyne, Sallie E., 108, 109, 198,
 205, 220
Crabtree, Cathrine, 220
Cranch, E. Berthan, 220
Cranch, Edward P., 195, 220

Crofton, Cora, 220
Cybis, Boleslaw, 51
Cybis, Marja, 51
Czarina's Summer Palace (Russia), 51
D
Dallas Pottery, Frederick, 140, 195
Daly, Matt A., 147, 148, 195, 198,
 220
Dalzee, -------, 61
Daniel, Mary, 33
Da Popovi, 142
Da Tony, 142
Daughtery, J. W., 63
Dautherty, Anna, 293, 345
Davenport, Charles, 43
Davenport, Maud, 43
Davidson, Paul, 271
Davis, Cora, 167
Day, Alfred, 129
DEDHAM POTTERY, 42–47
Dedonatis, Frank, 345
Demarest, Virginia, 220
Denny, W., 167
Denver China and Pottery Company,
 129
Denzler, Mary Grace, 110, 220
Dibowski, Charles John, 220, 345
Dickens, Charles, 277, 278, 280
Diers, Edward, 109, 110, 198, 220
Dirkson, Senator Everett, 88
Disney, Walt, 112, 174, 271
Ditmars, E., 29
Dodd, Olive W., 157
Dodd, W. J., 82
Dohrmann and Company (retailer), 17
Dowman, E., 29
Duell, Cecil A., 220
Dunlavy, Anthony, 240, 256, 294,
 345
Dunn, May, 157
Dunning, -------, 82
Dusenbery, C. A., 345
Duvall, Charles, 256
Duveneck, Frank, 198
Dye, Betty, 15
E
Eagle Pottery (Arkansas), 159
Eagle Pottery (New Jersey), 186
Eberlein, Harrie, 167
Eberlein, Hattie, 167
Edgerton Pottery Company, 171, 173
Elder, Paul (retailer), 43, 152
Elliott, Esther Huger, 157
Enfield Pottery and Tile Works, 352
England Laughhead, Dorothy, 282,
 322, 345
Epply, Lorinda, 220
Erickson, Ruth, 86
Essex Wire Company, 282
Estes, Alexandra "Lexy" Haeger, 88
Estes, Joseph F., 87, 88
Estes, Nicholas Edmund Haeger, 88
Excel, Cecil, 167
F
Fardy, -------, 29
Farney, Henry Francis, 220, 224
Farrington, Ellen R., 86
Fechheimer, Rose, 220
Felton, Edith R., 220
Ferguson, Douglas, 180
Ferrel, Frank, 163, 177, 227, 228,
 256, 281, 345
Fiacco, Dominick, 9
Ficklen, Bessie A., 157
Field, Kate, 220
Field, Marshall (retailer), 60, 152, 172
Filson, John, 140
Fischer, Benedict, 353
Florence Pottery, 192
Foermeyer, Emma D., 220
Foglesong, Mattie, 221
Fonthill (estate), 357
Ford, H., 29
Forman, Charles W., 257
Fort Boonesboro, 30
Foster, W., 25, 29
Foudji, Gazo, 227, 256
Fouts, Charles, 345
Fra (magazine), 24
Frank, Grace Lee, 64
Frank, John, 63–65, 71

Frank, Joniece, 63–65
FRANKOMA POTTERY, 63–72
Frazier, Bernard, 63
Fry, Laura A., 129, 131, 195, 196, 221
Fuchs, Henry, 282, 345
FULPER POTTERY, 73–81
Fulper Pottery, 87
Furukawa, Lois, 221
G
Galle, Emile, 261
Garcia, A message to, 24
Garland, Mae (Hice), 257
Gates, Ellis Day, 82
Gates, William D., 82
Gates, William Paul, 82
GATES POTTERY, 82–83
Gellie, Christina, 280
Gellie, Henri, 278, 279
Genter, P. H., 95, 114
Gerhardt, J., 27, 29
Gerhardt, M., 29
Gerwick, Gussie, 256
Gibson, M., 345
Gibson, W., 345
Gill Clay Company, 149
Gillie, Mary, 124, 128, 345
Gitter, Walter, J., 281–283
Gladding McBean Company, 281
Goetting, Arthur, 221
Golter, Katharine de, 221
Gonder, Lawton, 177, 192
Gonder Ceramic Arts, 177
Gonder Pottery, 192
Gorton, Elmer E., 82
Grafton, Charles O., 149
Grand Union Tea Company, 74
Grant, Frederick, 282
Graves, William H., 84
Gray, Charles, 167, 345
Gray, Martha E., 167
Gregory, Selina E. B., 157
Gregory, Waylande, 60, 61
Gregory Van Briggle, Anne
 Lawrence, 265
Grueby, William H., 84
Grueby Faience and Tile Company,
 84, 261, 352
GRUEBY POTTERY, 84–86
Grueby Pottery, 22, 82, 126, 262
Guerrier, Edith, 169
Guest, Alrun O., 88
H
Hackney, Ellen (Mrs. Albert
 Radford), 186
Haeger, David H., 87
Haeger, Edmund H., 87, 88
HAEGER POTTERY INC., 87–94
Haeger Pottery, 9, 10
Hall, Dr., -------, 17
Hall, Grace M., 221
Hall of Honour, 51
Hall, P., 29
Hall, William F., 256, 345
Hallem, David, 191
Hamilton, Mae, 272
Hamilton, Vieve, 272
Hampshire Pottery, 31
Hanscom, Lena E., 221
Harding, Denzil, 95, 96
Harper, Helen M., 131
Harper's Magazine, IV
Harris, -------, 29
Harris, Janet, 221
Harrison, Mrs. Learner, 163
Hart, Ruby S., 257
Harvey, Delores, 128, 167, 345
Haubrich, Albert, 120, 167, 187,
 305, 345
Haynes Pottery, 186
Heiden, Robert, 88
Heller, Cecile, 157
Helms, Delores, 9
Henderson, Sarah, 157
Hentschel, W. E., 205, 221
Herb, Hugo, 163
Herold, John J., 163, 226
Herschede Hall Clock Company, 199
Hertslet, Eric, 9
Hewett, Dr. E. L., 141, 142
Hickman, Katherine, 221

Hickman, Royal, 87, 91, 93, 94, 102
Hicks, Orville B., 221
Hipsh, Inc., 95
Hipsh, Mr. Charles, 95
Hirschfeld, N. J., 147, 148, 221
Hlumne, M., 29
Holabird, Alice Belle, 221
Holland, P., 29
Holmes, Frank G., 261
Holt, Sally, 157
Holtkamp, Loretta, 221
Homer, Sinclair, 63
Hones, -------, 29
Hood, -------, 117, 345
Hook, Roy, 168, 345
Hoover, Sam, 9
Horsfall, Bruce, 211, 212, 221
Horton, Hattie, 221
Hoskins, H., 168
Howorth, Guido, 163
Hubbard, Elbert, 24
Huger, Emily, 157
Hughes, Walter M., 282
Hummel, Richard, 61
Humphreys, Albert, 221
Hunter, W. H., 129
Huntington, Frank, 48
Hurley, E. T., 221
Hurst, Madge, 256, 289, 345
Hyten Brothers Pottery, 159
Hyten, Charles Dean "Bullet", 32, 159
Hyten, J. H., 159
I
Imlay, Josephine, 242, 256, 346
IMPERIAL PORCELAIN
 CORPORATION, 95–123
Imperial Porcelain Corporation, 96
Indian Affairs, U. S. Bureau of, 142
Industrial School, North Bennett
 Street, 169
Inness, George, 261
Ippolito, Arsenio, 9
Ipson, Louis, 171
Irvine, Sadie, 157
J
Jacobson, A. D., 61
Jacobus, Oscar I., 171
Jacobus, Pauline, 171
Jensen, Jens, 205, 216, 221
Jentshi, A., 29
Jervis, William P., 23
Jest, J. H., 196, 199
Jone, G. H., 29
Jones, Frances, 157
Jones, Katherine, 221
Joor, Hattie, 157
Josset, Raoul, 61
JUGTOWN POTTERY, 126–127
K
Kahn, Isaac, 349
Kappes, Karl, 125, 281, 346
Katon, -------, 29
Kebler, Florence, 221
Keenan, Mary Virginia, 221
Keep, Irene B., 157
Kekola, J., 29
Kendrick, George Prentiss, 84
Kennon, Roberta, 157
Kent, Rockwell, 112, 271
Kilpatrick, Doris, VI
Kimball (retailer), 172
King, Flora, 221
King, Ora, 221
Klemm, William, 221
Klinger, Charles, 221
Klinker, Orpha, 272
Knaus, L., 346
Koehler, Emil, 353
Koehler, F. D., 221
Koenig, Franz Joseph, 88
Kogan, Belle, 191
Koo-Poo-Hoo-Sha, 191
Kopman, Katherine, 157
Krause, George, 227
Kyker, Frances (Treadway), 257
L
La-Belle Potteries, 23
LaFarge, John, 261
Lang, A., 29
Langenbeck, Karl, 22, 163, 196, 265,
 353, 357, 359

Larkin, John Durant, 24
Larkin Company, 24
Larkin, John D. Jr., 24
Larzelere, Harry, 168
Laughead, Dorothy England, 318
Laughead, Frank, 282
Laurelton Hall, 262
Laurence, Sturgis, 221
Lawrence, Eliza C., 221
Le Buef, Jeanette., 158
LeBlanc, Maria Hoe, 153, 158
LeBoutillier, Addison B., 84–86
Ledbetter, Grady, 183
Leffler, Claude, 116, 346
Lenox China, Inc., 261
Lessell, Jenny, 32
Lessell, John (J. B.), 32, 33, 163,
 187, 281, 282, 346
Levy, Sarah B., 158
Lewis, A. V., 168
Lewis and Clark Exposition, 164, 265
Lewis, J. M., 10
Ley, Kay, 221
Library, Boston Public, 169
Ligowsky, George, 147
Liley, Florence S., 86
Lillbridge, Harry, 353
Lincoln, Elizabeth N., 202, 214, 217,
 221
Lindbergh, Charles A., 199
Lindeman, Clara C., 204, 221
Lindeman, Laura E., 109, 221
Lines, Frances E., 158
Lingenfelter, Elizabeth N., 221
Lingley, Anna V., 86
Littlejohn, Cynthia, 158
Little Journeys, 24
Long, Major, -------, 191
Long, W. A., 129, 131, 163, 277
LONHUDA POTTERY, 129–131
Lonhuda Pottery, 130, 163, 277
Lonnegan, Ada, 158
Longworth, Joseph, 195
Longworth, Nicholas, 195
Longworth Nichols Storer, Maria, IV, 42,
 140, 163, 171, 195, 198, 216, 265
Lorber, Rudolph, 280–283
Louisiana Purchase Exposition, 152
Low, John, 356
Low, John Gardner, 356
Low Art Tile Works, J. & J. G., 42, 84,
 352, 356
Lunt, Tom, 221
Lusitania, 24
Lybarger, M., 346
Lyons, Helen M., 221
M
Mac, F., 29
Maglio, Sabastiano, 88, 89
Majolica Ware, 32, 35, 37, 284
Marblehead Pottery, 31
Manship, Paul, 61
Marie, (signature on Maria ware), 141
MARIA POTTERY, 141–146
Maria Pottery, 87
MARKS, COMPANY
 Abingdon, 16
 Arc-En-Ceil, 190
 Avon--Vance Avon, 23
 Bybee, 31
 Buffalo, 29
 Camark, 38
 Cambridge, 41
 Cincinnati, 48
 Clewell, 50
 Clifton, 131
 Cordey–Cybis, 59
 Cowan, 62
 Dedham–Chelsea, 47
 Frankoma, 72
 Fulper–Stangl, 80, 81
 Gates–Teco Ware, 83
 Grueby, 86
 Haeger, 94
 Imperial Porcelain, 123
 Jugtown, 127
 Lonhuda, 131
 Low Art Tile, 356
 Maria, 146
 Matt Morgan, 148

McCoy, 139
M. McLaughlin, 140
Moravian, 357
Mosaic Tile, 357
Muncie, 150
Newcomb, 156
Niloak, 162
Owens, 167
Pauline, 172
Paul Revere, 170
Pennsbury, 176
Peters & Reed—Zane, 178
Pigeon Forge, 181
Pisgah Forest, 184, 185
Red Wing, 194
Robertson Art Tile, 360
Rookwood, 224, 225
Roseville, 254, 255
Southern Potteries, 260
Stangl—Fulper, 80, 81
Star Encaustic Tiling, 360
Teco Ware—Gates, 83
Tiffany, 262
Van Briggle, 270
Vance Avon—Avon, 23
Vernon Kilns, 276
Weller, 347, 348
Wheatley, 351
Zane—Peters & Reed, 178
Markland, Sadie, 222
Mars, Ed J., 29
Marshall Field (retailer), 17
Martin, Jose, 61
Martineau, Mignon, 256
Martinez, Julian, 141, 142
Martinez, Maria Montoya, 141, 142
Martinez, Tony, 142
Matawan Tile Company, 352
Matchette, Kate C., 222
MATT MORGAN ART POTTERY, 147—148
McCandless, Cora, 168
McClelland, Harry S., 177
McClelland, Mrs. Mabel Hall, 177
McCoy, J. W., 132
McCoy, Nelson Jr. & Sr., 132, 133
McCOY POTTERIES, 132—139
McCoy Potteries, 10
McCoy, W. Nelson, 132
McDermott, Elizabeth F., 222
McDonald, -------, 61
McDonald, Carrie, 168
McDonald, James, 22
McDonald, Margaret Helen, 108, 205,
 214, 222
McDonald, William P., 148, 195, 210,
 211, 222, 223
McGrath, L., 256
McHendry, Eunice, 9
McLaughlin, Charles J., 109, 222
McLaughlin, M. Louise, IV, 140, 195, 349
McLaughlin, Sarah Reid, 131, 304, 305, 346
McMillan, Bernice, VI, 9
Melick, D. L., 132
Melick, Nelson, 133
Melville, Herman, 271
Menzel, Earl, 222
Mercer, Dr. Henry C., 357
Merrill, Sharon, 272
Mersman, Ferdinand, 354
Metlox Pottery, 272
Metropolitan Museum of Art, N. Y.,
 60, 153
Meyer, Joseph Fortune, 151, 157
Michel, Julia (Horner), 158
Minton Pottery, 281
Minnesota Stoneware Company, 191
Missel, E., 29
Mitchell, Hattie, 128, 295, 346
Mitchell, Lillie, 256, 290, 346
Mitchell, Marianna, 222
Mitchell, Minnie, 346
M. LOUISE McLAUGHLIN POTTERY,
 140
Modinger, Hilda, 158
Montoya, Clara, 142
Moody, Frances, 9
Moody, Leslie, 9
Mora, F. Luis, 61
Moravian Pottery and Tile Works, 352,
 357
Morel, May, 158

Morgan, J. Pierpoint, 50
Morgan, Matt, IV, 147, 195, 359
Morgan Park Academy, 271
Morris, L., 346
Mosaic Tile Company, 22, 163, 226,
 228, 352, 357—359
Moshier, Hortense, 15
Mount Adams, 196
Mueller, Herman C., 147, 163, 353,
 357, 359
Mueller Mosaic Tile Company, 352,
 359
Mull, Gordon, 278, 346
MUNCIE POTTERY, 149—150
Muncie Pottery, 32, 36
Mundie, -------, 82
Munson, L., 29
Murray, Ernest, 177
Murray, Ray, 64, 100
Museum of Fine Arts, Boston, 84, 153
Myers, M., 239, 242, 256, 346
Nakolk, J., 29
National Tile, 359
Neff, Grace, 256
Neilson, Christian, 226
Nelson McCoy Sanitary Stoneware
 Company, 132, 133
Nelson, Ralph, 9
Neville Museum, Green Bay, Wisc., 172
Newcomb Memorial College, Sophia,
 IV, 151
NEWCOMB POTTERY, 151—158
Newcomb Pottery, 43
Newman, L., 29
Newman, Lillian, 86
New Mexico, Museum of, 142
Newton, Clara Chipman, 222
Nicholson, Leona, 158
NILOAK POTTERY, 159—162
Niloak Pottery, 32
Nonconnah Pottery, 182
Noonan, Edith, 110, 222
Norse, Elizabeth, 222
North Star Stoneware Company, 191
Norton, Capt. John, 73
Nourse, Mary, 110, 198, 206, 222
Novotny, Elmer, 61
 O
O'Brien, William (retailer), 152
Oklahoma, University of, 63, 64
Old Bridge Enameled Brick and Tile
 Company, 352
Olean Tile Company, 352
Olsen, Eric, 87, 88
Onondaga Pottery, 61
Osborne, Arthur, 356
Oshe, Miss -------, 168
Ostertog, Blanche, 82
Owen, Ben, 126
Owen, W. J., 187
Owens China Company, 257
Owens, E. J., 257
Owens Illinois Glass Company, 271
Owens, Ted, 257
Owens, J. B., 163, 187
OWENS POTTERY, 163—168
Owens Pottery, 32, 49, 129, 132,
 177, 186, 279, 281
 P
Paderewski, Ignace Jan, 274
Palmer, L., 27, 29
Pan-American Exposition, 153
Panama Pacific Exposition, 17
Pardee Works, C., 84, 352
Paris World's Fair, 42
PAULINE POTTERY, 171—173
PAUL REVERE POTTERY, 169—170
Park-Bernet Galleries, 262
Payne, Charlotte, 158
Peasley, -------, 82
Peirce, Mary L., 168
PENNSBURY POTTERY, 174—176
Perone, Lizzie, 346
Perkins, Mary L., 222
Perth Amboy Tile Works, 352
Peters, John, 177
Peters, Pauline, 222
PETERS AND REED POTTERY, 177—179
Peters and Reed Pottery, 186, 226, 228
Philadelphia Centennial Exposition, 42, 140,
 186, 195

Philistine (magazine), 24
Philleo, William, 191
Phillips, Dr. Fred, 95
Phoenix Glass Company, 149
Pica, Joe, 9
Pickens, E. L. (Ed), 280, 283, 290, 346
Picasso -------, 51
Pierce, Mary, 346
Pierce, Norma, 86
Pigeon Pottery, 10
PIGEON FORGE POTTERY, 180—181
Pillsbury, Hester, 117, 256, 300, 319,
 323, 346
PISGAH FOREST POTTERY, 182—185
Pitman, Agnes, 222
Pitman, Ben, 140
Pitman, Sir Isaac, 140
Pohl, Joseph, 191
Pons, Albert F., 222
Post, Wilhelmina, 86
Postgate, Margaret, 61
Pottery Queen, The, 281
Poveka (Maria's Indian name), 142
Poxon China Company, 271
Priest, Gertrude, 86
Providential Tile Company, 352
Pullman, Wesley, 222
Purdy, Ross C., 226
 R
Radford, Albert, 186, 187
Radford, Albert Edward, 186, 187
Radford, Fred W., 186, 187
RADFORD AND COMPANY, A.,
 186—190
Radford and Company, A., 132
Ramlin, M., 29
Ramlus, W., 29
Randolph, Beverly, 158
Rand, Sally, 64
Rauchfuss, Marie, 222, 346
Rea, William J., 24
Read, Sir Hercules, 357
Reading Railroad, 174
Reath, G., 29
RED WING POTTERY, 191—194
Red Wing Pottery, 10
Red Wing Stoneware Company, 191
Red Wing Union Stoneware Company,
 191, 192
Reed, Adam, 177
Reed, O. Geneva, 222
Rehm, Wilhelmina, 222
Rettig, Martin, 222
Revere, Paul, 169
Rhead, Frederick Alfred, 227, 280
Rhead, Frederick Hurten, 17, 23, 227,
 256, 346
Rhead, G. W., 280
Rhead, Harry W., 227
Rhead, Lois, 256
Richardson, Glenn, 88
Richardson, Mary W., 158
Ritter, E. A., 266
Roberts, Eugene, 319, 346
Robertson, Alexander W., 42
Robertson, George W., 360
Robertson, Hugh Cornwall, 42, 43, 360
Robertson, James, 42
Robertson, J. Milton, 43
Robertson, William, 43
Robertson Art Tile Company, 42, 352,
 357, 359, 360
Robin, H., 29
Robinson, Harry, 168
Robinson, Martha, 158
Rogers, Elizabeth, 158
Rogers, Will, 63
Roman, Amalie, 158
Roman, Desiree, 158
ROOKWOOD POTTERY, 195—225
Rookwood Pottery, V, 22, 82, 129, 140,
 147, 151, 159, 171, 177, 262, 265,
 349, 352
ROSEVILLE POTTERY, 226—256
Roseville Pottery, 17, 49, 163, 177, 187, 279
Ross, Hattie M., 168, 346
Ross, John, 15
Ross, Medora, 158
Roth, A., 29
Rothenbush, Fred, 222
Rousseau, Eugene, 261

Ruge, Clara, 82
Rum Rill Pottery, 108, 192
Rumrill, George, 192
Rowlandson, Thomas, 26
Rowley, F., 29
Royal Academy of Art (Copenhagen), 226
Ryan, Mazie T., 158
Ryman, C. P., 182
S
Sacksteder, Jane, 222
Saint John the Devine, Cathedral of, 84
Saint Louis Exposition, 42, 82, 84,
 197, 226, 265
Sales, Chic, 95
Samson, Thorwald P. A., 171
Sandburg, Carl, 88
San Francisco World's Fair, 42
San Jose State College (Cal), 17
Santana (signature on Maria), 142
Saturday Evening Girls, The, 17, 169
Sauter, E., 29
Sax, Sarah, 110, 199, 204, 222
Scalf, Virginia, 222
Schmidt, Carl, 222
Schreckengost, Viktor, 61
Schwerber, Aloysius, 281
Scudder, Raymond, A., 158
Seaman, Marie, 86
Sebaugh, Ed, 32
Sehon, Adeliza, 222
Seyler, David W., 222
Shafer, O., 29
Shaw, Elsa, 61
Shawnee Pottery, 192
Sheehan, N., 29
Sheerer, Mary G., 151, 158
Shephard, Craig, 63, 70
Shinnick, William, 357
Shirayamadani, Kataro, 109, 110,
 195, 196, 198, 222
Shoemaker, R. Lillian, 168
Sicard, Jacques, 113, 278, 279
Simpson, Albert, 9
Simpson, Anna Frances, 155, 158
Simpson, James, 9
Simpson, M., 29
Simpson, R., 29
Simpson, W. E., 29
Sinz, Walter, 61
Sketches of Maria Pottery, 145, 146
Slater, J. E., 9
Smalley, Marion H., 222
Smith, Carl, 9
Smith, Dr. Dwight, 95
Smith, Gertrude R., 158
Smith, Grace Lee (Frank), 65
Smith, Helen, 256, 346
Smith, Irvin, 282
Smith, Joseph, 42
Smith, Milton, 65
Smithsonian Institution, 17, 127,
 153, 265
Sned (or Snedeker), M., 29
Solon, Albert L., 17
Solon, L. M., 280, 353
Solon, Leon V., 353
Solon, Paul, 353
Souter, O., 29
SOUTHERN POTTERIES, INC., 257—260
Southwick, Albert, 261
South Zanesville Stoneware Company, 177
Spaulding, Jessie R., 131
Sprague, Amelia B., 110, 130, 131, 206,
 207, 222
Staffordshire Pots and Potters, 280
Stanbury, George, 353
Stangl, J. M., 73, 74, 87
STANGL POTTERY, 73—81, 174
Stanwood, Gertrude, 86
Star Encaustic Tiling Company, 352, 360
Starksville (Rookwood), 199, 218, 219
Steel, F., 256
Steele, Ida, 168
Steele, Tot, 256, 346
Stegall, Harley, 9

Stegner, Carolyn, 222
Steiner, M., 29
Steinle, Carrie, 109, 198, 205, 207, 222
Stemm, William, 168, 346
Stephen, Andrew, 182
Stephen, Nellie, 182
Stephen, Walter Benjamin (W. B.), 182
Stevens, Mary Fauntleroy, 168
Stickley, Gustav (retailer), 152
Stiller, -------, 29
Stockdale, V. B., 9
Stone, Williard, 64, 70
Stoneking, Laurence, 15
Storer, Bellamy, 196
Storer, Maria Longworth Nichols, IV,
 42, 140, 163, 171, 195, 196, 198,
 216, 222, 265
Storrow, Mrs. James J., 169
Strafer, Harriet R., 222
Streissel, L., 29
Stuart, Ralph, 24, 29
Stuntz, H. Pabodie, 222
Sulcer, -------, 346
Sulsberger, Dr. J. Diehl, 95
Susquehanna Broadcasting Company, 74
Swing, Jeannette, 223
T
Tardy, -------, 29
Tatankamani (walking buffalo), 191
Tate, R., 256
Taylor, Joseph R. (Prof.), 64, 71, 99
Taylor, Mary A., 223
Taylor, W. W., 196
TECO WARE, 82—83
Tennessee Valley Authority (TVA), 180
Terry, C. Minnie, 346
Thompson, M., 29
Tiffany, Charles L., 261
Tiffany Furnaces, 261
Tiffany Glass and Decorating
 Company, 261
Tiffany, Louis Comfort, 261, 262
Tiffany (retailer), 172, 261, 279, 349
TIFFANY POTTERY, 261—264
Tiffany Pottery, 279, 352
Tiffany Studios, 84, 261
TILES, 352—360
Tile Companies (List of), 352
Timberlake, Mae, 116, 117, 168,
 256, 346
Timberlake, Sarah, 168, 256, 346
Tischler, Vera, 223
Todd, Charles S., 108, 205, 215, 223
Toohey, Sallie, 109, 110, 204, 205,
 212, 223
Torrance, F. L., 9
Trent Tile Company, 352
Tropico Potteries, 352
Truitt, Naomi (Walsh), 346
Tuberculosis Sanatorium (Arequipa), 17
Tulane University, 151
Turnbull, Gale, 271
U
United States Encaustic Tile Works, 352
United States Quarry Tile Company, 352
Upjohn, Charles Babcock, 128, 277, 278,
 280
V
Vaise, R., 29
Valentien, Albert, 109, 195, 198, 223
Valentien, Anna M., 223
Van Briggle, Anne, 266
Van Briggle, Artus, 22, 197, 223, 265,
 266
Van Briggle, Leona, 223
VAN BRIGGLE POTTERY, 265—270
Van Briggle Pottery, V, 22, 32, 126,
 159
VANCE FAIENCE COMPANY (Avon),
 23
Van Horne, Katherine, 223
VERNON KILNS, 271—276
Vicar of Wakefield, 24
Village Store, The, 126
Vogt, N., 29

Vreeland, F. W., 223
W
Wade, A., 29
Wadsworth Atheneum, 50
Wagner, Arthur, 32, 33, 113, 281, 2
 346
Wal, F., 29
Walsh, Naomi (Truitt), 346
Wanamaker, John (retailer), 17
Wareham, John D., 196, 198, 199,
 223
Watts, Lena, 257
Waugh, Jack, 61
Wayson, -------, 29
Weaver, J. F., 226
Webb, Paul, 95, 114, 115
Wedgwood, 182, 186
Weigelt, Henry, 281, 282
Weigelt, Carl, 346
Weller, Harry, 282
Weller, Mrs. S. A., 280
Weller, Samuel A., 129, 177, 277, 28
WELLER POTTERY, 277—348
Weller Pottery, V, 10, 32, 49, 177,
 228, 352
Weller Theater, 280
Wells, Sabrina, 158
Wenderoth, Harriet, 223
Wenezel Tile Company, 352
Western Art Tile Works, 352
Western Stoneware, 10
Wheatley, Thomas J., IV, 140, 196,
 349, 350
WHEATLEY POTTERY, T. J. & CO
 PANY, 349—351
Wheatley Pottery, T. J. & Company,
Wheatley Pottery Company, 195, 35
Wheatley Tile and Pottery Company
 349
Wheaton Glass Company, 74
Wheeling Tile Company, 352
Wheeling Potteries, 23
White House, The (retailer), 17
Whitford, -------, 29
Wigley, J., 29
Wil, L., 29
Wilbur, Carrie, 346
Wilbur, Edna, 346
Wilcox, Frank, 61
Wilcox, Harriett E., 213, 223
Wilde, F. H., 17
Wildman, Edith L., 223
Williams A., 40
Williams, Arthur, 168, 256
Willits, Alice, 223
Wilson, Albert, 346
Wilson, Ernest, 180
Wilson, M. J., 29
Wilton, B., 29
Windisch, Robert, 228
Windle, Helen B., 346
Windsor, R., 29
Winter, Edward, 61
Winter, Thelma, 61
Wires, E. Stanley, 84, 353
Wisconsin State Historical Society
 Museum, 172
Wit, L., 29
Wood, Louise, 158
Woodward, Prof, Ellsworth, IV, 151
Workum, Delia, 223
Y
Yamada, Kiiche, 86
Young, Mrs. Anna, 226, 228
Young, George, 163, 177, 226
Young, Grace, 212, 223, 242
Young, Russell T., 227
Youth's Companion, 182
Z
Zane Pottery Company, 177
Zanesville Art Pottery, 186, 281
Zanetta, Clotilda, 223, 346
Zettel, Josephine E., 223

Art Pottery of America
Price Guide

by Mike Schneider

(In pictures where multiple pieces are shown, all prices are given left to right.)

Page	Item	Price
Page	**Item**	**Price**
10	Sang vase	$ 75
	Scarf dancer	290
11	Little Miss Muffet	300
	Humpty Dumpty	275
	Three Bears	145
	Jack in the Box	375
12	Quill bookends	90
	Seagull bookends	80
	Russian dancer bookends	90
	Horsehead bookends	60
	Abingdon dealer's sign	150
	Shepherdess and fawn	125
	Vase 181	50
	401 Tea tile	65
	708 Vase	50
13	Fruit girl	160
	Arc-de-Fleur	40
	Shell vase	75
	Hippopotamus	325
14	Penguin	45
	Flamingo	35
	Feeding goose	20
	Gazing goose	20
	Swordfish	40
	603 Grecian vase	70
	412 Valuti vase	95
	487 Egret vase	50
18	10 in. vase	550
19	8-3/4 in. vase	700
	6 in. vase	600
20	4 in. vase	500
	2-3/8 in. bowl	550
22	Avon vase	400
25	Deldare pretzel dish	475
27	Fallowfield Hunt plate	210
	Tulip Hall plate	625
30	7 in. handled vase	55
	8-1/2 in. bowl	45
31	Chamberstick	40
33	Le-Camark vase	300
34	Bunny	18

Item	Price
Cat pitcher	85
Bottom left vase	20
Bottom right vase	20

Page	Item	Price
35	805K basket	75
	N10 Pitcher	50
	Match holder	50
	bottom right vase	25
36	Top left vase	25
	Wallpocket	65
	Bottom left ewer	75
	Bottom right ewer	45
37	501 rooster	40
	Top right pitcher & plate	60
	Lower left pitcher	18
	598 vase	20
38	Top vase	20
	Swan vase	40
39	4 in. vase	110
	9 in. vase	130
40	George Washington vase	1500
43	Morning & night pitcher	675
44	8 in. plate	400
	Bird in orange tree plate	400
	Horse chestnut plate	275
45	Azalea plate	260
	Water lily plate	250
	Swan plate	375
	Magnolia plate	275
46	Duck plate	375
	Polar bear plate	350
	Grape plate	275
	Turkey plate	400
47	Dedham platter	650
	Iris plate	300
	Butterfly plate	450
52	7090 vase	150
53	5010 figure	75
	5027 figure	75
	5009 figure	70
	7066 swan	200
	1006 bowl	110

Page	Item	Price
54	9-1/2 in. figure	80
	5084 girl	200
	5042 boy	200
	5038 Napoleon	125
	5039 Josephine	125
55	5037 figure	80
	5048 boy	125
	5047 girl	125
	5013 figure	45
	5007 figure	45
	5015 figure	45
56	6004 bird	100
	7094 vase	160
	Candlesticks	60
57	Cybis China maid	200
58	Square box	50
	Oblong box	40
	Long bowl	45
	7096 perfume	125
	7025 perfume	100 ea
	5043 vase	65
59	Lamps	150 ea
	622 creamer	55
	623 sugar	55
61	4 in. vase	110
	3 in. green figure	65
	2-1/2 in. candlesticks	40 pr
	3-1/2 in. vase	55
62	5 in. card tray	50
64	Plaque	70
	Plate	PND
65	Bookends	400
66	1969 Christmas plate	35
	1968 Christmas plate	45
67	1967 Christmas plate	60
	1966 Christmas plate	75
68	1965 Christmas plate	300
	Conestoga Wagon plate	90
69	Wind chimes	40
	Christmas cards	25-95

70	Vase	30
	Squirrel	15
	Mug	10
	Horse	75
	Swan	40
	Red Irish setter	100
71	Fan dancer	400
	Bowl	25
	Bronco bookends	300 pr
	Indian maiden	50
	Center chief	80
	Right chief	10
	Mountain girl bookend	110 ea
	Puma	35
72	Swan	45
	Puma	45
	Donkey	80
	Boot	10
	Fish	50
74	Stangl dinnerware sign	75
75	Vase 5145	15
	Vase 4007	45.
	Casserole	60
	Sugar and creamer	25
	Pepper	10
76	Tray 4038	15
	Vase 3614	60
	Other vase	50
77	Covered box	175
	Short vase	110
	Tall vase	220
	Frog bowl	150
	Wig stand 5168	275
	Bird (painted bunting)	90
	Pitcher	40
78	Bobolink	100
	Double bluebirds	150
79	12 in. cockatoo	350
	Double wrens	125
80	Allen Hummingbirds	75 ea
	Scissortail flycatcher	650
	Parrot perfume lamp	525
83	Top, left to right	
	Vase	3500
	Vase	1000
	Vase	2500
	Vase	2000
	Vase	3000
	Vase	1750
	Vase	2250
	Vase	2000
	Bottom	450
85	Vase	800
	Tile	425

88	Re-issue vase	20
89	"World's largest vase"	PND
	15 in. ewer	20
	16 in. vase	20
90	Madonna	20
	Duck planter	10
	Bow vase	10
	Stork planter	12
91	Bowl with birds	35
	Covered box	20
	Peacock vase	25
	Girl planter	25
92	483 shell vases	20 ea
	R131 basket vase	20
	Swan planter	15
93	Cornucopia vases	15 ea
	Shell vase	25
	372 plate	5
	Console bowl	10
	Mermaid	30
94	Lamp	30
	Shell vase	35
	Rectangular sign	30
	Crown sign	75
96	Cardboard blotter	10
97	Deldare plate	425
	Dedham pitcher	675
	Camark vase	250
98	4048 bust	350
	5024 man	80
	5025 woman	80
	541 man	225
	Mate of 541 man	225
99	4013 girl	100
	Mate of 4013 girl	100
	403OB man	175
	4034B woman	275
	Fan dancer (rare color)	375
100	Indian chiefs	35 ea
	701 girl	go
	702 boy	100
	Fulper vase	350
101	Fulper basket	175
	3401 hen pheasant	200
	Double love birds	145
	Kingfisher	60
	Double wrens	100
	Oriole	60
	Double Orioles	125
102	Double hummingbirds	275
	237 birdhouse wallpocket	30
	Short vase	425

	Tall vase	600
103	R495 panther (large)	25
	R683 panther (small)	15
	R1742 cat	50
	R6343 matador	30
	R1510 bull	30
	Daisy Mae	250
	92 ashtray	150
104	95 ashtray	125
	Newcomb vase	1400
	Matt Morgan jug	650
105	Owens vase	350
	Owens lamp	750
	Pennsbury bowl	65
106	Pennsbury plaques	50 ea
	Pisgah Forest vase	55
	103 bird	180
107	Radford reproduction vases	50 ea
	3019 vase	75
	1122 schoolboy	200
108	616 pitcher vase	65
	Tiger eye vase	1000
	6-3/4 in. vase	250
	7-3/4 in. vase	300
	8-1/4 in. square vase	300
	8-1/4 in. round vase	325
	7-1/4 in. vase	275
109	Top	
	Seagreen glaze vase	2000
	Standard glaze vase	1250
	Iris glaze vase	1400
	Center	
	6-1/4 in. vase	425
	7 in. vase	450
	8-1/4 in. jug	600
	7-3/4 in. vase	450
	Bottom	
	6-1/2 in. vase	500
	7-3/4 in. vase	600
	7 in. vase	650
	7-1/4 in. vase	3000
	7-1/2 in. vase	1000
110	Top	
	4-3/4 in. vase	250
	7-1/4 in. covered vase	200
	9-1/2 in. vase	700
	7-1/4 in. covered vase	200
	6 in. vase	250
	Center	
	4-1/4 in. vase	PND
	Bottom	
	6 in. vase	400
	7 in. vase	450
	7-3/4 in. vase	600
	10-3/4 in. vase	750
111	Top	

	Rozane Mara vase	PND
	Rozane Royal vase	350
	Blue ware vase	200
	Center	
	Futura vase	700
	Bottom	
	7 in. pitcher	900
	10-3/4 in. pitcher	1800
	10-1/2 in. pitcher	3000
	9 in. vase	1500
112	Southern Potteries plate	150
	Salamina plate	65
	Baby Weems	300
113	Art Wagner vase	PND
	Sicardo plaque	1500
	8-1/2 in. vase	350
	5-1/2 in. vase	375
	7 in. vase	150
	8-1/2 in. vase	350
114	Advertising booklet	25
115	Paul Webb cartoon	25
116	16 in. Art Nouveau vase	400
	16 in. pictorial vase	2000
	9-1/4 in. vase	450
	10 in. vase	400
	11 in. vase	300
	11-1/2 in. vase	300
117	Jardiniere	600
	7 in. vase	500
	7-1/4 in. vase	300
	8-1/4 in. vase	450
	9-1/2 in. vase	450
118	99 mug	75
	93 pitcher	175
	94 Jake mug	85
	94B Gran Pappy mug	85
119	Donkey	50
	Drinker	100
	Baby	35
	Dog	35
	104 planter	100
	106 barrel	75
	104A bottle	110
	105 ashtray	65
	100B note box	85
120	7 in. Rosemont vase	170
	8 in. Flemish vase	200
	6-1/2 pink luster vase	30
	7-1/2 in. Brighton parrot	500
	14 in. Eocean vase	500
121	7 in. Delta vase	300
	10-1/2 in. Eocean vase	200
	11 in. Etna vase	275
	11 in. Rochelle pitcher	450
	8 in. Louwelsa vase	150

	12 in. Louwelsa ewer	325
	12-1/4 in. Louwelsa vase	200
122	102A Cigarette holder	60
	102 Planter	100
	103 Ashtray	65
	101 Planter	75
	97 Salt and pepper	90
	81 Ashtray	150
124	6 in. Silvertone vase	150
	8 in. Claremont vase	160
	8-1/2 in. Silvertone vase	225
	4 in. Louwelsa pitcher	140
	5-3/4 in. Louwelsa ewer	225
	7 in. Louwelsa ewer	275
	5-1/2 in. Louwelsa pitcher	175
	4-1/2 in. blue vase	350
	5-1/2 in. teapot	600
	9 in. blue vase	450
125	10-1/2 in. Indian vase	1400
	5 in. Sicardo vase	250
	11 in. Marengo vase	300
	12-1/4 in. Lamar vase	375
	8-1/4 in. Marengo vase	130
	11-1/2 in. Chengtu vase	150
127	8 in. vase	130
	5-1/2 in. vase	120
128	6-1/2 in. Aurelian mug	200
	13-1/2 in. Aurelian ewer	750
	7-1/4 in. Aurelian pitcher	275
	18 in. Dickens Ware vase	2000
	12 in. Wheatley vase	850
130	9 in. Ewer	300
	8 in. vase	275
	9 in. vase	150
133	7-1/2 in. Brush vase	25
	9 in. McCoy vase	15
134	Hand vases	
	Front row	15 ea
	Back row	25 ea
	Deer planter	45
	Retriever planter	45
135	Indian	300
	Teepee	275
	Davy Crockett	375
	Covered wagon	50
136	Creamer and sugar	25
	Teapot	35
	5-1/2 in. pitcher	150
	Wishing well planter	15
	Urn vase	10
	Hyacinth vase	25
	Double tulip vase	35
137	5-1/2 in. Loy-Nel-Art vase	225
	Cookstove	20

	Potbelly stove	35
138	9 in. Navarre vase	150
140	Left to right	
	Vase	800
	Vase	700
	Vase	900
	Vase	700
	Vase	800
143	Top vase	600
	Bottom vase	400
144	Top	600
	Bottom	500
147	Matt Morgan jug	650
148	Matt Morgan pitcher	700
150	8 in. Muncie vase	75
	6 in. Muncie vase	95
152	11 in. vase	1900
153	Maria LeBlanc vase	850
154	5 in. vase	700
	6 in. pitcher	750
	8 in. vase	1000
155	5-1/2 in. vase	950
	6 in. vase	900
	8 in. vase	800
156	7-1/2 in. vase	450
	5-1/2 in. vase	700
160	Rocking horse planter	35
	8 in. Mission vase	425
	Fox	50
161	Handled vase	45
	Duck	30
	Cornucopia vase	20
	Left deer figure	60
	Right deer figure	55
162	Short pitcher	18
	Tall pitcher	40
	6 in. pitcher	30
164	13-1/2 in. vase	350
165	11 in. vase	450
166	6-1/2 in. pitcher	300
	6 in. vase	375
167	5 in. vase	150
170	Top	
	Vase	700
	Individual teapot	400

	Cup and saucer	150
	Plate	100
	Single cup	150
	Rabbit border plate	100
	Cup, saucer and plate	300
	Creamer, bowl and plate	300
	Coffee pot	325
	Plate behind coffee pot	PND
	Middle	
	Large bowl	550
	Shaker	175
	Marmalade (3 pieces)	275
	Covered sugar	250
	Dark creamer	250
	Small bowl	200
	Tall light creamer	150
	Covered sugar	250
	Short light creamer	200
	Toothpick	150
	Large bowl	37
	Bottom	
	Cream pitcher	325
	Chocolate pot	375
	Mug	400
	Covered sugar	200
	Teapot	450
	Gravy boat with ladle	350
172	Chocolate pot	700
173	Cookie jar	500
	Statuette	500
175	4-3/4 in. mug	25
	4-1/2 in. mug	25
	Vinegar and Oil	90 pr
	Ashtray	20
176	8 in. plate	30
	11 in. plate	35
	10 in. plate	100
178	Mug	110
	Vase	100
	Tankard	250
179	6 in. chromal vase	220
	2-1/2 in. moss Aztec vase	35
	5-1/2 in. drip vase	50
	8 in. chromal vase	125
	5-1/2 in. Moss Aztec vase	75
	5-1/2 in. sheen ware vase	90
181	Sugar and creamer	20 pr
	7 in. pitcher	25
183	Vase	100
184	Creamer and sugar	70
	Miniature pitcher	35
189	Matched ewers	200 ea
	Chamber pot	100
	Jardeniere	300
	2 in. La Moro vase	60

	7 in. La Moro vase	140
190	6-1/2 in. vases	150 ea
	3-1/2 in. vase	60
	Lamp	250
192	Rumrill pieces	20-50
193	Plate	15
	Cup	10
	Teapot	25
	Cookie jar	95
	Pitcher	30
201	Vase	3500
202	Wax matt vase	400
	Maroon vase	200
203	Iris vase	1500
	Mica glaze vase	450
204	Jug with stopper	600
	Cup & saucer	225
	Jug without stopper	600
	6-1/2 in. vase	150
	3-1/2 in. vase	170
	5 in. vase	140
	6-3/4 in. vase	140
	9 in. vase	160
	7-1/2 in. vase	150
205	Top	
	Creamer & sugar	245
	5-1/2 in. vase	850
	Bottom	
	7-1/2 in. wax matt vase	220
	6 in. modelled matt vase	250
	7-1/2 in. painted matt vase	240
	6 in. butter fat vase	290
	8-1/2 in. etched matt vase	350
	6 in. butter fat vase	275
206	Top vase	750
	Bottom vase	550
207	Chocolate pot	600
	Inkwell	450
208	Geese	175
	Flower frog	125
	Cheetah	225
	Ombroso	275
209	Vellum black rook	190
	Ship	140
	Lady figure	175
	Geese	175
210	Bookends	350 pr
	Tray	290
211	Pitcher	6000
	Plaque	4500

212	Stein	5000
	Covered jar	1500
	Jug	3500
	Mug with Sterling cap	5000
213	Lamp	4500
214	Vellum vase	375
	Silver overlay vase	4000
215	11 in. vase	3000
	7 in. vase	400
216	7 in. vase	380
	10 in. vase	2800
217	7 in. vase	3000
	EGM	20
	MG	15
	TE	15
	O	20
	CBM	20
	VEL	25
218	7098	35
	2989	35
	6893	5
	6773	50
	7185	25
	7165	25
	778	30
	6870	40
	2691	50
	2545	25
	1236	25
	6777	30
	6937	25
	7201	25
	2816	15
	1880	35
	1881	35
	7158	35
	6064	50
	6514	30
	2556	35
219	7200A	30 ea
	7200	35
	7183	35
	7186	25
	7142	20
	7204	25
	7214	25
	7202	25
	861	25
	547	30
	7122	25
	7215	20
	7201	50
	2984	30
	7151	20
	7143	20
	7187	20
228	Vase	400

No.	Item	Price
229	Tall vase	900
	Short vase	375
230	216	85
	281	70
	283	80
	284	90
	273	70
	282	75
	285	85
	256	50
	287	120
	259	110 pr
	286	100
231	250	150
	217	60
	257	50
	230	45
	261	85
	266	70
	233	60
	267	65
	222	45
	240	50 set
	253	9
232	271 left	4
	271 right	9
	221	6
	272	6
	268	8
	288	9
	241	7
	289	10
233	242	60
	210	70
	274	40
	232	50
	231	70
	290	175
	218	120
	275	60
	263	80
234	226	75
	229	90
	227	75
	251	70
	252	70
	228	80
	208	85
	209	100
235	Rozane Mara vase	1800
	Tall Rozane Woodland vase	1500
	Short Rozane Woodland vase	1200
	Rosecraft vintage vase	125
236	Top	
	Donatello vase	1800
	Mock orange vase	85
	Ixia vase	80
	Bottom	
	Rozane Fugi vase	1200
	Rozane Fugi vase	1800
	Rozane Fugi vase	1200
237	Imperial I vase	140
	Mostique vase	100
238	Mongol silver overlay vase	1500
	Rozane Woodland vase	800
239	Donatello vase	225
	Rozane royal vase	600
240	Rozane vase	3250
	Mayfair vase	100
241	Rozane jug	375
	Magnolia pitcher	110
242	Rozane vase	350
	Rozane royal creamer	120
	Rozane royal pitcher	600
	243 Carnelian vase	80
	Rozane bowl	75
	Ming tree vase	110
	La Rose vase	120
	Fuchsia vase	110
	Imperial II vase	150
244	Ferrella vase	275
	Rosecraft hexagon vase	150
	Rosecraft vintage vase	100
	Magnolia planter	55
	Water lily vase	75
	Victorian art pottery vase	350
	Blackberry vase	250
245	Coors Pottery vase	30
	Florentine vase	75
	Moderne vase	65
	Mostique vase	55
	Tall panel vase	100
	Short panel vase	90
246	Dahlrose vase	75
	Rozane Egypto vase	325
	Silhouette vase	150
	Poppy vase	65
	6 in. pinecone vase	150
	8 in. pinecone vase	200
	5-1/4 in. pinecone vase	110
247	White rose vase	70
	Carnelian vase	100
	Sunflower vase	275
	Morning glory vase	300
	Wisteria vase	325
	Gardenia vase	85
248	Iris basket	115
	Clemana vase	75
249	Carnelian bowl	60
	Dogwood I vase	110
250	Olympic vase	3250
	Baneda vase	95
251	Pinecone vase	110
	Rozane basket	125
258	French peasant plate	65
	French peasant relish	85
	Rooster plate	20
259	Bird plate	20
	Chick pitcher	125
	American Indian	275
260	Spiral pitcher	40
	Betsy jug	60
263	Top	
	5 in. vase	1500
	8-1/4 in. vase	2250
	5-1/8 in. vase	1300
	4-3/4 in. vase	1200
	Bottom	
	Ivory Favrile vase	1900
264	Short mottled vase	1200
	Tall mottled vase	600
	Hand thrown vase	2500
267	Vase	450
	Console set	290
268	Top	
	Elephant	65
	Persian rose vase	35
	Creamer & sugar	75
	Rabbit	35
	Boot	20
	Middle	
	6-1/2 in. vase	35
	4 in. vase	40
	Card holder	350
	Covered jar	325
	Mug	160
	Bottom	
	Left	130
	Right	95
269	Top mug	175
	Bottom mug	325
	Plaque	375
270	Jug	550
272	Top plate	25
	Bottom plate	25
273	Republican plate	35
	9-1/2 in. plate	20
	10-1/2 in. plate	25
	12 in. plate	30
	16-1/2 in. plate	45

274	French opera plate	15
	Music masters plate	15
	Train plate	25
	Bridge plate	50
	Moby Dick plate	50
	Tapping for sugar plate	30
	Salamina plate	160
	Fantasia plate	100
275	Left Dumbo	120
	Right Dumbo	120
	Bowl	50
	Tyler Texas plate	10
	Moby Dick saucer	15
	Moby Dick cup	35
276	Sign	80
288	Admiral humidor	750
	Turk humidor	750
	Chinaman humidor	750
289	Aurelian vase	450
	Dickens Ware II vase	1000
290	White Dickens Ware II vase	1500
	Brown Dickens Ware II vase	1100
291	Top	
	Dickens Ware III vase	850
	Bottom	
	Golf vase	400
	Dragon vase	1100
	Other vase	600
292	Dickens Ware I vase	800
	Dickens Ware II vase	700
293	Dickens Ware II vase	650
	Etched matt vase	290
	Mug	950
294	Daring Fox vase	900
	White Swan vase	1500
295	6-1/2 in. vase	400
	7 in. vase	500
	7-1/2 in. vase	400
296	Fish vase	550
	Flower vase	600
297	Left Baldwin vase	250
	Right Baldwin vase	250
	Burnt Wood vase	185
298	Darsie candle holders	45 pr
	Left Etna vase	200
	Center Etna vase	300
	Right Etna vase	150
299	Hunter ewer	500
	Windmill vase	575
300	Top	

	9-1/2 in. vase	400
	Bottom	
	9 in. vase	250
	10-1/2 in. vase	300
	13 in. vase	500
	10 in. vase	150
301	Top left vase	450
	Bottom right vase	850
302	Top	
	9 in. vase	185
	7-1/2 in. vase	150
	6 in. vase	195
	10 in. vase	350
	Bottom	
	Lavonia candle holders	100 pr
	Lavonia bowl	100
	Lavonia figure	150
303	4-1/2 in. vase	150
	3-1/2 in. vase	120
	2-1/2 in. vase	140
	1-1/2 in. ashtray	100
	6 in. ewer	160
	Clock	700
304	Top	
	7 in. vase	200
	9-1/4 in. vase	210
	10-1/4 in. vase	210
	9-1/4 in. vase	225
	Bottom	
	6-1/4 in. vase	200
	5 in. vase	240
	7 in. vase	175
305	Louwelsa lamp	1250
	Pictorial vase	800
	Louwelsa vase	1000
306	Girl with swan	275
	Fishing boy	200
	Frog	125
	Kingfisher	250
	Cherub	140
	Garden girl	130
	Turtle	150
	Teapot	150
307	Sicardo vase	325
	Sicardo candlestick	500
308	Sicardo 7 in. vase	400
	Sicardo 10 in. vase	850
309	Top	
	Sicardo 5-1/2 in. vase	400
	Bottom	
	Sicardo left	400
	Sicardo center	450
	Sicardo right	650
310	Turada vase	425
	Turada umbrella stand	1000

311	Top	
	Dogs	325
	Middle	
	8-1/2 in. tree trunk	80 ea
	Foxes	160
	9-1/2 in. tree trunk	75
	Bottom	
	8-1/2 in. tree trunk	80
	Log	75
	Owl	225
312	L'Art Nouveau vase	400
	Marbleized vase	160
313	Figure	260
	Floretta mug	200
	6 in. Muskota bird	200
	Floretta jug	225
	9 in. Muskota bird	275
	Zona pitcher	135
	8-1/2 in. Muskota bird	210
314	Plaque	550
	Warwick vase	60
	Flemish inkwell	500
	Wood rose chamberstick	50
	Wood rose bucket	60
	Knifewood humidor	450
	Coppertone vase	150
315	Cornish vase	25
	Burnt wood vase	100
	Bouquet vase	25
	Blue drapery candlesticks	70 pr
	Rudlor vase	25
	Panella vase	25
	Roma vase	140
	Roma vase	30
	Loru vase	25
	Tutone planter	50
	Malvern vase	40
316	Luster compote	60
	Oak leaf vase	45
	Paragon vase	65
	Sabrinian pitcher	185
	Warwick vase	50
	Pumila vase	45
	Claywood vase	60
	Woodcraft squirrel	275
	Parian (pinecone) vase	85
	Florenzo jar	75
	Voile vase	95
	Ivory jardinlere	110
317	Greenbriar vase	17
	Oak leaf pitcher	15
	Ollas water bottle	10
	Bonito vase	5
	Stellar vase	110
	White & decorated ("Hudson") vase	140
	Noval vase	100
	Tivoli vase	65
	Roma Cameo vase	50

318	Noval compote	110
	Coppertone pitcher	350
	Louella vase	25
	Souevo ("Indian") vase	200
	Hudson vase	110
	Barcelona pitcher	200
	Delsa vase	35
	Silver deposit vase	475
	Forest vase	170
319	Top	
	Left white & decorated vase	150
	Center wht & decorated vase	300
	Right wht & decorated vase	150
	Bottom	
	6-1/2 in. patra vase	40
	11-1/2 in. wild rose vase	90
	6-1/2 in. wild rose vase	30
	8-1/2 in. blue ware vase	200
	8-1/4 in. chase vase	210
	7 in. blue ware vase	160
320	Top	
	Selma vase	175
	Muskota figure	200
	Patricia vase	35
	Terose teapot	130
	Pierre pitcher	45
	Pierre plate	20
	Silvertone vase	165
	Bottom	
	Zona sugar & creamer	100 yr
	Basket	PND
	Roma vase	85
	Hudson vase	120
	Florenzo vase	40
321	"Weller matt" bowl	PND
	Arcola candlestick	100
	Arcola bowl	140
	Etched matt vase	325
322	Dragonfly vase	150
	Frog vase	225
	Experimental vase	PND
	Ivory planter	80
	Barcelona bowl	100
323	Ragenda vase	50
	Classic vase	40
	Ethel vase	200
	Alvin bud vase	95
	Glendale vase	190
	Knifewood vase	130
324	Top	
	Left vase	100
	Right vase	85
	Center	
	Short roba pitcher	75
	Tall roba pitcher	120
	Zona pitcher	110
	Bottom	
	Left glendale vase	230

	Marvo vase	90
	Right glendale vase	200
325	1-C	125
	1-B	75
	1-A	55
	2	140
	3	260
	4	100
	5	95
	6	135
	7	75
	8	80 pr
	9	60 pr
	10	50
	11	40
	12	70
	13	100
	14	145
	15	100
326	1	65
	2	35
	3	50
	4	75
	5	75
	6	55
	7	85
	8	100
	9 (bowl)	75
	10	175
	12	45 pr
	13 (frog)	45
	14	90 pr
	20	85
	21	135
	22	100
	23	65
	24	65 pr
327	Top row	
	1	100
	2	95
	3	65
	4	90
	5	110
	6	90
	7	100
	8	120
	9	85
	10	85
	11	95
	12	90
	2nd row	
	1	110
	2	130
	3	95
	4	115
	5	110
	6	130
	7	100
	8	100
	9	110
	10	95
	11	110

	12	100
	3rd row	
	1	130
	2	85
	3	100
	4	85
	5	85
	6	110
	7	80
	8	120
	Bottom row	
	1	160
	2	80
	3	175
	4	250
	5	90 pr
328	2	135
	3	135
	4	110
	5	125
	6	120
	7	120
	8	90
	9	90
	10	135
	11	140
	12	130
	13	150
	14	130
	15	140
	16	230
	17	200
	18	275
	19	250
	20	250
	21	275
	22	275
	23	325
329	1	75 pr
	2	75 pr
	3	95
	4-A	75
	4-B	75
	5	45
	6	55
	7	55
	8	50
	9	65
	10	75
	11	65
	12	65
	13	65
	14	100
	15	95
	16	175
	17	75
	18	65
	19	85
	20	100
	Eocean vase	400
	Middle	
	B	200
	D	525

No.	Item	Price
	B	250
	B	200
	D	250
	Bottom	
	E	300 pr
	F	350
	H	500
	H	400 pr
	J	500 pr
331	2	45
	4	95
	7	90
	9	110
	10	95
	11	70
	13	100
	17	100
	19	100
	21	125
	24	185
	25	185
	27 Bowl	75
	Frog	40
332	Ivoris covered jars	100 ea
	Ivoris vase	75
	85	50
	86	40
	87	35
	633	40
	636	60
	638	75
	639	80
333	31	700
	32	750
	33	675
	34	600
	35	800
	36	875
	37	1000
	47	650
	48	600
	49	700
334	1	40
	4	50
	5	55
	6	60
	7	70
	8	50
	9	90
	10	100
335	2	35 pr
	12	65 pr
	14	100
	16	120 pr
	17	140
	19	160
	31	30
	32	50
	33	90
	Flower frog	25
	Large low bowl	75
336	401	160
	402	65
	403	55
	404	75
	405	60
	406	55
	407	50
	408	60
	409	100
	410	75 ea
	411	35 ea
	412	40
	413	45
	414	55
337	1	40
	2	85
	3	80
	4	80
	5	80
	6	95
	7	110
	8	100
	9	85
	10	110
	11	90
	12	70
	13 Bowl	75
	Candleholders	40 pr
	14 Bowl	80
	Frog	30
	15	100
	16	130
	17	165
	18	180
	19	200
	20	200
	21	125
	22	75
338	7D Forest	250
	63B Flemish	200
	7B Forest	175
	195 A Roma	210
	600 B Blue	200
	83 B Roma	235
	1C Pearl	375
	600C Blue	325
	16A Flemish	300
339	22 B Blue Drapery	65
	22 C Blue Drapery	95
	129 B Roma	225
	41 Roma	230
	40 Roma	200
	39 Roma	150
	7 A Woodcraft	200
	77 A Flemish	250
	18 A Flemish	200
340	4 Forest	300
	29 Woodcraft	90
	49B Woodcraft	75
	117B Roma	160
	184 Roma	100
	107B Roma	85
	14 Knifewood	130
	179 Roma	65
	15 Pearl	150
	153 Roma	90
	10 Knifewood	150
	16 Blue Drapery	60
	609 Blue	200
	15 Blue Drapery	50
	18 Pearl	200
	17 Woodcraft	165
	165 Roma	140
	12 Knifewood	260
341	No. 10	400
	No. 16	375
	No. 25	500
	No. 38	675
	No. 67	300
	No . 87	PND
	No. 233	PND
342	Prices not available	
343	72	45
	73	65 pr
	74	50
	75	60
	76	50
	77	45
	78	45
	79	45
	80	65
	81	61
	82	65
	83	PND
	84	PND
	85	100
344	Prices not available	
351	6-1/2 in. vase	600
	5-5/8 in. vase	800
353	Tile	150
354	Fortune and the Boy tile	150
	Delft tile	130
	King Lear plaque	PND
355	Prices not available	
356	Plaque	PND
358	Bear	125
	Tile	65
359	Bottom left	85
	Top right	85
	Center right	85
	Bottom right	855
	Top right	85
	Center right	85
	Bottom right	85